COURT HOUSE
A PHOTOGRAPHIC DOCUMENT

EDITED BY RICHARD PARE

CONCEIVED AND DIRECTED BY

PHYLLIS LAMBERT

THE WRITERS OF COURT HOUSE

PHYLLIS LAMBERT RICHARD PARE THE HONORABLE PAUL C. REARDON CALVIN TRILLIN

HENRY-RUSSELL HITCHCOCK & WILLIAM SEALE

THE PHOTOGRAPHERS OF COURT HOUSE

HAROLD ALLEN LEWIS BALTZ RICHARD BARTLETT DOUGLAS BAZ CALDECOT CHUBB WILLIAM CLIFT JIM DOW

FRANK GOHLKE ALLEN HESS PIRKLE JONES LEWIS KOSTINER ELLEN LAND-WEBER PATRICK LINEHAN NICHOLAS NIXON

IRA NOWINSKI TOD PAPAGEORGE RICHARD PARE STEPHEN SHORE BCB THALL JERRY THOMPSON CHARLES H. TRAUB

PAUL VANDERBILT LAURA VOLKERDING GEOFF WINNINGHAM

HORIZON PRESS

ACKNOWLEDGMENTS

The Court House Project was made possible by Joseph E. Seagram & Sons, Inc., who supported the research, the photography, this book and the preparation of material for a traveling exhibition being circulated in the United States and abroad under the auspices of The American Federation of Arts and The National Trust for Historic Preservation.

It would not have been possible to complete the project without the help of many individuals and organizations. For their assistance in the early stages of photography and their recommendations and support, we would particularly like to thank Aaron Siskind and John Szarkowski; also Harold Allen and Emmet Gowin. For their work in gathering research materials and documenting all the buildings in this book and many more besides, we would like to acknowledge the help of Minnette Bickel, Pauline Chase Harrell, Charles Hasbrouck, Virginia Huber, Susan Dynes, Herbert Mitchell, Adolph Placzek and the staff of Avery Library; also the staff of the Historic American Buildings Survey and the National Register of Historic Places. The National Trust for Historic Preservation, and particularly Mary C. Means and Cheryl Krieger of the Midwest office, were most generous with their knowledge of the county court houses of the Midwest. Above all, Paul Goeldner's TEMPLES OF JUSTICE: NINETEENTH CENTURY COUNTY COURTHOUSES IN THE MIDWEST AND TEXAS, which provided the basis of research on over five hundred buildings in the states covered, was an invaluable resource. So many county officials gave information and time that it is not possible to name them; without their cooperation all across the country neither the photography nor the research could have been completed. The enthusiasm with which they assisted photographers and supplied information and pictures of their buildings for our research files is greatly appreciated.

Our most invaluable assistants were Carla Caccamise Ash for her editorial suggestions and preparation of the manuscript and the captions; and Caroline Sederbaum, who assisted us from the beginning of the project, setting up the initial procedures and accumulating a working knowledge of the photographs. Together they organized and executed much of the work involved.

For administrative help, many people within the Seagram organization gave freely of their time, particularly C. Joseph Blunt, John Brunson, Earl Fries, Joan Grayson, Noel Manfre, Annette Perlman, Gideon Rabin and Al Rosa.

Tom Consilvio and Peter Bellamy printed many of the pictures to the most exacting standards. Dimension Color Labs made the color prints from which most of the separations were made.

Others who helped at various times and in most valuable ways were John Albers, Alice Cahn, Cathaline Cantalupo, Amy Clampitt, Cheryl Mercer, Alice Meyer-Wallace, Sonia Moskowitz, Weston Naef, the late Eleanor Pearson, Jonathan Rinehart, Lynn Strong, Wayne Thompson, Nancy Wechsler and Jerry van de Wiele.

The type for this book was kindly made available by the Printing Department of the University of California, for whom it was originally designed by Frederic Goudy; it was composed in San Francisco by Mackenzie-Harris Corporation. The book was printed by the Acme Printing Company, Medford, Massachusetts, and bound by Publishers Book Bindery in New York. The paper was made by the S. D. Warren Company. The book was designed by Eleanor Morris Caponigro, whose work turned an idea into a reality and who, having seen the idea evolve from something much more simple, remained undaunted.

The archive on which this book is based is placed at the Library of Congress. Prints of these photographs and many others not in this volume are available from the Prints and Photographs Division, Library of Congress, Washington, D.C. 20540.

PHYLLIS LAMBERT, DIRECTOR, and RICHARD PARE, EDITOR

CONTENTS

INTRODUCTION

Because there was no town until there was a court house, and no court house until . . . the floorless lean-to rabbit-hutch housing the iron chest was reft from the log flank of the jail and transmogrified into a by-neo-Greek-out-of-Georgian-England edifice set in the center of what in time would be the town square. . . .

—William Faulkner, REQUIEM FOR A NUN

This exploration of county court houses in the United States is gathered from an archive assembled with the intention of providing insights into the characteristics of these particularly American buildings. The court house, from the very beginning of each community, has been an integral part of the life of every settlement as it evolved into a county. It was there that celebrations were held and emergencies brought to the attention of the populace. Court houses provided mustering places during the War of Independence and the Civil War, and victories and reverses were first announced by bulletins posted on their doors. Because they were often completed before the local churches, they frequently served as meeting places—for religious services, dances and Masonic gatherings—as well as fulfilling their primary function, the dispensation of justice. Court days were times of great activity in the county seat and the population, as it does even now in the more rural parts of the country, would gather to hear the trials and exchange the news. Traces of all these activities remain. They have become analogues for the history of the country and have been recorded in their turn in the photographs for the project on which this book is based. The construction techniques, the architectural vocabulary, the environment in which a building stands and the patina of use, when taken together, describe the social and symbolic importance of court houses at least as much as their architectural prominence.

During the two and a half centuries spanned by the book, the structures which have served as court houses have changed radically in outward appearance but only a little in their symbolic significance and purpose until the twentieth century, when the changing needs of a technological age have modified the function and scale of the buildings.

The photographs make it clear that the court house, from the earliest time to the present, has been a denominating factor, making the transition from a settlement without focus to an awareness of its role as the judicial and administrative center of the county. An example of the transition may still be seen in the second half of the nineteenth century in the two court houses which have served Hinsdale County, Colorado—the first, a log cabin of about 1865, was replaced some twelve years later by the still modest but more commodious court house of 1877 (Plates 10, 214). Lake City, having boomed early, soon stabilized and had no further need to replace it. As one might expect, however, most of the early court houses are to be found in the Eastern Seaboard states, one of the three areas extensively documented for this book. The eastern states provide a wide range of fine examples. The building of 1725 for King William County in Virginia is the earliest surviving court house which has remained in continuous use (Plate 153). The solidity of this brick building has something to say about the country in which it stands; regional differences can scarcely be better pointed out than by comparing it with the light wood frame structure of the court house built a generation later at Plymouth, Massachusetts (Plate 33). These buildings were superseded by a tradition in the Greek or Roman mold, evidenced most strongly in the East; for example, Winchester, Virginia,

of 1840, and Worcester, Massachusetts, of 1843–45, which was extended in the same manner in 1898 (Plates 36, 50).

The second area of the country to be extensively documented includes the Midwest and Texas. The photographs show a rapidly expanding nation in the full confidence and optimism of the period immediately succeeding the Civil War. Particular emphasis was given to Indiana in order to provide a broad and indicative view of the subject. Since special laws had made it possible for the county commissioners to finance great flights of fancy in the best materials, this state was found to contain some of the richest court house architecture of the period.

Fine examples from the Midwest representing a large part of the nineteenth century are: Starke County, Illinois, of 1856–57 (Plate 13); St. Louis, Missouri, of 1839–62 (Plate 47); Davis County, Iowa, of 1877–78 (Plate 77); Miami County, Ohio, of 1885–88 (Plate 78); and Starke County, Indiana, of 1897–98 (Plate 1). In Texas the most elaborate are the court houses for Ellis and Wise counties (Plates 272, 274) to the northwest and southeast of Fort Worth. It is extraordinary that these two buildings, constructed almost simultaneously in 1884–87 and 1885–87, and less than one hundred miles apart, are so nearly identical that care is required to distinguish between them. The architect of these buildings, J. Riely Gordon, continued to use this same plan for many of his seventy-two court houses—modifying only the materials and the detailing—until at least 1901, when he completed the court house in Harrison County, also in Texas.

The third area to be widely photographed was the West. Here, because the county unit is much larger, there are far fewer counties, and it was correspondingly simple to cover the territory extensively even though the mileage between county seats is greater than in the significantly smaller counties of the East. Indeed, Massachusetts would fit quite comfortably into Nye County, the largest in Nevada and among the largest in the country. Because the West was generally settled later, the court houses are newer. When they are in rural communities, however, where the population is still small, they have been replaced only relatively recently. Some of those that have remained are virtually timeless; they have kept a sense of the country as it was, with a basic simplicity imbued with the atmosphere of the frontier which has elsewhere often been overlaid or replaced. Examples that come to mind are Mariposa County, California, of 1854 (Plate 186), Hinsdale County, Colorado, of 1877, and San Juan County at Silverton, of 1906, in the same state (Plates 214, 26).

Throughout the country, court houses are archives where the history of each county is preserved, not only in the deeds, tax rolls, registry of birth and death, and the basic records of property, but in other and more human histories; the commemorated dead of the nation's wars are celebrated in photographic displays and rolls of honor in the halls, and on the greens outside almost every building are memorials to those who

served and died; busts of famous citizens appear everywhere; the industry or produce of the county is displayed and promoted by the chamber of commerce. Every courtroom contains the same objects: a desk for the clerk, tables for attorneys and their clients, a witness stand, and the judge's bench. These are of greater or lesser elaboration, with slight regional and local variations. The judge's position is always at the focus of the proceedings to signify his status as arbiter, and also elevated and apart to denote the dignity of his role and his impartiality. On the walls the portraits of judges of the past, by the differences in dress, give a strong sense of chronology. The medium in which these are made has also changed; where once an elaborately framed oil portrait was chosen, now an eight-by-ten-inch glossy black-and-white print will often suffice.

All this reinforces the primary role which the court house once fulfilled, further emphasized by its position in a square in the middle of town or occupying the highest eminence, and often crowned by a tower which rises above its surroundings. When it was originally constructed as the largest and most prominent building in town, it effectively denoted the pride and resourcefulness of the community. The status of the county seat was often hotly contested and was much sought after, for it brought distinction and the desired prize of greater commercial activity—of which all the outward and visible signs may still be seen in the elaboration of the court house. On occasion, these efforts have involved counties in exorbitant public debt; one example is the building for Macoupin County, Illinois, discussed in the text (Plate 66). Periods of plenitude may be plotted by the court houses of each era, with more activity during the boom years and little or none during times of national crisis—wars and economic depression. The pattern is obscured in the depression era of the twentieth century, when buildings were funded by the Works Progress Administration, an agency of the federal government.

With the end of the First World War, the story changes. The time when the nation was made up of loosely combined independent county units was over, and the attitude of the country was different. This came about with increased mobility and more rapid communication. The shift of the center of power toward the federal government left the counties in an ambivalent situation compounded by the gathering momentum of sectors of the population to the cities. The rapid expansion of administrative services outstripped the capacities of the existing structures in the major urban centers, many of which were replaced by far larger court houses. The increase has affected the architecture, with a greater proportion of space devoted to offices, and as a result the buildings have become more impersonal. Another consequence is a small number of high-rise court houses, one of the most distinguished early examples being Woodbury County, Sioux City, Iowa, built in 1918 (Plate 329) though obviously designed with reluctance to break from the tradition of monumentality, so that its high-rise section devoted to offices is still a hesitant reinterpretation of the idea of a tower as landmark. A more recent example is the new Government Center for Hennepin County in Minneapolis, 1971–75, which stands beside its predecessor (Plate 152).

Even the sites have sometimes changed, reflecting the change in the symbolic significance of the court house as well as the growth of business and manufacture that has moved the emphasis to the town's periphery; the new court house is occasionally sited away from the center, leaving the old one vacant and liable to destruction. After the First World War, the cost of fine materials escalated rapidly, and because of different attitudes there was no longer the will to utilize fine materials and craftsmanship in county buildings. The decline in the social function of the court house enforced a new austerity, and few

opportunities have arisen for an architect to utilize a contemporary vocabulary to good effect. Part of the problem for modern court house designers is the lack of an adequate definition of what a court house should be; the disparity of function and scale from one situation to another has robbed architects even of certainty of purpose. The individualism of the nineteenth century has been extinguished, and in all but a few cases the new buildings betray the confused attitude concerning their function.

The court house in particular, the linch-pin around which the town developed, may be removed only at great hazard to the fabric of the environment. Too many have been destroyed, and with them, examples of fine craftsmanship have vanished into the realm of memory or are preserved only in photographic documentation. Such buildings—some with interiors fitted out with fine wood and plasterwork, imported marble and mosaic floors, and ornamental light fixtures of iron and glass, and others remarkable for their elegant simplicity—are part of the heritage of the country, and their survival is of crucial value to the future. The court house is frequently the most interesting and individual building in the county. That it may not be the foremost architectural example is not important; it fulfills its role as a focus and point of orientation. By careful modification and imaginative reuse, many fine buildings all across the country may be enabled to continue to serve the community in which they stand. Kings County, California (Plate 306), and Marshall County, Iowa (Plate 230), are good examples, but the situation remains uncertain for Buchanan County, Missouri (Plate 231), and Warren County in the same state (Plate 70). Placer County in California (Plate 305), one of the most prominently sited of all court houses, was in jeopardy for some time but is now in process of restoration.

The above conclusions are drawn largely from the photographs on which this book is based. Gathered over three years from September 1974, the documentation constitutes the largest resource on the subject and includes more than eight thousand negatives and images of over one thousand court houses. These are supplemented by research material which consists primarily of the correspondence carried on with all the counties and many organizations involved directly or peripherally with the court house, together with most of the available literature on the subject.

The photographs were made specifically for this project to show the full spectrum of the buildings and to give a strong sense of their role. It was intended that this book should communicate something of the way these buildings feel as well as the way they look.

Photographers of architecture have only limited resources at their disposal. Much depends on time of day and time of year. Selection of the significant detail and the choice of where to stand (determining what to include within the frame and what to eliminate), are basic tools. Images may carry an enormous sense of symbolic meaning with small reference to the structures of which they represent a small part (Plates 3, 106); others, again with only small reference to the structure, by the breadth of the photographer's vision give a sense of a building as part of the fabric of the city (Plates 53, 94). Images such as these are locational; they provide insights into the diversity of county seats. The problem of the portrayal of interior spaces is one of suggestion; it is important, both within and beyond the frame, to try to evoke a sense of how it feels to move through rooms and hallways. Photographs can only be interpreted by those who see them through the eye of their experience—what may be created by the imagination and by recall of similar situations. Thus it is the task of the photographer to make that act of recreation possible, choosing the most salient point of view and achieving a portrayal of the subject as a whole with great economy of means.

The photographer must consider the interiors and the relationship to the environment as inseparable attributes of the building, and the depiction of them is part of the challenge in photographing architecture. Many of the photographs in the files are straightforward documents made as simple records and do not transcend the normal expectations for images of this kind. A large number, however, are visually powerful statements, elevated—through the selective ability of the photographers —to higher levels of interpretation. Both types of image are represented here to resonate one upon the other and provide a more complete view of the subject.

This book is based on a body of material which includes photographs of court houses from each of the forty-eight contiguous states. Of the 3,043 counties in the country more than one-third were photographed—a generous cross section, broad enough to be indicative of breadth and chronology as well as the spread of architectural ideas. In order to develop these extensive resources, twenty-four photographers were commissioned to work in widely distributed areas of the country. Each brought insights and a personal vision to the project, creating a far richer resource than conformity could have accomplished. The subject itself was closely enough defined to set its own limits within which the widest possible freedom was available to the photographers. The pictures they made enabled me to see the subject from constantly changing points of view and were continually assessed in order to build an image of the court house. The diversity they imparted made it possible to do justice to the subject of this book and to the exhibition which it complements.

RICHARD PARE

THE RECORD OF BUILDINGS AS EVIDENCE

Each generation has left a visible trail of its passage across the face of the earth—such as religious monuments, public or private—and it is through the study of these monuments that, today, we may form an exact idea of the various civilizations. —Charles Nègre, 1854

This book is in a sense a detective story—a search for the image of the county court house, the most significant regional building in the United States. Perhaps it is because the court house lies deep in the conscience of the nation that it is still unrecognized as a representative building. Court houses, nodal points in the network of thousands of counties throughout the country, have been unique in serving both the basic needs and the formal expression of communal aspirations. The conviction that the study of this building type across the nation over two and half centuries would add to an understanding of history moved me to conceive and direct this project.

As a representative building the court house as a subject is ideal. It provides a sampling on a national level large enough to be significant, and yet is manageable since its numbers are more limited than most building types for commercial or residential purposes or for public use —banks, libraries, post offices, city halls. The court house is a public building with which everyone comes into contact in the course of a life span: those who own land which they register there, those who may be helped or punished there—every citizen visits it on ordinary and special occasions. Thus its architectural expression is apt to be more relaxed than that, say, of the State House. Those who built the county court house were not officials desiring to relate to a wider constituency, but citizens whose concerns were local. The standard was the next county seat rather than a remote city, so that the buildings tend to reflect those local values rather than more formal architectural concerns, and they represent the institution for which citizens of the United States bear a profound respect—the Law.

The buildings which a society constructs convey information at a symbolic level. Collectively, they are a formal expression of its needs, values and aspirations. While structural soundness and functional suitability are requirements of a good building, the ordering of the materials and the means of construction, consciously or not, also represent abstract concepts. In architecture at its finest, symbolism is inherent in the way the building is put together, as exemplified in Gothic and the best of modern architecture. At times, however, the architectural vocabulary of one civilization has become the metaphor for another. For example, the early American republic adopted the Greek temple as the fitting expression of a new democratic society, and it came to be closely associated with the court house as the "Temple of Justice."

The subtleties in the changes of symbolism attendant on the growth of a country go beyond a pure formal vocabulary, and in making a document it is necessary to present varied aspects of the subject. Therefore, the photographs in this book show the court houses in their widest architectural sense. First, they depict location: in the semi-tropics or the western mountain ranges; in a remote village, a small town or a

major city; on a hill, dominating a square or overshadowed by high-rise office buildings; dignified by a fringe of palm trees or diminished by a network of signs, lightpoles, traffic signals and electric wires. They also document the architecture of the exterior and interior as well as the way the court houses have been used, changed, added to; and they record the memorabilia thought important by those who used them. This composite image tells us much about the structure and the values of a developing country.

Three essays supplement and sharpen the visual evidence. Justice Paul Reardon, from long experience as distinguished jurist of the Massachusetts Supreme Court, sets the historical context of the county system. Calvin Trillin, out of his continuing interest in the life of small communities, gives a sense of the politics, the characters and the lore of county court houses. Henry-Russell Hitchcock and William Seale, from both the photographic evidence in this book and a vast and singular knowledge of the architecture of the United States, establish the buildings within architectural history.

In these texts the relationship between different county systems and architectural expression is suggested and questions of the appropriateness of architectural vocabulary are raised: the continuance of the Classical as the symbol of the court house; the similarity of churches and court houses in New England; the rejection of the Gothic used for many other building types because it was considered ecclesiastical and therefore inappropriate; the wide acceptance of the architecture of Henry Hobson Richardson which promised to become a national style; and finally, in Frank Lloyd Wright's Marin County Civic Center, the coming together of Jeffersonian ideas of democracy with the vibrancy of the Midwest in the most recent flowering of court house architecture.

The role of the architect is brought into focus, not only in the progression from the journeyman-builder to professional practice, but most significantly in the existence of many local offices, notably in the Midwest and Texas, which reveal the strong indigenous character of American communities.

The morphology of the court house is implicit: the arrangement of the courtroom, its placement on the second floor, its relationship to the grand stairway and to other parts of the building. Answers to questions about such matters as the laws and attitudes affecting the financing of construction, the choice of site, the details of plans and the debates on vocabulary and symbolism are to be found in the archives of each county seat. Still other issues remain, among them the changes of the role and of the architecture in relation to the shift of power to the federal government, and the social relationship of the court house to the civil rights battle of the 1960s. These and many other aspects invoke future

study. It is hoped that by presenting this initial body of material the book will provide the context for further investigation so that the court house and other areas of American architecture may be respected as evidence of the accomplishments and aspirations of the first two hundred years of the United States.

Court House—A Photographic Document belongs to a long tradition of representations of buildings that began to be made methodically in Europe in the sixteenth century. In France, from the time of François I, carefully engraved plates were bound in sumptuous volumes. Their intent was in essence political, beginning with Les plus excellents bastiments de France by Jacques Androuet du Cerceau, issued in Paris 1576–79, publicizing the power of the king and his domain which evolved into the more subtle cultural imperialism reflected in the superbly detailed volumes of 1878 by architect Charles Garnier to show his new Paris Opera House. Photographic documentation began in France in the 1850s and maintained the tradition, already established by graphic artists, representing the stature of the country through its buildings. Some of the early masters of photography—Hippolyte Bayard, Charles Nègre, Henri le Secq, Edouard Baldus, the Bisson frères—made exhaustive records of buildings and great engineering works for various government departments under the Second Empire. Many of those photographs were known to the European public from international exhibitions, salons and showings by photographic societies in Paris, London, Brussels, Vienna and New York; and from portfolios sold by influential publishers such as Blanquart-Evrard and Goupil fils. Some photographs, such as the extensive record made by Baldus of the new Louvre erected between 1852 and 1863, must have been partly responsible for the profound impact of the buildings in North America.

In a more romantic way, but still based on national pride, lithographers and photographers in France contributed to ambitious publications describing historic monuments and remains as well as the landscape. These works were modeled on Baron Taylor's Voyages pittoresques et romantiques dans l'ancienne France, published in twenty volumes from 1820 through 1878, and on his pioneering use of lithography.

Roman ruins had long been a preferred subject for graphic artists. They had been measured, drawn and presented in architectural treatises since the Renaissance in order to provide models for new buildings with the intention of inspiring certain moral and spiritual qualities in society. Picturesque views of the ruins, made for the pilgrims at Rome, began to be gathered in 1544 by the first great print publisher, Antoine Lafrery, who issued collections of prints under the title Speculum Romanae Magnificentiae, "the mirror of Rome's magnificence."

Early photographers continued the picturesque tradition. They also documented the great buildings of the past which began to be widely known in the 1860s once a way was found to manufacture quantities of prints of uniform quality. By the 1880s such photographer-publishers as Alinari in Florence reproduced images of buildings as souvenirs for a modern version of the Grand Tour. In the last decades of the nineteenth century this became a frantic activity: thousands of tourists and architects from Europe and the Americas, pouring off newly improved trains and steamboats, snapped up stereograms and too often debased prints mounted on cards assembled in albums, as armies of photographers swarmed around every ancient monument; it conjures up the image of fast-frame mob chase scenes in the films of Buster Keaton. Nevertheless, the prints and albums, along with the more formal treatises, spread architectural concepts while providing source material for scholars—especially for historians of architecture, who were becoming increasingly aware of the importance of empirical data. The

accuracy of photographic representations made it of special value, preferable to hand-drawn examples. Above all, the dissemination of material ultimately served to establish knowledge of and hence respect for the buildings reproduced, and led to a desire for their preservation which, in turn, became an impetus to photographic documentation.

Initially, it was historical interest rather than physical preservation of buildings that motivated documentation of ancient monuments and city quarters. Following the Napoleonic Wars this interest in the past flourished in France, where monuments were prized as primary evidence in the study of history. The Comité des Monuments Historiques, formed in 1837, initiated a program of photographing imperiled historic buildings throughout France in 1851. Baron Haussmann, in restructuring Paris for Napoleon III as Prefect of the Seine, destroyed entire streets and neighborhoods. Ironically, he countered criticism of his actions with the promotion of historical research directed at the compilation of a detailed record of all that was to be swept away. A department within the city government of Paris was responsible for developing techniques of photography and reproduction; photographers documented archaeological specimens; and Charles Marville was commissioned by the city to photograph its old quarters before demolition. Only after the resignation of Haussmann and the Franco-Prussian War, in 1870, did a strong preservationist movement develop in France.

A distinct sense of the past and its moral virtues also appeared in early nineteenth-century England. Augustus Welby Pugin, an architect of the Houses of Parliament, and reformists such as the Ecclesiological Society in Cambridge believed that the reinstatement of certain features of the past would help restore a desirable spirituality. Their publication of measured drawings of early Gothic churches profoundly influenced architectural expression in England and North America during the mid-nineteenth century.

Preservation later became an important issue in Britain as in France. The Society for Photographing the Relics of Old London, a private group formed in the late 1870s, commissioned Dixon and Bool as photographers, and during the next eleven years the Society issued one hundred and twenty photographs of threatened buildings. Significantly, this project was part of an effort to save the buildings. In Scotland, Thomas Annan documented the old closes and streets of Glasgow for the City Improvement Trustees in 1868. Old Country Houses of the Old Glasgow Gentry, published in 1870, with photographs by Annan, was a conscious attempt to prevent the structures from being forgotten. The introduction to the book stated, "We get nothing for nothing in this world, and our wonderful present prosperity costs us, among more valuable things, many an interesting monument of the past in Glasgow and round Glasgow." The form of the book was patterned on previous English volumes containing engraved images of dwellings and "descriptive notices," printed largely for subscribers who were usually the owners of the structures shown, but the objective of the earlier publications was to record rather than to preserve the buildings. One example, Neale's Views of Seats of Noblemen and Gentlemen in England, Wales, Scotland and Ireland (1818–29), declared its intention "to mark with fidelity the rise and gradual progress of our subject, exhibiting the rapid and successive changes that have taken place in the national taste during three centuries."

The North American experience was different from the European. The primeval landscape and conquest of virgin territory were compelling features. Instead of consciously documenting past glories, North Americans used the camera to record the path of advancing civilization and the retreating wilderness. In the early nineteenth century the Lewis and

Clark Expedition was in part a "scientific and literary" survey of little-known western territories. The records of the Expedition, including the leaders' diaries, specimens, maps, and sketches by William Clark, provided valuable information and fell within the tradition of the numerous reconnoitering surveys made by topographic artists of the Royal Engineers during British Colonial rule. The mandate of many such expeditions was substantially political; for example, Lewis and Clark's was largely to lay claim to territory and to locate a route to the Pacific Ocean for the newly united states. Where they initiated documentary undertakings, territorial explorations were an impetus to the development of photography in North America. Most were for the government. Before the Civil War, photographers usually making daguerreotypes, now mostly lost, accompanied geographic expeditions to locate the land features which would influence road and rail routes to the Pacific. After 1865, photographers, many trained by the experience of the Civil War, were employed on surveys for railroads and on many government geological expeditions. To these we owe the heroic and hardly believable landscape photographs of Timothy H. O'Sullivan, Andrew Joseph Russell, William Henry Jackson and the two photographers from San Francisco, Carlton E. Watkins and Eadweard J. Muybridge, who were engaged in exploratory expeditions on their own. Some of these photographs have an architectural quality: rocks take on the attributes of sculpture; mountains become the monuments of America. The large contact prints of the landscapists made under incredibly difficult circumstances served both scientific and legislative purposes. T. H. O'Sullivan worked on the government survey for a ship canal in Panama, and W. H. Jackson's photographs of Yellowstone in 1871 had a direct effect on early preservationist law and were instrumental in passage of the Congressional bill creating the Yellowstone National Park in 1872.

Systematic documentation of buildings in the United States seems not to have gathered momentum until the end of the nineteenth century. Engravings, lithographs, and eventually photographs introduced from Europe reinforced by the effect of the influx of new immigrants from Central Europe made a wide range of architectural vocabularies available at a time when towns and cities were proliferating across the United States. These had a far-ranging influence intensified by the quickening of communications on the taste and significance of architecture in North America.

American publications relating to buildings, monuments and engineering works for the federal government were not infrequent in the 1830s and '40s, yet, unlike the European publications, they were sparsely illustrated by plates. There was, however, one major exception: at least thirty-eight issues, totaling some four hundred plates, of PLANS OF PUBLIC BUILDINGS IN COURSE OF CONSTRUCTION, published in 1855–56 under the direction of the Secretary of State. The line engravings are in the best European architectural tradition, but the statement of purpose was more American: it was hoped that the improvements shown, the "wholly new" use of iron beams and girders and other details, might prove useful.

Although printed handbooks for architects and advice published for home builders popularized architectural details and construction techniques, buildings were not documented with the same degree of intensity and conviction as the land. More often existing buildings were made known outside their locales through daguerreotypes and stereograms. Studies of daguerreotypes have demonstrated that almost every American city was covered to some extent, and occasionally by impressive multi-plate panoramas, as in San Francisco and Cincinnati; however, few daguerreotypes of cities survive. Stereograms, widely viewed in innumerable parlors, informed Americans of the great fires and re-

building of cities, the growth of new towns and the rash of new civic buildings constructed after the Civil War. Yet these floods of photographs did not combine to form a valued corpus of knowledge. They were presented not as data, but as news.

Of a more lasting impact were images of buildings printed in books. Woodcuts of American buildings appeared in local histories as early as the 1830s. When presented collectively, before the 1880s, their format often followed the English pattern of text and images describing the houses of the famous. G. P. Putnam issued HOMES OF AMERICAN AUTHORS in 1853; the following year HOMES OF AMERICAN STATESMEN by the same publisher contained the first photographic print to illustrate a book in North America. VILLAS ON THE HUDSON, 1860, was the first book in the United States in which photographs were transformed into lithographs for the purpose of reproduction. A generation later houses of the wealthy were referred to as "country seats" and elaborately published in limited editions. One such volume proclaimed American villa and cottage architecture to be a result of a renaissance in American art brought about by the Centennial Exhibition at Philadelphia of 1876. Again the organizing principle was not to document, for such work focused not on history but on success, purportedly to show "how art is affected by the individual character of a wealthy and cultivated portion of our citizens" and that "the domestic architecture of no nation in the world can show trophies more original, affluent or admirable."

As the centennial celebrations approached, the growing pride of the country in its buildings became visible in a type of popular documentation comparable to those being produced at the same time in Europe. A counterpart of VOYAGES PITTORESQUES by Baron Taylor is PICTURESQUE AMERICA, edited by William Cullen Bryant and published in 1872, though in two volumes rather than twenty. Books on buildings in the United States had begun the critical transformation from simply presenting to actually documenting structures of the colonial and revolutionary periods. By 1874, such works were also clearly being inspired by a concern for preservation of the built as well as the natural environment. The first issue in 1874 of a monthly publication, THE NEW YORK SKETCH BOOK OF ARCHITECTURE, edited by H. H. Richardson, explained that in part the editors "hope to be able to do a little toward the much needed task of preserving some record of the early architecture of our country now fast disappearing."

There seems little doubt that the centennial encouraged a flowering of pride in American architecture; we are just beginning to discover the types and extent of the material. One of the most interesting examples is provided by the American counterpart of Alinari, Albert Levy, who published a photographic series on architecture in the 1880s. Thirty-three are known. At about the same time, monographs on individual buildings began to appear. Architectural journals, which had first appeared in the 1870s and later increased in number and influence, also issued architectural monographs. Commercial firms and architects published albums of photographs showing their buildings. Universities and especially cities were popular subjects for numerous and various types of publications. A series entitled ART WORK portrayed many cities in the United States and Canada, each consisting of several fascicles. Photographs were also commissioned for popular histories of cities; the NEW YORK METROPOLIS, a compendium of three hundred years of New York's history, boasted a thousand illustrations, and Moses King published a large series of views and handbooks during the last twenty years of the nineteenth century. Such books and photographs, as well as builders' guides and architectural magazines, gave wider circulation to building models once half-tone reproduction became practical in the 1880s. By the time of the World's Columbian Exposition of 1893 in

Chicago, such works were common, and the many different books illustrated with photographs must account in some measure for the considerable influence the Chicago fair had on architecture and city planning in North America.

In contrast to official celebrations and fashionable homes and buildings of the affluent and powerful so proudly displayed, other documentary projects made North Americans aware of a very different aspect of the urban environment although they were not concerned directly with buildings. How THE OTHER HALF LIVES, with photographs and text by Jacob Riis, published in the 1890s, and, two decades later, the widely published photos of Lewis Hine showed different aspects of the appalling living conditions which disgraced American cities. Such documentary works were a contributing factor in the passage of remedial legislation. During the depression, the impressive power of visual documentation was demonstrated through the vast photographic undertaking of the Farm Security Administration to bring to public awareness the waste, poverty and destitution in the United States. It was the most comprehensive photographic document ever achieved. The photographs, published everywhere, gave Americans a new view of themselves.

It is fitting to conclude this view of concepts related to documenting the built environment, that is, the record of buildings as evidence, with some account of the broad schemes which were planned by photographers, though rarely completed. Because of the range and breadth of subject matter which it could cover, the camera opened new possibilities of viewing man and his works in a universal context, an urge which has appeared throughout recorded time. In the Renaissance the view of a world with man at the center permeated all art forms. The printed book made known representations of Vitruvian man and the ideal city related to a totality through the paradigm of Pythagorean geometry. A seventeenth-century work published in France included a view of cities of the world integrated with a description of the world systems, ancient and modern geography, and a vision of the universe. Less than half a century later, the first general survey of architecture drawing on various sources was published by a German architect, Fischer von Erlach.

When the International Institute of Photography, an arm of the Répertoire Iconographique Universal, was founded at the beginning of the twentieth century, it became part of a world-wide inventory which sought to illustrate human activity in all manifestations. This scheme was mentioned in THE CAMERA AS HISTORIAN, published in 1916 to establish methods of handling the vast photographic record already accumulated since the 1880s. Several ambitious schemes of a like nature were initiated, but only two were completed and published: for LES EXCURSIONS DAGUERRIÉNNES, over one hundred views in Europe, Africa and North America were made between 1840 and 1844 and printed as aquatints for the publisher N. M. P. Lerebours in Paris; and EGYPTE,

NUBIE, PALESTINE ET SYRIE, with photographs by Maxime Du Camp, was published in Paris in 1852.

Among the projects which failed in the planning was that of H. E. Insley, a daguerreotypist who asked colleagues to participate in collecting views of cities and villages in the United States. Other schemes came closer to meeting their objectives: for example, the National Photographic Record, formed in 1897 by Sir Benjamin Stone, was partly completed. Stone sought to record "not only the buildings—the places which have a history or are beautiful in themselves—but the everyday life of the people." The archive, consisting of prints made by regional photographic societies, was to form a permanent record of contemporary life across the British Isles showing "the manner and customs, the festivals and pageants, the historic buildings and places." These documentary studies were to be deposited in the British Museum. More than four thousand photographs, twelve hundred taken by Stone himself, were housed in the Museum's print room in 1910 when the record was dismantled because it was felt that the work could more effectively be carried on by county and other local societies. Similar groups appeared in the United States, leaving some historical societies with important holdings for research. Unfortunately, these records are known only to a few specialists because of a general failure to recognize their value, their context and the importance of making them broadly available through publication.

The extraordinary document of Paris by Eugène Atget, whose work was begun about 1898 but was little known before his death in 1927, was never published in its entirety. Individually, Atget's photographs have been important as models, but his systematic approach is only now being increasingly acknowledged. Year after year, he photographed subjects by categories, among them historic buildings, architectural details, fountains, the statues in the parks of Paris and of Versailles, churches, markets, vendors, street scenes, shop windows, and houses which were solidly comfortable as well as the most decrepit of buildings.

Even the grand objectives never realized have left important statements of man's conditions and aspirations, whether through written declaration or visual record; nothing would otherwise have existed. One such fertile project belongs to the early years of photography. Charles Nègre in 1858 drafted a memorandum to Napoleon III proposing a photographic catalogue of the history of man, his civilization and his planet. The commission was not granted. A few years previously, Nègre had undertaken on his own, from 1852 to 1854, a portfolio entitled MIDI DE FRANCE. It is from his manuscript, perhaps intended to serve as the introduction to this portfolio, that the epochal statement which opens this article is drawn: ". . . it is through the study of these monuments that, today, we may form an exact idea of the various civilizations."

PHYLLIS LAMBERT

COURT HOUSE

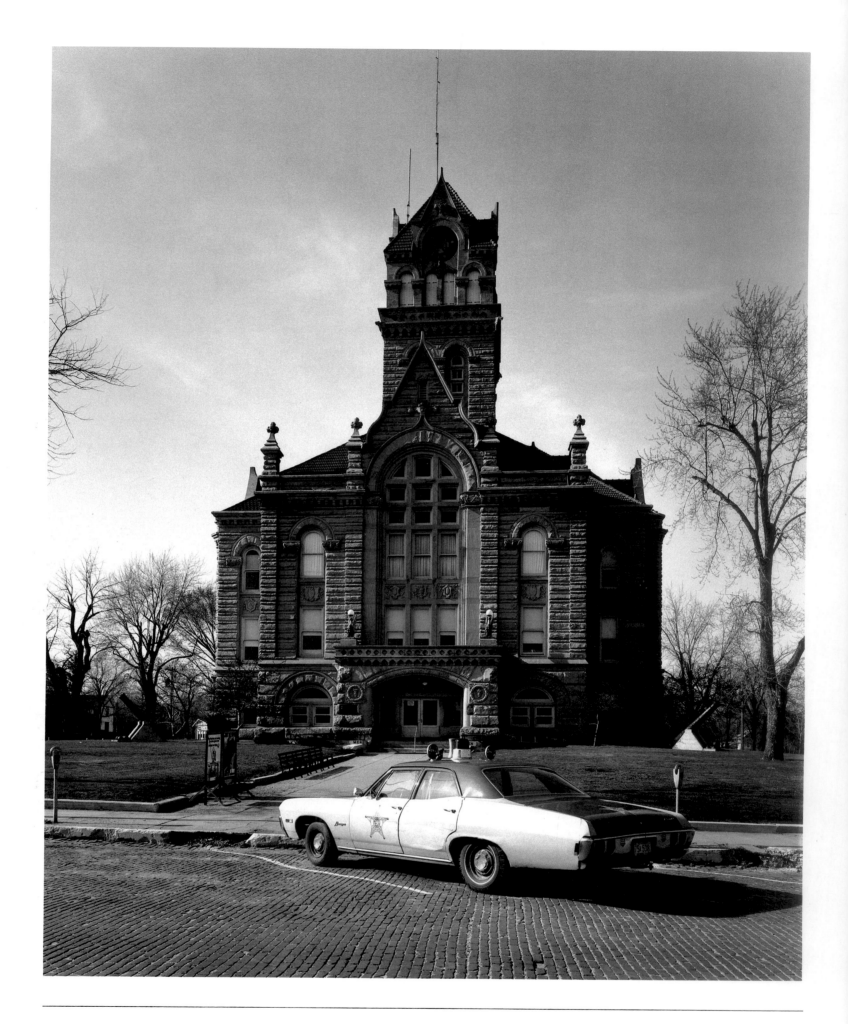

Plate 1. Starke County Court House, Knox, Indiana, 1897-98. Architects Wing & Mahurin. Photograph by Bob Thall.

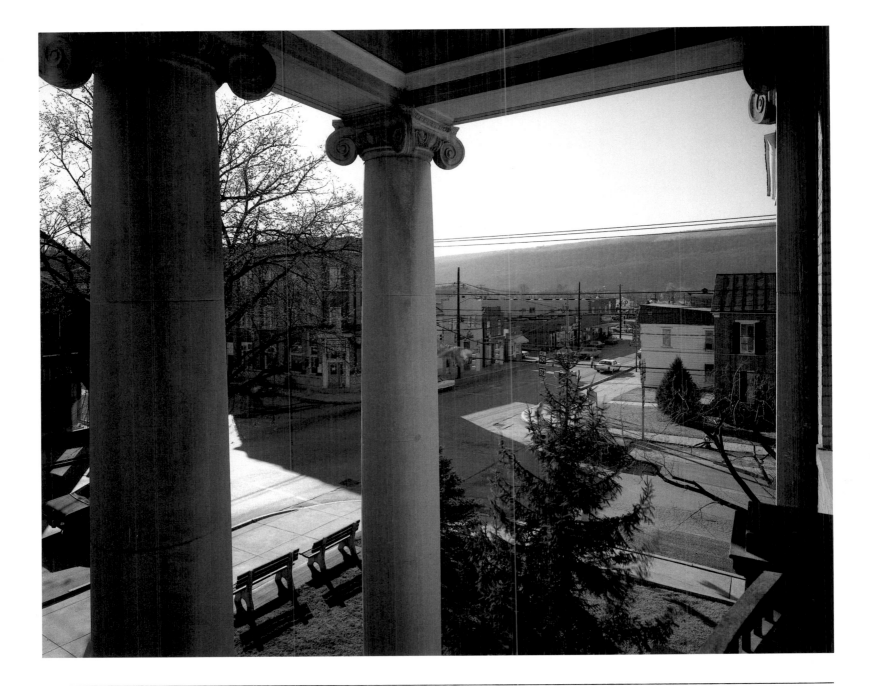

Plate 2. View from Hampshire County Court House, Romney, West Virginia, 1833-37, rebuilt 1922. Photograph by Stephen Shore.

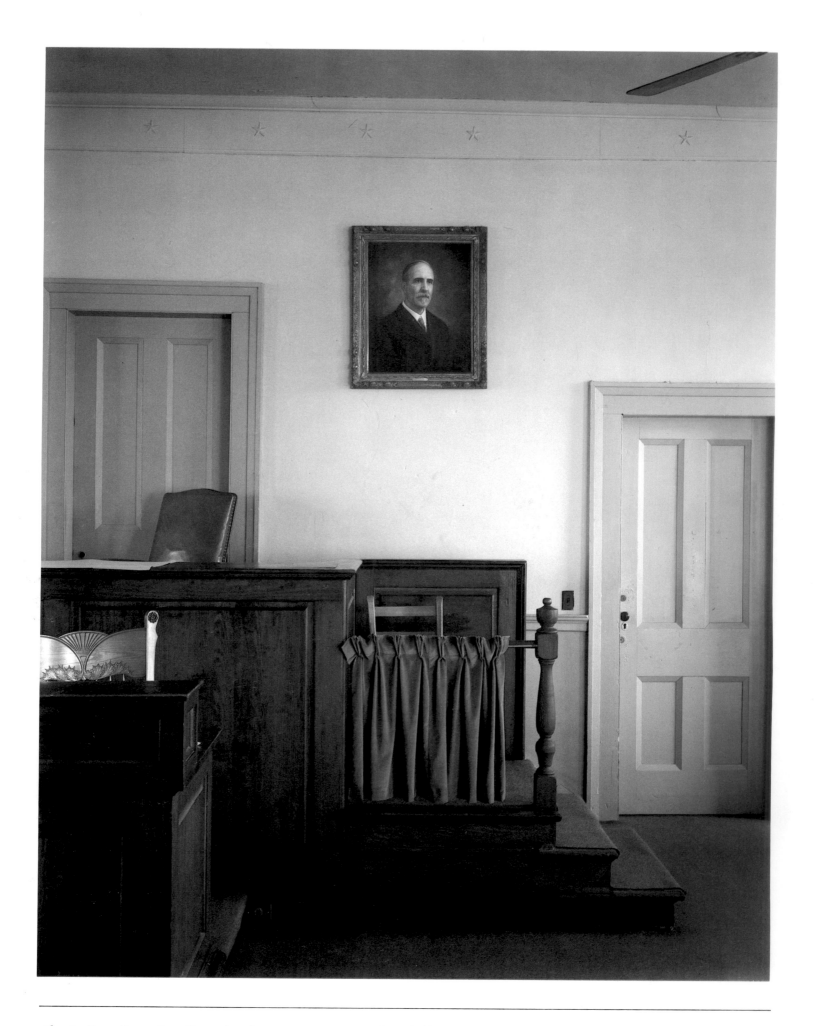

Plate 3. Greene County Court House, Greensboro, Georgia, 1848-49. Architect-builders Atharates Atkinson and David Demarest. Photograph by Stephen Shore.

THE ORIGINS AND IMPACT
OF THE COUNTY COURT SYSTEM

THE HONORABLE PAUL C. REARDON

The court houses in this volume are witnesses of the warp and woof of America. Countless dramas have been played out within and around these landmark buildings. It is they that have brought our heritage of law most directly to the people. In a very real sense, they are our history.

Many Americans have seen pictures of the nation's Capitol—but not the Capitol itself. To them Washington and even their own state houses are *terra incognita*. Not so their county court house. Here local murderers were placed on trial and sentences imposed. Here neighbors' quarrels were adjudicated, land titles settled, family estates probated and distributed, marriages performed and dissolved, orphans succored. Here in the depths of a New England winter or the steamy air of a southern summer the citizens of the county assembled to hear the trial and disposition of some un-usual case. In the great cities the court houses are often simply another group of buildings competing for attention with larger structures devoted to commerce and to industry. But in the rural areas the county court house is frequently the largest and most impressive edifice for many miles around. It is the center of local activity and interest, the common headquarters for a sizable geographical area. It is, in short, the axis of local society. These court houses, hushed though they are in the pictures, are testimony of the motives of those who built them. They tell us something about our national fabric that, at the beginning of our third century, we do well to ponder.

There are more than 3,000 counties in the United States. Yet, writing in 1906, Sidney and Beatrice Webb bemoaned the fact that in England, as here in the United States, "No convenient treatise on County Government is known to us." While the American county has not yet received extended treatment from legal or other historians over the years, its history and impact are not to be disregarded.

The origins of the county system are clouded in the indis-tinct past. It would appear, however, that the Anglo-Saxons brought to England with them German concepts of law and German courts. There is very early evidence that in the seventh century in Kent, the entire judicial system oper-ating locally there under a sheriff was identical to its German antecedents. Several centuries later under Alfred the Great, the community unit in Wessex was the "mark," a a collection of "marks" making up a shire.

Thereafter the concept of shires and shire courts grew even stronger in England, as the generations passed, while it waned in the countries of the continent that first devised the system. The inexorable growth of county government con-tinued unchecked in England from the earliest days to the twentieth century. In the reign of Henry VIII, England and Wales were divided into fifty-two counties with geograph-ical areas as diverse in size as our own. The Webbs refer to Rutland containing only 150 square miles, as opposed to Devonshire with 2,600 square miles; their populations in 1689 were 15,000 and 300,000, respectively. Each English county conducted its affairs much as all others. One local gentleman of distinction, customarily a noble or great landowner, as *Custos Rotulorum*, kept all the records and doubled in brass as the Lord Lieutenant, agent for the King as commander of the armed forces of the county. This latter function dated from about 1550. Just behind the Lord Lieutenant in importance but holding an office of much greater antiquity was the Sheriff or High Sheriff, appointed, as was the Lord Lieutenant, by the Crown. In the days be-fore the revolution in 1689, the Sheriff in each county represented the King in financial and judicial matters. As the royal representative he administered justice, served writs, kept the peace and summoned a posse when he felt he needed one. He also appointed a battalion of underlings, deputies, bailiffs and the like. He or an Under Sheriff held

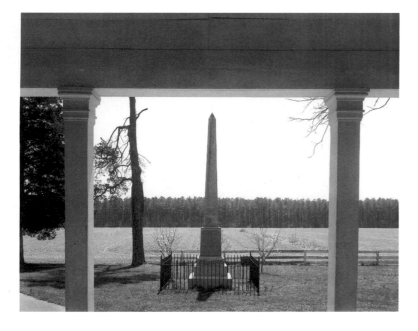

Plate 4. View from Charles City County Court House, Charles City, Virginia, c.1730. Photograph by William Clift.

the county court for the recovery of civil debts. Later came High Constables with powers *inter alia* to whip vagrants and levy rates.

The county also commanded the services of coroners to hold inquests with juries for the purpose of determining whether to commit individuals for trial at the assizes where these juries had returned a preliminary finding of murder or manslaughter. The routine criminal work in the several counties was handled for centuries by Justices of the Peace who, formed as a Commission, met at the General Sessions of the Peace at least quarterly during the year and disposed of the run-of-the-mill criminal business as well as the major portion of civil administration of the county. Each justice had the interesting power of dealing individually on the spot with profanity or drunkenness when he personally witnessed such aberrations. The result to the malefactor was an immediate sentence to the jail or the stocks. This peremptory power might also be employed against those conveying goods or working on the Lord's Day. "Our prudent legislators," said John Disney in 1710, "foreseeing how hardly the greatest part of magistrates would be got to execute such laws, have left it in the power of any one Justice of the Peace that has a sense of religion and his duty, to act in these things, that he might not be wind-bound by the vicious negligence of his brethren." This robust and immediate disposition was, of course, well in advance of

and not at all compatible with our contemporary Miranda and associated decisions, which cause a potential defendant to be informed of his rights prior to official interrogation.

The judicial power lodged locally with the justices about the time of Henry II was largely superseded by the Assize Courts, which were manned by judges who were appointed by the Crown and who traveled on circuit.

This, then, was a structure which developed through the centuries since the Jutes, the Angles and the Saxons brought to England what was an essentially Teutonic device, the shire. Its evolution, roughly sketched above, and the basically harmonious government which it provided for the England of 1600 were, of course, thoroughly understood by the newcomers to our own shores, particularly in Massachusetts and Virginia. Through them we are the inheritors of county government as we know it.

How these two colonies adapted English experience was in large measure an outgrowth of their respective geographies and their different economic bases. New England, by virtue of its physical attributes, its thin soil and its harsh climate, was a good theater for fishing or trading or conducting manufacture. Virginia, with its large number of navigable streams, its rich and promising soil, and its milder climate, was more suitable for rural activity. New Englanders congregated in towns which very quickly became their focus of

Plate 5. Old Court House, Northampton County, Eastville, Virginia, 1731. Architect unknown. Photograph by Richard Pare.

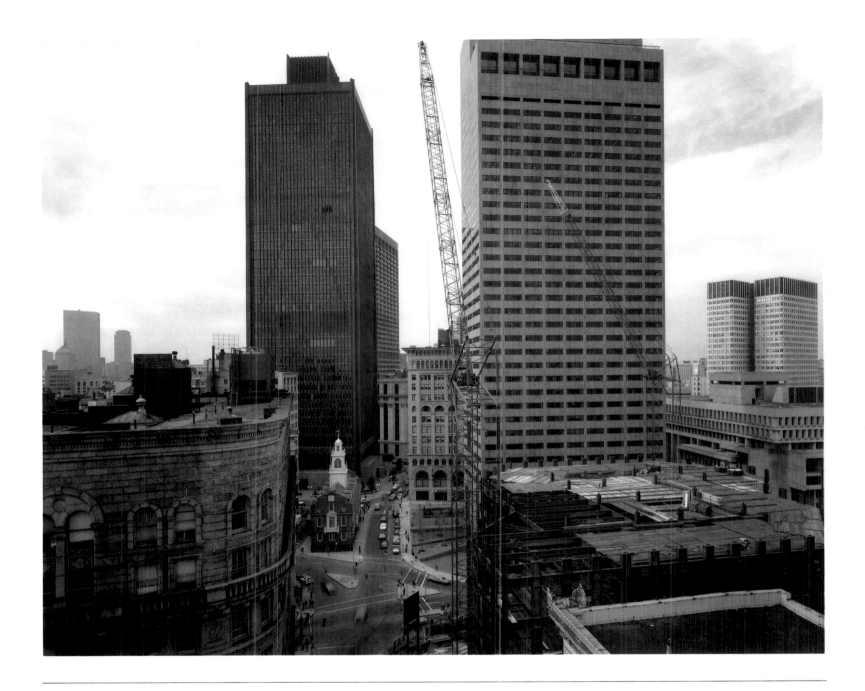

Plate 6. Old State House, Boston, Massachusetts, 1748. Architect unknown. Remodeled 1830 by Isaiah Rogers. Photograph by Nicholas Nixon.

government. Virginia was soon characterized by large plantations and consequently had no need for the form of town government espoused to the north. The Virginia plantation owners constituted an upper class which very early assumed political dominance along lines parallel to those that gave English noble families the rule in their counties. In New England, on the contrary, political control rested from the beginning in the people. Aristocracies eventually sprang up in both colonies, but that of Virginia was landed, while that of New England was bottomed on mercantile wealth. It is not surprising, then, that Virginia led in adopting the county system by passing an act in 1634 pro-

mulgating seven shires to be "governed as the shires in England."

In 1643 the colony of Massachusetts Bay followed suit and the whole colony, then including the present state of New Hampshire, was divided into four shires apparently organized for military and defense purposes. A lieutenant was appointed for each new county with power to marshal the able-bodied men of the towns at appropriate times. Many of the administrative functions of the English counties had been assumed by the towns in Massachusetts and were exercised by them, but in due course the old provincial

21

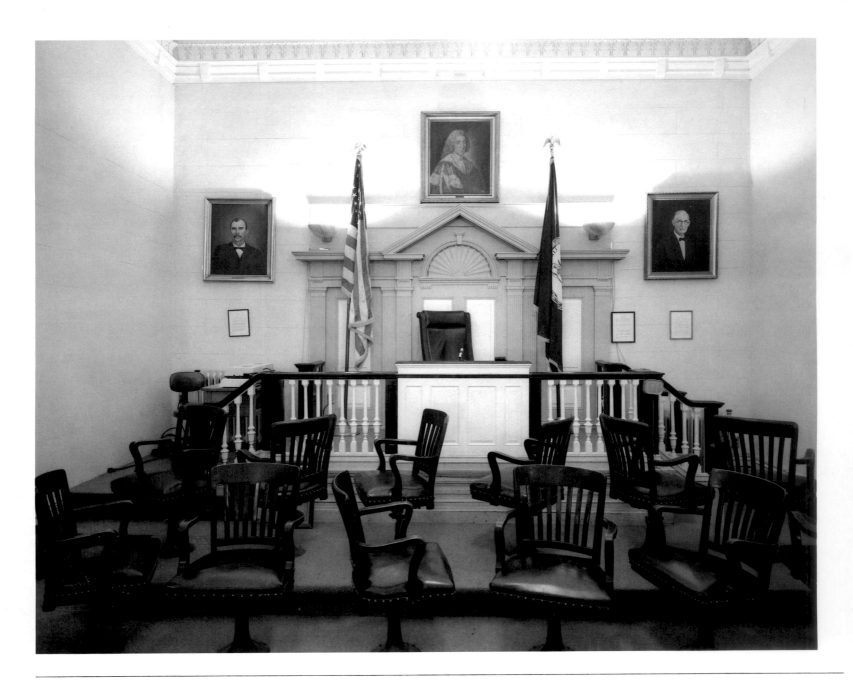

Plate 7. Pittsylvania County Court House, Chatham, Virginia, 1853. Architect L. A. Schumaker. Photograph by Stephen Shore.

county court houses became the center of judicial administration and activity.

Virginia, on the other hand, retained the traditional powers of the English county. Roads, bridges and highways were the charge of the county. As in Massachusetts, each county had a lieutenant. But the Virginia lieutenants possessed powers greater than those of their military brothers in Massachusetts. The Virginia sheriffs were also much more powerful than their Massachusetts counterparts. Collection of various tax levies, a town matter in Massachusetts, was accomplished by the sheriff in Virginia. Next down the line in Virginia local government was the parish, in general a geographical district for religious purposes with little relevance to the county. The vestry of each parish cared for the poor, supervised the tobacco crop and had other unspecified duties. In overall governmental significance, however, the Virginia parish did not approach the New England town.

The course followed in Massachusetts and Virginia is important, for it was in those two colonies that the county in America experienced its chief development. This is not to say that other experiments with it were not being pursued elsewhere. Albert Bushnell Hart pointed out that by the time of the Revolution there were four types of county

government in the colonies, and every one of the 3,000 American counties has followed one of these distinct types.

First, there was the New England model, in which the county was subordinate to the town. States such as South Carolina and Maryland came to follow this model since they were subject to economic and geographic factors similar to those of New England.

Secondly, there was the New York form of county government, in which each county had a board of supervisors, all chosen by respective townships. Michigan, Illinois, Wisconsin and Nebraska, to mention four states, followed New York.

A third pattern was developed in Pennsylvania, where county officials for the most part were elected. Hart wrote that as new states were created in the northern and western parts of the country, the Pennsylvania model was generally followed.

The fourth was the Virginia model. This made the county, as has been stated, the most powerful local government. Most of the southern states have walked in the footsteps of Virginia as they have established their counties, and Virginia's model was also followed to a degree in certain western states.

The foregoing account of the origin of our American counties gives little hint of the lively goings-on that all of our counties have seen from time to time. Since county seats were, apart from the churches, the only central places of meeting in early days, the court houses became points for the dissemination of propaganda as well as halls of justice. Grand juries convening in Massachusetts were frequently lectured well beyond their duties by colonial judges dispensing the policies and even politics dictated by the royal governors. Judges were usually untrained in the law. Of thirty-three high court judges sitting in Massachusetts from 1692 until 1775, only four had legal educations. Nor was this atypical of the situation elsewhere. Colonial judging ofttimes verged on the informal. Well before the Revolution one Virginia enactment provided:

"Whatsoever justice of the peace shall become soe notoriously scandalous upon court dayes at the court-house, to be

soe farre overtaken in drinke that by reasen thereof he shall be adjudged by the judges holding court to be incapablle of that high office and place of trust, proper to inherett in a justice of the peace, shall for his first offense be fined five hundred pounds of tobacco and cask."

Provincial court judgments were terse and meaningful. One such read, "That if Mister Holmes does not quit worrying Mr. Jones and making him curse and swear so, he shall be sent to jail."

Hardship of colonial travel assailed all county offices. The sheriffs had their problems in effecting service and in Virginia certain writs had these returns:

"Not executed by reason there is no road to the place where he lives."
"Not executed by reason of an axe."
"Not executed because the defendant's horse was faster than mine."

The circuit riding of judges in the early days also was not without hazard. In 1695 a Massachusetts statute discontinued the sessions of the court in certain outlying counties "forasmuch as it is hazardous for the justices of the Superior Court of Judicature [the highest court] to ride the eastern and western circuits . . . and draws a great charge to the publick for a guard to attend them for their safe passing."

The height of embarrassment for a peripatetic court was achieved in the year 1791. The place was a back road running behind the town of Freeport, Maine—Maine then being a part of Massachusetts. The day was Sunday. The travelers were the justices of the Supreme Judicial Court of Massachusetts accompanied by the French Consul at Boston. They were employing the traditional day of rest to make their way from a sitting at Portland, where they had been delayed, to a sitting at the old court house at Pownalborough to the east, where they were due the day following (*Plate 15*). "The procession would have slipped by unnoticed," the old account states, had not the Consul, "who rode in a 'chair,'" and who was French, "trotted down in the heart of the town in search of a hairdresser, with the result that his vehicle broke down, and caused a delay which attracted attention." The warden came out, and in the name of the Commonwealth of Massachusetts arrested the whole company for traveling on the Lord's Day. They were subse-

quently all indicted by the grand jury for Cumberland County. This charge lay heavy on the Court for many months thereafter, and it took an act of the Massachusetts legislature finally to free the justices from the stigma and consequence of their illegal peregrination, so reminiscent of those against whom Justices of the Peace might have acted in peremptory fashion in the England of years before.

The practical problems of colonial travel which so bedeviled the judges were also faced by the customers of the courts, and this led to occasional redefinition of county boundaries. In 1702, for instance, Virginia adopted a measure dividing Charles City County, employing this language:

"Whereas sundry and divirse incomveniences attend the inhabitants of that part of Charles City County Wch Lyes on the South side of James River when they have any occasion to prosecute law Suites in the sd. County Court or to go to any other publick meeting, by reason of the difficulty in passing James River . . ." (Plate 4)

As the days of the Revolution drew closer, however, the Royal Judges came to travel in ever more splendid style. The last Royal Chief Justice in Massachusetts is described as proceeding to a sitting in the 1749 court house at Plymouth in a coach and four with a postilion and outriders, to be met at the town line by the officials of the community. American judges have rarely so proceeded since, although these ancient assize formalities are still observed in England.

The approach of revolution was heralded in more than one colonial court house. Were one to identify a single courtroom incident which did most to light the fires of revolt it would unquestionably be the hearing on the Petition of Lechmere, which was argued beginning on February 24, 1761, in the court room of the old State House in Boston. The issue was the legality of the Writs of Assistance, authorized by the British Parliament and amounting to carte blanche for the King's officers to initiate searches not limited as to place, scope or time. These writs were being employed under the direction of the Royal Governor, Francis Bernard, a strong aristocrat who brooked no compromise in his enforcement policies. James Otis, a noted colonial advocate, undertook to attack the writs. The action took place in a court room hung with impressive portraits of Charles the Second and James the Second. Let John Adams describe the scene as he remembered it after a lapse of nearly sixty years:

"In this chamber, round a great fire, were seated five judges, with Lieutenant Governor Hutchinson at their head as Chief Justice, all arrayed in their new, fresh, rich robes of scarlet English broadcloth; in their large cambric bands and immense judicial wigs. In this chamber were seated at a long table all the barristers-at-law of Boston and of the neighboring county of Middlesex, in gowns, bands and tie wigs. They were not seated on ivory chairs but their dress was more solemn and pompous than that of the Roman Senate, when the Gauls broke in upon them. Otis was a flame of fire. With a promptitude of classical allusions, a depth of research, a rapid summary of historical events and dates, a profusion of legal authorities, a prophetic glance of his eye into futurity, and a torrent of impetuous eloquence, he hurried away everything before him . . . Every man of a crowded audience appeared to me to go away, as I did, ready to take arms against writs of assistance. Then and there was the first scene of the first act of opposition to the arbitrary claims of Great Britain. Then and there the child Independence was born."

In truth the child had been born, but there were rough years between 1775 and 1781. As provincial government collapsed, the counties of the colonies increasingly carried the burden of political administration. This proved of invaluable assistance in the interim before the new nation, first with the Articles of Confederation and then with the Constitution of 1787, came into being. In the initial decades of the Republic, the respective state constitutional conventions and the state legislatures generally laid out the policies to be carried out by local officers. This followed naturally from the deep distrust of centralized power harbored by early Americans. For local enforcement the citizenry looked to the sheriff. The county sheriff was clothed with most of the powers of his English predecessors. He had wide powers of arrest; he too could summon a *posse comitatus* of private citizens; and it was natural that he should run the jail. Eventually there came into being a prosecuting officer of each county, a feature first authorized by Connecticut in 1704. There followed the creation of the office of clerk of the county court to keep the records, and the early days of the Republic saw the coroner also added to the list of county officers. Sheriff, prosecutor and clerk, this soon became the standard official group for

all counties as they burgeoned in the wake of a population migrating westward.

Structurally, the county governments varied somewhat depending on the origins of those who established them. Thus the settlers in the Western Reserve at first brought with them New England ideas, which they later exchanged for the Pennsylvania model. Under the influence of immigration from New York, Michigan took New York notions on counties for its own. Kentucky and Tennessee leaned on Virginia. To the west, influences from the North and Virginia collided with some interesting results. The northern part of Illinois, for instance, was settled by northerners and embraced the township-supervisor plan. The southern part of the state, where the population came from Virginia and the South, adopted the southern form of county government.

There were anachronisms as well as anomalies. In the South, at least until 1830, county government was generally quite undemocratic. At the time of the Missouri Compromise only the people of Georgia, Alabama and Louisiana elected their county governors. In the rest of the South, the county court administered justice, levied and collected taxes, and controlled the police and militia in addition to other functions. Each such court designated its members, who held office for life. The people had nothing to say. As Thomas Jefferson said of Virginia—and the statement would have had equal force relative to Kentucky and certain other states—the county governors were "self-appointed, self-continued, holding their authorities for life, and with an impossibility of breaking in on the perpetual succession of any faction once possessed of the bench." Departure from this tight oligarchic form of control in the South came only gradually.

And yet, the people of the old South had a warm feeling for their counties and their court houses. The typical southerner looked to his county as his governing unit. His county court house was the center of his life. As narrated in one account, "Most Southerners, by making an early start, could ride horse-back to the court house, transact business, gossip with friends, and return home all in a day's time. Usually they timed their visits for the Mondays when the county court was in session, for on those days the county seat was transformed from a sleepy village into a confusion of men, horses, and carriages. Aside from the business of the court, men bargained for livestock and provisions, auctioneers sold land

and slaves, vendors of panaceas plied their trade, and grogshops were busy. Farmers and planters assembled to carry on private as well as public business, to lay political plans, to catch up on the news, and to enjoy the society of their friends. Though the court was the excuse for the day, the day was a social institution in itself, one of the most important in the antebellum South." A friend of the old order once remarked: "I like the old-fashioned mode of the Virginia people in coming together, and sitting down and having a good dinner and drinking a glass of toddy . . . and sitting side by side on the court green . . . and exchanging opinions."

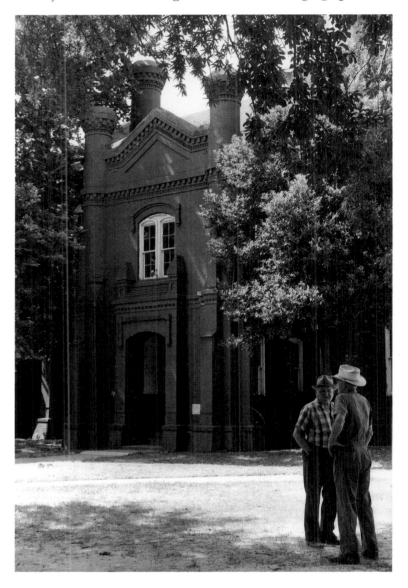

Plate 8. Shelby County Court House, Center, Texas, c. 1883-85. Architect J. J. E. Gibson. Photograph by Geoff Winningham.

From the outset the western states made their county governments much more democratic. In some fifteen or seventeen states, the sheriffs, the treasurers, the assessors, engineers and prosecuting attorneys were elected. The board of super-

25

visors or commissioners sitting in overall charge were also elected. The eminent historian of the West, Frederick Jackson Turner, designated the termination of the frontier to have occurred in 1890, but well before that in certain sparsely settled areas these more youthful adjuncts to the nation chose to act on wholly democratic lines.

In 1962 the U.S. Bureau of the Census declared there to be 3,043 county governments functioning as independent organizations in the United States, with eighty-eight county geographical divisions possessing no independent governments. These 3,043 counties were to be found in forty-seven states. Rhode Island and Alaska never had county government, and Connecticut eliminated counties in 1960. The District of Columbia, of course, never had anything resembling a county setup. In some areas county government was lodged in a town or municipal authority; Nantucket and Suffolk in Massachusetts are examples (*Plate 119*). New York City's five boroughs were once counties but ceased to be so in 1898. In other locations, city and county government were combined; Philadelphia, San Francisco and Denver are examples of this phenomenon (*Plate 211*).

American counties are now as varied in size and population as their English predecessors. Arlington County, Virginia, contains 25 square miles, while San Bernardino, California, covers 20,109 square miles, four times the size of the state of Connecticut, which can boast only 5,009 square miles. Among the California counties, Alpine not long ago had a population of around four hundred souls, which was much less than the daily accretion to Los Angeles County, the population of which was already in the millions. The number of counties in each state varies greatly. There are but three in Delaware, while Texas contains 254.

It is no longer possible to define in a brief compass all the duties assumed and performed by the counties of the United States. In addition to functions discussed above, welfare, education and hospitals all became parts of a governmental apparatus that traces its lineage back to English shires and towns. In many areas the county form of government now duplicates the same functions and public expense that also burden hard-pressed state governments. And, as many a county limps along saddled with ancient trappings long out of date, county functions are transferred to the state and then, on occasion, transferred back again. Many county

nabobs are as resistant to change as they are to the concepts of sound fiscal and business administration. And the people, bedeviled by long ballots and arcane county operations, too often suffer inefficiency in silence.

Notwithstanding the noble purpose it has served in the progress of America through the years, the county has also had its seamy side historically. Some years ago one writer opined that in nine-tenths of American counties public affairs were in the hands of "what the irreverent call the 'court house gang '" He described the gang as a fairly permanent group of elective and appointive officeholders, together with private individuals, contractors, printers, suppliers and lawyers inhabiting the local probate courts, bankers snuggled close to the county treasurer, and others, all of whom combined to do quite well indeed in their relationship with the county which gave them hearty sustenance and financial support. The extreme examples of this have been seen from time to time in such instances as what was termed "the gorgeous pillaging of a Tweed." If morality

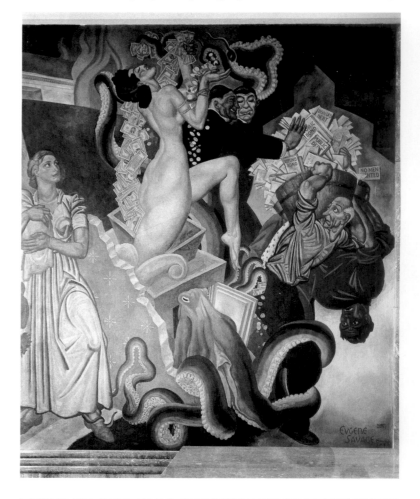

Plate 9. Mural by Eugene Savage, Fountain County Court House, Covington, Indiana, 1936. Photograph by Bob Thall.

hasn't improved much over the years, communications and transportation undeniably have. And that could be reason enough why at long last many county functions may have to be permanently transferred to the state government. We leave such considerations to others and turn to the court houses themselves.

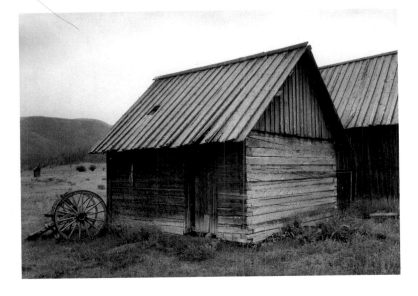

Plate 10. *Old Court House, Hinsdale County, San Juan Ranch, Colorado, c. 1874. Architect unknown. Photograph by William Clift.*

What infinite variations are theirs. They range from the one-room log cabin at Hinsdale County, Colorado (*Plate 10*), to the massive brain child of Henry Hobson Richardson at Pittsburgh, built many years later. Many were built under liberal appropriation laws which allowed strange and costly contracts entered into by building committees. In other instances, size and general beauty were circumscribed by supervisors who, charged with possible extravagance, replied as did one Illinois board: ". . . recognizing that this Board is the servant of the people and not their bosses . . . we hereby pledge ourselves to cause to be erected and completed a Court House the cost of which shall come within the terms of the Resolution." This particular Illinois board had before it the horrible example of the Carlinville court house of Macoupin County in that state (*Plate 11*). Authorized originally in 1867 for a total expenditure of $50,000, the Carlinville court house cost the taxpayers of that county $60,000 a year thereafter for forty years. The county celebrated its completion in 1910 with two days of fireworks.

Yet court houses were regarded as juridical spiderwebs set to catch many a lucrative commercial fly. Towns fought for

them as a lure for increased business and heightened land values. An impressive edifice was usually a matter of pride for the whole community. Conversely, it could engender scorn. A committee from Pike County, Illinois, visiting the court house at Clinton, Missouri, duly reported to its own constituents that ". . . after you have gone through [it] leaves you feeling that you are sorry you entered . . . It gives you a mean opinion of the people of the County." There was widespread sentiment, then, that the beauty sometimes and the size often of the local dispensary of justice was in fact a mirror of the aspirations and character of the county which it served.

Plate 11. *Dome over Judge's bench, Macoupin County Court House, Carlinville, Illinois, 1867-70. Architect Elijah E. Myers. Photograph by William Clift.*

And what tales most of these court houses could tell. Those in Boyle County, Kentucky (*Plate 191*), and Hinds County, Mississippi (*Plate 189*), could recount the sufferings of the wounded in the War Between the States; both served as hospitals. The Vicksburg court house in Warren County,

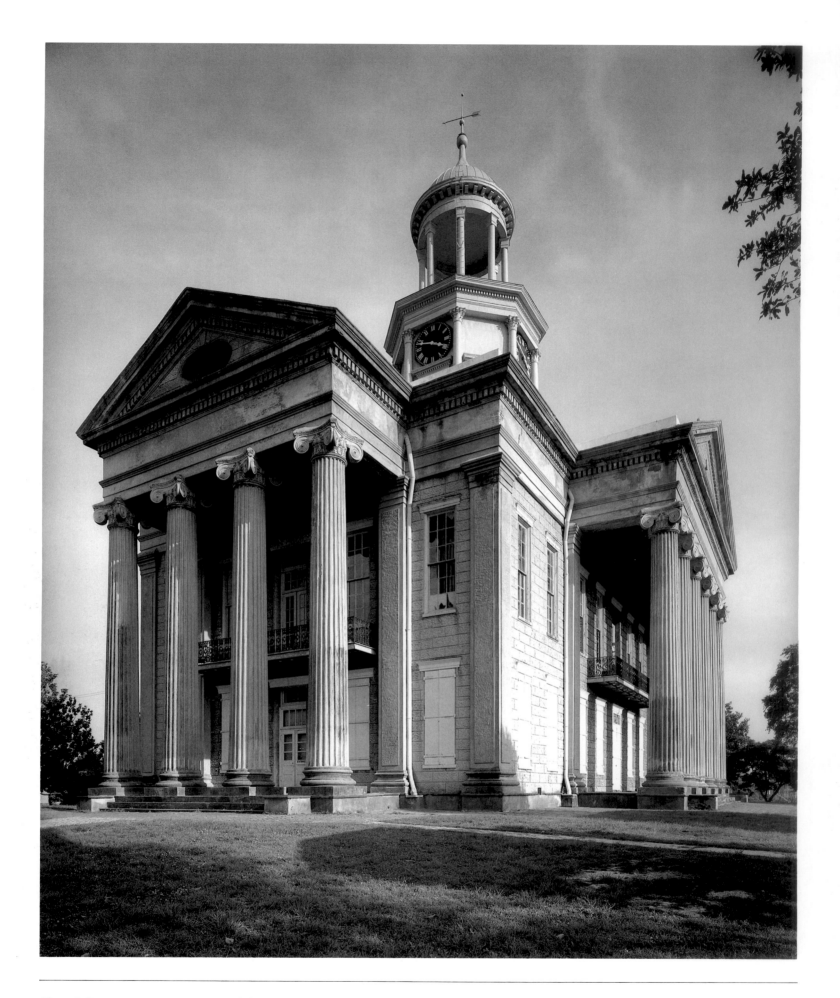

Plate 12. Warren County Court House, Vicksburg, Mississippi, 1858-61. Architect-builder William Weldon. Photograph by Jim Dow.

Mississippi, could describe the siege of forty-seven days by Grant; its cupola provided him with a central aiming point and, after the surrender, a flagstaff from which the Stars and Stripes was flown (*Plate 12*). The building in Herkimer, New York, could recount the trial of Roxalina Druse, the last woman hanged in that state, or of Chester Gillette, which gave Dreiser his story for *An American Tragedy* (*Plate 15*). New Bedford court house in Bristol County, Massachusetts, might enlighten us as to the guilt or innocence of Lizzie Borden (*Plate 259*). The court houses of Woodford and Stark counties in Illinois heard the voice of Lincoln as an advocate (*Plate 13*). That in Buchanan County, Missouri, was the scene of the trial of the Ford Brothers in 1882 for the murder of Jesse James (*Plate 231*). The notorious D'Autremont brothers were brought to justice in Jackson County, Oregon. The last of the Molly Maguires was convicted in 1878 in the court house of Northumberland County, Pennsylvania (*Plate 207*).

Each temple made its mark in its own way, even if only for some simple eccentricity. One thinks of the county center in Greensburg, Decatur County, Indiana, noted chiefly for the aspen tree which grows inside and pokes its branches from the top of its tower (*Plate 197*). That in Colfax County, New Mexico, is distinguished because its cupola allegedly contains a gallows ready for any final action necessitated by adverse results attending the trial of defendants on the floors below.

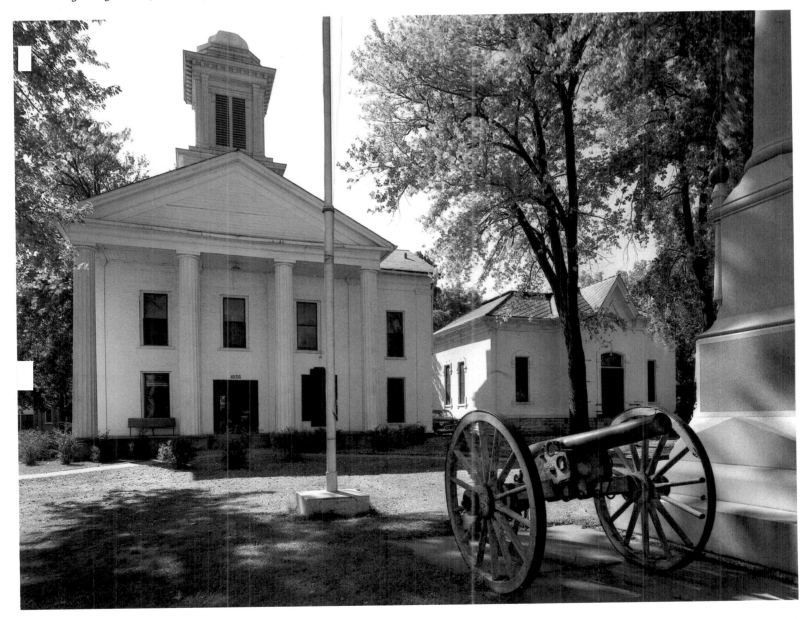

Plate 13. Stark County Court House, Toulon, Illinois, 1856-57 with later addition. Builders Parker C. and Elias Spaulding. Photograph by Harold Allen.

Equally noteworthy, at least in some instances, are the days of celebration that attended the dedication of these buildings as they commenced their useful careers. At Lake City, Hinsdale County, Colorado, on the wet and blustery night of June 8, 1877, a massive ball was held although the windows had not yet arrived and the drapes were blown in by a gale of wind and rain (*Plate 14*). A pioneer attorney, recalling the day that court house first found employ, later noted: "I was present in Lake City in 1877 when court convened for the first time in their new court house. The entire town was assembled in the court room for the occasion. The sheriff was Henry Finley. The judge was not prompt in arriving. He finally appeared, however, and, edging his way through the crowd, managed with some difficulty to reach the bench. . . . Taking his seat, he looked over the room for a moment, then removed his cigar from his mouth, blew a large volume of smoke into the air, and said to the sheriff, 'Turn her loose, Fin.'" And turned loose it was, for six years later the notorious Alferd (that's the way he spelled it) Packer, otherwise known as The Colorado

Cannibal, was tried and sentenced to death for eating five of his companions during the sixty days they were caught in high land and winter weather. He himself managed to live another twenty-four years.

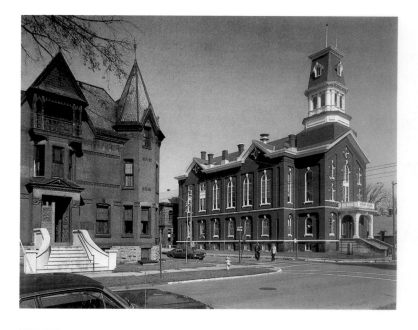

Plate 15. *Herkimer County Court House, Herkimer, New York, 1872-74. Architect A. J. Lathrop. Photograph by Patrick Linehan.*

To single out the most celebrated trials held in county court houses over two hundred years is not an easy task. Slight reference has already been made to some. There are others that will live in history for a long time. The Dred Scott case, the Scopes trial, the Sacco-Vanzetti case and the trial of Bruno Hauptmann for the Lindbergh kidnapping, all are unquestioned leaders in the litany of famous American state trials. Each caught national attention in its day, and the passage of time has not dimmed interest in any of them.

The Dred Scott case, which wound its way through nearly twelve years of state and federal litigation, began in the still unfinished court house at St. Louis in 1846 (*Plate 16*). The case began when Dred Scott filed a petition for permission to bring a suit to establish his status as a free man. This was granted by Judge J. K. Krum, who had been Mayor of Alton, Illinois, when the abolitionist editor Elijah Lovejoy was murdered. A chain of proceedings then commenced in the long, rectangular room situated at the west end of the court house. Missouri was a slave state and Scott had come to St. Louis as a slave, the property of a migrant from Virginia. Upon the death of his owner he was sold by a

Plate 14. *Hinsdale County Court House, Lake City, Colorado, 1877. Architect-builder Jonathan Ogden. Photograph by William Clift.*

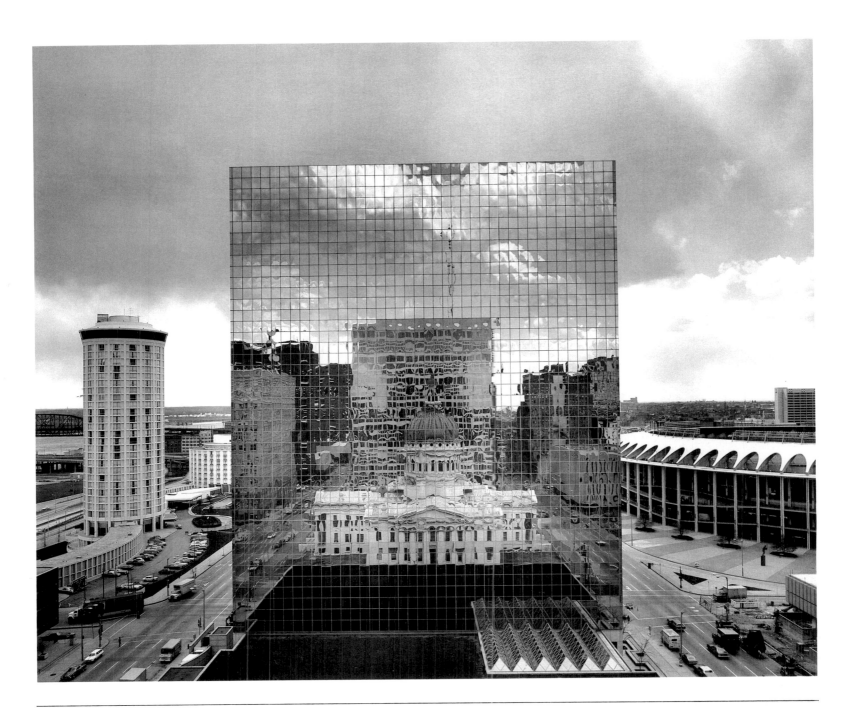

Plate 16. Old St. Louis County Court House reflected in The Equitable Building. Photograph by William Clift.

daughter to an army surgeon who took him first to Rock Island, Illinois, and then to Fort Snelling, farther up the Mississippi River in what then was Wisconsin Territory. For five years he lived in both places on free soil. Dr. Emerson, the surgeon, then returned to St. Louis and there died, leaving Scott to his widow. The widow resisted Scott's claim that residence on free soil had made him free.

A series of hearings ensued, culminating in a jury verdict in the circuit court in 1850 which gave Scott and his family their long-sought liberty. Their freedom lasted only from January 23 to February 14, 1850, when the Missouri Supreme Court, having convened to consider the case which was by now a national *cause célèbre*, reversed the lower court in the face of a strong dissent by its Chief Justice. The case then proceeded through a tangle of hearings and delays until, at long last, in 1855 and 1856 it reached the Supreme Court of the United States. Notwithstanding some notable interference from outside sources, especially from incoming President James Buchanan, as well as serious disarray among the justices themselves, a decision was finally reached. The Court discussed the entire background of

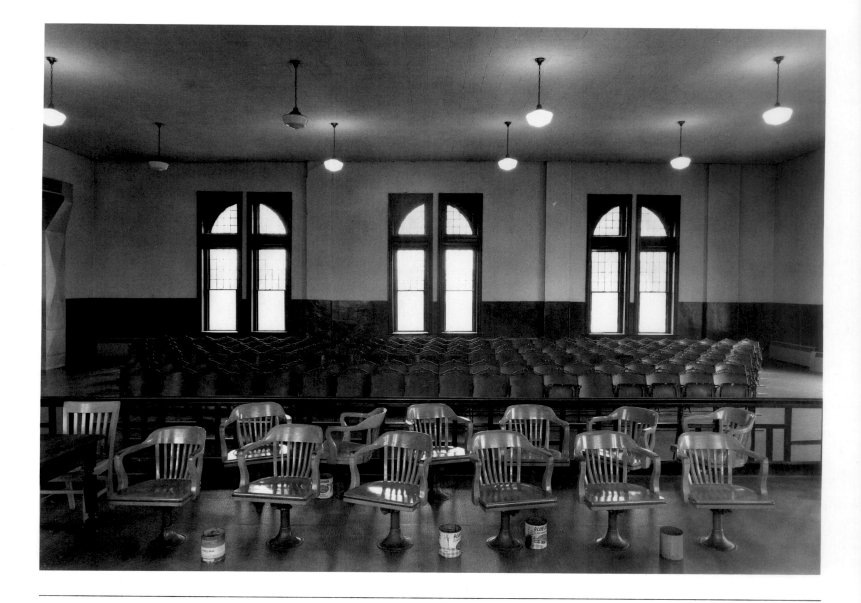

Plate 17. Rhea County Court House, Dayton, Tennessee, 1891. Architect W. Chamberlin & Co. Photograph by Geoff Winningham.

slavery, the status of Scott, the authority of Congress and various other factors. But, the nub of the decision was that Scott was a slave and not a citizen and, thus, had no right to sue; further, the Missouri Compromise which had legislated certain free territory was ruled unconstitutional since Congress did not possess the power to prohibit slavery in territories. The Court said that the right to hold slaves was a property right with which Congress could not interfere. The decision shook the entire nation and sharpened the division that led to the war a few years later.

The trial of John Thomas Scopes in the Rhea County Court House at Dayton, Tennessee, produced what Gilbert Murray, the distinguished Regius-Professor of History at Oxford, termed with some exaggeration "The most serious setback to civilization in all history" (*Plate 17*). William Jennings Bryan, who led in the prosecution of the serious and self-effacing teacher, would have disagreed. Clarence Darrow for the defense would undoubtedly have disagreed in turn with Bryan. Scopes had been brought to trial for violation of the Butler Act, enacted only months before, which forbade the teaching of evolution in the schools of Tennessee. Distinguished lawyers flocked to aid in the defense. The town of Dayton became the stage for a melodrama that commanded national and international coverage during the hot summer of 1925. The judge, fearful that the court house might collapse under the weight of the spectators at the trial, transferred a portion of the proceedings to the lawn outside.

The characters and personalities of the two principal advocates heightened the tensions and the public interest.

Darrow finally called Bryan as a witness and in the ensuing examination Bryan was utterly destroyed. The judge had ruled the Tennessee statute constitutional, which left only the question of the guilt of Scopes under its terms. The jury convicted Scopes, but the Supreme Court of Tennessee later reversed on the narrow ground that having fined Scopes one hundred dollars, the judge had gone beyond his powers in that fines of over fifty dollars were by law to be assessed by the jury and not the judge. Thus ended what H. L. Mencken called "The Monkey Trial," but not without leaving behind its indelible imprint. A series of United States Supreme Court decisions since 1925 have emphasized the separation of Church and State, but not until 1967 did Tennessee repeal the Butler Act.

A third landmark case was fought out in the Norfolk County Court House in Dedham, Massachusetts (*Plate 170*). Commonwealth vs. Sacco, better known as the Sacco-Vanzetti case, arose from the murder of two shoe factory paymasters. The trial took place at a time when many Americans saw Wobblies on every hillside, and United States Attorney General A. Mitchell Palmer was engaged in rounding up and deporting hundreds and otherwise punishing more members of what was being called the radical fringe. What started off as just another murder case caught fire with the introduction of statements that the defendants were anarchists and soon captured the attention of the entire world. When the matter came to its bitter end in 1927, and the two defendants were executed by the Commonwealth of Massachusetts, there ensued an international storm of marches, meetings and protests.

Even today the case inspires fierce controversy. A whole body of literature exists written by those who consider that the two Italian immigrants were railroaded to their deaths because of their alleged radical affiliations. Others insist that Sacco and Vanzetti got a fair trial, notwithstanding subsequent intemperate remarks by the trial judge. Some authors began their works convinced of the innocence of the accused and ended up equally convinced that Sacco was unquestionably guilty and Vanzetti was possibly guilty also. The clamor on this case erupted anew in the summer of 1977 when the Governor of Massachusetts took the unusual step of issuing a proclamation designed to "remove the stigma and disgrace" of the convictions from defendants now dead over a half a century. This case will also live in history.

And there was the notorious trial of Bruno Richard Hauptmann for the kidnapping and murder of the infant son of Charles and Anne Lindbergh. Held in the rural county seat at Flemington, New Jersey, this hearing was a newspaperman's dream. The fame of the parents, the peculiar circumstances of the crime and the long-delayed detection of the alleged murderer focused universal attention on what went on at Flemington under the careful guidance of Judge Trenchard. In the five years preceding March 1, 1932, the day the Lindbergh baby was kidnapped, there had been no less than three hundred reported cases of kidnapping for ransom. That alone was enough to generate a public demand for correction. Rarely in this country, before or since, has such a variety of experts testified on such a variety of subjects. Rarely, too, has the presence of the press been more mightily on display. The conviction and execution of Hauptmann seemed to slow down the incidents of kidnapping. Tough new state and federal laws went into effect. If any good at all emerged from the sacrifice and pain of the Lindbergh family, it appeared to be the improvement of the law with consequent deterrent effect on those willing to hazard kidnapping for money. Recent events in this country and abroad, however, make it clear the lesson was tragically impermanent.

So the American county court houses, sentinels of and for the people, have played out their unique roles, sometimes inspiring, sometimes tragic, always witnessing. Age and change have robbed them of some of the functions for which they were built. Too many, sadly, have been sentenced to the wrecker's ball by a forgetful society. Others, such as the colonial building at Pownalborough, Maine (*Plate 159*), the old State House at Boston (*Plate 6*), and the former county court house of Vanderburgh County at Evansville, Indiana (*Plate 293*). have been saved by enlightened community efforts and given new roles as museums or have been turned to other practical uses. Many other old court houses, now in their final days of service, deserve to be and hopefully will be left standing to join this honored list.

Whatever their individual histories, the American county court houses together have had a deep and lasting influence on the United States and its people. They have reflected the citizens whom, as inheritors of ancient law and tradition, they have served. They are, as the pictures in this volume demonstrate, eloquent monuments to democracy.

COUNTY THOUGHTS

CALVIN TRILLIN

The county court house—the one whose picture I carry in my mind—stands in the middle of a town square, with law offices pressing in on it like cocktail party guests bellying up to the hors d'oeuvres table. The building tries for height. The wide concrete stairs on the outside are high, and the ceilings are high, and, above the third floor, a high cupola displays on all four sides a clock that comes within fifteen or twenty minutes of telling everyone downtown the right time. Just inside the front door, a bulletin board displays the schedule of the circuit court and a notice about where to obtain crop-spraying advice and a poster from the Army recruiting service and a letter from the Department of Health, Education and Welfare about food stamp eligibility and a brittle old piece of paper telling citizens what to do if they happen to be in the building paying their taxes or disputing their assessment at the moment of nuclear attack.

There are offices on either side of a broad hallway—with small signs, like old-fashioned lawyers' shingles, extending into the hall above each door to identify the county clerk or the county treasurer or the county assessor. A wooden sign on the wall indicates with an arrow the direction of the jury room. The broad wooden steps leading to the second floor are bowed in the center from use. (A narrower flight of stairs leads down to the sheriff and his radio dispatcher and his jail in the basement, where there is no attempt at height.) On the second floor, court is in session. A lawyer with carefully tended sideburns and white patent-leather shoes is trying to explain why the skinny, miserable-looking teenage boy next to him should not be forever branded a felon merely because he yielded, just this one time, to the temptation of an unlocked Pontiac. The judge looks bored. The courtroom is otherwise empty except for the court clerk and the teenager's mother and a few elderly men who like to pass the time watching trials. On a bench outside the courtroom, a couple of men with tattoos and untended sideburns sit smoking, waiting their turn. Two or three small groups of people stand in the hall, each group dominated by a lawyer who is holding a fat brown file-envelope.

Downstairs, I enter the office of the county clerk. Printing on the frosted glass of the door identifies him once again by both name and title. I am there as a reporter from outside the county—to ask what the county clerk thinks about a dispute in the local schools or about the prospects of a murder defendant or about the fortunes of the local Democratic party (of which he happens to be the chairman). The county clerk's office has been modernized. The ceiling has been lowered and is made of white perforated squares. The walls have been covered in the sort of masonite made to simulate wood paneling. A couple of glass partitions mark off an office for the county clerk's secretary. There is no one at the secretary's desk. In a moment, the secretary returns. She has been at the vending machines that are tucked under the stairs. It is almost ten o'clock in the morning—time for her first Coke of the day.

When I worked as a newsmagazine reporter in the South, at the beginning of the sixties, everyone always seemed to be asking me where I was from. At the time, white people in the South preferred to believe that only ignorant and hopelessly vindictive Yankee reporters could portray racial turmoil as the product of genuine grievances rather than outside agitation. Loyalty to geography was assumed. County sheriffs seemed to have a particularly strong interest in my origins. "Where you from?" was always among the first questions a county sheriff asked. Often, he spoke while studying my press identification or my business card or even my driver's license (outside reporters occasionally had difficulty keeping their cars stationary at a stop sign long enough to qualify for what the local sheriff considered a full stop), and he sometimes ended the question with my first name, just to remind me where we stood. "I work out of the Atlanta bureau" was not considered an adequate response. That would only bring a sad shaking of the head and a loud "huh-uh." (There is no way to reproduce on paper the sound of a Southern sheriff's "huh-uh," but I suspect some philologist somewhere has classified it as the "adenoidal negative.") Then the sheriff would ask his second question: "Where you really from?" That meant, "Where were you born?"

Plate 18. *Greene County Court House, Eutaw, Alabama, c.1869-70. Architect unknown. Photograph by Stephen Shore.*

As it happens, I was born in Kansas City, Missouri. I could have done worse. The worst place to have been born was undoubtedly New York, the Center of Evil. If an outside reporter who had been born in New York was asked by a Southern sheriff where he was really from, the only sensible course open to him was perjury. In my case—my fellow stop-signs runners and I decided—there were better and worse ways to state the literal truth. Missouri, for instance, sounded less incriminating than Kansas City, only partly because Missouri had been a border state. To a Southern sheriff, practically any state would have sounded less ominous than practically any city. A county would have sounded best of all.

For a lot of Americans, county still means country. It implies, at least, the absence of a big city. The county sheriff and the county court house are often identified with the South partly because the South remains the least urbanized region of the United States. There are, of course, places where "out in the county" refers to a collection of suburbs that elects a slick county executive to sit in a modernistic county center and fiddle slickly with zoning laws designed to keep out people no poorer than the Southern sheriffs who were interested in my birthplace. There are huge cities that conduct the business of the county seat in a downtown office building indistinguishable from the city hall; as it happens, Kansas City is one of

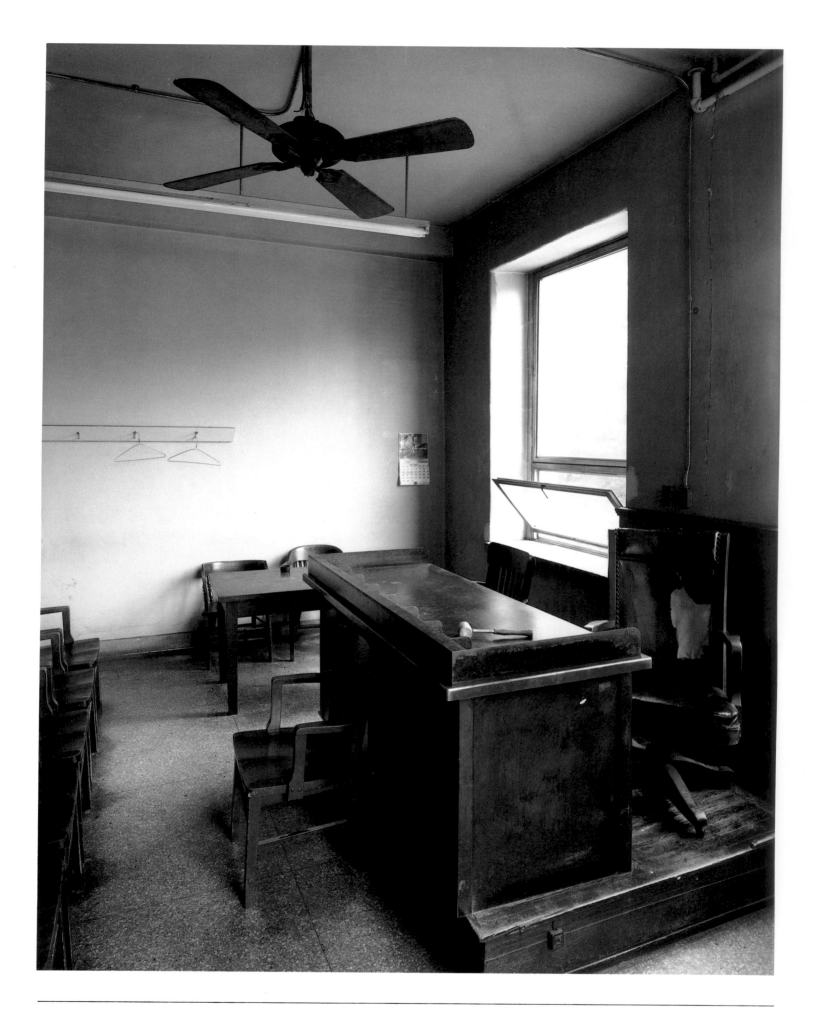

Plate 19. Harlan County Court House, Harlan, Kentucky, 1918-21. Architect unknown. Photograph by Jim Dow.

them. But I think the picture of a county court house that a lot of Americans have in their minds is similar to my picture of the county court house in the town square. County still means country, and my best answer to the sheriff's question—if I had ever worked up the nerve to use it—would undoubtedly have been "Up around Jackson County, Missouri."

I once visited a copper town in Arizona that was about to lose its copper mine. The town was nestled in some mountains not far from the Mexican border, and the company in charge had, as mining people say, "recovered" just about all the copper that could be taken from the mountains at a profit. Architecturally, the town looked pretty much as it must have looked in the first decade or so of the century—partly because of some preservationist sentiment that is uncharacteristic of Western towns, and mostly because of some commercial lethargy that is quite characteristic of company towns. There were residents who believed that, once mining was over, the town—because of its quaint appearance and its splendid setting in the mined-out mountains—would prosper as an artists' colony or a tourist center. There were also residents who held out hope for the town simply because it was a county seat. In rural counties, the court house is an important industry. It provides not just county jobs but also lawsuits for lawyers and stationery orders for the office-supply store and repair work for the garage. It might mean a county hospital, and it is likely to mean a county newspaper. In the last century, tiny settlements often fought over designation as the county seat on the theory that the court house could mean survival. In this century, in areas where rural counties have lost population to the cities, the theory still holds.

The district attorney is a county official even in cities so large that a gaggle of assistant district attorneys is required to keep up with the trial work. In those cities, an assistant district attorney often turns out to be a neatly dressed young man with winged-tip shoes who conducts the trial methodically, following a loose-leaf notebook he keeps on the table in front of him. Occasionally, a flashy assistant district attorney comes along to play to the courtroom buffs and cultivate the press—he is likely to specialize in pornography trials or the showier murders—but normally assistant district attorneys are relatively

cautious about what they say outside as well as inside the courtroom. In criminal trials, reporters tend to be more comfortable with defense attorneys, who are often indiscreet enough to hint that their client is, in fact, guilty—the assumption being that a defense attorney who wins acquittal for a guilty client must be particularly brilliant. At lunch with a reporter after the jury goes out, a defense attorney may raise his martini and say, "To Justice—whoops, what am I saying! To Not Guilty." A defense lawyer can afford the style of a man not haunted by the prospect of having a victory reversed on appeal; there being no appeal from Not Guilty, he only has to win once. The caution of an assistant district attorney comes not only from the danger of reversible error but also from the conditions of his employment: a defense lawyer is engaged in private enterprise and an assistant district attorney is a man who works for the government.

In large counties, the district attorney tends not to do much trial work himself, husbanding his courtroom skills for the occasional case that happens to be politically significant or particularly juicy. In the late sixties, about the only case anybody in Houston could remember the district attorney of Harris County having tried personally was one in which Lee Otis Johnson, the noisiest black militant in town, was sentenced to thirty years in the penitentiary for allegedly giving away one marijuana cigarette. The most trialwise district attorney I ever met—a commonwealth's attorney officially, since that is what the D. A. is called in Kentucky—was a man named Daniel Boone Smith, who practiced his art for thirty or forty years in Harlan County, one of the Appalachian counties in the eastern part of the state. Smith, who seemed to be called Dan'l Boone by just about everyone in the county, was said to have tried more capital cases than anyone in the history of the republic. Eight or nine years before I met him, Smith got curious about how many murder defendants he had prosecuted or defended—he did some defense work on the side in other counties—and his secretary counted up 750. Smith was able to amass a record like that partly because of longevity and partly because he was a quick worker. ("Some people will take three days to try a murder case," he told me. "I usually try to get my case on in a day.") and partly because Harlan County, which used to be called Bloody Harlan, has traditionally offered a lot of opportunity for anyone interested in murder trials. Harlan

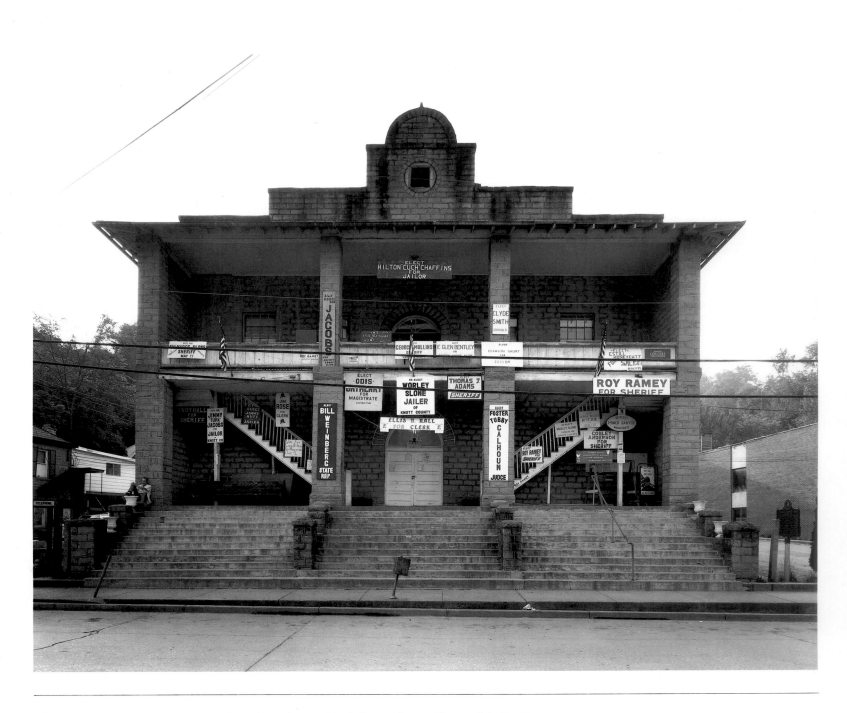

Plate 20. Knott County Court House, Hindman, Kentucky, c.1930. Architect unknown. Photograph by Jim Dow.

County got to be known as Bloody Harlan in the thirties, when unions were trying to organize the mines, but mountain feuds had made it bloody long before that. Thirty years after the labor wars, Harlan had murders that often seemed the product of sudden drunken anger—one member of a family mowing down another who is breaking down the door trying to get at a third.

Smith, a man who knew his county, was renowned in eastern Kentucky for his ability to select a jury. In the urbanized counties of the Northeast, jury selection sometimes seems to be an exercise in ethnic studies. Is the Irish housewife a strong enough Catholic to take seriously what the Archbishop says about pornographic bookstores? Would the Polish construction worker be particularly anti-black or just normally anti-black? Does that Italian or Jewish grandfather have the sort of warm family feeling that would make him particularly sympathetic to the survivors of a young person killed needlessly in an auto crash? In a place like Harlan County, Kentucky, jury selection has a lot to do with local history—remembering which prospective juror's uncle may have had a boundary dispute with which witness's grandfather twenty years before. Daniel Boone Smith knew his local history. He also knew

Plate 21. Notice board, Anderson County Court House, Lawrenceburg, Kentucky. Photograph by Lewis Baltz.

how to talk to eastern Kentucky jurors—how to get his point across with a personal recollection or a country anecdote that had Dan'l Boone Smith as the butt. Hearing him talk to a jury—hearing him recall old Uncle Bob Woolford who used to work up at Evarts or describe a case he once had over at Coldiron—it was hard to keep in mind that he was, as he confessed to me shortly after we met, a graduate of Harvard Law School.

Plate 22. Election returns, Democratic primary 1976, Logan County Court House, Paris, Arkansas. Photograph by Jim Dow.

Until the early sixties, all Democratic primaries in Georgia were operated under something called the County

Unit System. The Democratic primary was the only primary that counted, of course, since the Republican nomination for state office at the time was, as the county politicians would have said, "not worth a bucket of warm spit." Under the County Unit System, carrying a county,

Plate 23. Jurors' chairs, Warren County Court House, Warrenton, Missouri, c. 1869-71. Photograph by William Clift.

by whatever margin, gave the candidate unit votes that varied according to the population of the county—the kicker being that the largest county in the state had only six votes and the smallest county had two. There are 159 counties in Georgia, and some of them, it is sometimes said, amount to no more than a court house and a speed trap. Even the smallest one had a third the vote of Atlanta. When Gene Talmadge was running for governor, he used to say that he never bothered to campaign in a county large enough to have a streetcar.

The years just before the federal court finally struck down the County Unit System were particularly frustrating for the civic leaders of Atlanta, who were then trying to build

the city's reputation as a progressive commercial center that was, in the words of its mayor, William B. Hartsfield, "too busy to hate"—a slogan I always thought of as Babbittry Over Bigotry. Atlanta boosters were embarrassed at being represented in Congress by a distinctly non-progressive type named James Davis, who, because of the County Unit System, could win the nomination every two years even without carrying the city. Judge Davis, as he was always called, was not too busy to hate. In fact, he struck people in Washington as the sort of man who would drop anything he happened to be doing if a good opportunity for hating came along.

In 1960, Mayor Hartsfield finally got so irritated at Davis's continual nomination that he ran an ape against him in the general election. The ape lived in the Atlanta zoo and was himself named Willie B., after the mayor. Hartsfield held a press conference at the zoo to introduce Willie B. and compare his progress on the scale of political evolution favorably with that of Judge Davis. Willie B. actually received a few hundred votes. On election night, a sign in the city room of the Atlanta *Constitution* said, "Vote for Willie B.—Let Us Begin Again."

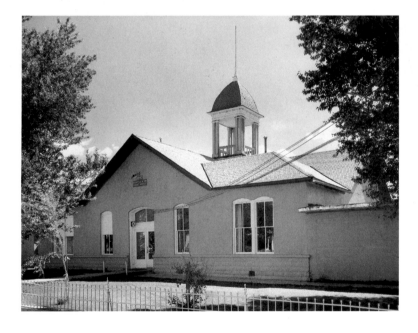

Plate 25. Costilla County Court House, San Luis, Colorado, 1886-96. Architect unknown. Photograph by William Clift.

I once attended an auction of land sold for taxes at the Costilla County court house, in San Luis, Colorado. Costilla County was settled by Spanish-Americans from around

Taos and Chama, in northern New Mexico, who came in the 1850's as *pobladores*, or settlers, on something called the Sangre de Cristo land grant. The court house, a plain, one-story building of adobe, was built in 1870. Some of its offices have been modernized, but the courtroom, where the land auction was being held, looked pretty much the way it must have looked in the nineteenth century. It did have electricity—a couple of naked lightbulbs hanging from the ceiling by electric cords. The walls of the courtroom were bare except for what seemed to be a large square of upholstery fabric taped behind the judge's chair—provided, I gathered, so that the judge could, during slow summations, tilt back and lean his head comfortably against the wall.

Plate 24. County Clerk, Grant County Court House, Canyon City, Oregon. Photograph by Ellen Land-Weber.

The county clerk, who was acting as auctioneer, would describe each parcel in some detail, often continuing the description from his own knowledge after he finished reading what was on the official list. Some of the parcels went for as little as fifteen or twenty dollars. I happened to be in Costilla County because of an argument over the use of a 67,000-acre tract of land that had been purchased for $500,000—an argument about whether the descendants of the *pobladores* had hunting and grazing and gathering rights even though an outsider had bought and obtained clear title to the land. The county clerk could also describe that tract without reference to notes. So could the county

Plate 26. San Juan County Court House, Silverton, Colorado, 1906. Architect James Murdock. Photograph by Lewis Kostiner.

Plate 27. Sheriff, Grand Isle County, North Hero, Vermont. Photograph by Douglas Baz.

treasurer. It was all there in the court house—the deed and the surveys and the correspondence over assessment disputes and the tax receipts.

Land—real estate—is often at the center of disputes around the country, although normally not as overtly as in the Costilla County controversy. Usually, the argument seems on the surface to be about industrial development or the environment or schools or highway construction, but in the background is often the question of who owns what

real estate and how its value will be affected by what happens. The county court house keeps score.

County Sheriff is a job that comes with not only a salary and a police cruiser but a persona. The folklore that clings to a county sheriff is strong—the fearless sheriff seen in Western films, the fearsome sheriff in Southern civil rights demonstrations. In New England, where the sheriff is often the man in charge of the jail, I have seen sheriffs who could be mistaken for the county clerk or an assistant

district attorney, but most of the sheriffs I have met look like sheriffs. They wear a star. They wear a wide-brimmed hat. They often wear boots. They like large silver belt buckles. A lot of sheriffs walk alike and talk alike and wear their stomachs over their gun belts in the same style.

A sheriff I once knew in Cole County, Missouri, outraged an Iranian exchange student—a young man who, as a form of protest, had gone limp rather than walk to his cell—by saying, in what I have come to think of as a Sheriff Accent, "Well, jus' lay there, you damn Commanus." The student's anger at being called a Communist, I decided, was based on the assumption that the word was meant to describe political ideology; he didn't realize that a county sheriff might call a man a Communist as an alternative to calling him a sissy or a yellow dog. A lot of sheriffs—compassionate sheriffs as well as brutal sheriffs, sophisticated sheriffs as well as xenophobic sheriffs—do a Sheriff Act.

I suppose there are sheriffs these days who wear double-knit suits and sheriffs with computerized headquarters and even sheriffs who act like those coldly polite, sharply creased state troopers who call everybody "sir" while continuing to complete the required report. But the sheriff whose picture I carry in my mind looks something like the sheriff of Cole County, Missouri—a man I once described as having "an old-fashioned county-sheriff speech pattern that tends to relax the formality of his headquarters, as well as an old-fashioned county-sheriff build that tends to tighten the pressure on the lower buttons of his shirt." He is asking me where I am really from. And I am telling him that I am really from right there in Missouri—over around Jackson County.

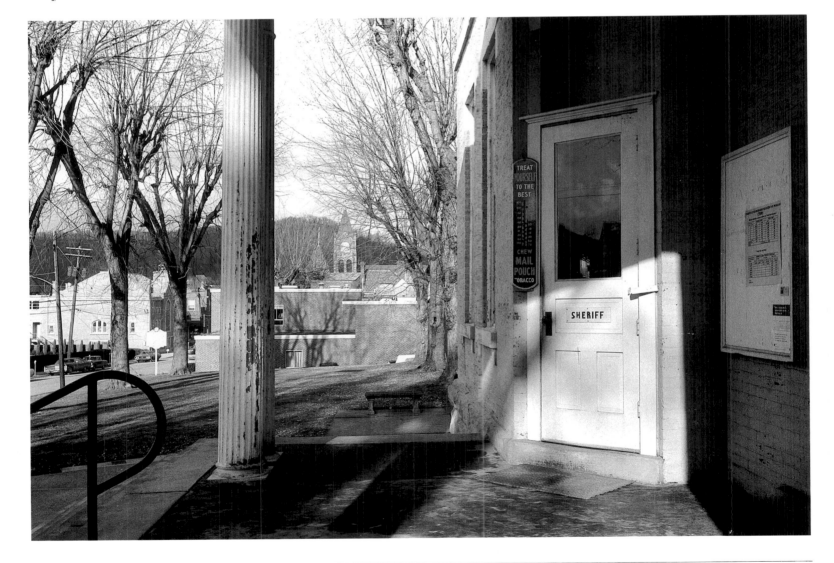

Plate 28. Sheriff's office, Lewis County Court House, Weston, West Virginia, c. 1877. Architect unknown. Photograph by Lewis Baltz.

COURT HOUSE
A PHOTOGRAPHIC DOCUMENT

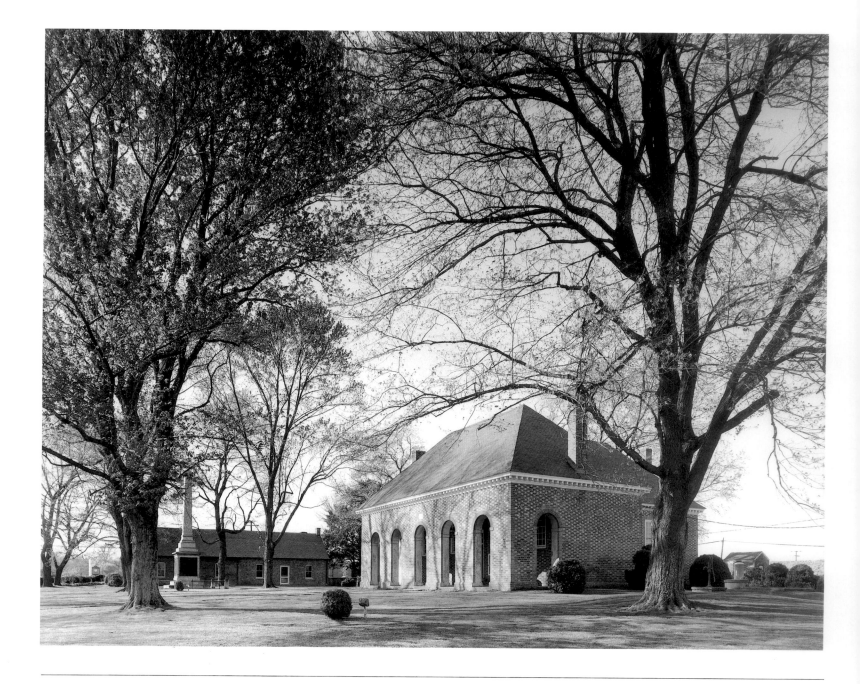

Plate 29. Hanover County Court House, Hanover, Virginia, c.1735. Architect unknown. Photograph by Richard Pare.

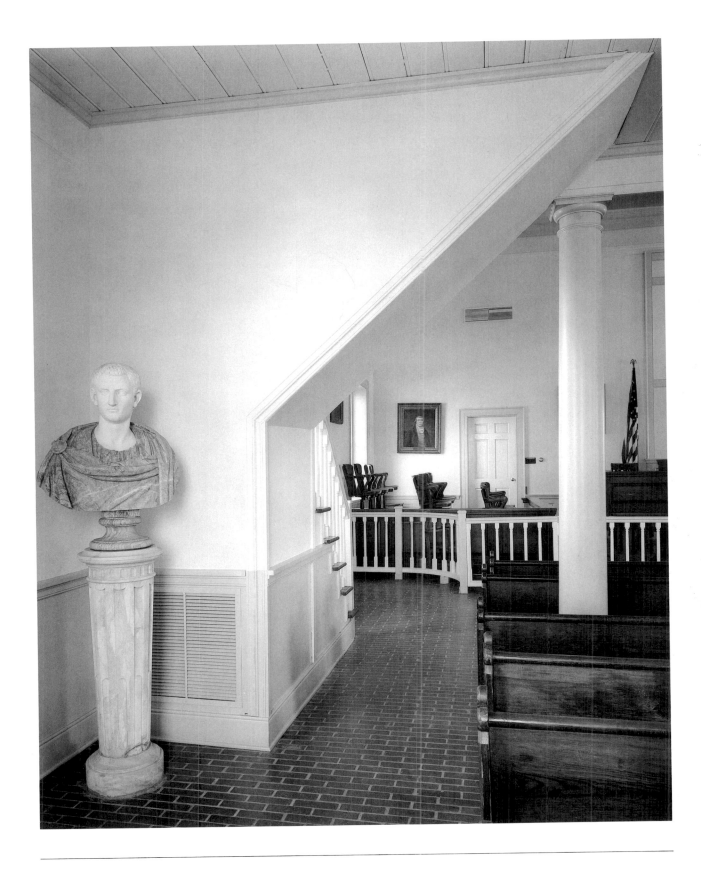

Plate 30. Charlotte County Court House, Charlotte, Virginia, 1823. Architects: Committee of seven. Photograph by William Clift.

Plate 31. Old Debtors Jail, Northampton County, Eastville, Virginia, c.1743. Architect unknown. Photograph by Richard Pare.

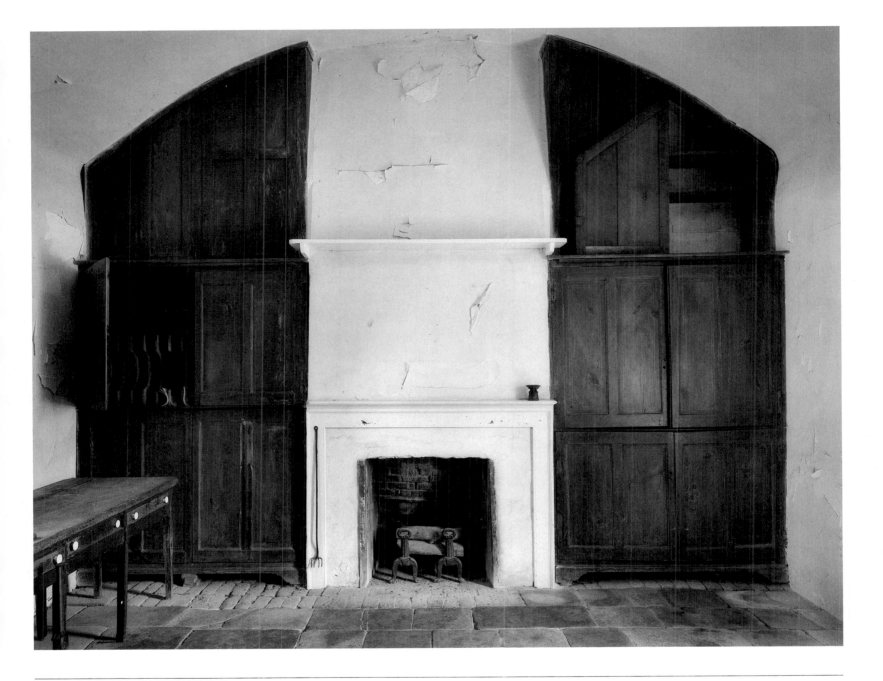

Plate 32. Old Clerk's Office, Northampton County, Eastville, Virginia, c.1725–50. Architect unknown. Photograph by William Clift.

Plate 33. Old Plymouth County Court House, Plymouth, Massachusetts, 1749. Architect Judge Peter Oliver (attributed). Photograph by Nicholas Nixon.

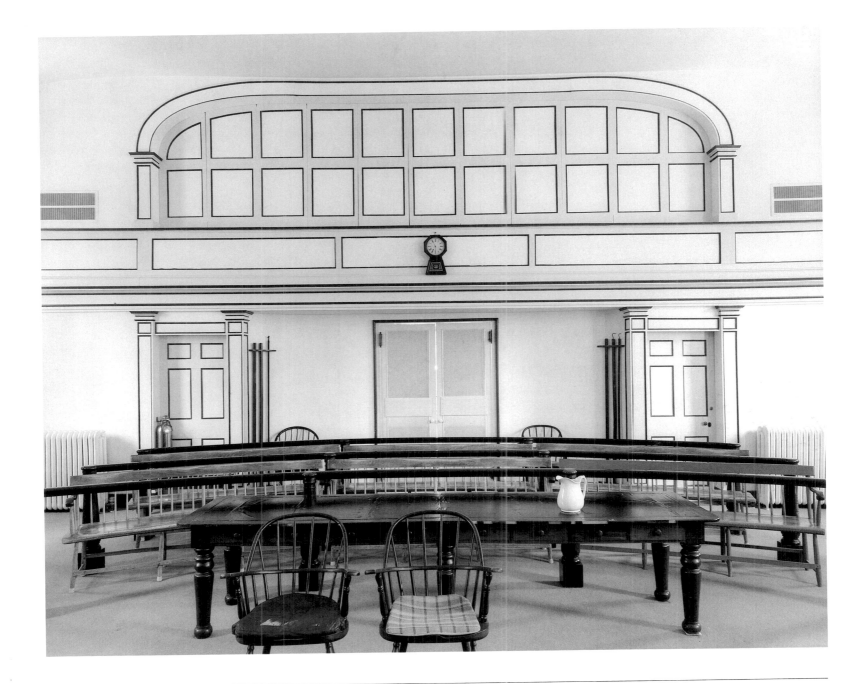

Plate 34. Lincoln County Court House, Wiscasset, Maine, 1824. Architect-builder Tileston Cushing. Photograph by Douglas Baz.

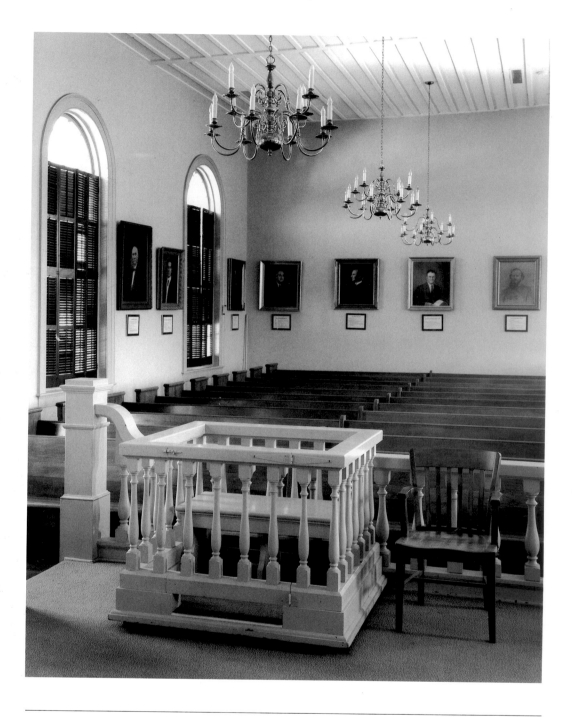

Plate 35. Witness stand, Edgefield County Court House, Edgefield, South Carolina, completed 1838. Architect Robert Mills (attributed). Photograph by Caldecot Chubb.

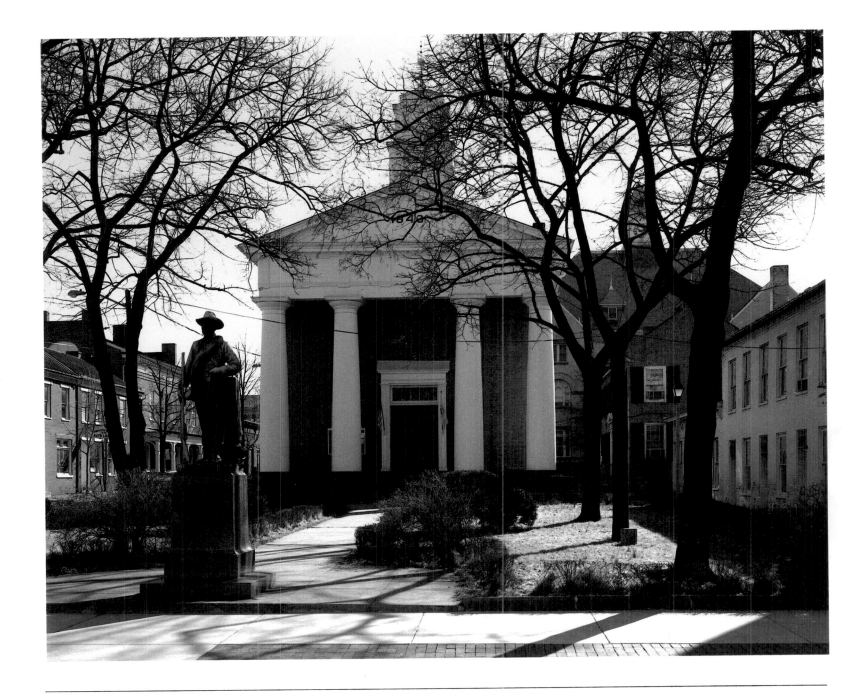

Plate 36. Frederick County Court House, Winchester, Virginia, 1840. Architect: Robert Cary Long. Photograph by Stephen Shore.

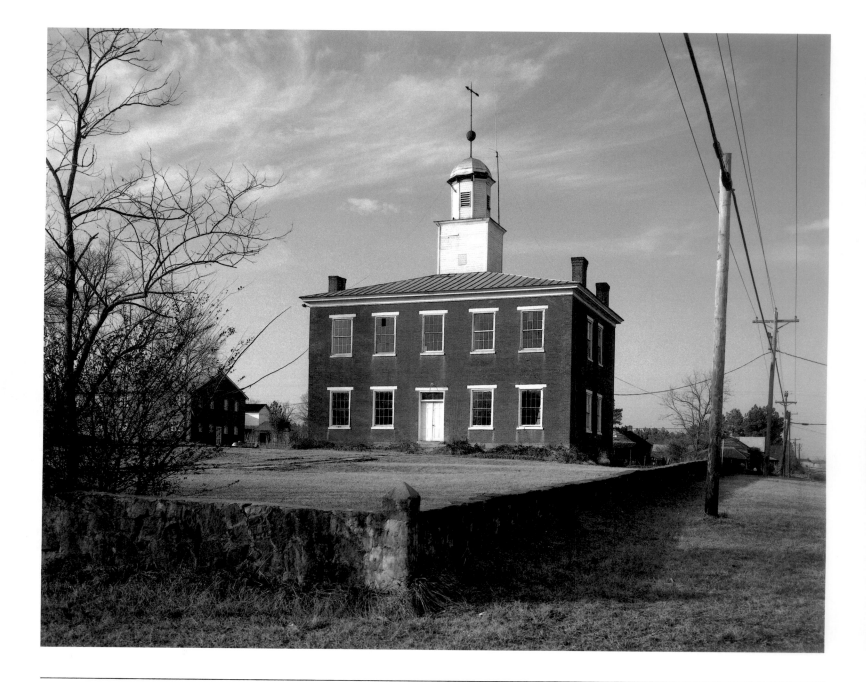

Plate 37. Old Morgan County Court House, Somerville, Alabama, 1837. Architect unknown. Photograph by Stephen Shore.

Plate 38. View from Mason County Court House, Maysville, Kentucky. Photograph by William Clift.

Plate 39. Anne Arundel County Court House, Annapolis, Maryland, 1824. Architect unknown. Photograph by Tod Papageorge.

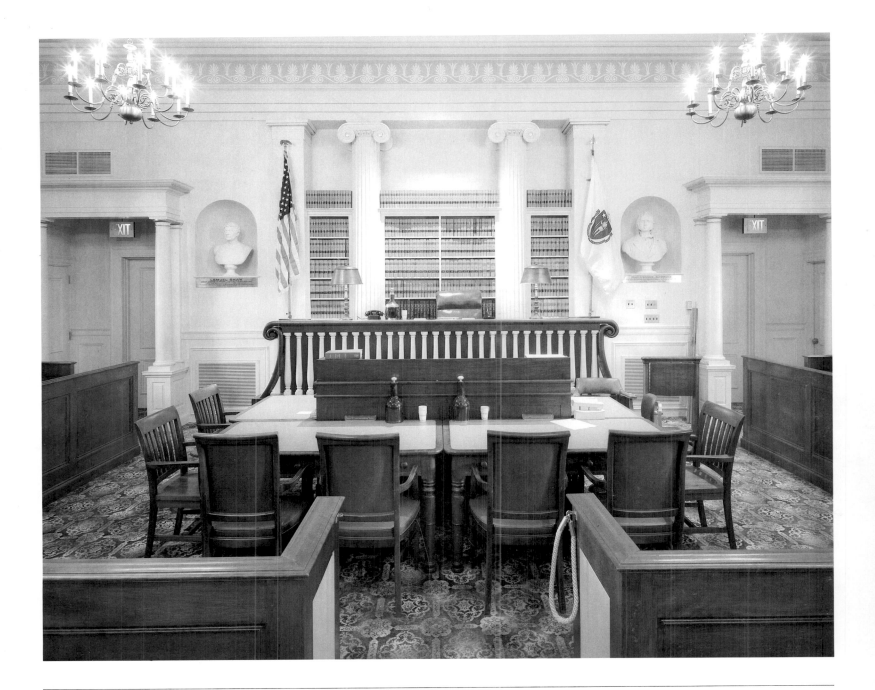

Plate 40. Barnstable County Court House, Barnstable, Massachusetts, 1831–32. Architects Jacob and Abner Taylor. Photograph by Nicholas Nixon.

Plate 41. Richmond County Court House, Warsaw, Virginia, 1748–50. Architect unknown. Photograph by Richard Pare.

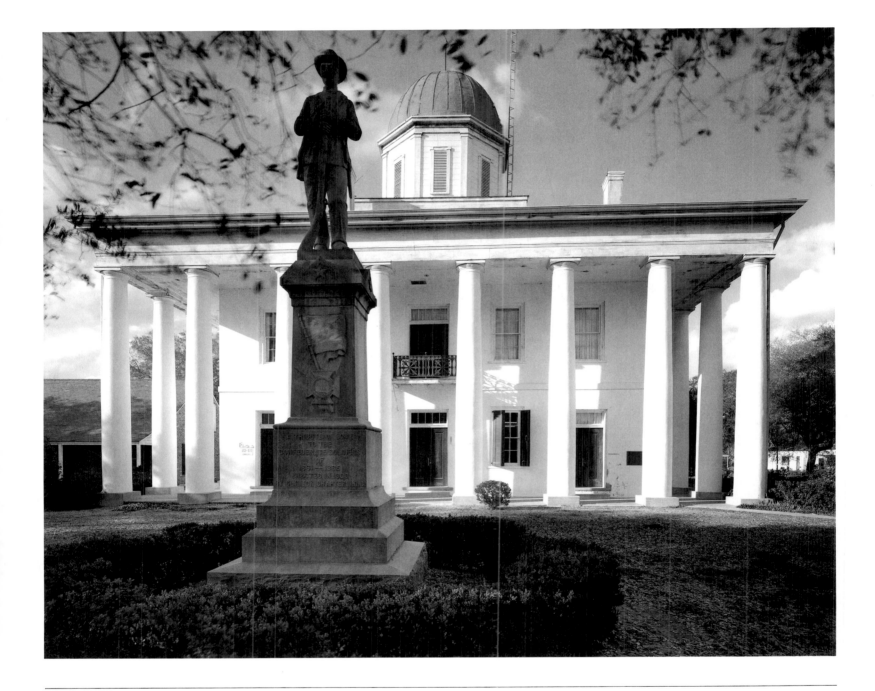

Plate 42. East Feliciana Parish Court House, Clinton, Louisiana, 1839–40. Architect J. S. Savage. Photograph by Jim Dow.

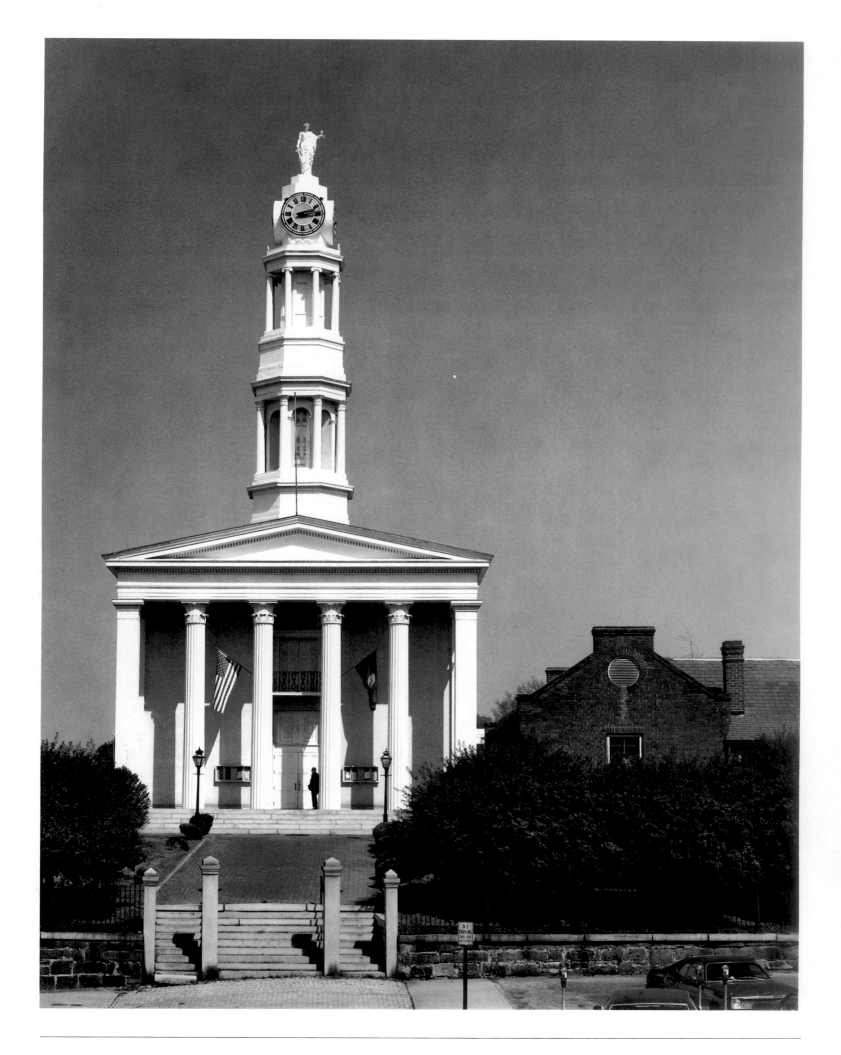

Plate 43. Petersburg Court House, Virginia, independent city, 1838–40. Architect Calvin Pollard. Photograph by William Clift.

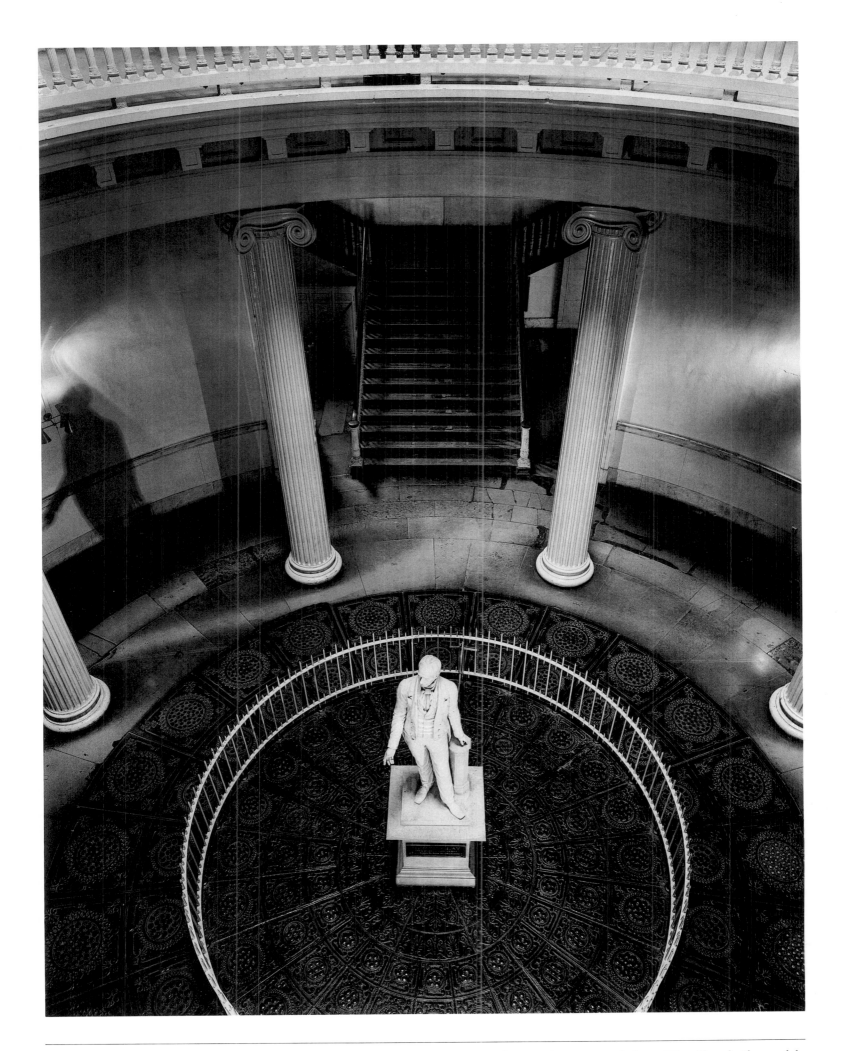

Plate 44. Rotunda with statue of Henry Clay by Joel T. Hart, Jefferson County Court House, Louisville, Kentucky, 1838–39. Architect Gideon Shryock. Photograph by Bob Thall.

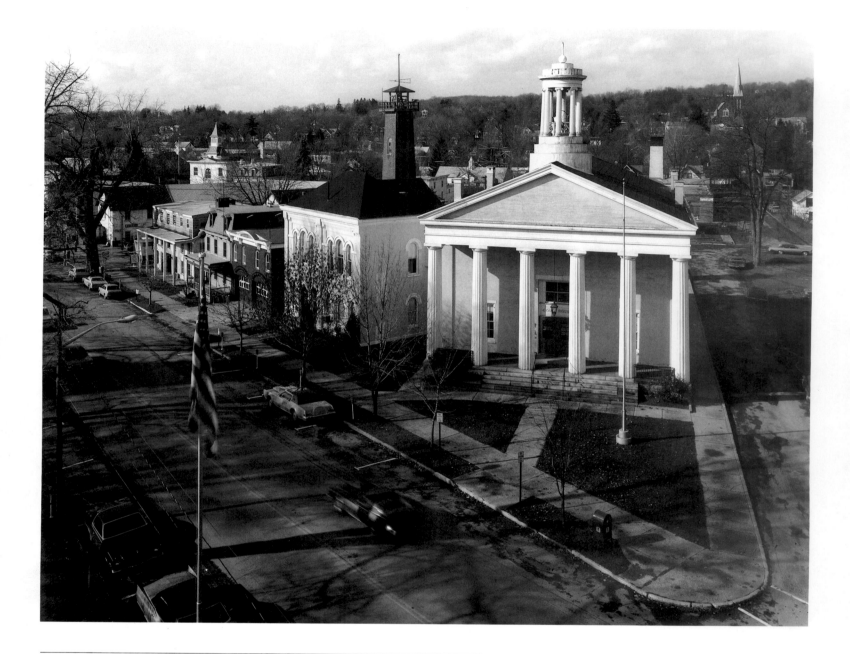

Plate 45. Old Orange County Court House, Goshen, New York, 1841–42. Architect Thornton MacNess Niven. Photograph by Patrick Linehan.

Plate 46. Grand Isle County Court House, North Hero, Vermont, 1824–25. Builders Joseph M. and James Mott, Alburg and Nathan Strong. Photograph by Douglas Baz.

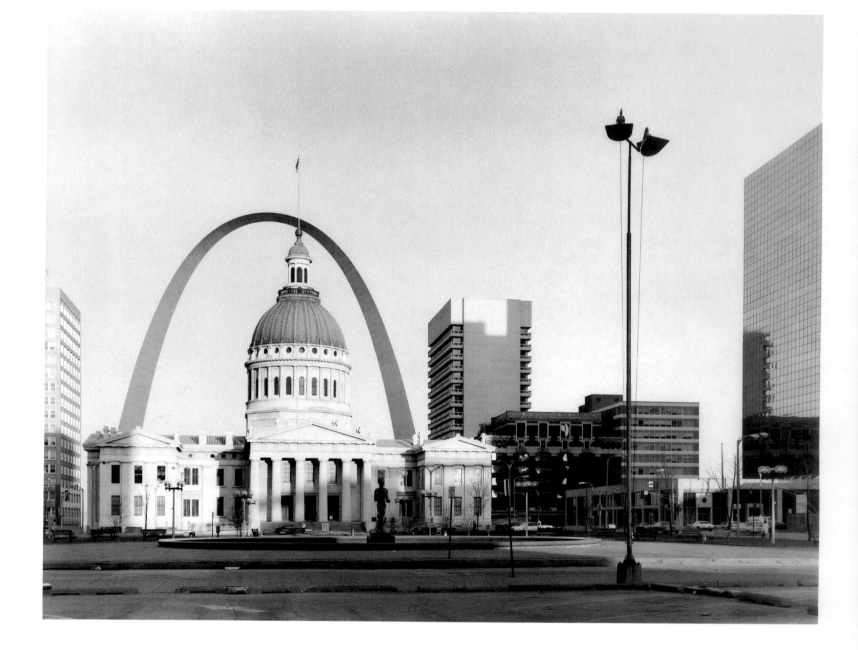

Plate 47. Old St. Louis County Court House, St. Louis, Missouri, now an independent city, 1839–62. Architect Henry Singleton, completed by William Rumbold and others.
Photograph by Richard Pare.

Plate 48. View from Worcester County Court House, Worcester, Massachusetts. Photograph by Nicholas Nixon.

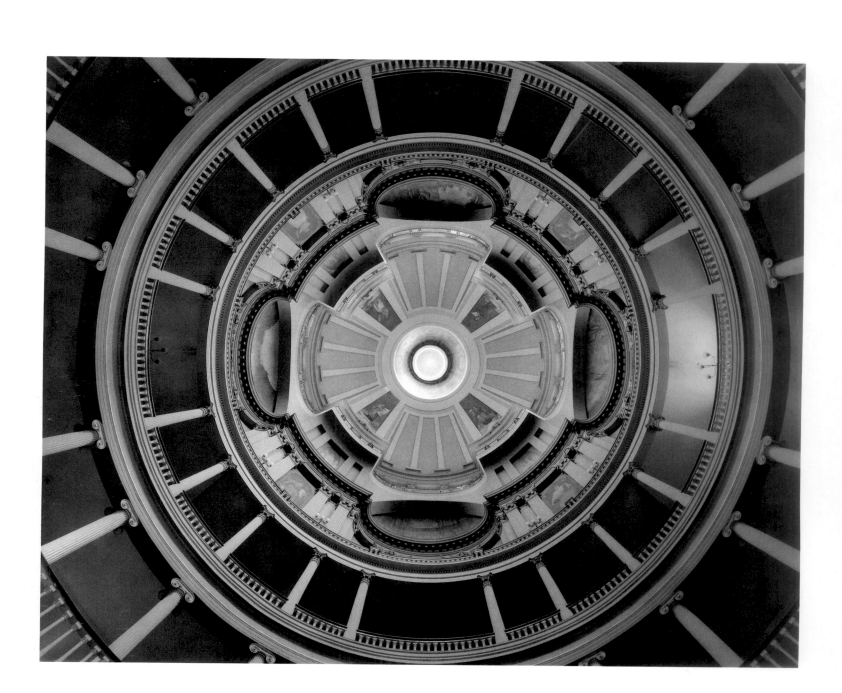

Plate 49. Rotunda and dome, Old St. Louis County Court House, St. Louis, Missouri, 1839–62. Architect Henry Singleton, completed by William Rumbold and others. Photograph by Richard Pare.

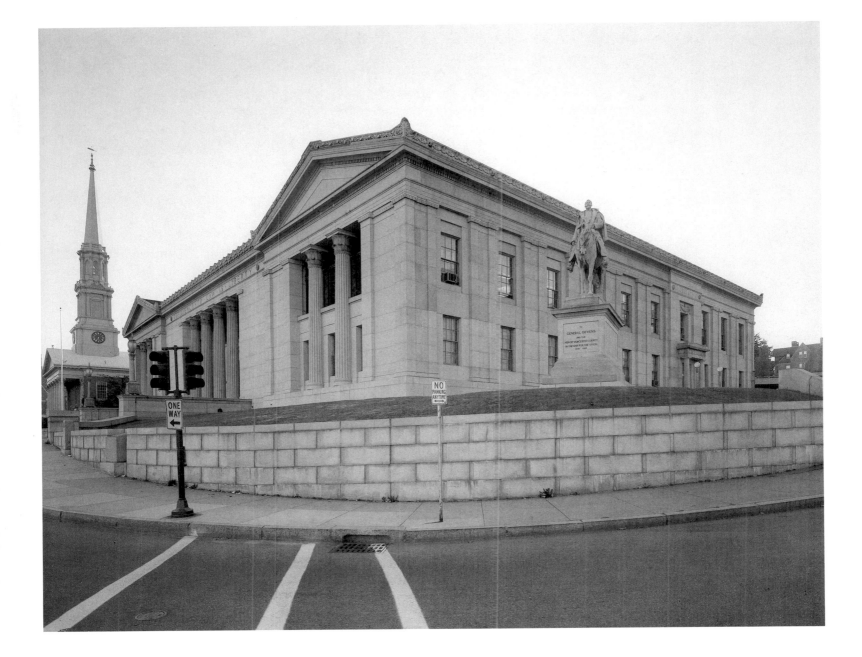

Plate 50. Worcester County Court House, Worcester, Massachusetts, 1843–45 with later additions Architect Ammi Young. Photograph by Nicholas Nixon.

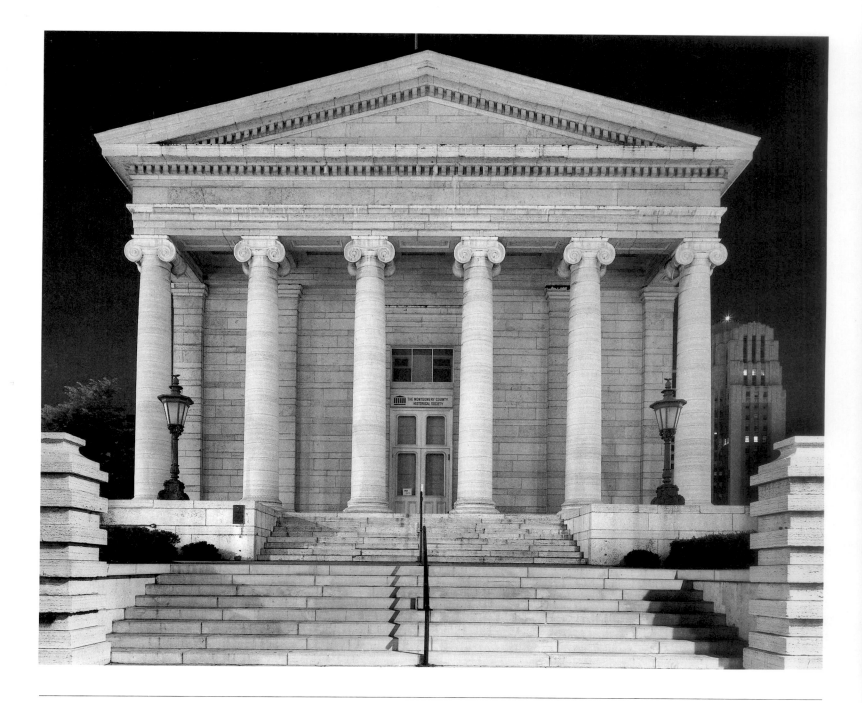

Plate 51. Montgomery County Court House, Dayton, Ohio, 1847–50. Architect Howard Daniels. Photograph by Allen Hess.

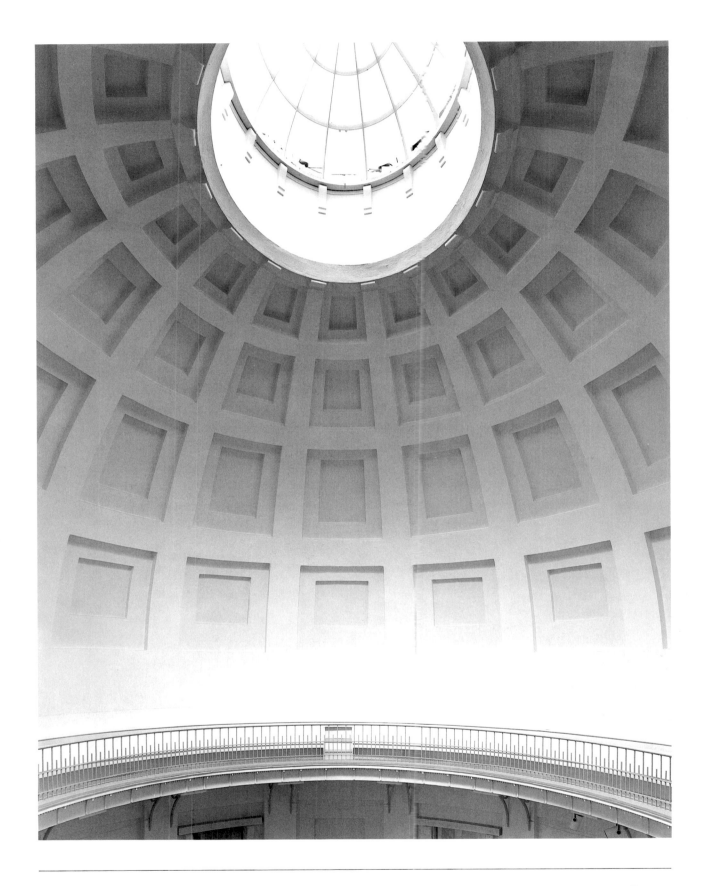

Plate 52. Interior of dome, Montgomery County Court House, Dayton, Ohio, 1847–50. Architect Howard Daniels. Photograph by Allen Hess.

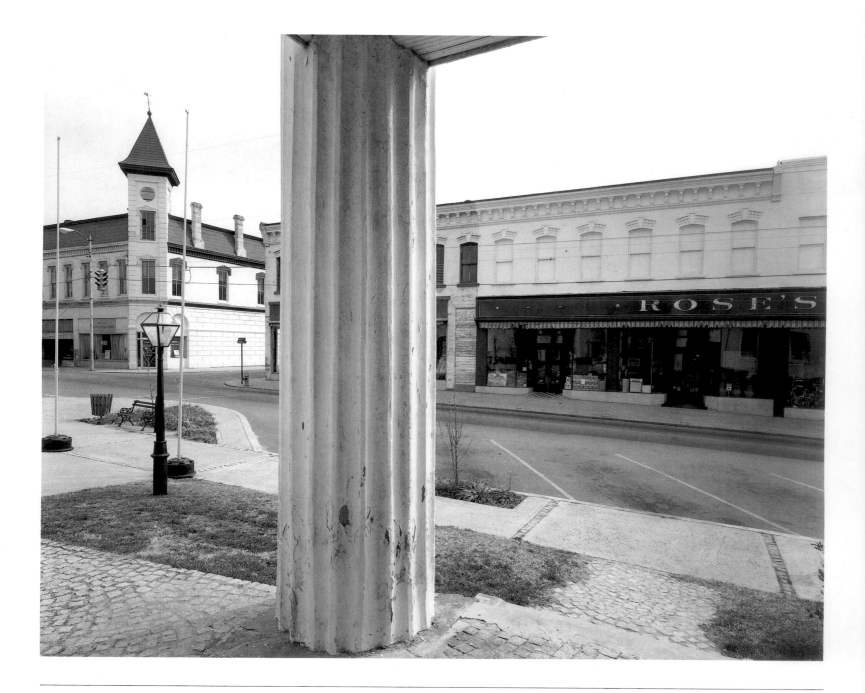

Plate 53. View from Newberry County Court House, Newberry, South Carolina. Photograph by Jim Dow.

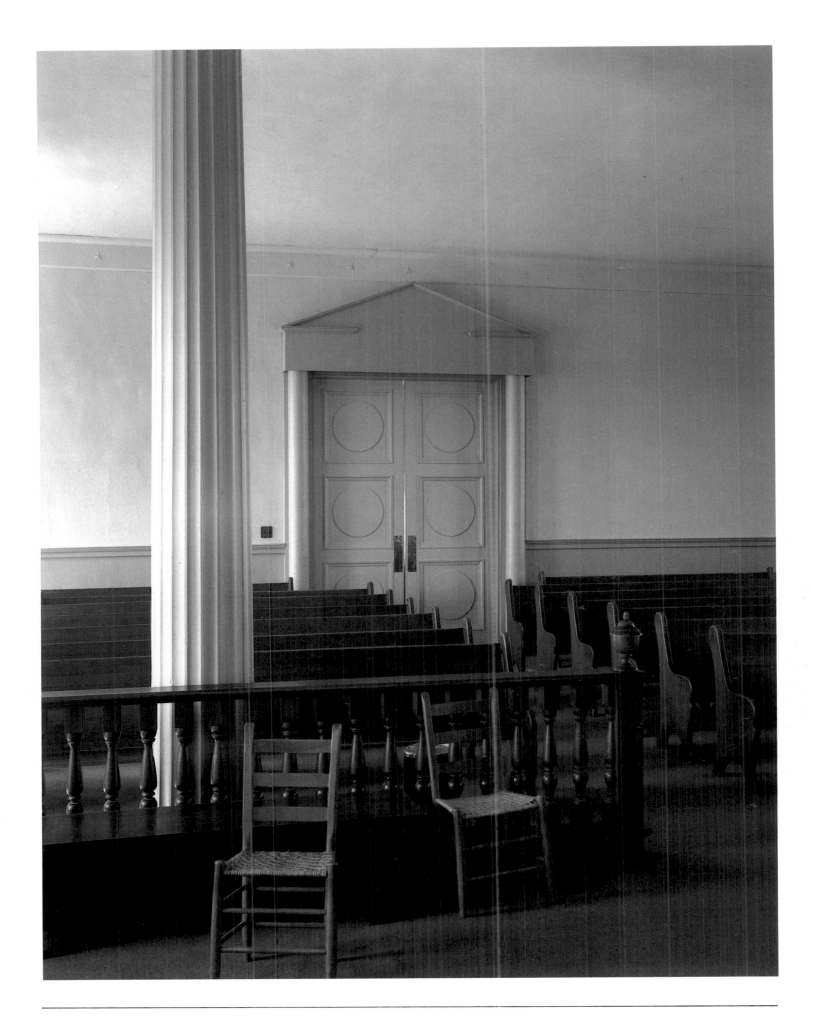

Plate 54. Greene County Court House, Greensboro, Georgia, 1848-49. Architect-builders Atharates Atkinson and David Demarest. Photograph by Stephen Shore.

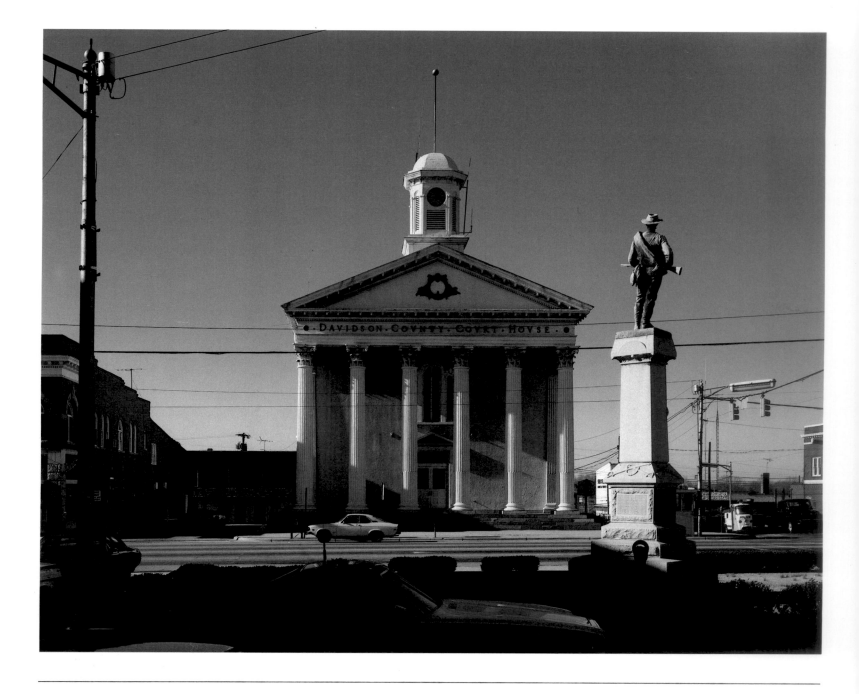

Plate 55. Davidson County Court House, Lexington, North Carolina, 1856-58. Architects Dudley & Ashley. Photograph by Stephen Shore.

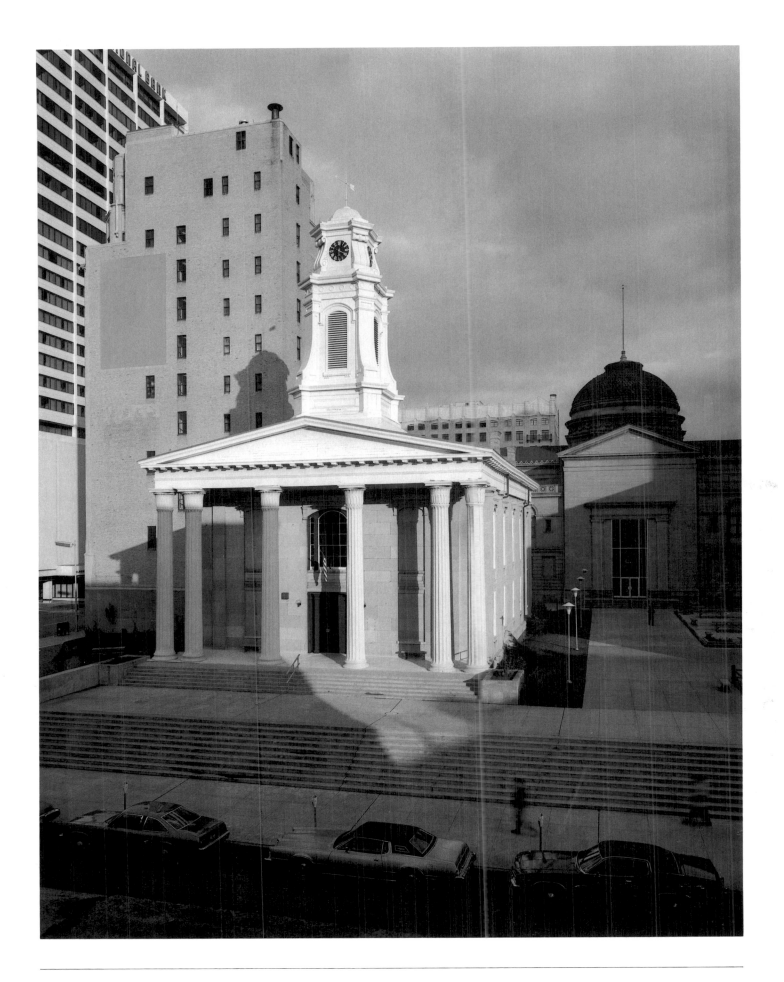

Plate 56. St. Joseph County Court House, South Bend, Indiana, completed 1855. Architect John Mills Van Osdel. Photograph by Bob Thall.

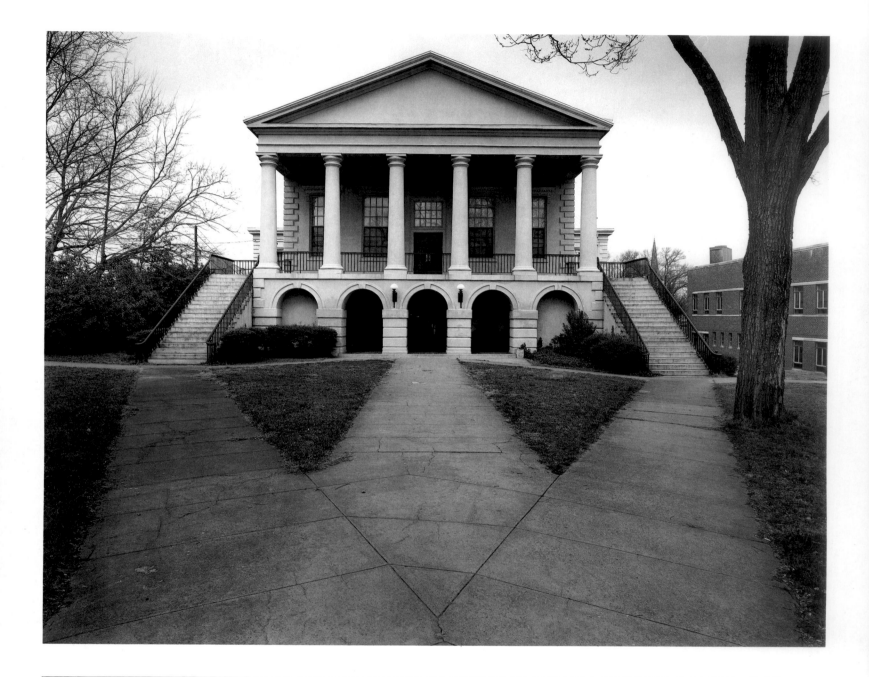

Plate 57. Chester County Court House, Chester, South Carolina, c.1850. Architect unknown. Photograph by Jim Dow.

Plate 58. Dukes County Court House, Edgartown, Massachusetts, 1858. Architect Harold Sleeper. Photograph by Nicholas Nixon.

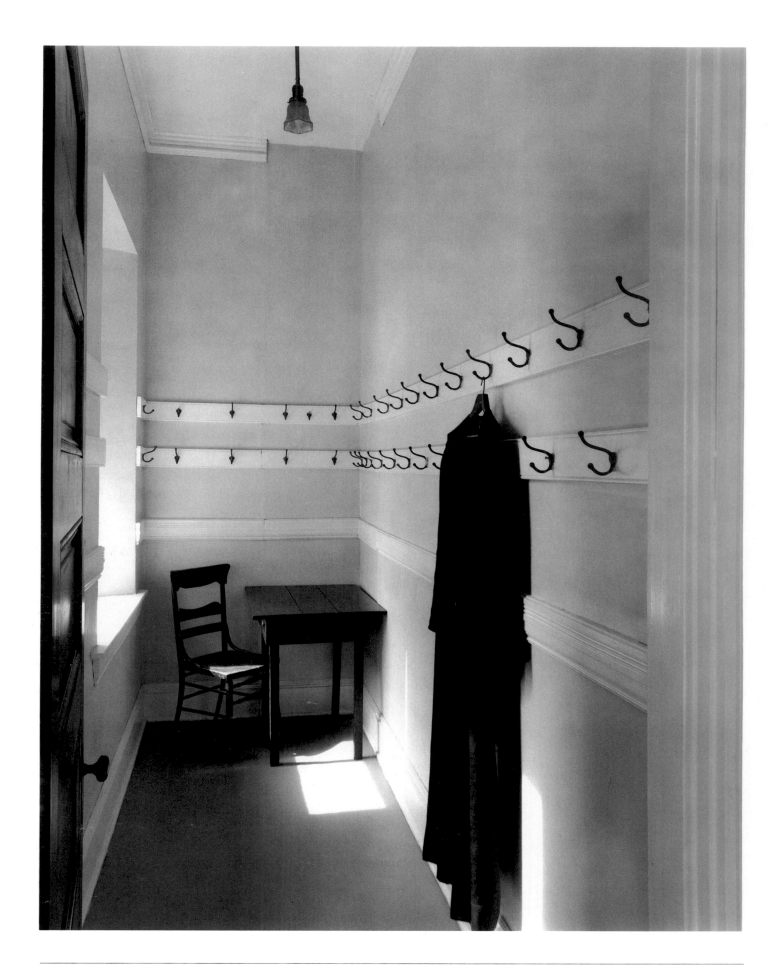

Plate 59. Grand Isle County Court House, North Hero, Vermont, 1824–25. Photograph by Douglas Baz.

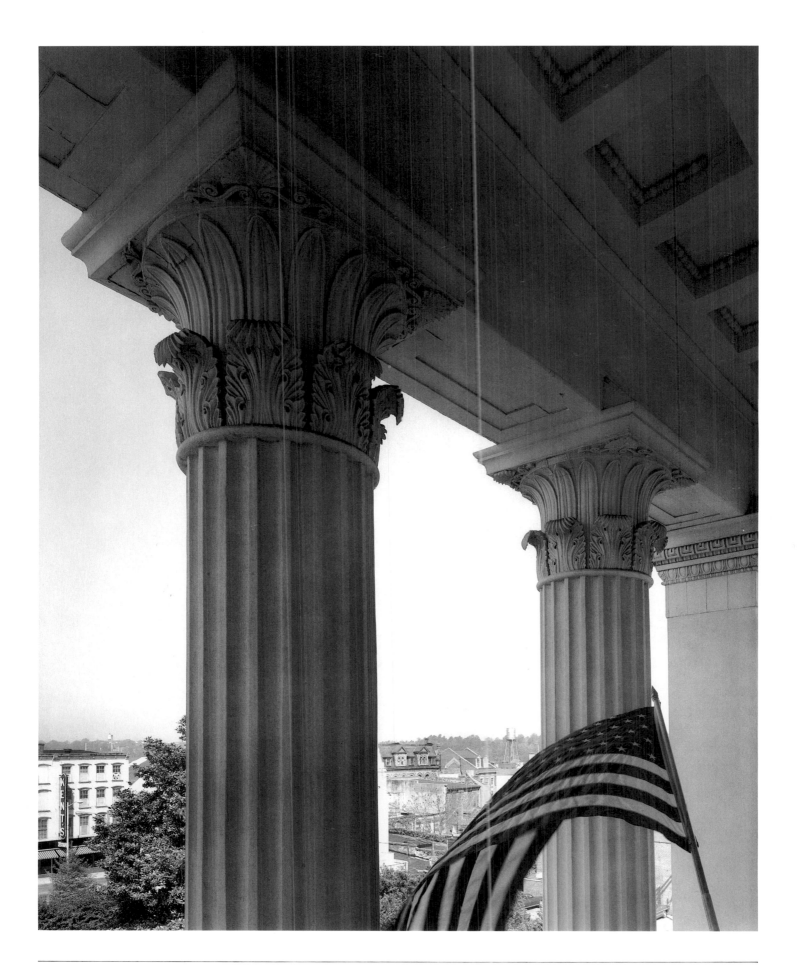

Plate 60. View from Petersburg Court House, Virginia, independent city, 1838–40. Architect Calvin Pollard. Photograph by Richard Pare.

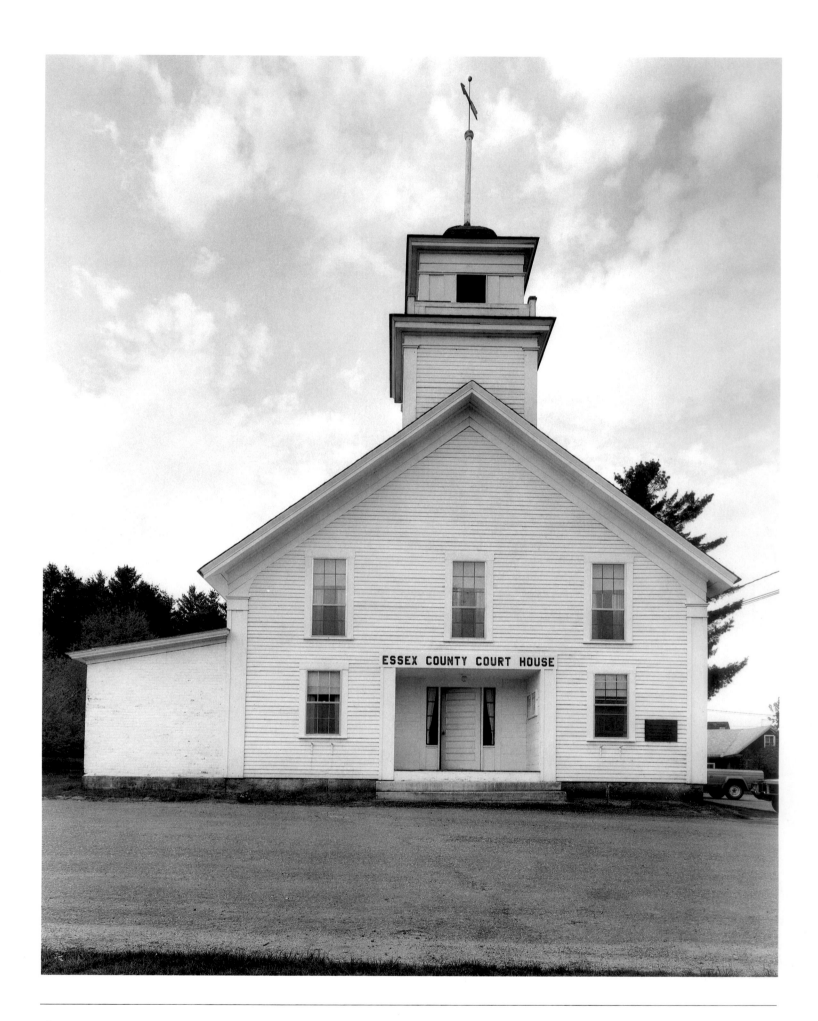

Plate 61. Essex County Court House, Guildhall, Vermont, 1850. Architect unknown. Photograph by Douglas Baz.

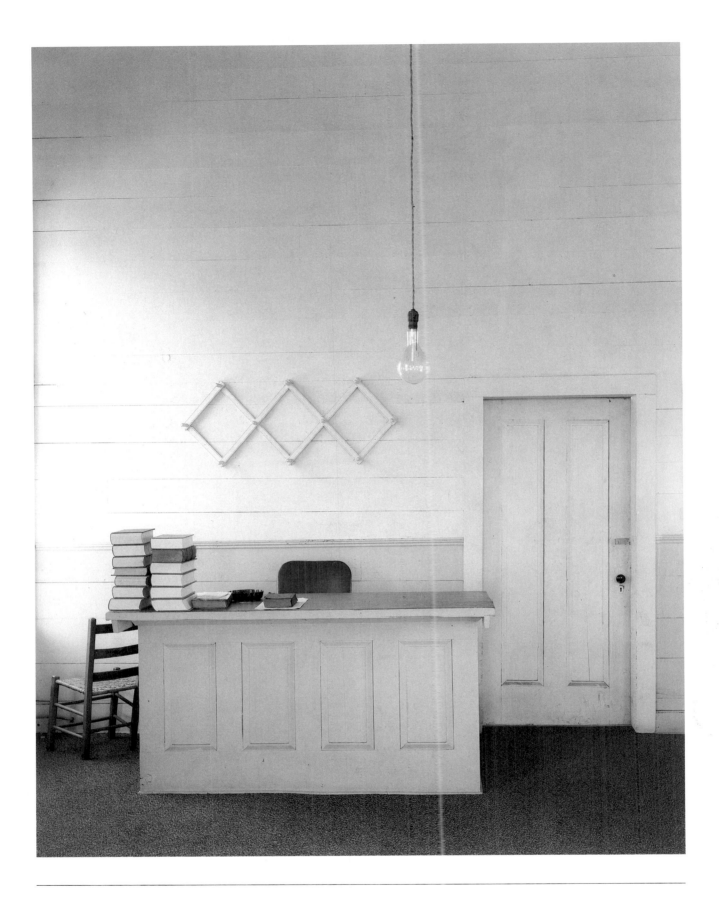

Plate 62. Banks County Court House, Homer, Georgia, 1860. Architects Samuel V. and John Willis Pruitt. Photograph by Jerry Thompson.

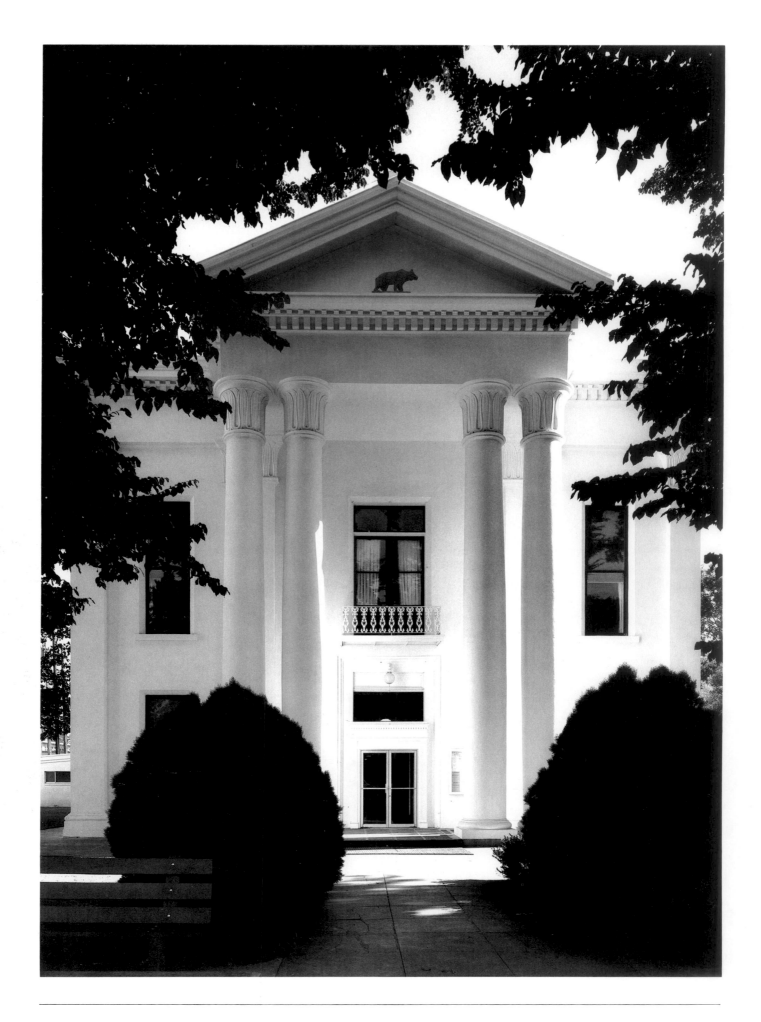

Plate 63. Colusa County Court House, Colusa, California, completed 1861. Architect Vincent Brown. Photograph by Pirkle Jones.

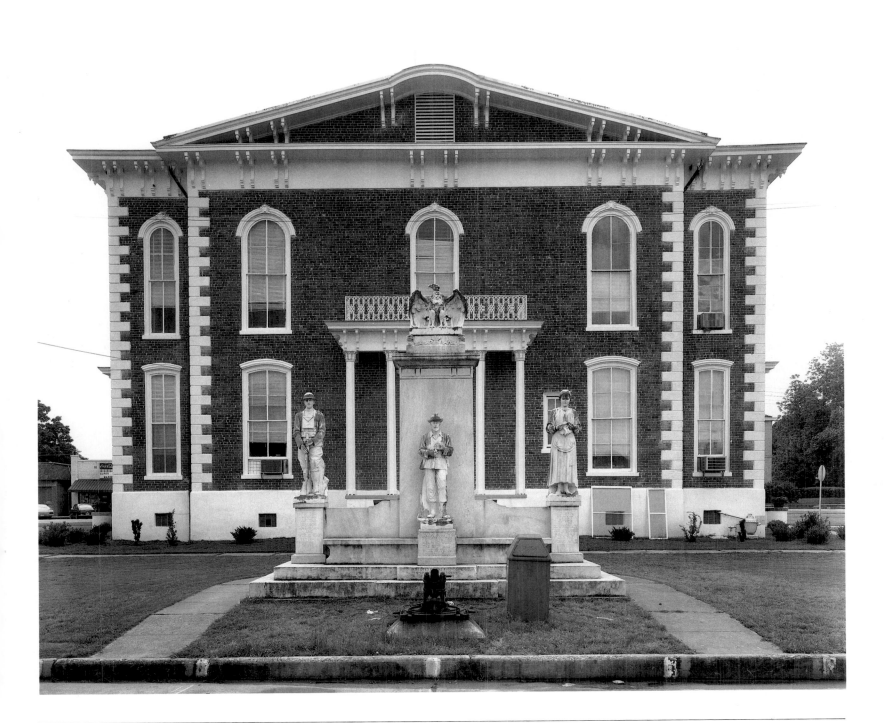

Plate 64. Pickens County Court House, Carrollton, Alabama, c.1876–77. Architect unknown. Photograph by Jim Dow.

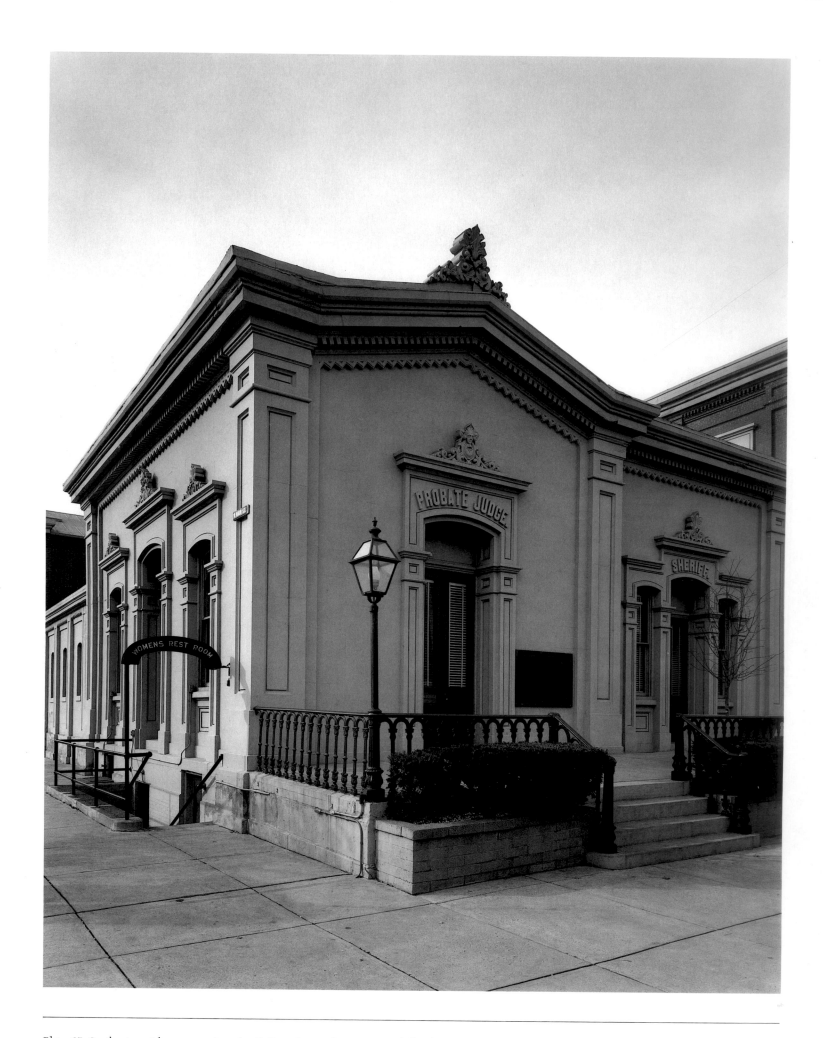

Plate 65. South wing with some cast-iron detail, Ross County Court House, Chillicothe, Ohio, 1855. Architects Collins & Autenrieth. Photograph by Allen Hess.

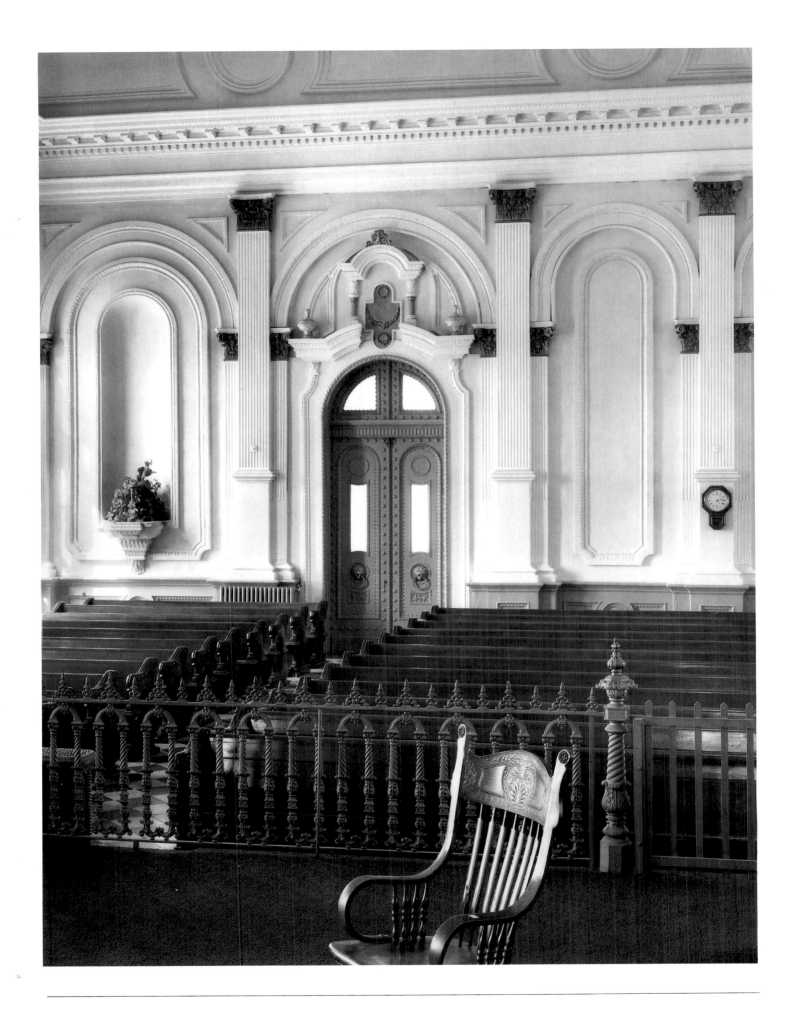

Plate 66. Courtroom with cast-iron elements, Macoupin County Court House, Carlinville, Illinois, 1867–70. Architect Elijah E. Myers. Photograph by William Clift.

Plate 67. Moniteau County Court House, California, Missouri, 1867–68 with later additions. Architect William Vogdt. Photograph by William Clift.

Plate 68. Johnson County Court House, Wrightsville, Georgia, 1895. Architects Golucke & Stewart. Photograph by Jim Dow.

Plate 69. Pitkin County Court House, Aspen, Colorado, 1890–91. Architect William Quay. Photograph by William Clift.

Plate 70. Warren County Court House, Warrenton, Missouri, c.1869–71. Architect Thomas W. Brady. Photograph by William Clift.

Plate 71. Hinsdale County Court House, Lake City, Colorado, 1877. Architect-builder Jonathan Ogden. Photograph by William Clift.

Plate 72. Old Wakulla County Court House, Crawfordville, Florida, 1893. Architect McGlynn. Photograph by Stephen Shore.

Plate 73. Fountain, c.1890, by Variety Iron Works, York, Pennsylvania. Frederick County Court House, Frederick, Maryland, 1861-64. Architect Thomas Dixon. Photograph by Stephen Shore.

Plate 74. Concourse with sculptured capitals by Alexander Calder, Philadelphia City Hall, serving county functions, Philadelphia, Pennsylvania, 1871–81. Architects John McArthur, Jr. & Thomas U. Walter, Associates. Photograph by William Clift.

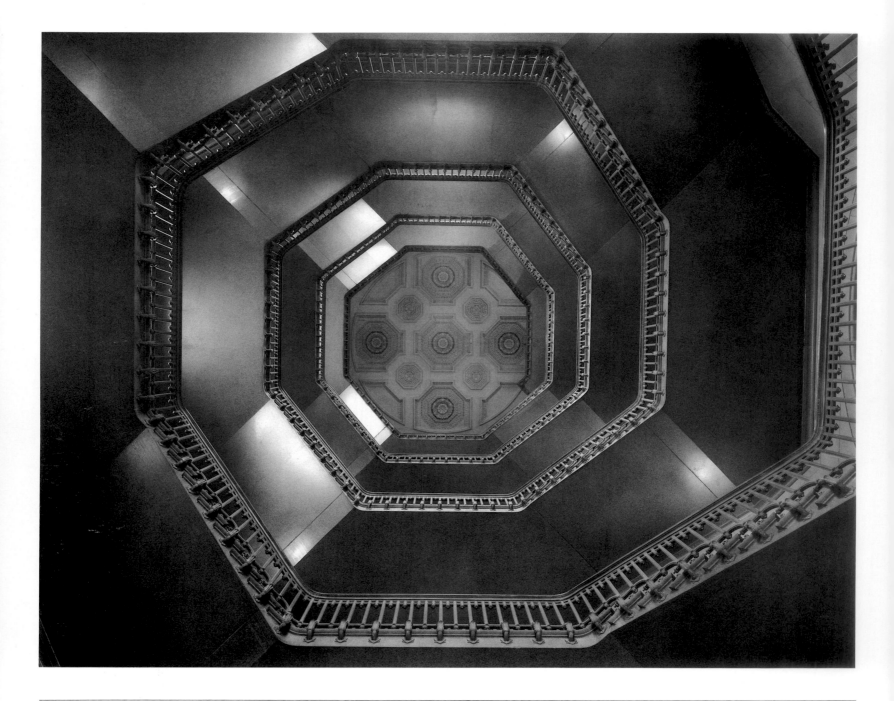

Plate 75. Stairwell, Philadelphia City Hall, serving county functions, Philadelphia, Pennsylvania, 1871–81. Architects John McArthur, Jr. & Thomas U. Walter, Associates. Photograph by William Clift.

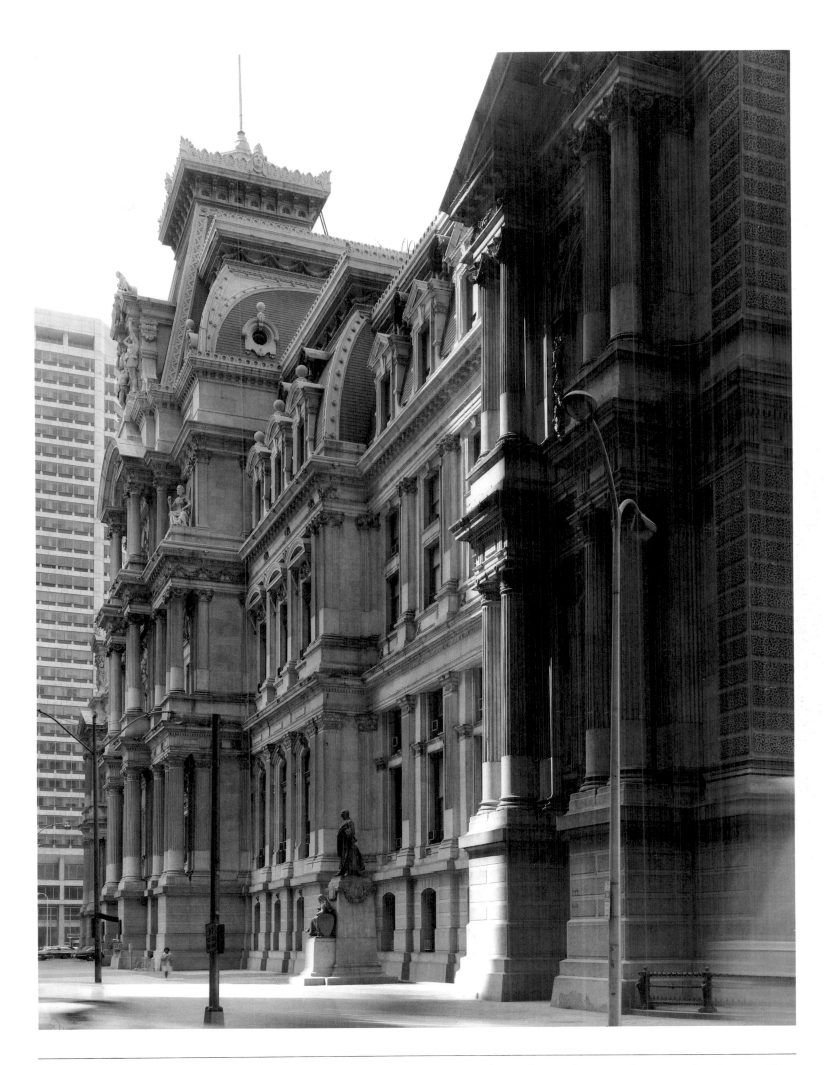

Plate 76. Philadelphia City Hall, serving county functions, Philadelphia, Pennsylvania, 1871–81. Architects John McArthur, Jr. & Thomas U. Walter, Associates. Photograph by Richard Pare.

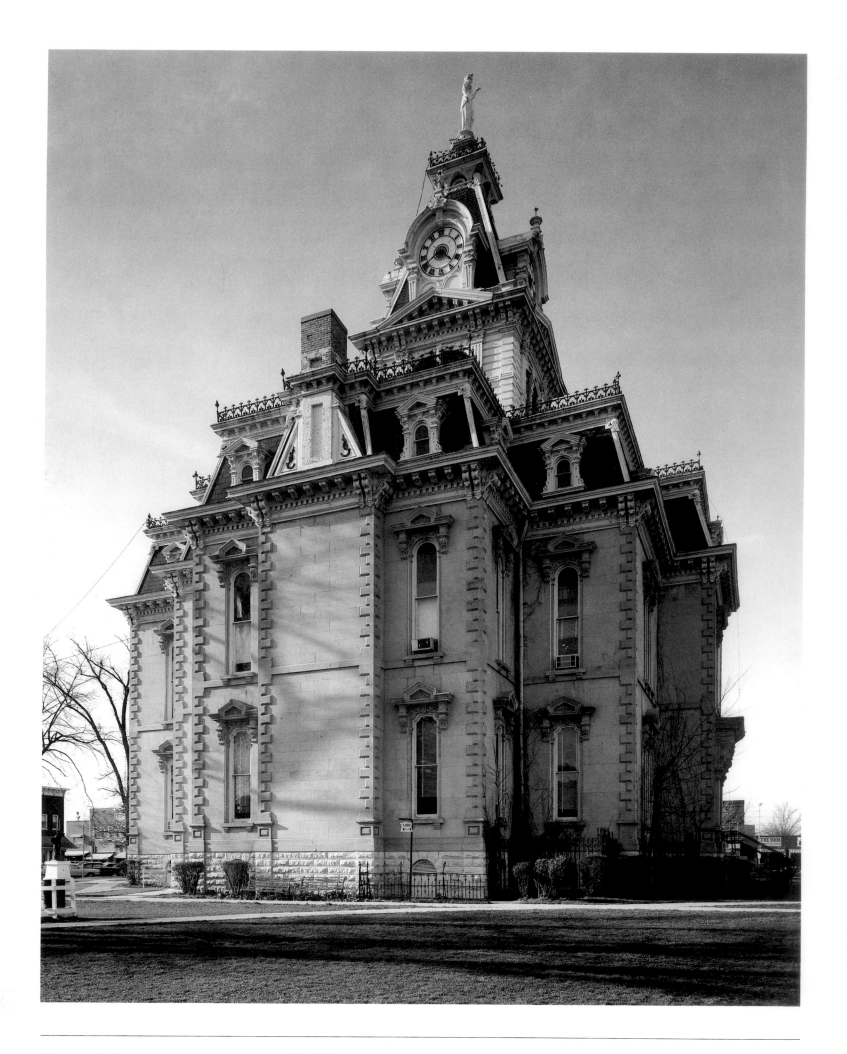

Plate 77. Side elevation, Davis County Court House, Bloomfield, Iowa, 1877–78. Architects Thomas J. Tolan & Son. Photograph by Bob Thall.

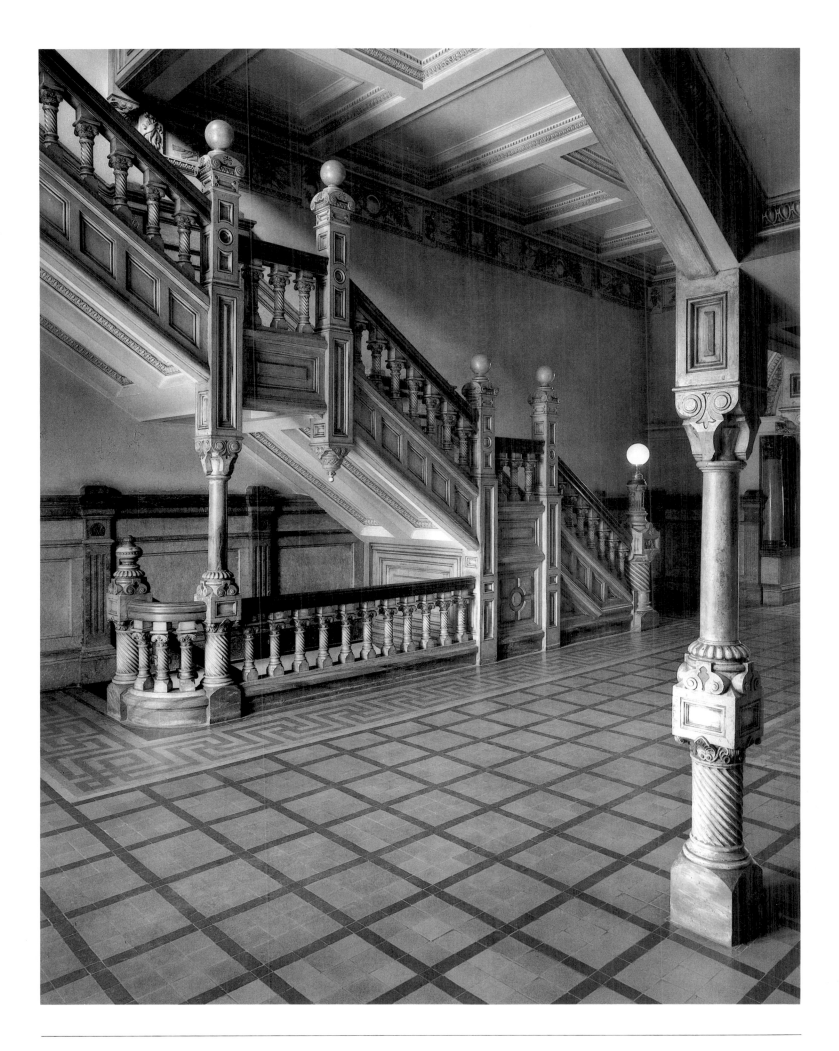

Plate 78. Main lobby, Miami County Court House, Troy, Ohio, 1885–88. Architect Joseph Warren Yost. Photograph by William Clift.

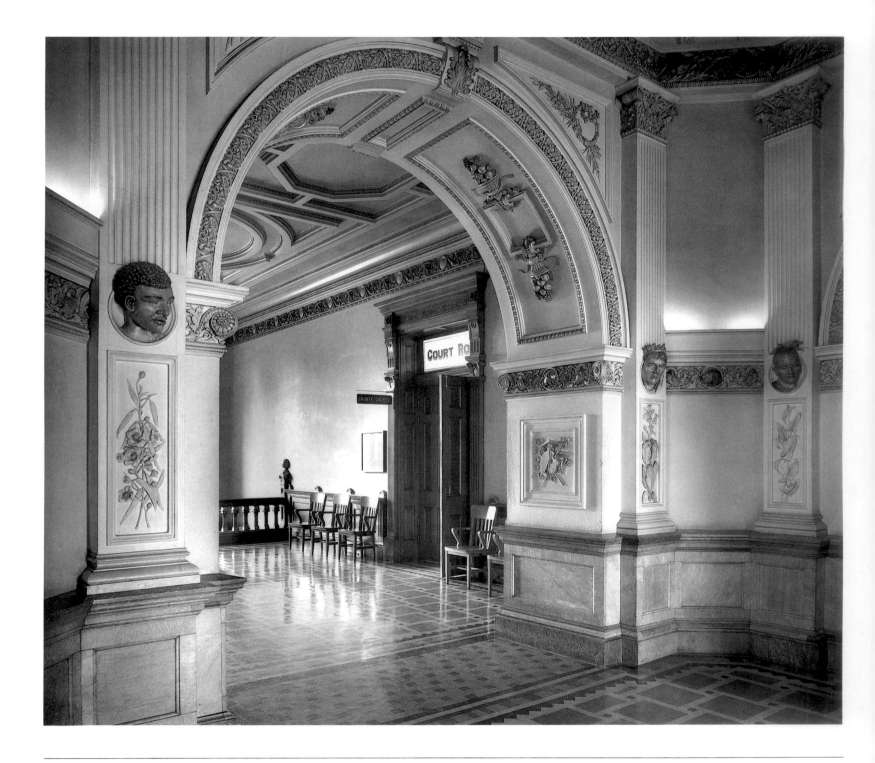

Plate 79. Second-floor hallway, Miami County Court House, Troy, Ohio, 1885–88. Architect Joseph Warren Yost. Photograph by William Clift.

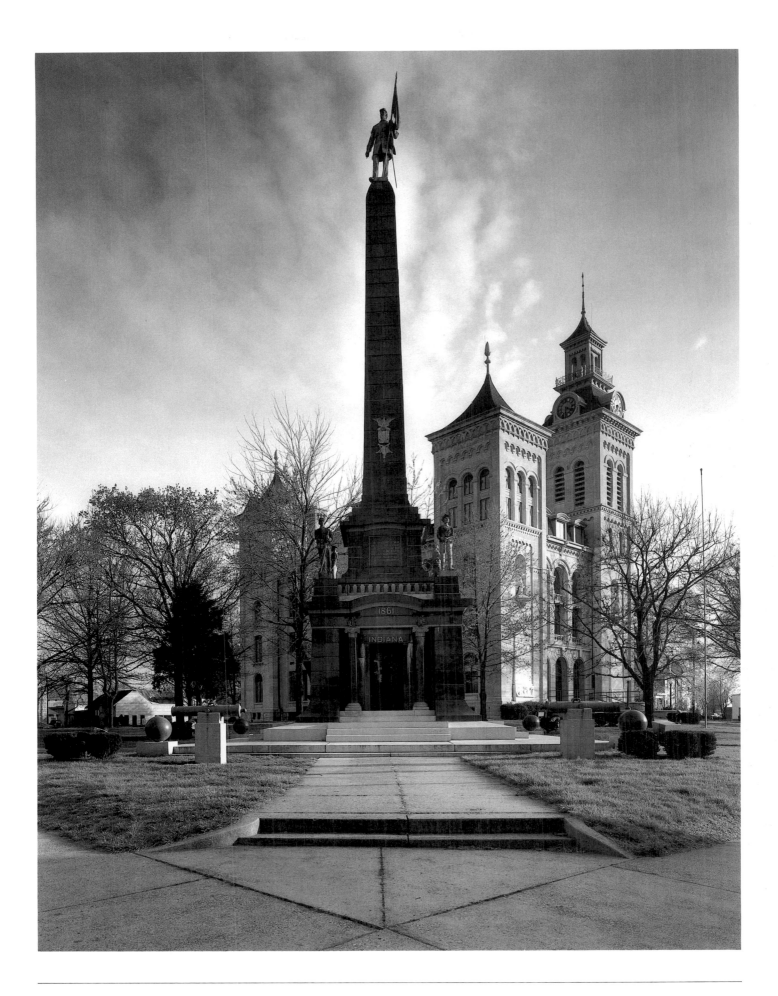

Plate 80. Knox County Court House, Vincennes, Indiana, c.1872–76. Architect Edwin May. Photograph by William Clift.

Plate 81. The Judge, Elkhart County Court House, Goshen, Indiana, 1868–71. Architects J. H. Barrows & George O. Garnsey. Photograph by Lewis Kostiner.

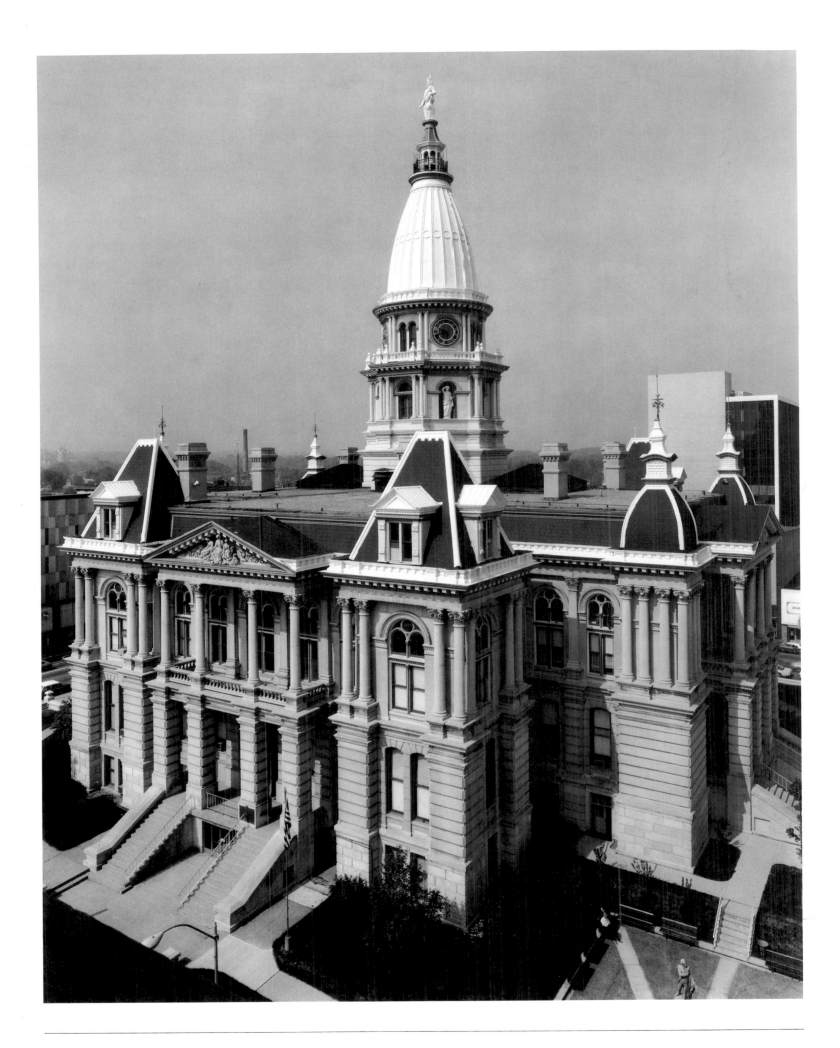

Plate 82 Tippecanoe County Court House, Lafayette, Indiana. 1881–85. Architect Elias Max. Photograph by Bob Thall.

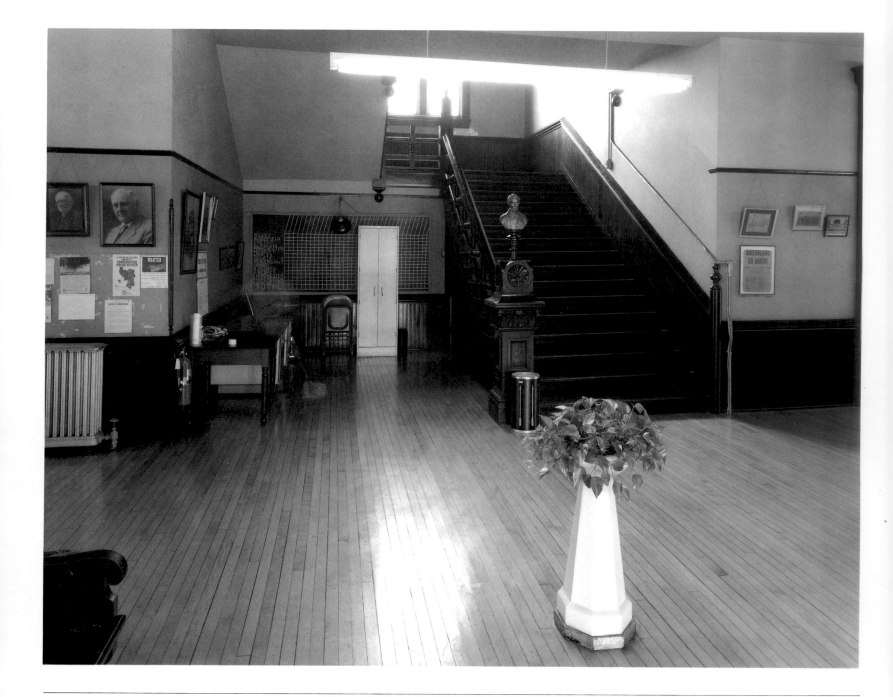

Plate 83. Lobby, Scott County Court House, Winchester, Illinois, 1885. Architects James Stewart & Co. Photograph by Tod Papageorge.

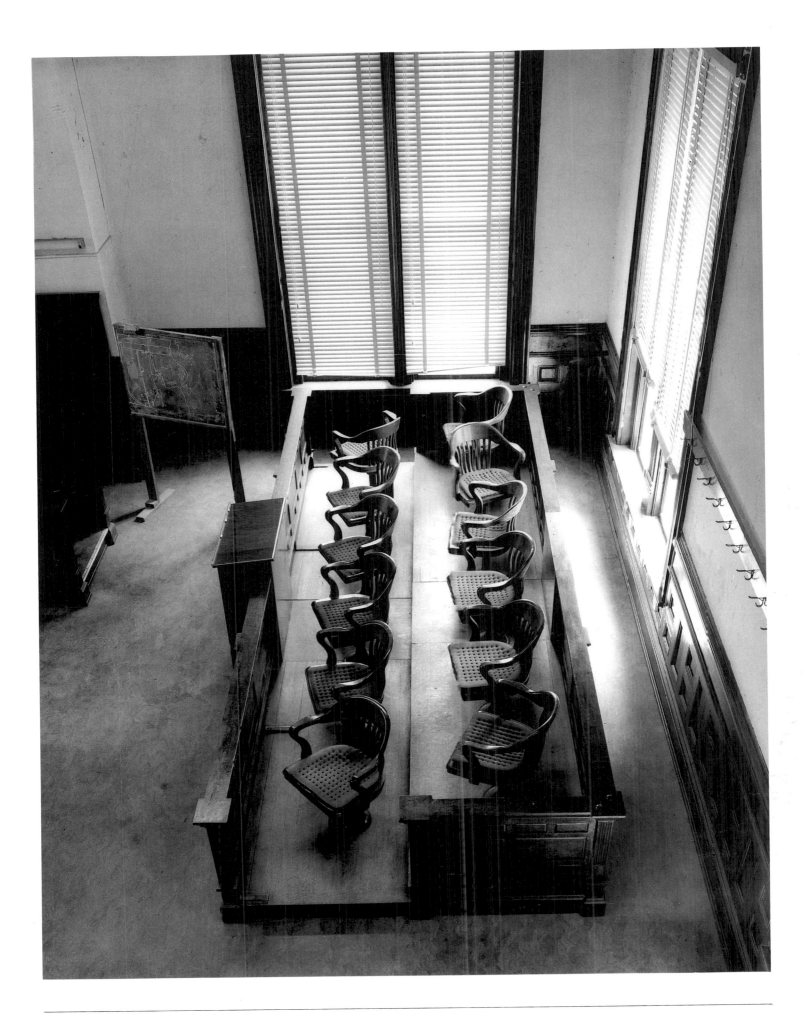

Plate 84. Hill County Court House, Hillsboro, Texas, c.1889–91. Architect W. C. Dodson. Photograph by Geoff Winningham.

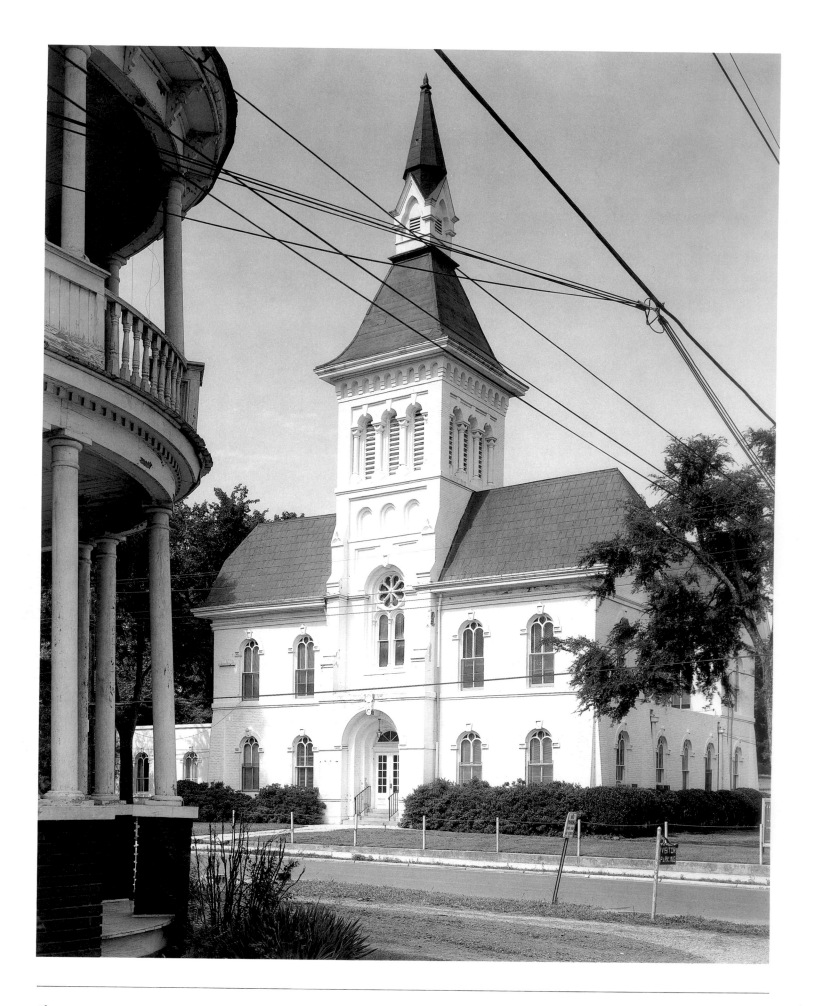

Plate 85. Tate County Court House, Senatobia, Mississippi, 1875. Architect unknown. Photograph by Jim Dow.

Plate 86. Pressed-metal ceiling, Pike County Court House, Zebulon, Georgia, 1895–96. Architects Golucke & Stewart. Photograph by Jim Dow.

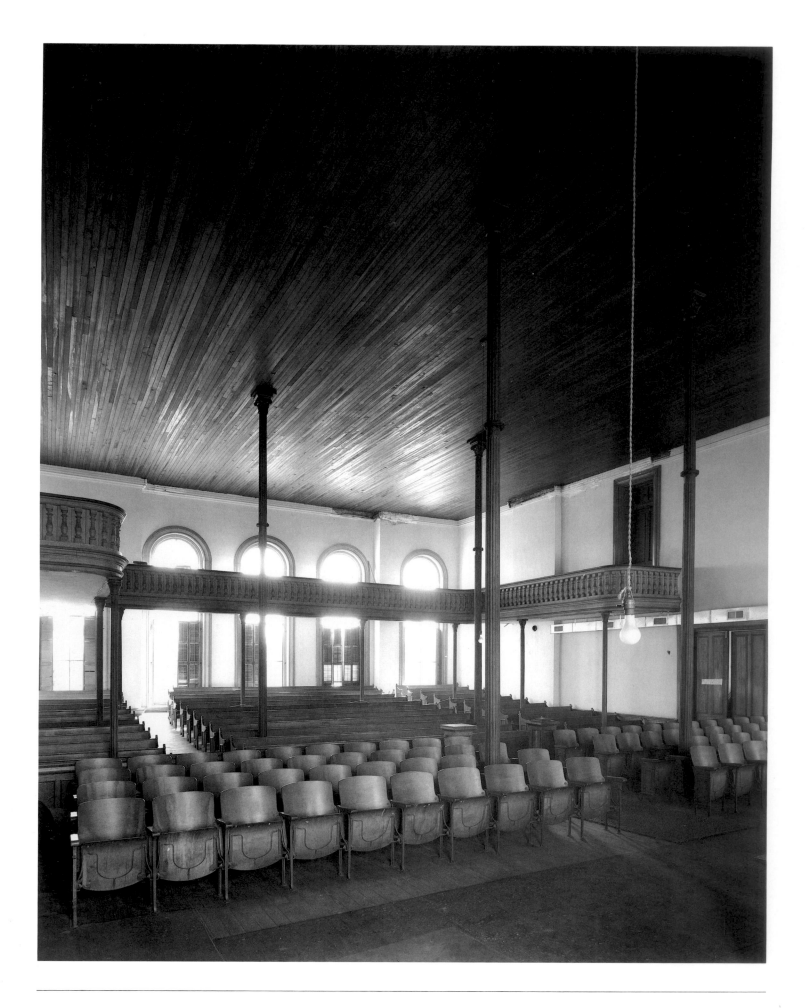

Plate 87. Hancock County Court House, Sparta, Georgia, 1881–83. Architects Parkins & Bruce. Photograph by Jim Dow.

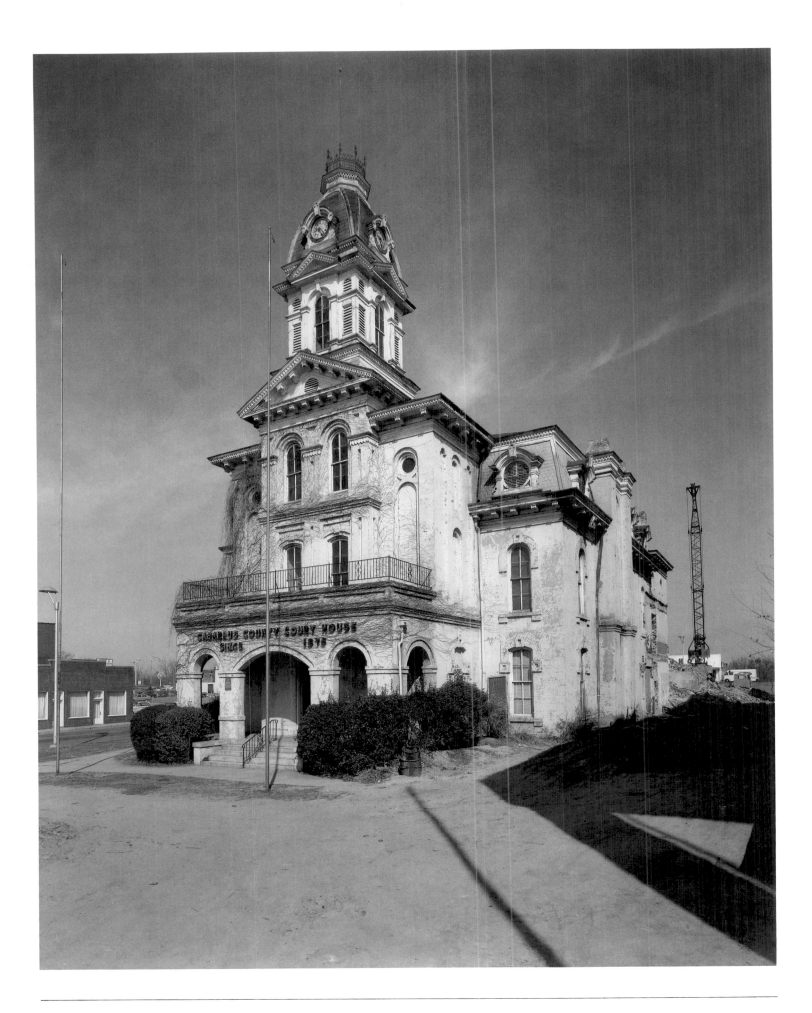

Plate 88. Cabarrus County Court House, Concord, North Carolina, 1875–76. Architect G. S. H. Appleget. Photograph by Jim Dow.

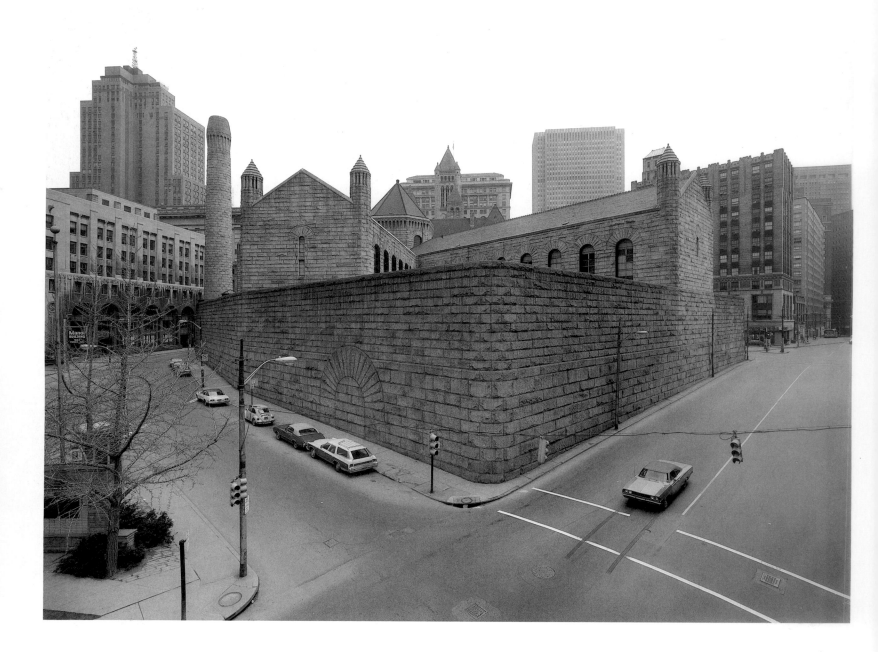

Plate 89. Jail, Allegheny County Court House, Pittsburgh, Pennsylvania, 1884–88 with later additions. Architect Henry Hobson Richardson. Photograph by Richard Pare.

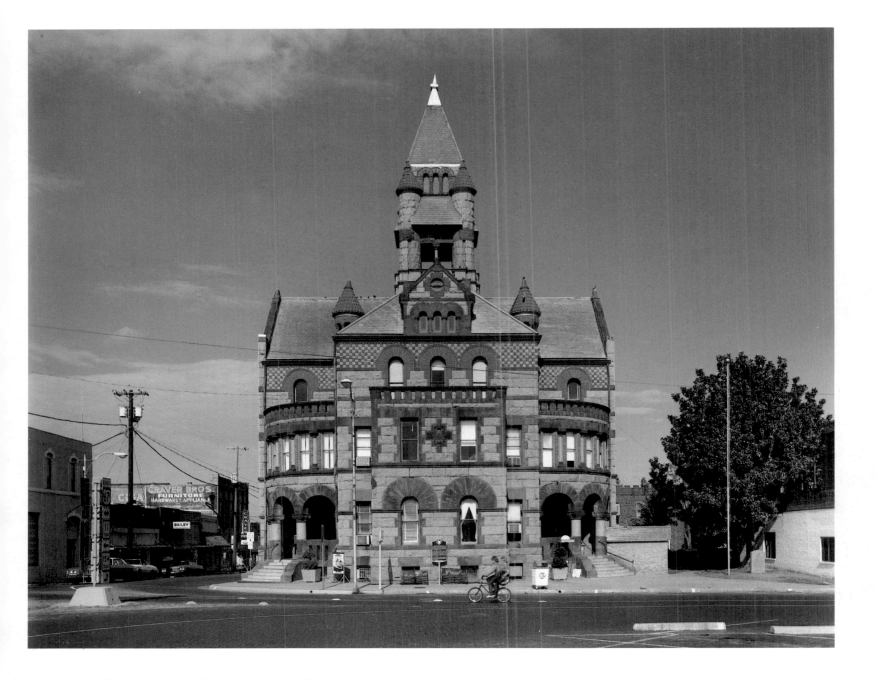

Plate 90. Hopkins County Court House, Sulphur Springs, Texas, c.1894-95. Architect James Riely Gordon. Photograph by Geoff Winningham.

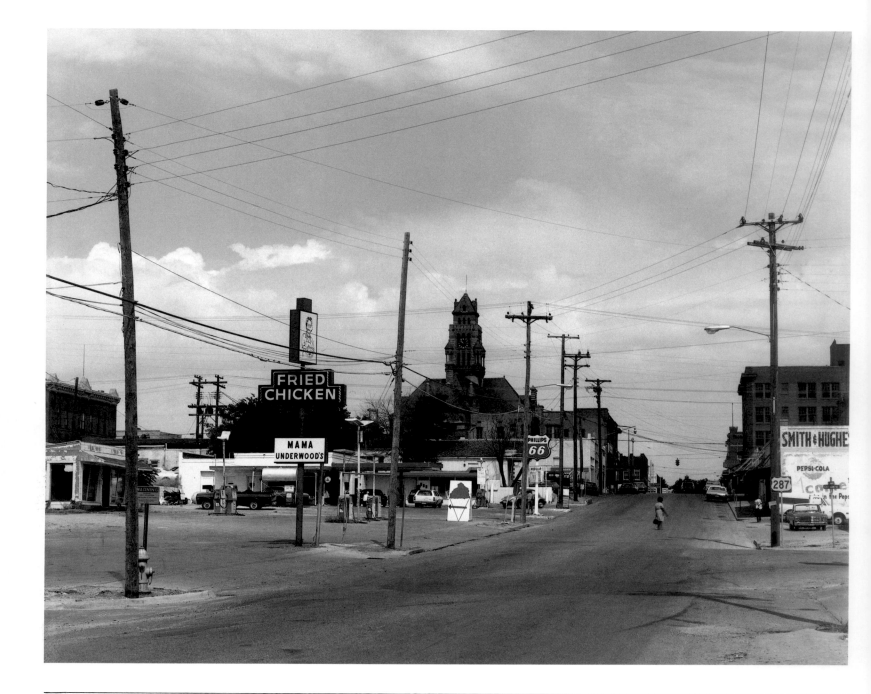

Plate 91. Ellis County Court House, Waxahachie, Texas, 1894-97. Architect James Riely Gordon. Photograph by Geoff Winningham.

Plate 92. Parker County Court House, Weatherford, Texas, 1884–86. Architects W. C. Dodson & W. V. Dudley. Photograph by Frank Gohlke.

Plate 93. Clerks, City and County Building, Salt Lake County, Salt Lake City, Utah. Photograph by Ellen Land-Weber.

Plate 94. City and County Building, Salt Lake County, Salt Lake City, Utah, 1891–94. Architects Proudfoot, Bird & Monheim. Photograph by Tod Papageorge.

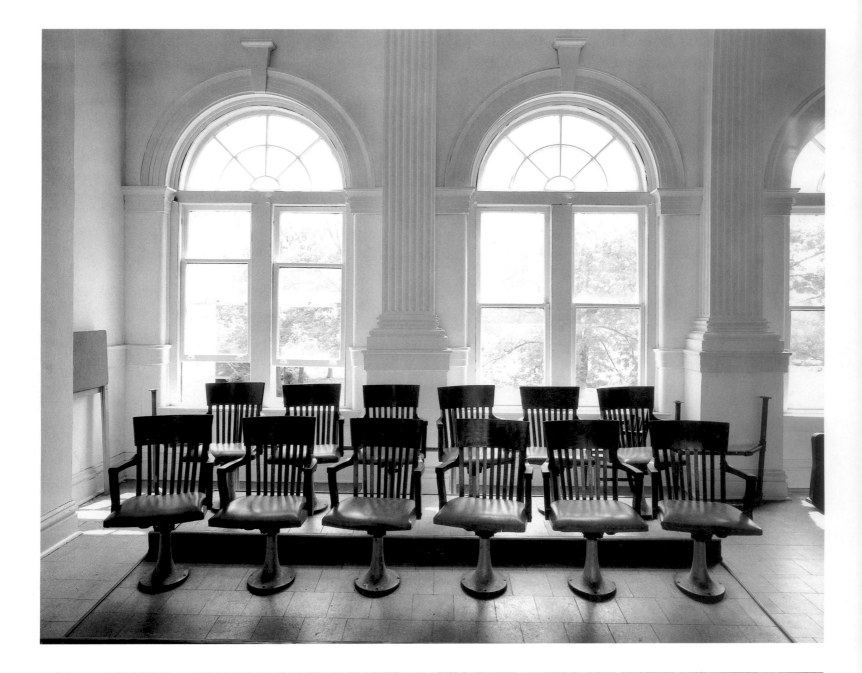

Plate 95. Grady County Court House, Cairo, Georgia, 1908–09. Architect Alexander Blair. Photograph by Jim Dow.

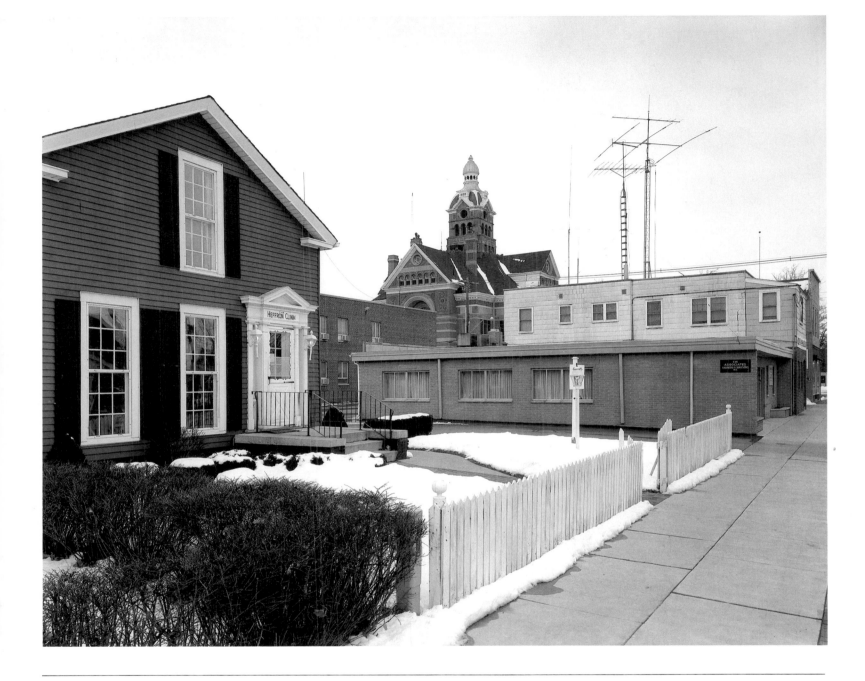

Plate 96. Lenawee County Court House, Adrian, Michigan, 1884–86. Architects E. O. Fallis & Co. Photograph by Nicholas Nixon.

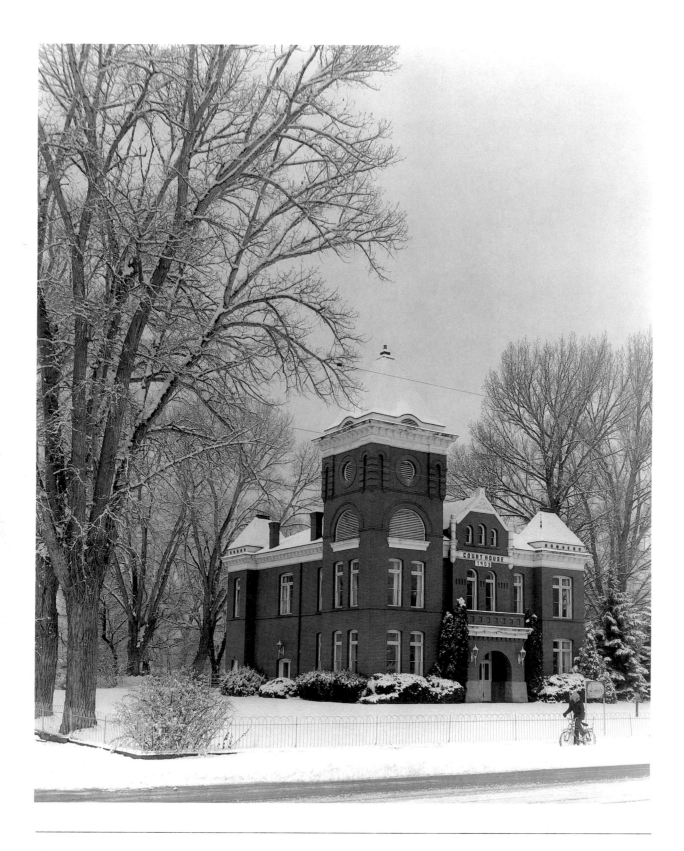

Plate 97. Piute County Court House, Junction, Utah, 1903. Architect R. C. Watkins. Photograph by Ellen Land-Weber.

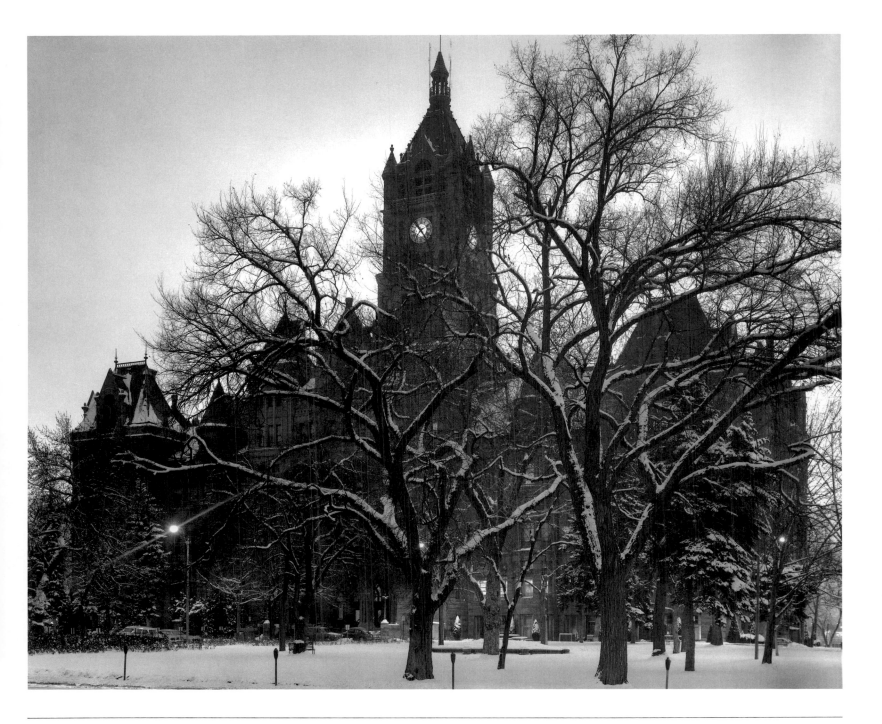

Plate 98. City and County Building, Salt Lake County, Salt Lake City, 1891–94. Architects Proudfoot, Bird & Monheim. Photograph by William Clift.

Plate 99. Bristol County Court House, Taunton, Massachusetts, 1892–95. Architect Frank Irving Cooper. Photograph by Nicholas Nixon.

Plate 100. Chief of Police and Sheriff, Millard County Court House, Fillmore, Utah. Photograph by Ellen Land-Weber.

Plate 101. County convention room, Clay County Court House, Brazil, Indiana, 1912–14. Architect J. W. Gaddis. Photograph by Bob Thall.

Plate 102. Pumpkin festival, De Kalb County Court House, Sycamore, Illinois, 1903. Architects Watson & Hazleton. Photograph by Laura Volkerding.

Plate 103. *Janitor and Sheriff, Malheur County Court House, Vale, Oregon. Photograph by Ellen Land-Weber.*

Plate 104. Fourth of July, Essex County Court House, Guildhall, Vermont, 1850. Architect unknown. Photograph by Richard Pare.

Plate 105. Detail of lobby, Union County Court House, Liberty, Indiana, 1890–91. Architects George W. Bunting & Son. Photograph by Lewis Kostiner.

Plate 106. Roll of Honor, Pulaski County Court House, Winamac, Indiana. Photograph by Bob Thall.

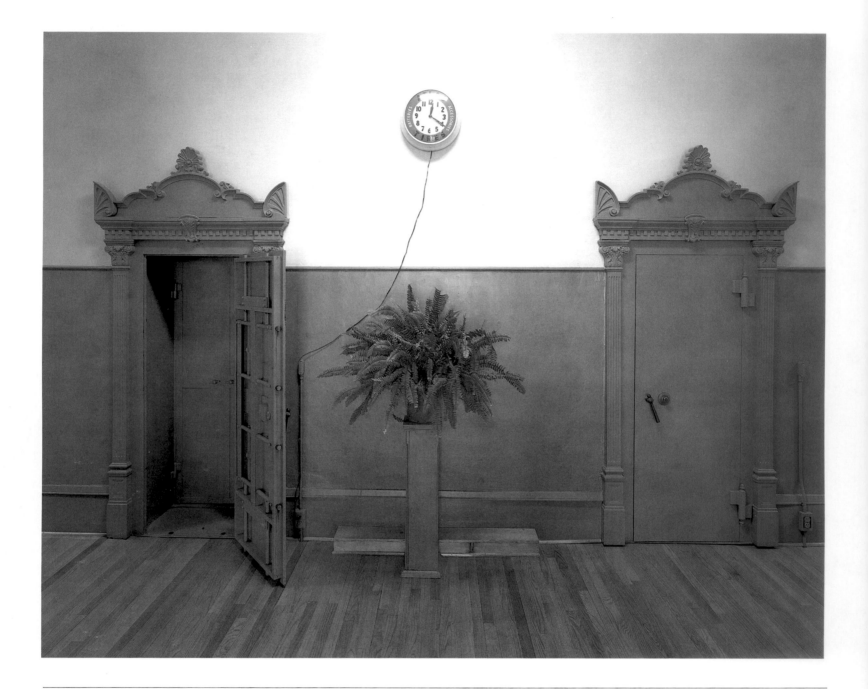

Plate 107. Greene County Court House, Greensboro, Georgia, 1848–49. Architect-builders Atharates Atkinson and David Demarest. Photograph by Stephen Shore.

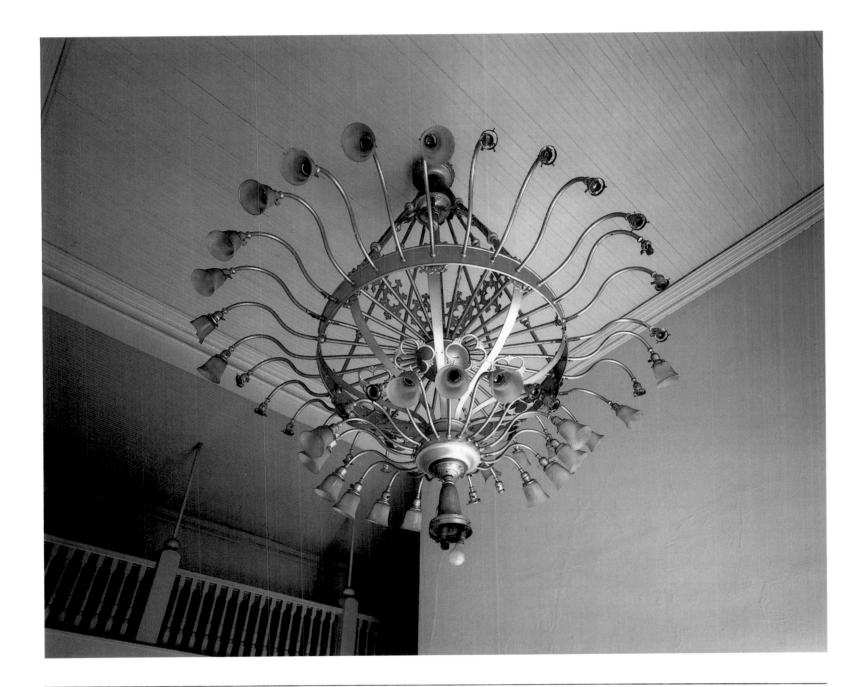

Plate 108. Decatur County Court House, Bainbridge, Georgia, 1902. Architect Alexander Blair. Photograph by Stephen Shore.

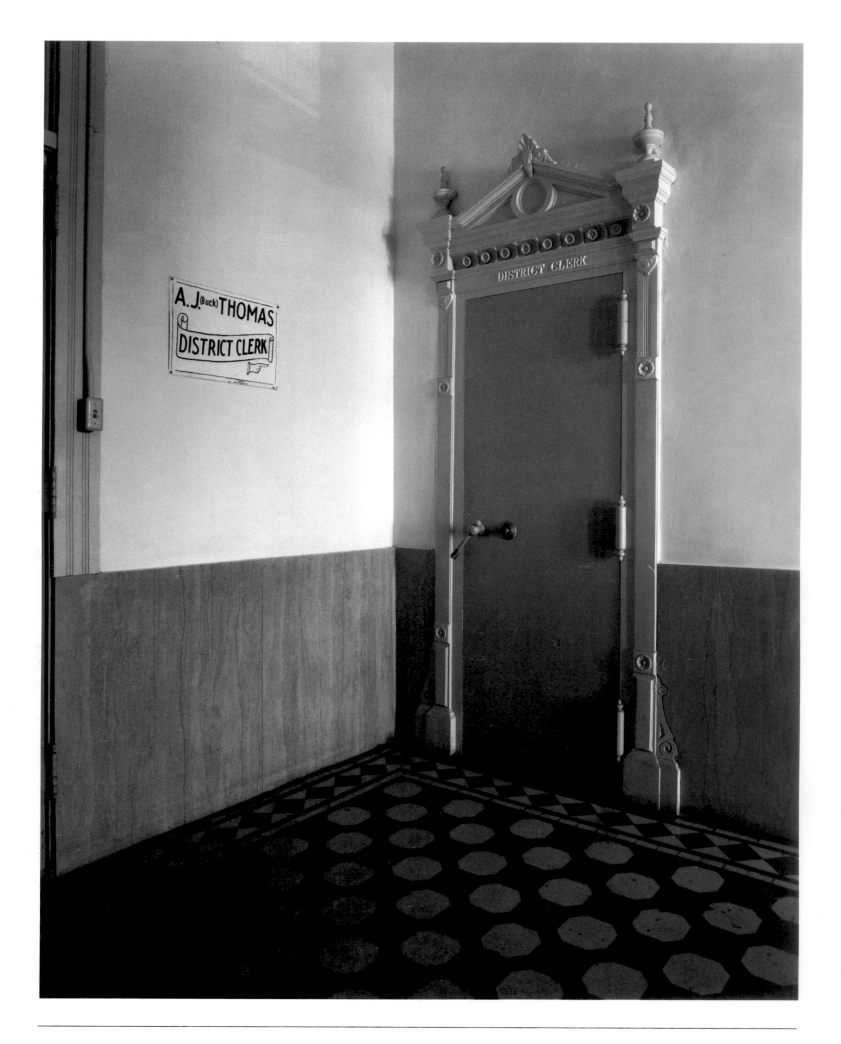

Plate 109. Hill County Court House, Hillsboro, Texas, c.1889-91. Architect W. C. Dodson. Photograph by Geoff Winningham.

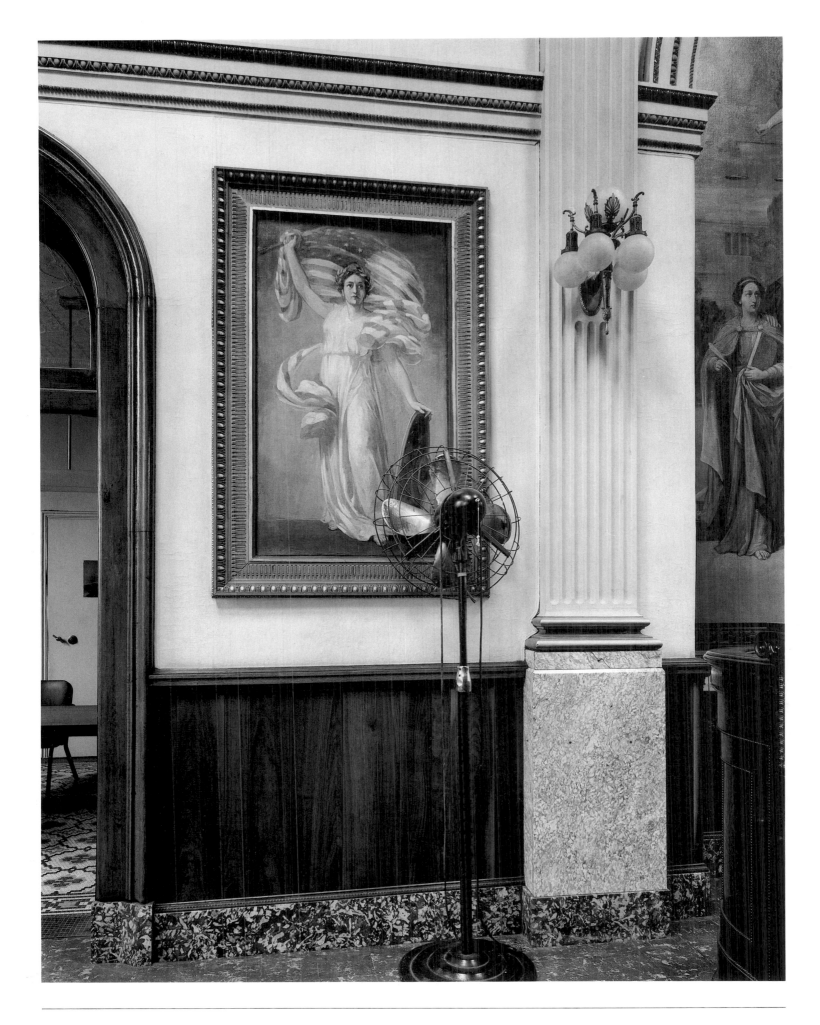

Plate 110. Fulton County Court House, Wauseon, Ohio, 1870–72. Architect C. C. Miller (attributed). Photograph by Bob Thall.

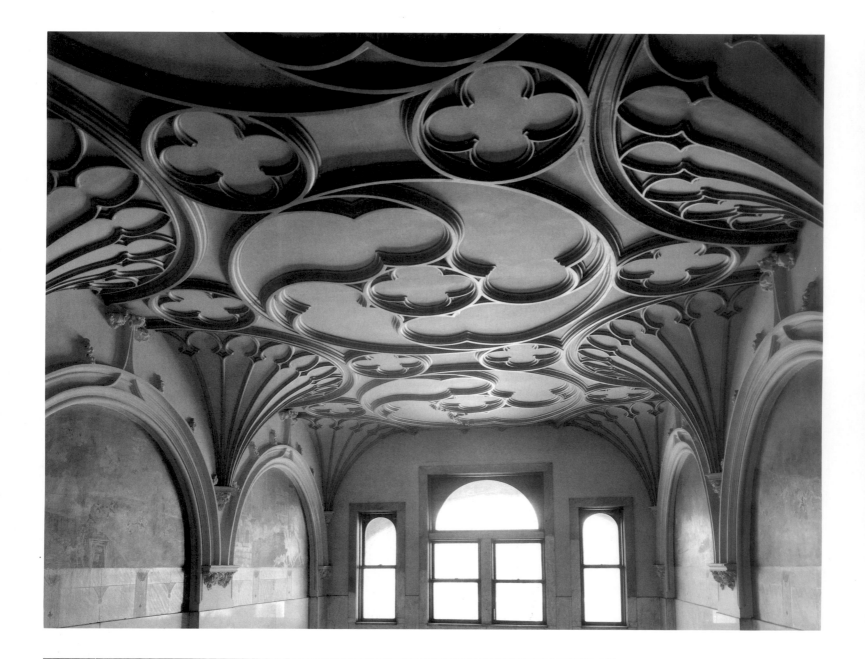

Plate 111. Lobby ceiling, Hancock County Court House, Greenfield, Indiana, c.1896–98. Architects Wing & Mahurin. Photograph by Lewis Kostiner.

Plate 112. Dubuque County Court House, Dubuque, Iowa, c.1890–93. Architects Fridolin Heer & Son. Photograph by Bob Thall.

Plate 113. Vigo County Court House, Terre Haute, Indiana, 1884–88. Architect Samuel Hannaford. Photograph by Bob Thall.

Plate 114. Clay County Court House, Brazil, Indiana, 1912–14. Architect J. W. Gaddis. Photograph by Bob Thall.

Plate 115. Jasper County Court House, Rennselaer, Indiana, 1896–98. Architects Alfred Grindle and Charles R. Weatherhogg. Photograph by Bob Thall.

Plate 116. City-County Municipal Building, Hennepin County, Minneapolis, Minnesota, c.1887–1906. Architects Long & Kees. Father of Waters sculpture by Larkin Goldsmith Meads. Photograph by Frank Gohlke.

Plate 117. City-County Municipal Building, Hennepin County, Minneapolis, Minnesota, c.1887–1906 Architects Long & Kees. Photograph by Frank Gohlke.

Plate 118. Rotunda, Essex County Court House, Newark, New Jersey, 1902-07. Architect Cass Gilbert. Photograph by Stephen Shore.

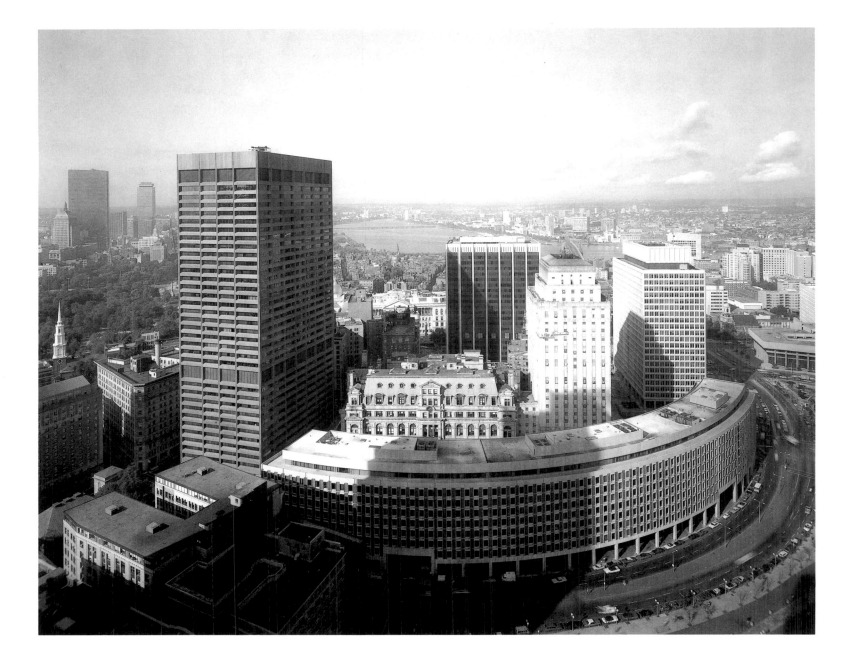

Plate 119. Suffolk County Court House, Boston, Massachusetts, 1886–94 with later additions. Architect George A. Clough. Photograph by Nicholas Nixon.

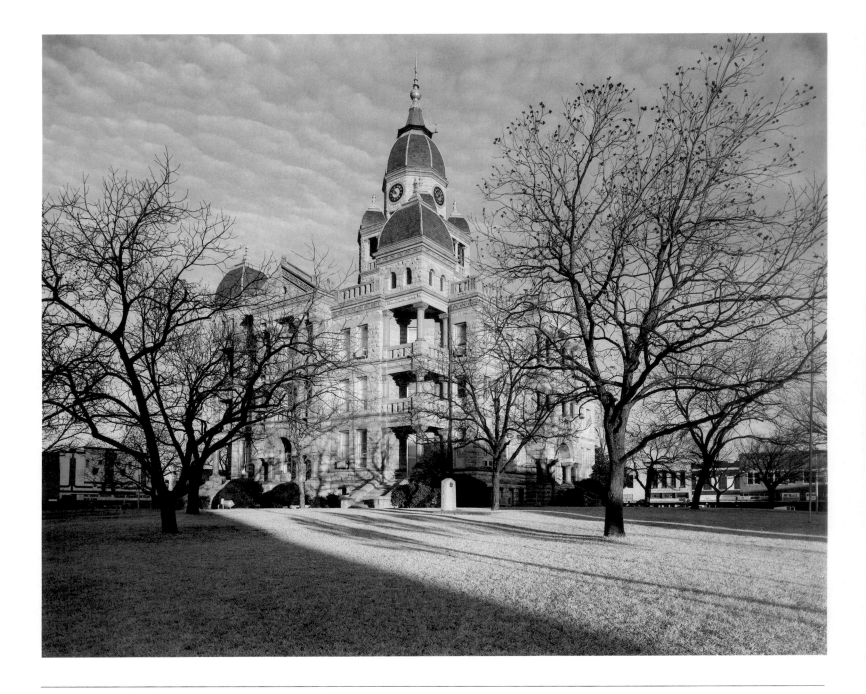

Plate 120. Denton County Court House, Denton, Texas, 1895–97. Architect W. C. Dodson. Photograph by Frank Gohlke.

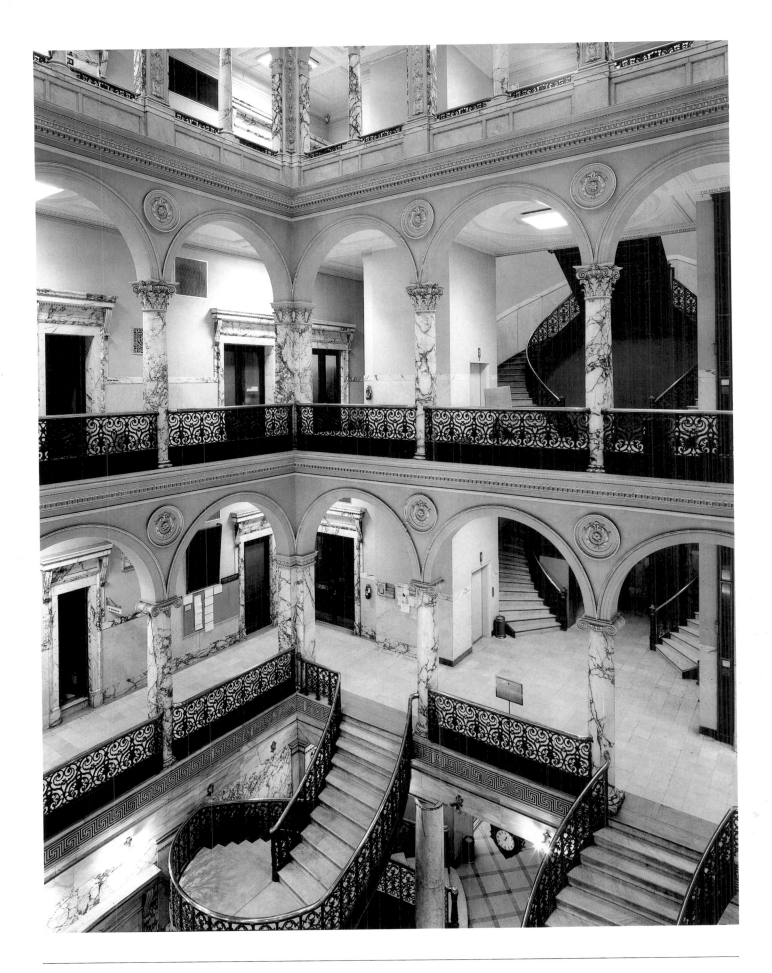

Plate 121. Central court, Monroe County Court House, Rochester, New York, 1894–96. Architect J. Foster Warner. Photograph by Jim Dow.

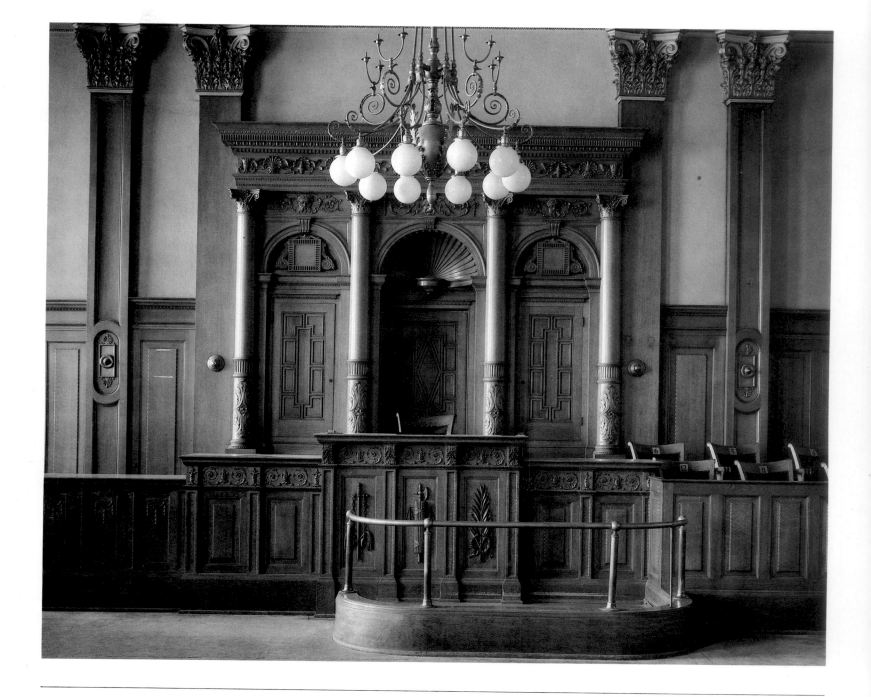

Plate 122. El Paso County Court House, Colorado Springs, Colorado, 1903. Architect A. J. Smith. Photograph by William Clift.

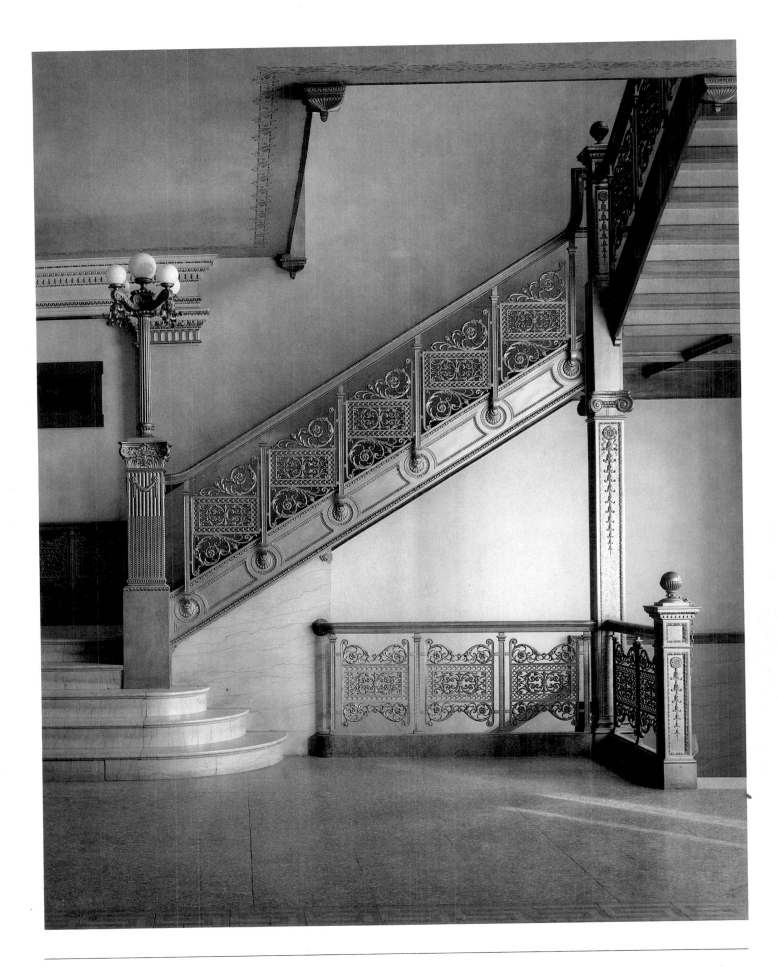

Plate 123. El Paso County Court House, Colorado Springs, Colorado, 1903. Architect A. J. Smith. Photograph by William Clift.

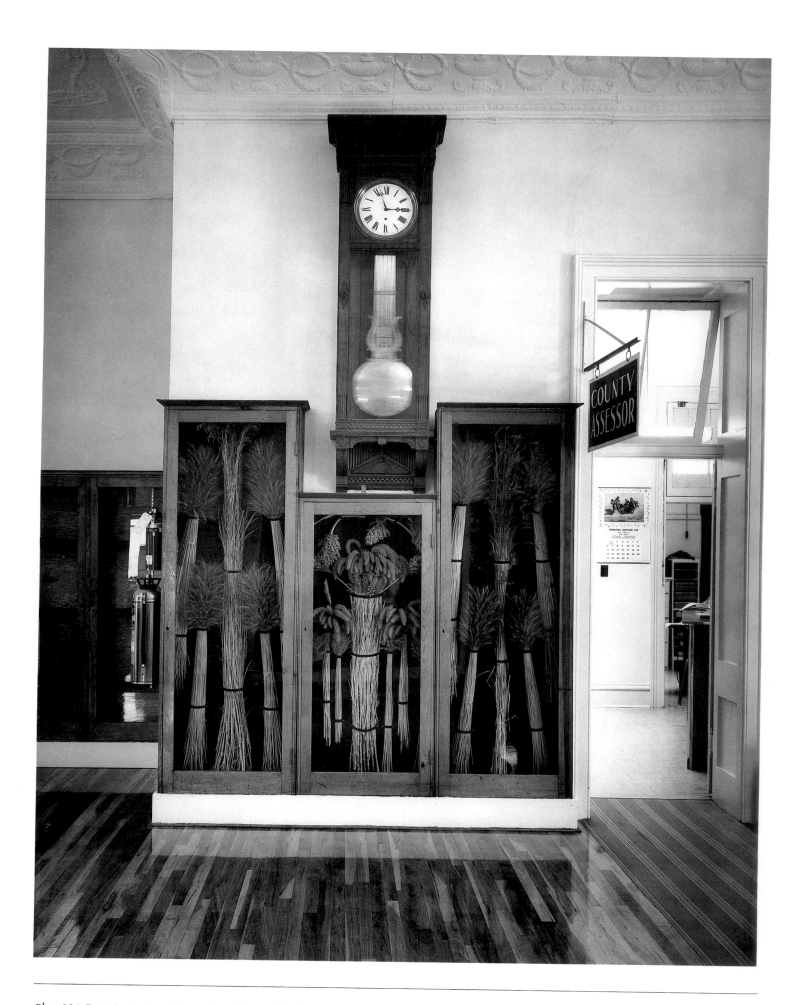

Plate 124. Bent County Court House, Las Animas, Colorado, 1886–89. Architects Holmberg Bros. Photograph by William Clift.

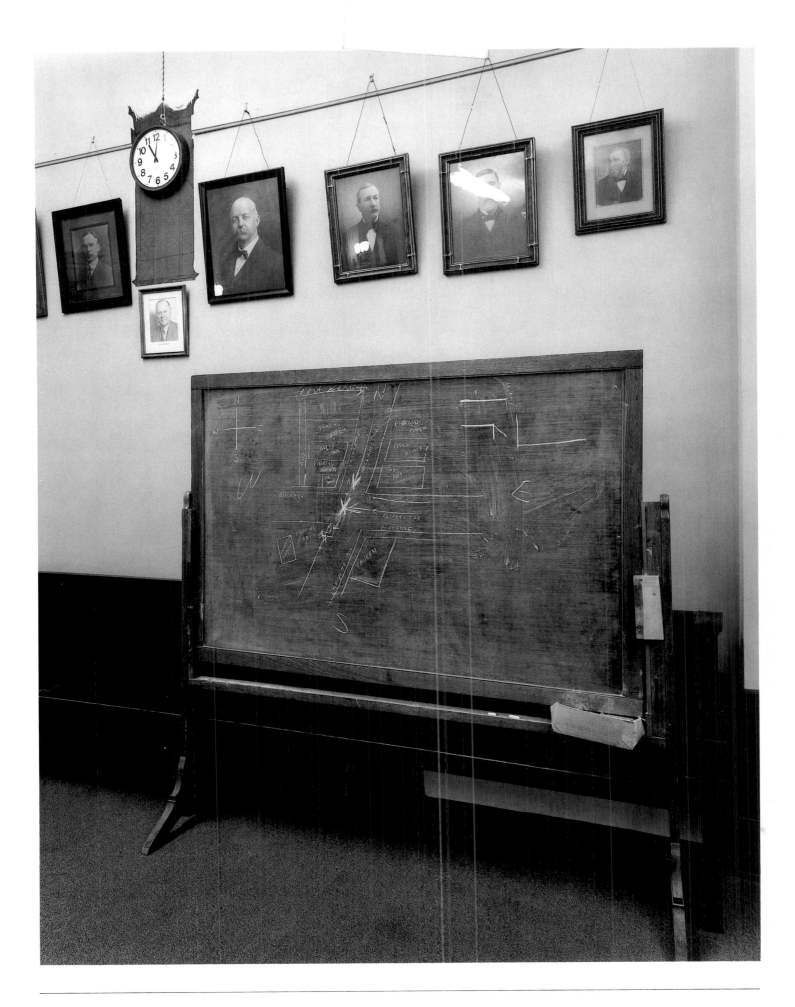

Plate 125. Courtroom detail, Clay County Court House, Brazil, Indiana. Photograph by Bob Thall.

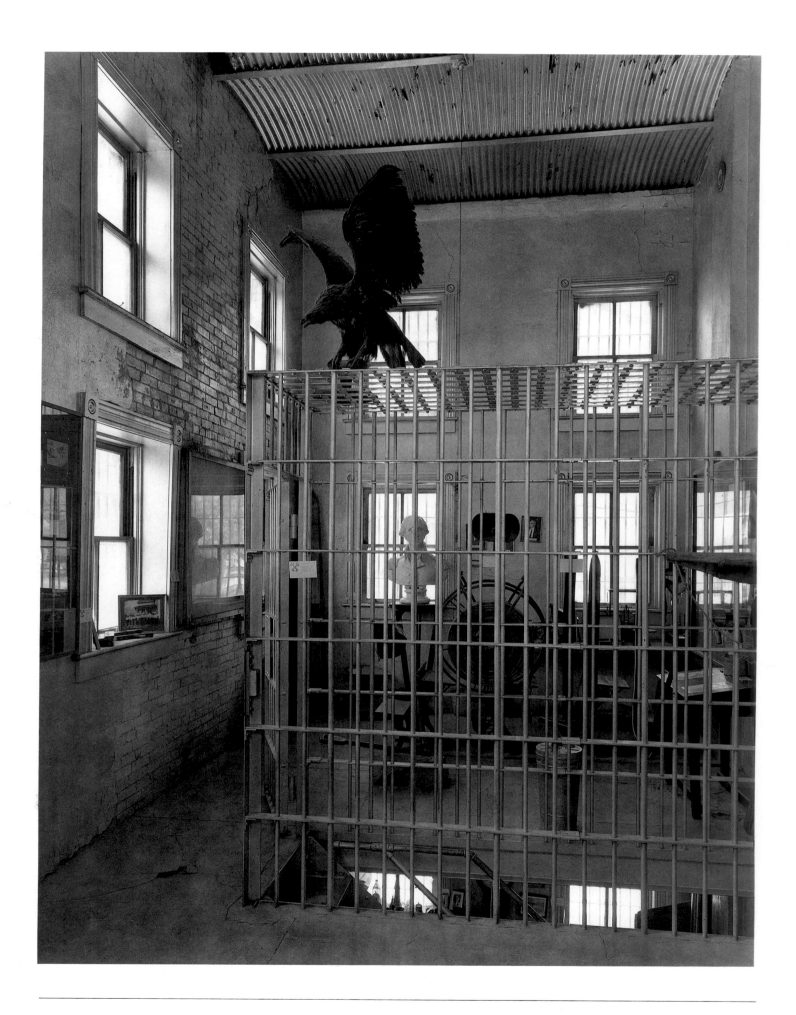

Plate 126. Old jail, San Juan County Court House, Silverton, Colorado, 1906. Architect James Murdock. Photograph by Lewis Kostiner.

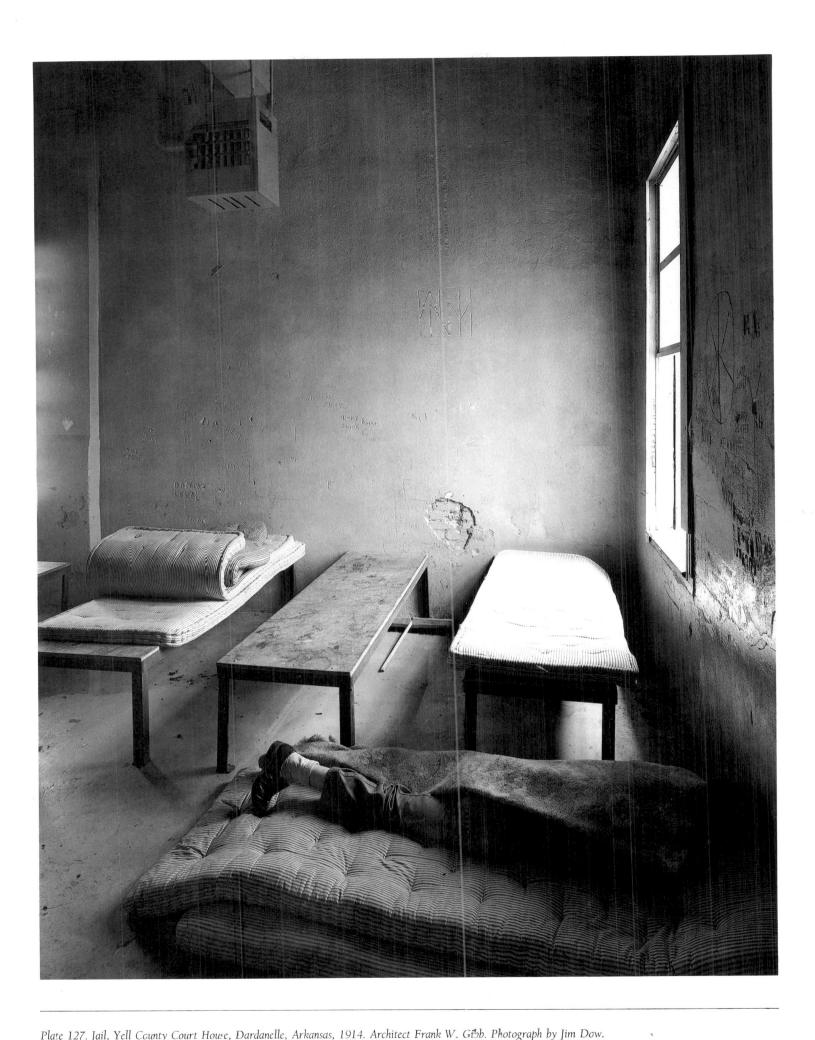

Plate 127. Jail, Yell County Court House, Dardanelle, Arkansas, 1914. Architect Frank W. Gibb. Photograph by Jim Dow.

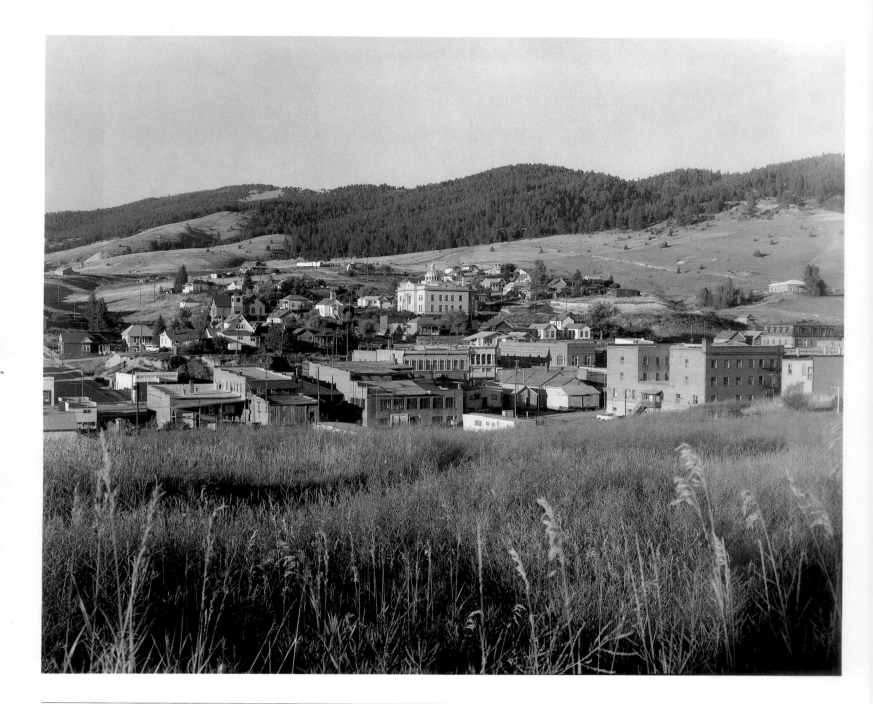

Plate 128. Granite County Court House, Philipsburg, Montana, 1912. Architects Link & Haire. Photograph by Laura Volkerding.

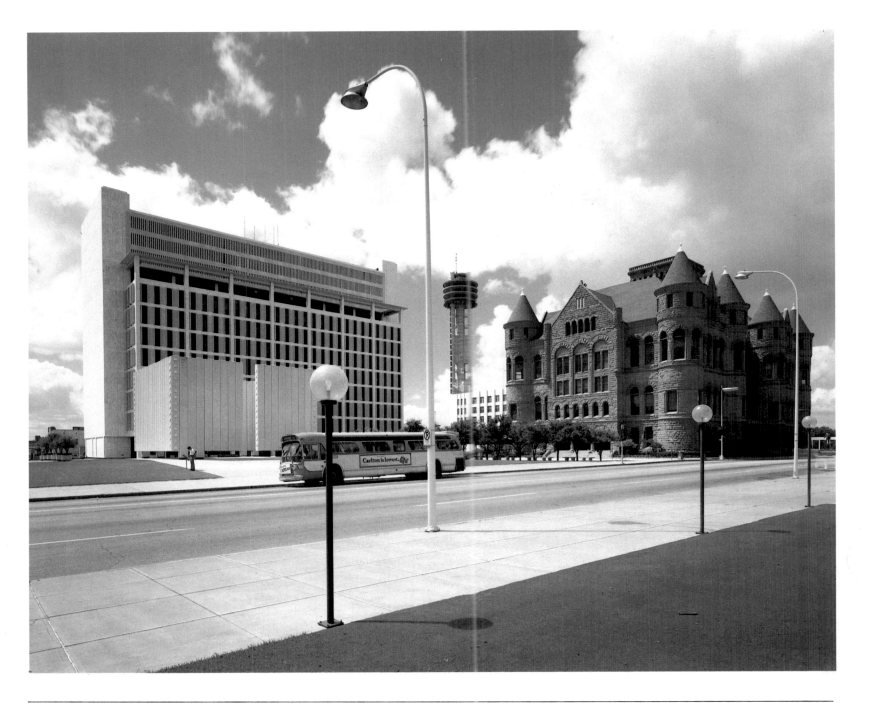

Plate 129. Dallas County Government Center, Dallas, Texas. Left: completed 1965 by Associated Architects & Engineers Right: 1890-91 with later alterations, architects Orlopp & Kusener. Photograph by Jim Dow.

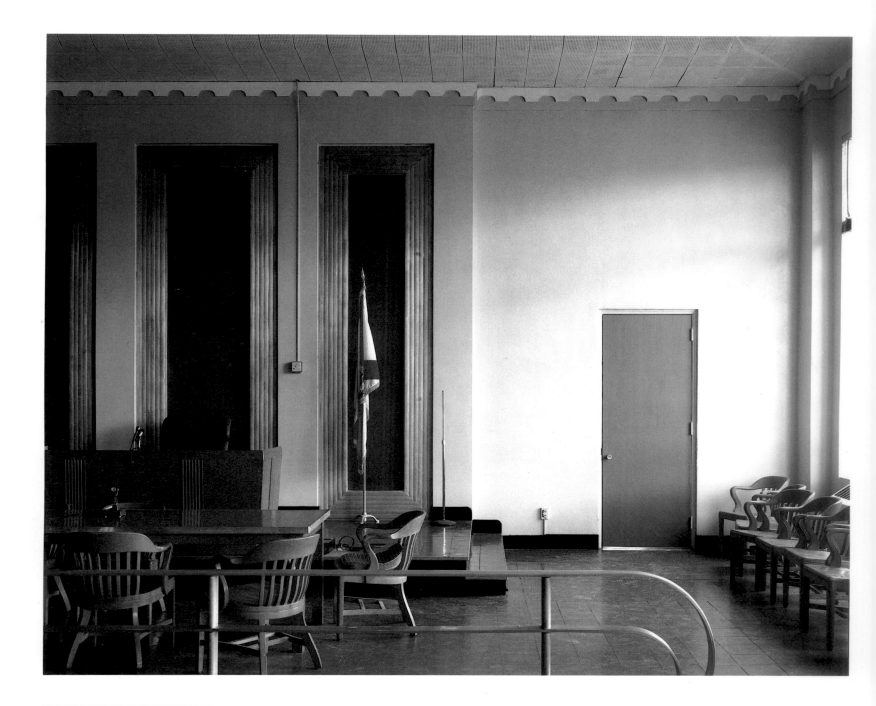

Plate 130. Wakulla County Court House, Crawfordville, Florida, 1948-49. Architect James A. Stripling. Photograph by Stephen Shore.

Plate 131. Courtroom detail, Howard County Court House, Kokomo, Indiana, 1936. Architect Oscar F. Cook. Photograph by Bob Thall.

Plate 132. *View from lawn, Boulder County Court House, Boulder, Colorado. Photograph by Tod Papageorge.*

COUNTY CO

Plate 133. Monterey County Court House, Monterey, California, 1937–38. Architects Robert Stanton and Thomas Mulvin. Sculptor Jo Mora. Photograph by Pirkle Jones.

Plate 134. Woodbury County Court House, Sioux City, Iowa, 1918. Architects William L. Steele and Purcell & Elmslie. Sculptor Alfonso Iannelli. Photograph by Bob Thall.

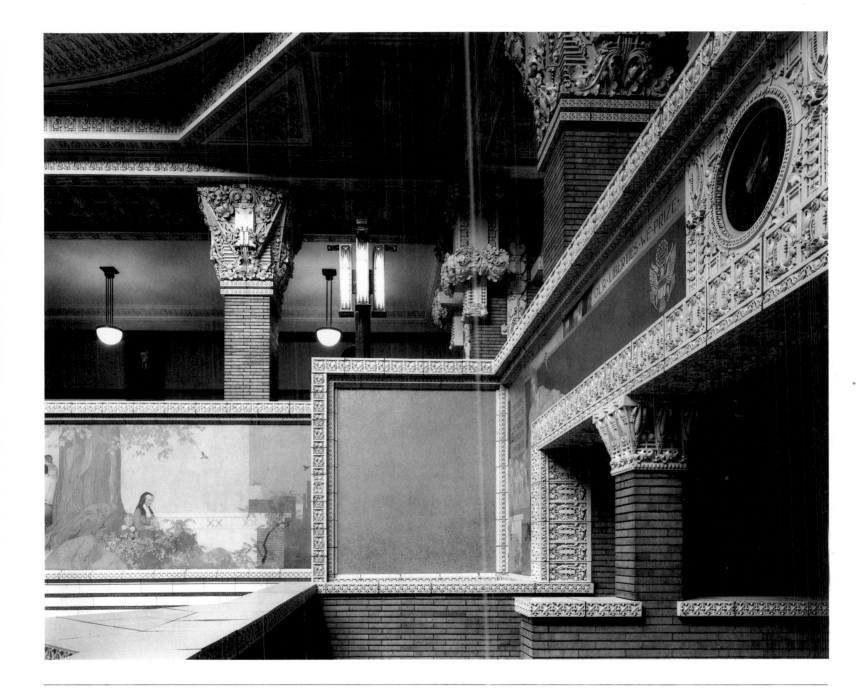

Plate 135. Woodbury County Court House, Sioux City, Iowa, 1918. Architects William L. Steele and Purcell & Elmslie. Murals by John W. Norton. Photograph by Bob Thall.

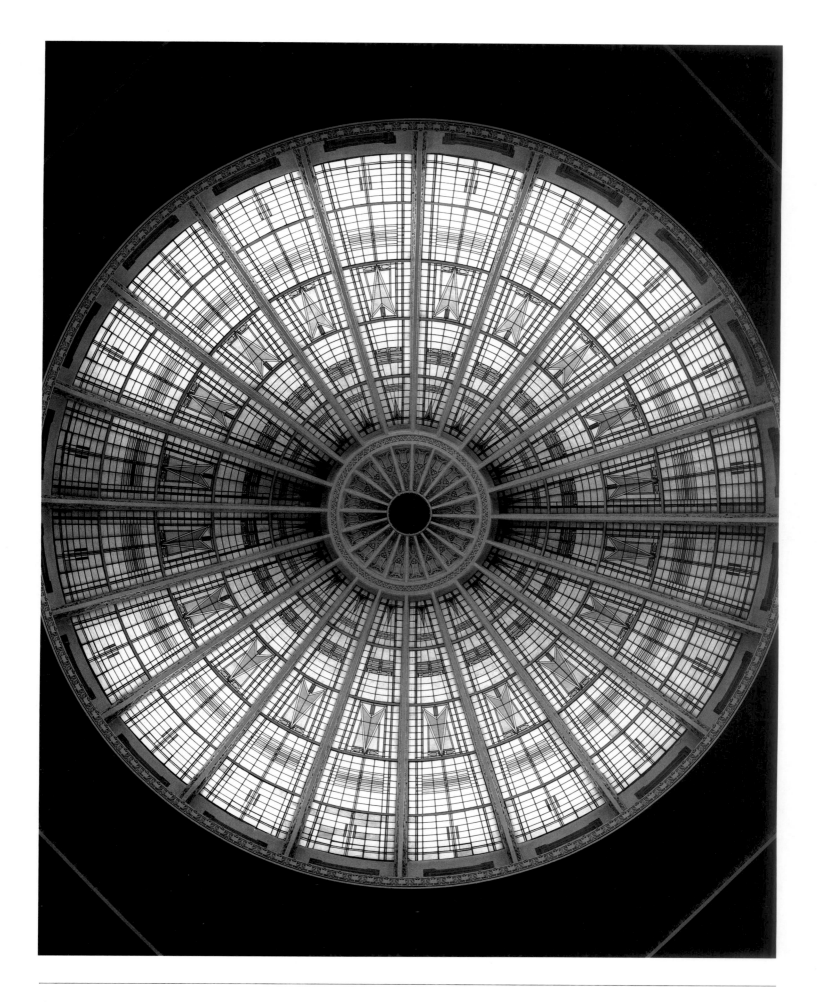

Plate 136. Stained-glass dome, Woodbury County Court House, Sioux City, Iowa, 1918. Architects William L. Steele and Purcell & Elmslie. Photograph by Bob Thall.

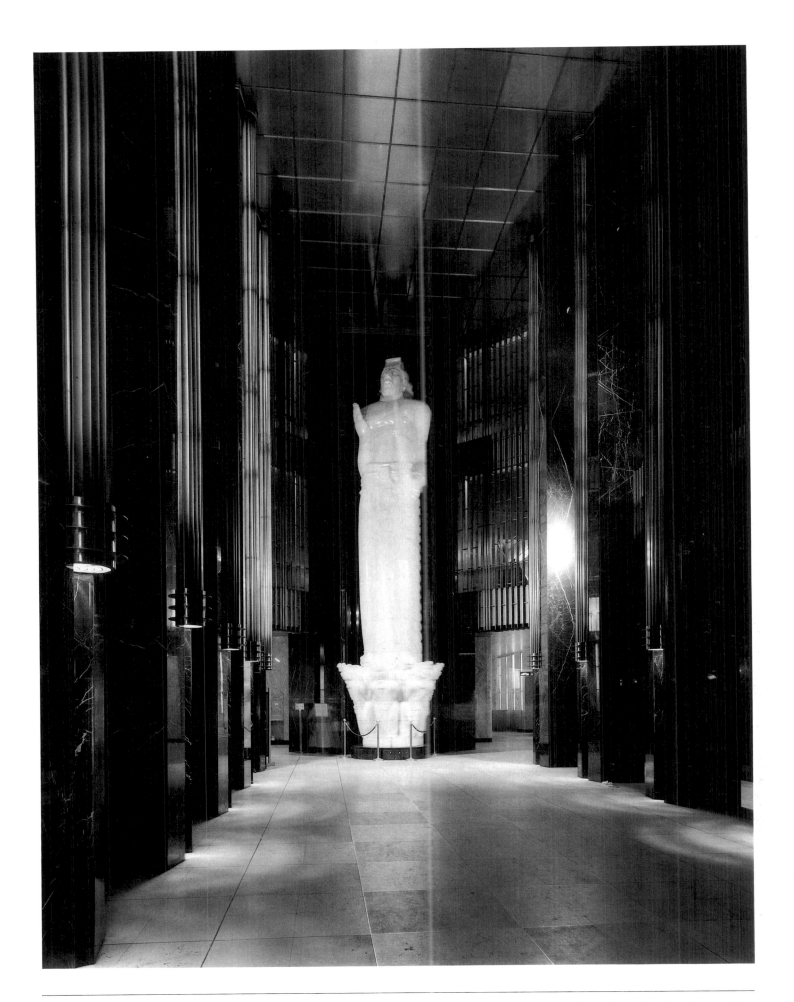

Plate 137. St. Paul City Hall and Ramsey County Court House, Minnesota, 1931–32. Architects Ellerbe & Co. God of Peace by Carl Milles. Photograph by Frank Gohlke.

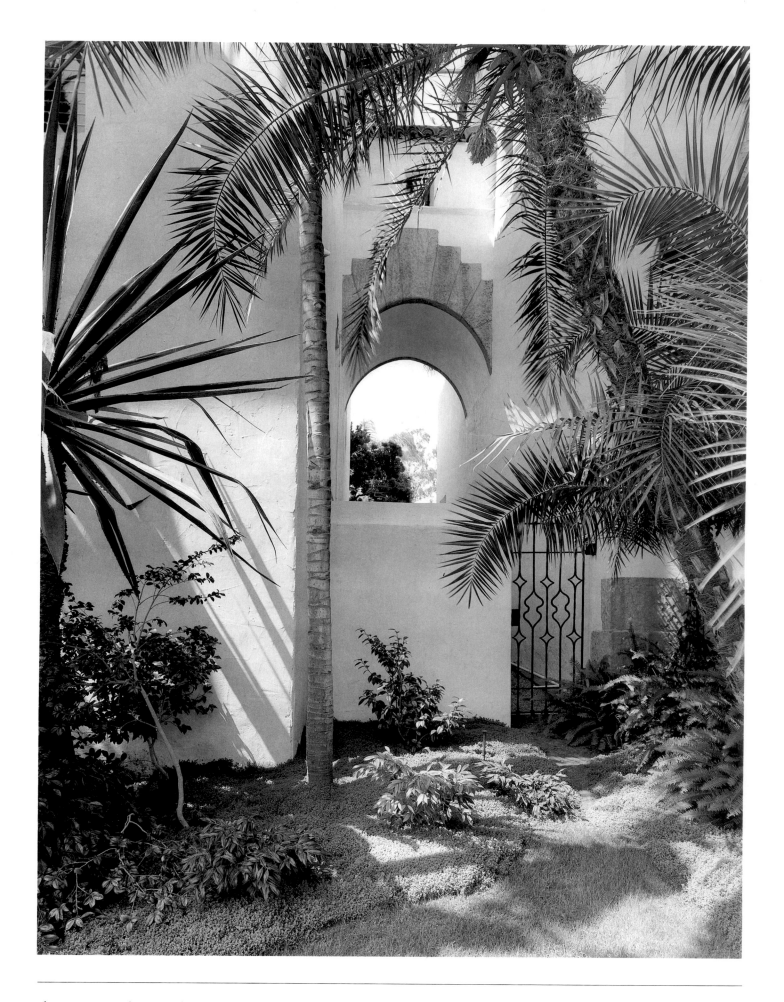

Plate 138. Courtyard, Santa Barbara County Court House, Santa Barbara, California, 1927–29. Architects William Mooser Co. Photograph by Lewis Kostiner.

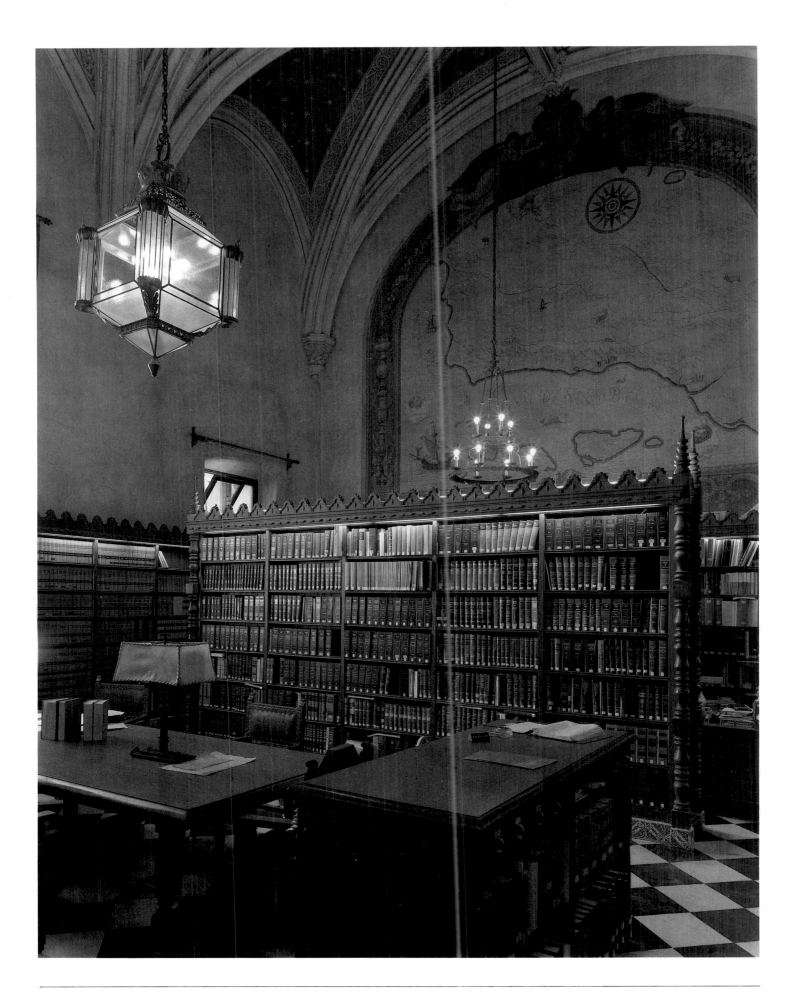

Plate 139. Library, Santa Barbara County Court House, Santa Barbara, California, 1927–29. Architects William Mooser Co. Photograph by Lewis Kostiner.

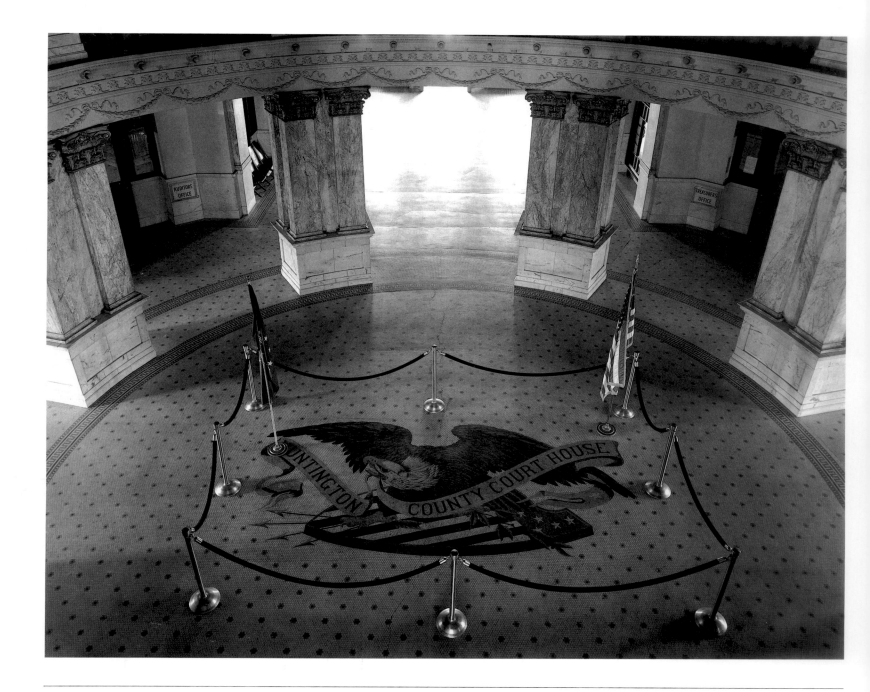

Plate 140. Mosaic floor in rotunda, Huntington County Court House, Huntington, Indiana, 1904–06. Architect J. W. Gaddis. Photograph by Lewis Kostiner.

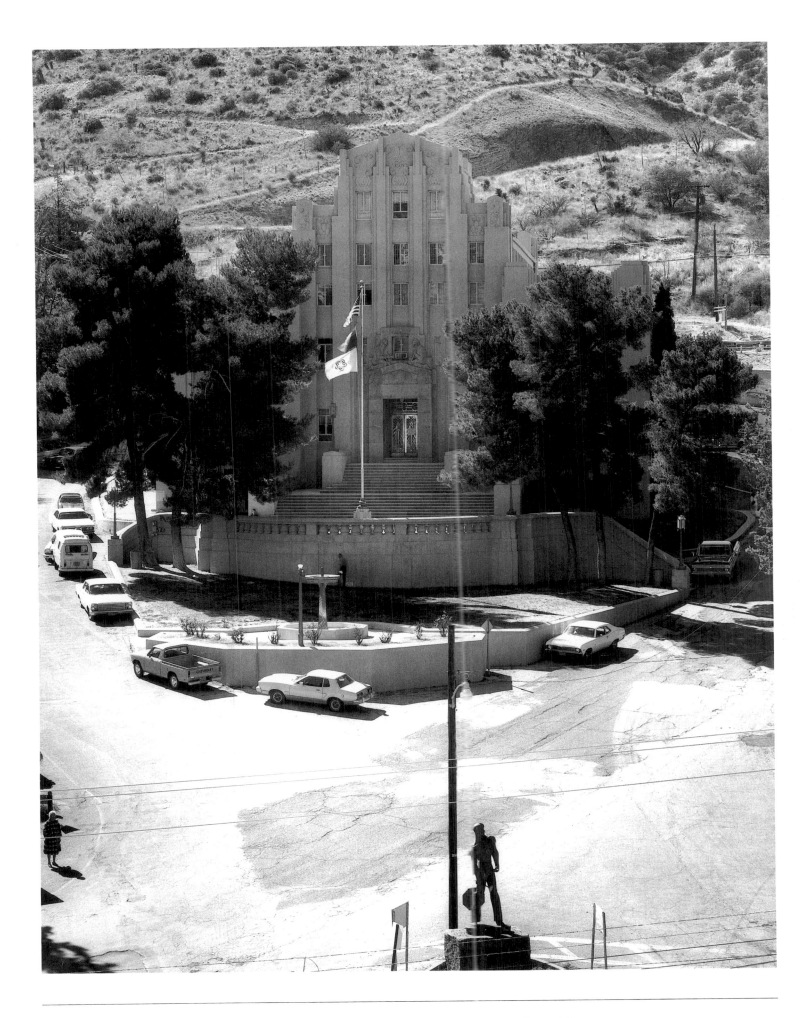

Plate 141. Cochise County Court House, Bisbee, Arizona, 1931. Architect Roy Place. Photograph by William Clift.

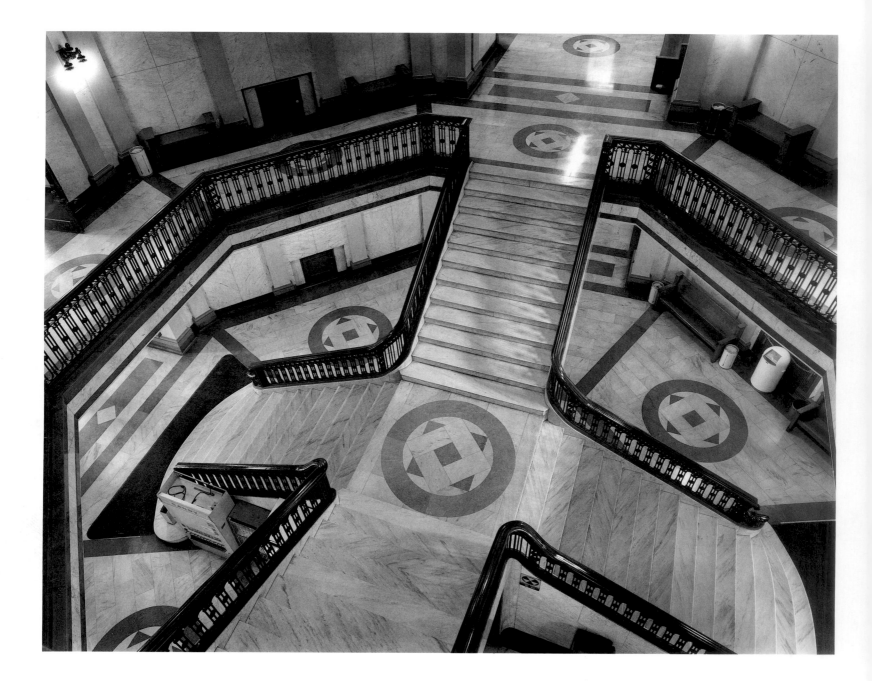

Plate 142. Rotunda, Jay County Court House, Portland, Indiana, 1916-19. Architects McLaughlin & Hulskin. Photograph by Lewis Kostiner.

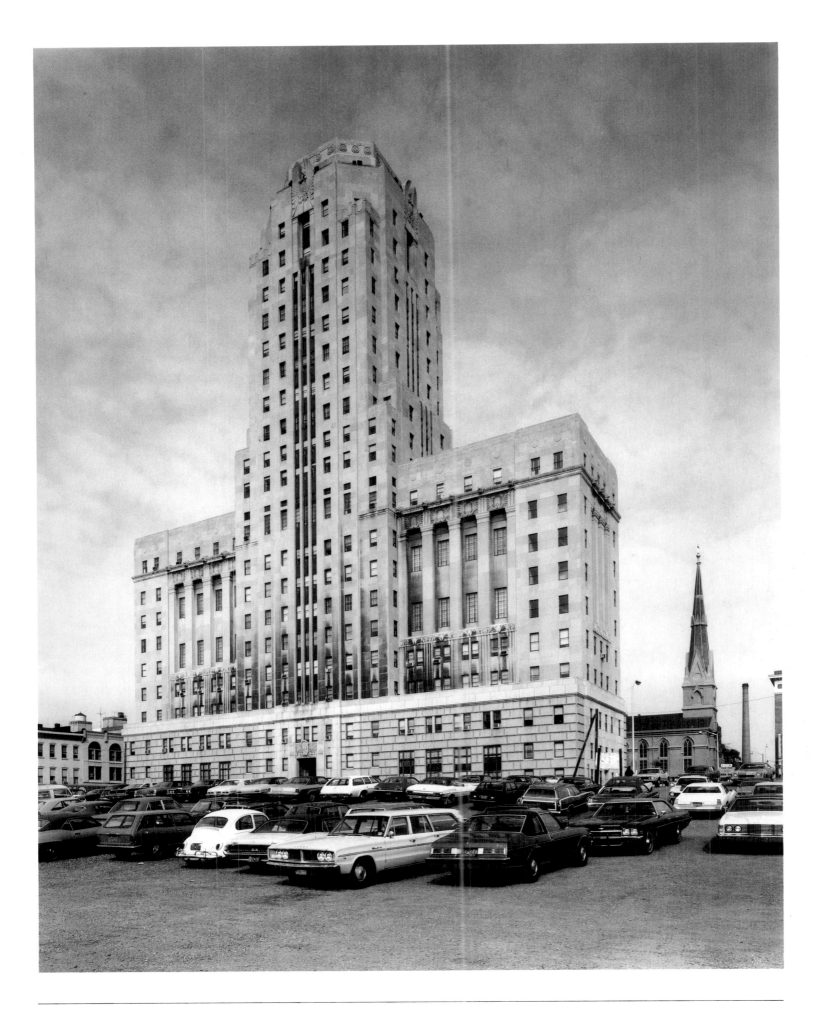

Plate 143. Berks County Court House, Reading, Pennsylvania, 1931–32. Architect Miles B. Dechant. Photograph by Bob Thall.

Plate 144. Butler County Court House, Morgantown, Kentucky, 1975. Associated Architects and Engineers Howard, Nielsen, Lyne, Thomas, Aldred, Henry & O'Brien, Inc. Photograph by Lewis Baltz.

Plate 145. Dunn County Court House, Menomonie, Wisconsin, 1959–60. Architects Schubert, Sorenson & Associates; Eckert & Carlson. Photograph by Paul Vanderbilt.

Plate 146. Rockingham County Court House, Exeter, New Hampshire, 1966. Architect Maurice E. Witmer. Photograph by Douglas Baz.

Plate 147. Los Angeles County Court House, Los Angeles, California, 1954–58. Architects J. E. Stanton, Paul R. Williams and Adrian Wilson; Austin, Field & Fry, Associates. Photograph by Lewis Kostiner.

Plate 148. Floyd County Court House, New Albany, Indiana, 1960–61. Architects Walker, Applegate, Oakes & Ritz. Columns from previous court house by Stancliff & Vogdes, 1865–67. Photograph by Bob Thall.

Plate 149. Terrace with fountain, Davidson County Court House, Nashville, Tennessee, 1937. Photograph by Tod Papageorge.

Plate 150. City-County Building, Wayne County, Detroit, Michigan, 1955. Architects Harley, Ellington & Day, Inc. Old court house at far left. Photograph by Nicholas Nixon.

Plate 151. Marin County Civic Center, San Rafael, California, 1957–59. Architect Frank Lloyd Wright; completed by The Taliesin Associated Architects. Photograph by Pirkle Jones.

Plate 152. View from court house of 1889 showing new Hennepin County Government Center, Minneapolis, Minnesota, 1971–75. Architect John Carl Warnecke. Photograph by Frank Gohlke.

NOTES ON THE ARCHITECTURE

HENRY-RUSSELL HITCHCOCK & WILLIAM SEALE

The church or meetinghouse on the green and the court house on the square are images characteristically American. In the states that were the original colonies churches often still command the townscape, where later commercial architecture does not rival them, as it does not in much of New England. In the lands settled after American independence the court house, not the church, became the architectural focus of a "county seat" and held its position, rarely contested, to the Pacific.

This domination of the secular is not difficult to understand. The pioneer in new country, prior to cutting trees, grubbing stumps, and stacking fences, saw to it that his land was partitioned on paper. The paper might be a claim or a purchase, or in time the settler might be after squatter's rights. Whatever its kind, the resulting paper was sacred; after all, romantic notions aside, it was the paper alone that secured his ownership of land, thus making him a landholder. Housing land-deeds safely was no small concern. A place for the protection of official records and vital statistics was practically always established early, and it was usually a part of the court house, often very grand, a sort of jewel box or ark of men's covenant with the land.

Court houses were important also because they were houses of justice. Here a county's domestic history unfolded in never-ending anecdotes of love, hate, sorrow, joy, and simple misunderstanding. The elected judge and citizen juries heard them all, and still hear them in settings sometimes unchanged since the nineteenth century. County court houses are now and then the scenes of trials watched with interest throughout the world. At the court house in Dedham, Norfolk County, Massachusetts, Sacco and Vanzetti were condemned to die; the court house in Dayton, Tennessee, was the stage for the celebrated Scopes "Monkey Trial" (*Plates 170, 300*).

Until the post-Civil War decades most court houses had few other uses than as archives and places for the courts to sit. The county clerk was the lone regular inhabitant day after day. Since typewriters were unknown before the late nineteenth century, most of the clerk's work was in copying by hand the endless and wordy transactions. Sometimes there were assistants, more often there were none. Yet the numbers of handwritten volumes continued to grow; there were maps, land plats, letterpress books, and files of letters and contracts to crowd the clerk's quarters further and overrun his vault. Likewise the proceedings and judgments of the courts, when bound, first filled shelves and, later on, endless rows of filing cabinets.

The early court houses are as local in their architectural character as they are in other respects. Seldom, apparently, did their builders aspire to national notice. The clients, while in name a commission, were ordinary citizens of the county. Building a court house could be almost as personal an affair as building a house. There is little comparison between court-house construction and state-capitol building by the states or customhouse building by the federal government, where the clients often looked far away and even abroad for inspiration and up-to-date architectural ideas. Court houses were intended to please those who see them the most. But, in addition, they can be signboards for the county, using a particular architectural vocabulary in a way quite comparable to a signpainter's use of graphic design.

There is a quality of directness in court-house architecture that has remained rather consistent since colonial times. Their openness and, often, the free spirit of their design contribute to what is seen as "distinctly American" about them. Their provinciality derives from innocence, not from hostility toward established modes; ambition manifests

itself more in scale and in ornamentation than in copying what had been built in grander places. Yet judged on their own terms even the most modest court houses rarely fail as architecture, indeed less often than the more pretentious ones.

No comprehensive survey, this is a photographic sampling brought together less from the point of view of architectural history than with the hope of capturing the essence of American court houses as they survive today. Even so, the pictures have a great deal to tell about the architecture of court houses, from the eighteenth century to the present. They make evident that court-house architecture was nearly always, in relation to contemporary styles, behind the times; they show that court-house builders were often quite independent, not in blazing new paths, for they certainly did not do that—but in their choice and combination of established forms.

The stylistic interest in court houses is usually restricted to their exteriors; seldom were the interiors at all monumental or even particularly ornamental. Court houses were intended as focal ornaments of the towns in which they stood. They boasted clocks and bells in their towers and often a dissonant profusion of varied shapes, forms, and surface treatments as well. More often than not, the exterior was merely a shell masking hives of plain rooms devoted to everyday uses which, though considered very important, required no adornment.

Ornament, on the other hand, can mean different things at different times. Monumentality likewise shifts its meaning with the generations. Beginning with the earliest court houses here recorded, and continuing through the most recent, the selection of buildings illustrates these points. The works that are included also give more than a taste of general trends, not only in court-house design but in American architecture of other sorts.

The earliest court houses still standing date from the second quarter of the eighteenth century. There are only a few. In the South these have something of the character of strongboxes; in New England they are more like town halls. But in any case they all follow the English Georgian vernacular that was current in domestic building of the more ambitious sort in the British colonies through the middle and later decades of the eighteenth century. The oldest court house in

the United States still in use is a case in point, that in the town of King William, King William County, Virginia (*Plate 153*). The original portion of this building remains largely unchanged. It is a trim rectangle in brick, with a steep though not abrupt hipped roof. The architectural treatment is subtle, with emphasis on the five-bay arcaded porch and on the arches and windows framed by brick "rubbed" smooth with sandstone for a tighter bond. Fine also are the expanses of plain wall in brick, usually laid up in Flemish bond with glazed headers. Very similar to that at King William, but some ten years later, is the Hanover County Court House at Hanover, Virginia (*Plate 29*).

As is true of all the eighteenth-century court houses illustrated here, craftsmanship had become, in the King William County Court House, an integral and positive element in the design. It is said that the building dates from 1725, though that is not certain. If so, it was built only a decade after the advent of George I in England, so that it must be considered very early Georgian. This little building is one of many resulting from a vigorous movement at the turn of the eighteenth century to strengthen the colonies under the Royal control. Such a building program was symbolic of a renewed effort to make America an integral part of England's growing mercantile empire. In such a system, monumental public architecture could serve as a reminder of the still dominant presence of the mother country. The most dramatic manifestation of this new symbolic architecture intended to make Americans conscious in their daily rounds of the mother country was the 1699-1705 Capitol at Williamsburg, Virginia, and its counterpart and contemporary in Manhattan, the City Hall. The Williamsburg Capitol burned in the mid-eighteenth century, but was reconstructed in 1929-31 from rather complete records. Admiring the arcade on the King William Court House, one can hardly doubt its potent influence on public building elsewhere in Virginia. But an even more striking echo of that Capitol is the court house at Smithfield, Isle of Wight County, Virginia, which has a rear wing forming a semicircular apse, a diminutive version of the same treatment at Williamsburg (*Plate 156*). This building is also remarkable since it was built no earlier than 1750, actually several years after the destruction of the Capitol.

Unquestionably the finest examples of eighteenth-century court houses now extant are in Virginia. They are, for the most part, country court houses in country settings. The

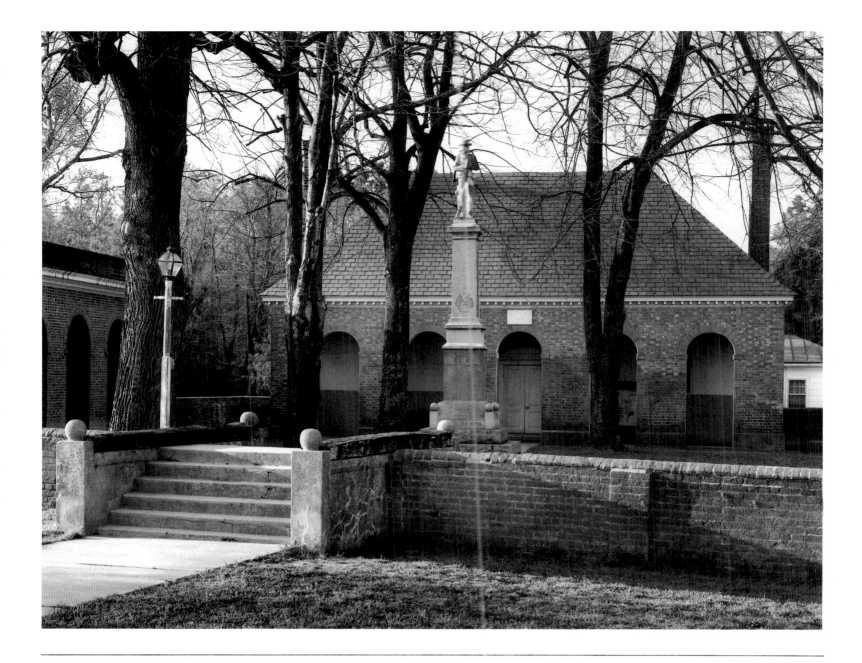

Plate 153. King William County Court House, King William, Virginia, c.1725. Architect unknown. Photograph by William Clift.

squares upon which they stand are large and green. The buildings themselves are usually characterized by an arcaded front, which is cut out of the solid, rectangular block of the building. The heavy look of these court houses is only relieved by the arcades, not obliterated. They have a permanent, immovable air befitting their first role as county archives and the second, also very important, as the places where the judges sit.

Quite different in every respect from the court houses of Virginia is the very early court house at Newport, Newport County, Rhode Island, built in the late 1730s (*Plate 158*). It had a builder-architect whose name has survived, Richard Munday. The Old Colony House, as it is called, was a colonial "capitol" upstairs and a court house below. There was not, apparently, an archive, beyond a small room set aside upstairs for the colony. The court house, on the lower floor, is one large paneled room, its ceiling supported by fine fluted piers, which were shells to conceal the real support: ships' masts cut to fit. Externally the dual role of the building was carefully articulated; the second floor and roof were the richly decorated areas, addressing the port and greeting the traveler approaching Newport, while the lower story was rather plain, its smooth brick surfaces and great windows inconspicuous in the daily hustle and bustle of the town.

167

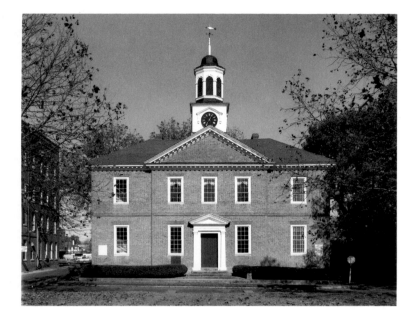

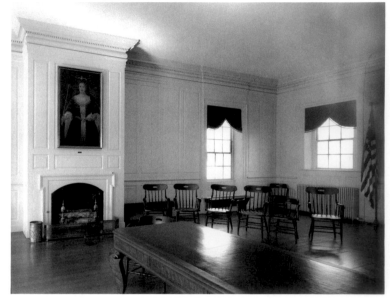

Plate 154. Chowan County Court House, Edenton, North Carolina, c.1767. Architect Gilbert Leigh (attributed). Photograph by Caldecot Chubb.

Plate 155. Chowan County Court House, North Carolina. Photograph by Caldecot Chubb.

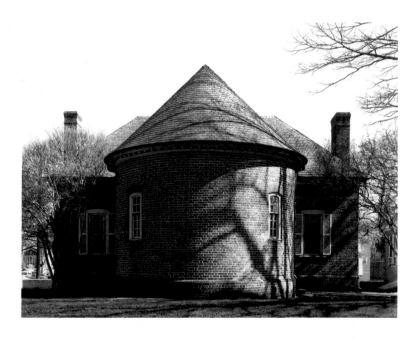

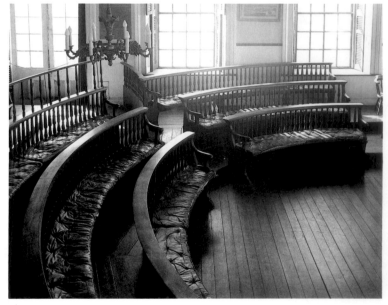

Plate 156. Isle of Wight County Court House, Smithfield, Virginia, c.1750. Architect unknown. Photograph by William Clift.

Plate 157. Courtroom, Old Colony House, Newport, Rhode Island. Photograph by Richard Bartlett.

The Newport Old Colony House is, of course, familiar to even the most casual student of colonial architecture as one of the most important early buildings in America. It is rivaled among colonial court houses only by one in the South, that of Chowan County, at Edenton, North Carolina, completed around 1767 (Plate 154). There is a supposed architect, Gilbert Leigh, who is said to have once lived in Williamsburg. The plan is Virginian in that the courtroom is central, with the clerk's office to one side; as in many court houses of the eighteenth century and many more to come, there was provision for a Masonic hall upstairs.

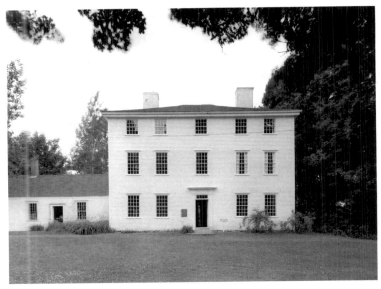

Plate 159. Lincoln County Court House. Pownalborough now Dresden, Maine, 1761. Builder Gersham Flagg. Photograph by Douglas Baz.

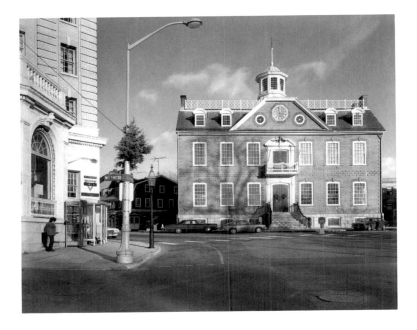

Plate 158. Old Colony House, used as Newport County Court House, Newport, Rhode Island, 1734–41. Architect Richard Munday. Photograph by Russell Hart.

Most early court houses in New England resemble private houses. Examples of this are the Plymouth County Court House of 1749 in Plymouth, Massachusetts, and the more handsome, three-story wooden one at Pownalborough, Maine, built in 1761 by Gersham Flagg from Boston (Plates 33, 159). This is not so much the case in the South. Yet the Edenton court house does look more like a private house than a public building. Set unusually far forward on its large square, it would have a wholly urban look, did it not survey a long expanse of water which has, since the beginning, been dotted with boats. The walling is red brick, laid up in Flemish bond. A pedimented central projection breaks the rectangular facade and, together with a neatly designed and well executed doorway, also pedimented, comprises the only

ornamentation. There is a very ambitious cupola, however, once Edenton's beacon, for there the watch hung his lantern and kept an eye open for fires at night.

To compare the Old Colony House to the Edenton court house is to contrast architectural adornment of one kind with another. Newport's Old Colony House is almost as decorative as a garden folly; compared with most other colonial structures it seems more an amusing fantasy than a public building. The Edenton court house is at the other extreme, yet thanks to its rubbed brick work, the sweeping apse at the rear, the tall tower, and the particular excellence of the proportions, it cannot be called simple, much less plain. Both buildings achieve monumentality, but by different means; elsewhere monumentality was not common in colonial architecture.

A somewhat universal effort to be monumental, or at least not so domestic, in the design of court houses began after the Revolution. The first such building included in this selection is the Charleston County Court House in Charleston, South Carolina (Plate 160). Designed about 1789 by the amateur architect William Drayton, a judge—as was the court house of 1749 in Plymouth, Massachusetts, reputedly designed by Judge Peter Oliver of nearby Middleboro—it replaced the old statehouse, which had burned down. The building represents a striking departure from the colonial past, for it is a great rectangle, rising directly from the sidewalk, with a semi-

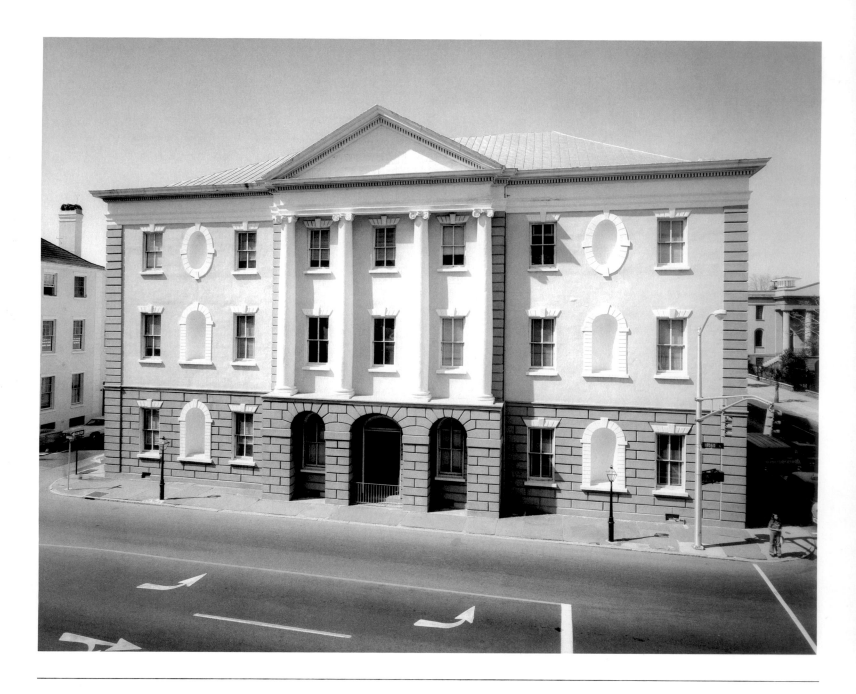

Plate 160. Charleston County Court House, Charleston, South Carolina, 1789–92. Architect Judge William Drayton. Photograph by Jim Dow.

detached portico raised on the arcade through which one enters the building. The Charleston Court House bears a striking resemblance to the White House, and may also have been inspired, as that probably was, by a plate in James Gibb's *Book of Architecture*. For an American building, and not least for a court house, the Charleston building is richly Neo-Classical. It was designed at the same time that P. C. L'Enfant was remodeling Federal Hall in New York City to receive the new federal government when that city was briefly the United States' capital; while by no means as theatrical or as rich, this is quite as much an example of the new mode which would soon be adopted as the "national"

style for the architecture of the Federal City on the Potomac.

Other court-house designers lingered in the past, hardly aware of columns, stucco-coating, and the other features that went with the new national mode. The court house at Mount Holly, Burlington County, New Jersey, built about 1796, is an example of this (*Plate 161*). The transitional variant used here is often called "Federal" since these were the earliest years of our constitutional government as a nation. The Federal mode—which, of course, is actually late Georgian, not yet fully Neo-Classical—continued as a sort of vernacular in provincial building design through the end

of the eighteenth century and in some places as late as the 1830s. The Mount Holly court house is a handsome structure. Its scale is domestically diminished by large windows, rectangular above and round-headed with light "Gothic" muntin-patterns below, the latter somewhat like those of contemporary churches. Its horizontal line is heavily accented by the rich cornice and a belt-course between the stories. In its general form it is not unlike the Edenton court house because of the central projection on the facade. Otherwise, with its lofty lantern, this building is far more decorative, approaching the ornamental richness of the Old Colony House at Newport, but it is not so carefully articulated as that.

The Mount Holly court house, an excellent example of the Federal style, is also a notably cohesive work—court houses were not often so cohesively designed. For example, the court house of Caroline County, Bowling Green, Virginia, brought to completion in the six years after 1803, has a curious inde-

cisiveness (*Plate 162*). Basically, this is reminiscent of the familiar eighteenth-century Virginia mode, but of two stories instead of one. There is the usual arcade sunk into the block and the rubbed-work in brick. Up to the cornice the building could be of 1750; but it was not erected in total ignorance of the recently completed Virginia Capitol, the structure Jefferson himself had based on the ancient Maison Carrée at Nîmes in the south of France. The new dependence on more Classical architectural detailing is reflected at Bowling Green in the great pediment and the deep cornice. Even the little bell-tower, which sits like a party hat on the ridge of the roof, may reflect that the Virginia legislature at this time, 1803, wanted to add one to the roof of Jefferson's Classical temple. The building is thus a combination of sources not difficult to trace. Doubtless the commissioners responsible were all mature men who had lived most of their lives in the eighteenth century. A court house to them meant a structure of a certain form and even a certain design. Yet they were also men of their times. The architectural show-

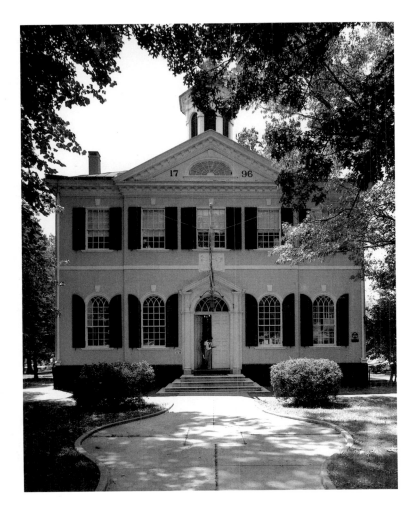

Plate 161. Burlington County Court House, Mount Holly, New Jersey, 1796. Architect Samuel Lewis. Photograph by Tod Papageorge.

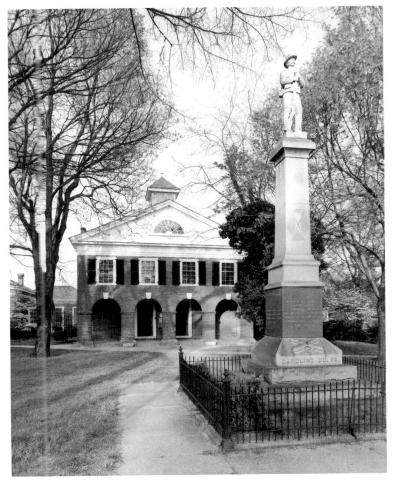

Plate 162. Caroline County Court House, Bowling Green, Virginia, 1803–09. Architect unknown. Photograph by Richard Pare.

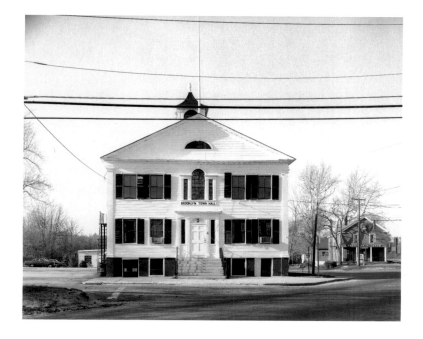

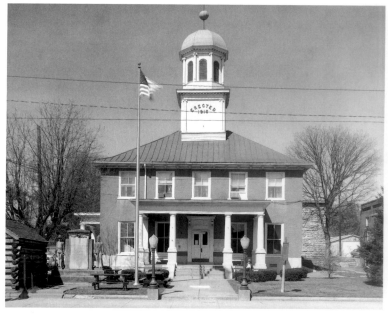

Plate 163. *Old Windham County Court House, Brooklyn, Connecticut, 1820. Architect Benjamin E. Palmer. Photograph by Jerry Thompson.*

Plate 164. *Washington County Court House, Springfield, Kentucky, 1814–16 with later additions. Architect Thomas H. Letcher. Photograph by Jim Dow.*

piece of Virginia at Richmond had not escaped their notice, nor failed to influence their notions of what a public building in the new nation should be.

Adherence to the old forms is not hard to understand in a new country, and less so in the older states. Especially domestic in appearance is the white-clapboarded Windham County Court House, now the city hall of Brooklyn, Connecticut, built by Benjamin E. Palmer in 1820 (*Plate 163*). Only the pediment really suggests that this was always a public building. The Washington County Court House in Springfield, Kentucky, was completed in 1816, after the end of the war with England, and is very old for Kentucky (*Plate 164*). Though changed considerably over the years, its original out-of-date character is evident still. This is essentially a Georgian building. It would have been at home in the colonies along the Atlantic seaboard, from where, one may suppose, the men who built it had originally come. Others in later years tried to update it: in 1840 a cupola was added which was quite as retarded in character as the main 1816 structure; at the time of World War I, ironically enough, it was re-colonialized by the architect Frank Brewer.

The Federal period was quite naturally marked by a certain architectural confusion in America, particularly in public architecture. Boldly, the federal government had adopted the

Neo-Classical of the late eighteenth century as a national style; but in the 1820s, as Washington City, emerging from the woods, took urban shape, a new mode swept America: the Greek Revival. That the court houses of the Federal era were rooted in the immediate colonial past is certainly understandable. Ventures into unfamiliar stylistic realms were always hesitant, but they did begin. The question of what was appropriate for American public architecture, an architecture of democracy, remained very much an issue until the arrival of the Greek Revival, when the image of a Classical temple on a hill became strongly appealing since it seemed singularly appropriate historically, and closed the doors on the past.

The Greek Revival, which was the dominant mode in American architecture in the second quarter of the nineteenth century, has been presented in the writing of some scholars as a peculiarly American national style. Although this ignores the parallel production of the age abroad, there is, indeed, some reason to evaluate the Greek Revival as a national style in the field of court-house design. The mode was used first for banks in the great Eastern cities, but within a few years it was widely accepted for private houses, all the way from the eastern seaboard southward to the Gulf and westward across the Middle West, and for public buildings, prominent among which were court houses.

Neither the Panic of 1857 and the ensuing depression nor the Civil War years of the early '60s brought to an end the construction of Grecian court houses. In Nevada in the Far West there are examples as late as that of Lander County in Austin, Nevada, of 1869-71 (*Plate 165*). These very late examples vary enormously. On the one hand, there is the nearly vernacular simplicity of the last-mentioned, lacking a portico and with very little detail of any sort, yet a certain Grecian dignity in its proportions; on the other, there is the almost metropolitan grandeur of the post-Civil War court house completed for $100,000 for Christian County at Hopkinsville, Kentucky, in 1869, and the one for Dearborn County at Lawrenceburg, Indiana, completed in 1875 (*Plates 166, 167*). These are almost of the size and pretention of state capitols. For all this pretention in their laggard but monumental design, these late "temples" were usually the work of local architect-builders, men who did not know how to use very accurately the Classical orders as they had been prescribed for more than a generation through the plates in the Builders Guides published by New Englander Asher Benjamin, New Yorker Minard Lafever and others.

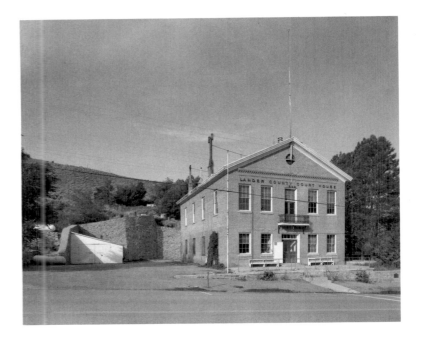

Plate 165. Lander County Court House, Austin, Nevada, 1869–71. Architect D. P. Bell. Photograph by Tod Papageorge.

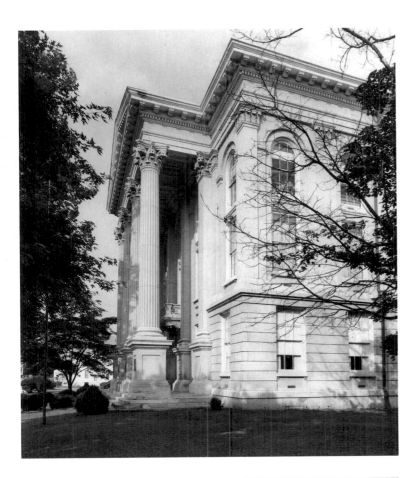

Plate 166. Dearborn County Court House, Lawrenceburg, Indiana, c.1871–75. Architect George Kyle. Photograph by Lewis Kostiner.

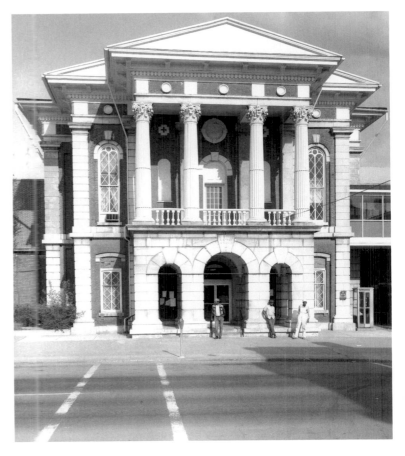

Plate 167. Christian County Court House, Hopkinsville, Kentucky, c.1865–69 with later additions. Architect J. K. Frick. Photograph by Jim Dow.

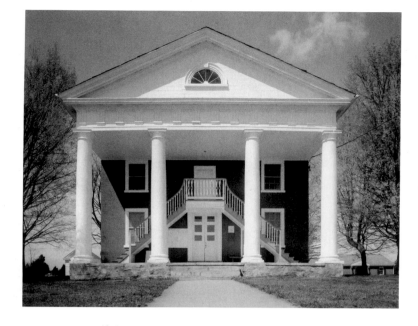

Plate 168. Lunenburg County Court House, Lunenburg, Virginia, 1827. Architect unknown. Photograph by William Clift.

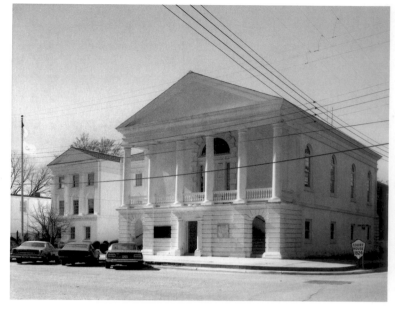

Plate 169. Georgetown County Court House, Georgetown, South Carolina, 1824 with later addition. Architect unknown. Photograph by Stephen Shore.

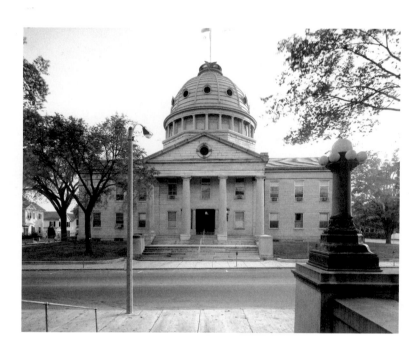

Plate 170. Norfolk County Court House, Dedham, Massachusetts, 1827 with later additions. Architect Solomon Willard. Photograph by Nicholas Nixon.

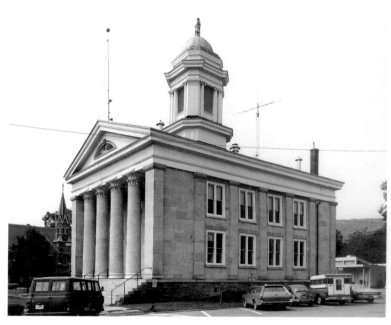

Plate 171. Chenango County Court House, Norwich, New York, 1837–39. Supervisors William Randall and William Knollton. Photograph by Patrick Linehan.

The finest of the Grecian county court houses were built much earlier. In several cases these were the work of leading Eastern professionals, although the temple-form was actually introduced to America by an amateur.

In designing the Virginia State Capitol at Richmond in the 1780s Thomas Jefferson, assisted by the French architect Charles Clérisseau, had taken as his model a Classical temple, the Maison Carrée at Nîmes in southern France, thus becoming the first in America—and indeed in the world—to adapt the ancient temple form for use as a modern public building. It took some forty years for the idea to be adopted, usually at a much smaller scale, for court houses. Perhaps the earliest example, still Roman rather than Grecian in the

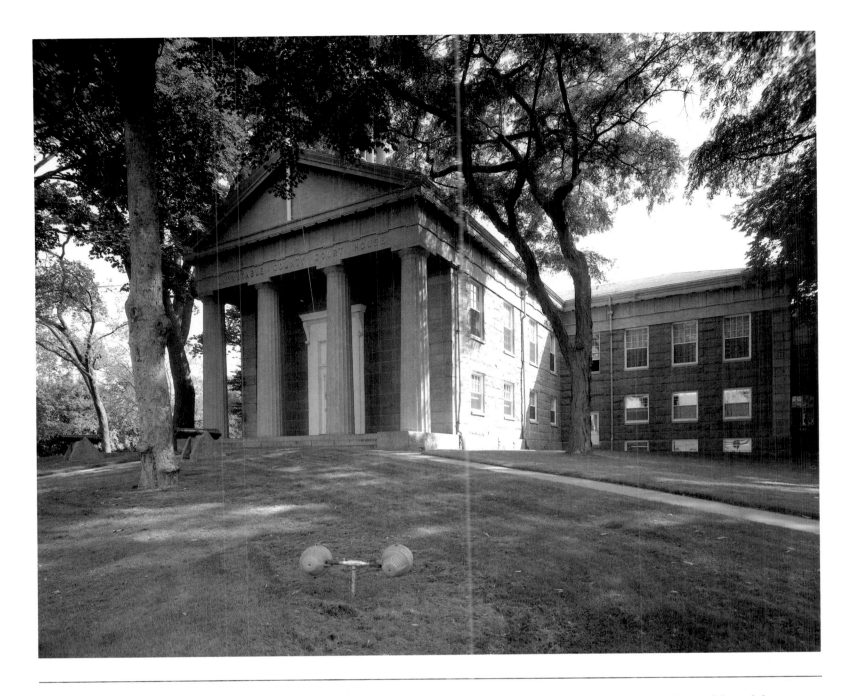

Plate 172. Barnstable County Court House, Barnstable, Massachusetts, 1831–32 with later additions. Architects Jacob and Abner Taylor. Photograph by Nicholas Nixon.

details of the portico, was that erected in the South in 1824 for Georgetown County, South Carolina, at Georgetown. The six Roman Doric columns of the portico rise to the dominant pediment over a rusticated basement with arched openings. Grecian examples followed within a very few years, but this first example should perhaps be considered Federal still since it is not yet Greek (*Plate 169*).

In the North, in Dedham, Massachusetts, the Norfolk County Court House is the work of Solomon Willard, best known for the design of the Bunker Hill Monument in Charlestown, Massachusetts, but also responsible for the Greek Ionic

portico fronting Alexander Parris's St. Paul's Cathedral in Boston (*Plate 170*). The date of the Dedham court house is 1827 but in the 1860s, three matching bays were added on each end and, in 1892-95, a more extended wing at the rear as well as the big saucer-dome, all by the elderly Boston architect Gridley J. F. Bryant. Thus only the portico of four widely spaced and unfluted Grecian Doric columns is original. The wide spacing reflects Asher Benjamin's modification of the Greek Doric order for use in wooden construction.

No architect is known for the court house, also of 1827, in Lunenburg, Lunenburg County, Virginia (*Plate 168*). The

175

order is Roman as at Georgetown, South Carolina, and there is a double stair behind the portico leading to a central balcony. By contrast, the court house in Barnstable, Barnstable County, Massachusetts, in the North, is correctly Grecian (*Plate 172*). It has moreover an exceptionally tall doorway in the center, modeled on that of the Erechtheum, with a cornice over it carried on scrolled brackets. This was built in 1831-32 by Jacob and Abner Taylor, but has large wings added later—fortunately set well back—by J. W. Beal, in 1893; Guy Lowell, in 1905; and in 1923-24, again by Beal. Contrasting with this Massachusetts court house is the vernacular Grecian one of 1837 at Somerville, Alabama, for Morgan County (*Plate 37*). That shows how builder-architects in handling simple elements could profit from Greek models other than the orders which they found in the plates of the Builders Guides. The result, here, as often elsewhere, is barely distinguishable, except for the modest lantern, from a good-sized Grecian private house.

Considerably grander, but less elegant, is the court house at Norwich, New York, for Chenango County of 1837-39 (*Plate 171*). The order of four columns in antis on the front has capitals based not on Asher Benjamin's correct Grecian models, but on Minard Lafever's more original foliated type, here somewhat elaborated. The side facade, phrased by antae, is disfigured by modern windows, but the rather heavy lantern is original, recalling those of the day on the front of churches.

Gideon Shryock, a pupil of William Strickland in Philadelphia, designed for his native Kentucky the first Grecian State Capitol at Lexington in 1827. Shryock's Jefferson County Court House at Louisville of 1838-39, altered, completed and extended twenty years later by Albert Fink and Charles Stamclift, is a rather heavy-handed rectangular block with antae on the wings and four Doric columns carrying a pediment on the front. Exceptional in a county court house, however, is the rotunda surrounded by fluted Ionic columns (*Plate 44*).

Petersburg, Virginia, is an independent city, not part of a county (*Plate 43*). It therefore has its own equivalent to a county court house. To design this in 1838 the local authorities called on an established New York architect, Calvin Pollard, who completed it in 1840. The result is hardly distinguishable from contemporary Grecian churches and is exceptionally grand in size and scale for a court house. At the front, over the correctly shallow pediment carried on terminal antae and four Corinthian columns in antis, rises a three-stage octagonal lantern topped by a clock over which is a statue of Justice. Happily, the late annex of 1965 is not visible from the court square and the result, if somewhat ambiguous in its symbolic character, is exceptionally monumental. It calls to mind such a free-standing European monument of the day as St. Vincent-de-Paul in Paris that was completed by Hittorff. The Petersburg Court House contributes similarly to the interest and meaning of the urban scene here in the city's very center. Doubtless there were once many comparable pairings of court houses and central squares of which the original character has now been lost because of later rebuilding of neighboring sites.

The court house at Maysville, Kentucky, for Mason County, of 1838-44, though the work of the local builder-architects Ignatius Mitchell, Christopher Russell and Ignatius Purnell, is a standard example, with a four-columned portico and a two-stage lantern above (*Plate 177*). This lantern has clocks in the lower square stage and, above, a simple octagon with a domed cupola. The raising of the whole structure on a basement, with double stairs leading up to the portico at the front, achieves monumental emphasis with the plainest means.

Of quite a different character is the court house of 1839-40 at Clinton, Louisiana, for East Feliciana Parish (*Plate 42*). The architect J. S. Savage rivaled contemporary plantation houses of the state by using not a temple portico but a peripteral two-story colonnade. The domed octagonal lantern does suggest its status as a public building, but the result is so local as probably to be considered unique.

Equally exceptional among court houses of these decades before the mid-century, though not completed until 1862, is that at St. Louis, Missouri, which, like Petersburg, is an independent city (*Plate 47*). The original architect of this large structure, which looks more like a state capitol than a court house, was Henry Singleton, who won the competition for it. He was succeeded in 1851 by R. S. Mitchell, who was most responsible for the building as erected. The full story is very complicated: first came the rotunda, designed by Singleton in 1839; then his west wing, built in 1839-45, which was followed by Mitchell's east wing of 1852-56 and

his south wing in 1853-56. Next, Thomas D. P. Lanham, who was in charge for only two years, began the north wing in 1857. Finally William Rumbold, who came on the job in 1859, completed the work in 1861. But Rumbold's great contribution was the cast-iron dome, a rival to Thomas U. Walter's in Washington, which had been begun considerably earlier than Rumbold's, but was not completed until two years after his (*Plate 49*).

This grandest of all the Grecian court houses—thanks to its size and its central location in a big city—lacks, however, the elegance of Calvin Pollard's in Petersburg. The five-part composition is made up of familiar elements: a wide Greek Doric portico at the center, antae repeating the rhythm of the wings, and, above, the dominant dome. The dome is not at all Grecian, but simplified from Walter's in Washington as are those over so many state capitols of the post-Civil War decades.

Far more typical of the American court house image, more usually associated with towns and small cities than with a regional metropolis such as St. Louis, is the modest Doric temple at Winchester, Virginia, for Frederick County of 1840 with its four-columned portico (*Plate 36*). The columns here are of the Grecian Doric in the version that is only fluted just below the capitals. Above, there is a small two-staged lantern. The architect was R. C. Long, a leading professional in Baltimore, which perhaps explains the exceptional sophistication of the design. Here the setting in a small square is exemplary and well preserved.

A more impressive Grecian court house is the one in Batavia, New York, for Genesee County (*Plate 174*). Without the usual portico, it nonetheless has a full entablature above the upper story and a more modest one over the first story on the front, where a shallow terrace is approached by central stairs. Completed in 1843 after several years in building at a cost of only $17,000, credit for the sophisticated elegance of the design goes to John Tomlinson and Paul Richards, who had been supervising the construction for several years.

Although in these decades new Grecian court houses, as has been indicated, were rising in the Eastern states, it was in the Middle West, coming to early political and economic maturity in these decades before the Civil War, that the most have survived more or less intact. Characteristic is the

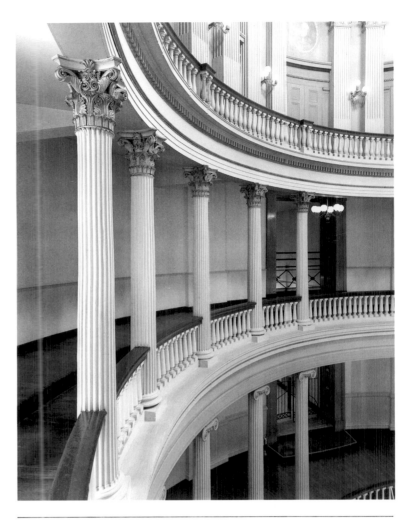

Plate 173. Rotunda, Old St. Louis County Court House, St. Louis, Missouri, 1839–62. Architects Singleton and Rumbold. Photograph by Richard Pare.

one at Oquawka, Illinois, for Henderson County of 1841-42 (*Plate 175*), which is all but indistinguishable from contemporary Grecian churches both in the East and in the Middle West. Similar, but with a wider portico and a more elegant open circular lantern, is that of the same years, 1841-42, at Goshen, New York, for Orange County (*Plate 45*). The architect was Thornton MacNess Niven, probably a local man dependent on the contemporary Guide Books for his models. In the interior, for instance, he borrowed the design of his door frame from the published works of Minard Lafever.

Ammi Young is best known as a government architect, and after the building of his controversial customhouse in Boston —of which the Greek elements were violently attacked by such local critics as Arthur Gilman—he turned early to Romantic alternatives. But his Worcester County Court House in Worcester, Massachusetts, built in 1843-45, was still Grecian. This was more than tripled in size by additions to the north in 1878 and by further extensions in 1898 and

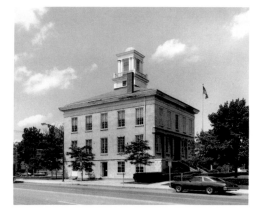

Plate 174. Photograph by Patrick Linehan.

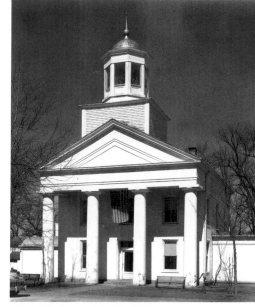

Plate 175. Photograph by Harold Allen.

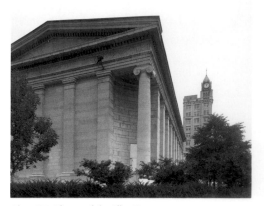

Plate 176. Photograph by Allen Hess.

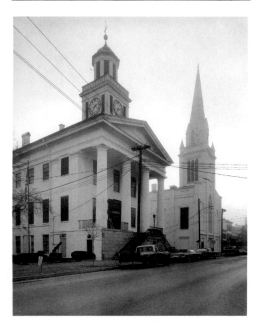

Plate 177. Photograph by William Clift.

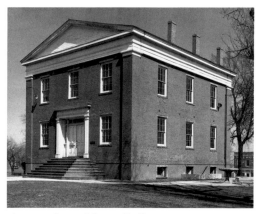

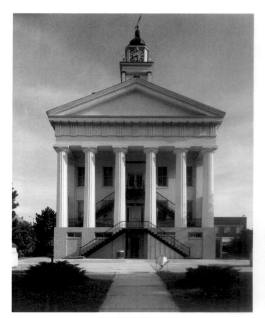

Plate 178. Photograph by Harold Allen.

Plate 179. Photograph by Bob Thall.

Plate 174. *Genesee County Court House, Batavia, New York, c.1840–43. Supervisors John Tomlinson and Paul Richards. Plate 175. Henderson County Court House, Oquawka, Illinois, 1841–42. Architect unknown. Plate 176. Montgomery County Court House, Dayton, Ohio, 1847–50. Architect Howard Daniels. Plate 177. Mason County Court House, Maysville, Kentucky, 1838–44. Architects Ignatius Mitchell, Christopher Russell and Ignatius Purnell. Plate 178. Logan County Court House, Mt. Pulaski, Illinois, 1847. Architect unknown. Plate 179. Orange County Court House, Paoli, Indiana, 1847–50. Architect unknown.*

in the 1940s (*Plate 50*). By 1898, taste had come full circle and both architects and public respected the Greek forms once more. Young's detail was copied with such accuracy that the whole structure looks today as if it were all by Young; doubtless, indeed, he would have been pleased with it in its enlarged form.

A simpler Grecian court house, without columns, and therefore all but domestic in appearance, is that of Logan County at Mt. Pulaski, Illinois (*Plate 178*). The date is 1847 and it cost only a few thousand dollars. A more standard Middle Western example, that for Orange County, Indiana, was built in 1847-50 at Paoli (*Plate 179*). The high basement and the

divided stairs are set in front of the portico; another stair within produces, together with those, an exceptionally monumental effect so that the court house, though small, easily dominates the town's court square.

Of the same year as the preceding is the grandiose stone-built court house of Montgomery County in Dayton, Ohio (*Plate 51*). Its front portico of six Ionic columns contrasts, both in scale and in the accuracy of its execution, with the more usual porticos of four Doric columns. The architect, Howard Daniels, was a professional from Cincinnati. Very unusual is Daniel's treatment of the rear corners with concave quadrants hollowed out behind free-standing columns

(*Plate 176*). Exceptional also, and most effective visually, is the bonding of the fine ashlar with alternate wide and narrow courses. This illustrates well the distinction trained architects could still give to the Grecian formulas of design—in contrast to the dull repetitions of established models by local carpenter-builders.

Atharates Atkinson—Grecian even to his given name—and David Demarest, the architects of the Greene County Court House at Greensboro, Georgia, of 1848-49, provided no such original treatment, but their court house cost only $7,440 and the materials were brick and wood, not freestone (*Plates 3, 54*).

Among the national leaders in architecture in the 1830s and '40s, one of the busiest, first in association with Ithiel Town out of New Haven and then out of New York with other partners, was A. J. Davis. Employed in the South as well as in the North and the Middle West, he provided the design for the Powhatan County Court House in Powhatan, Virginia, which was erected in 1848-51 (*Plate 181*). On the exterior, a two-columned portico was inserted on the front between solid elements which are framed by antae repeated also along the two sides. This is more original than the temple model he had earlier followed in working with Town on the Connecticut and the Indiana State Capitols. The treatment here recalls a little the very original theme of overlapping antae on the ends of his North Carolina State House. The material here, however, is not stone but stuccoed brickwork, as was more often true in this period than has generally been recognized. The stucco was sometimes stippled to suggest ashlar masonry of granite.

Far to the West, at Monterey in Monterey County, California, the structure used from 1850 as a court house had been completed the year before from the design of the chief magistrate for that region, the Reverend Walter Colton, to house the town hall and Colton Hall School (*Plate 180*). Despite two ungainly columns and a pathetically skimped pediment, there is in this amateur work really no reflection of the Grecian mode that was by this time reaching the Pacific coast, particularly the Northwest. But the double stair on the front, added in 1872, and the length of the masonry facade, once covered in stucco, give a certain presence to a composition that is still almost in the Federal or even the Colonial vernacular.

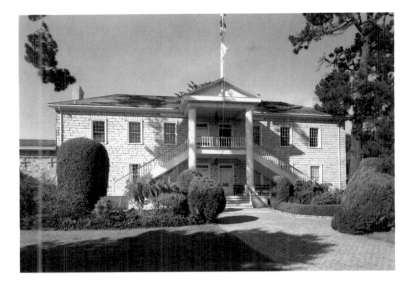

Plate 180. Old Monterey County Court House, Monterey, California, built as school, 1849. Architect Reverend Walter Colton. Photograph by Pirkle Jones.

The Newberry County Court House in Newberry, South Carolina, by Jacob Graves, replaced at a cost of $9,100 in 1849-53 an earlier court house by Robert Mills (*Plate 183*). Mills's earlier work is suggested here by the projecting stair and balcony between the columns. The porches at the sides and the carved eagle on the tympanum in front were added by Osborne Wells in a remodeling of 1880. Even more Millsian is the grander contemporary court house of Chester County at Chester, South Carolina (*Plate 57*). The six-columned portico—Roman rather than Grecian as regards the bases of the columns—the arcaded base and the exceptional stairs, not in the center but on either side, taken together achieve a distinctly monumental effect, one that exploits the advantages of the open site effectively as so many much more correctly detailed temple court houses fail to do. Perhaps there was some intention here of recalling the earlier court houses of 1795.

Among the mid-century architects of Philadelphia, which remained a leading cultural center, Samuel Sloan was one of the most prolific with regard to both executed buildings and published projects. If the Lancaster County Court House in Lancaster, Pennsylvania, of 1852-55, was designed by him, as is reputed, it has little of the High Victorian look of his later buildings and designs (*Plate 184*). The richness of the Corinthian order on the front and sides and the heavy pediments over the side windows, and the tall, rusticated basement, even though consistently expressed in Academic terms, suggests the reaction, already well advanced in such

179

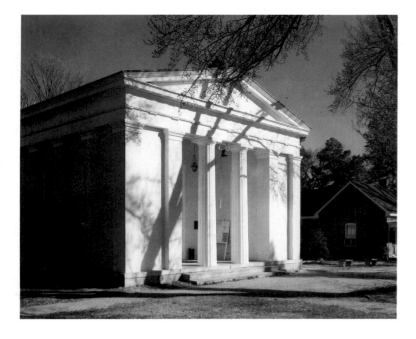

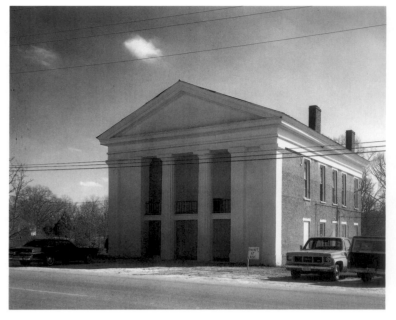

Plate 181. Powhatan County Court House, Powhatan, Virginia, 1848–51. Architect Alexander J. Davis. Photograph by Stephen Shore.

Plate 182. Marengo County Court House, Linden, Alabama, 1848. Architects Town & Davis. Photograph by Stephen Shore.

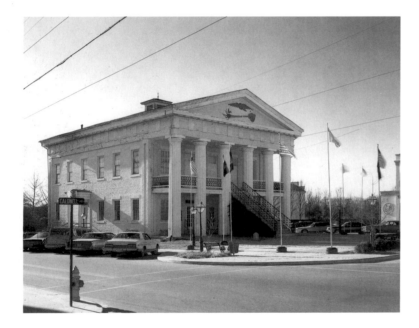

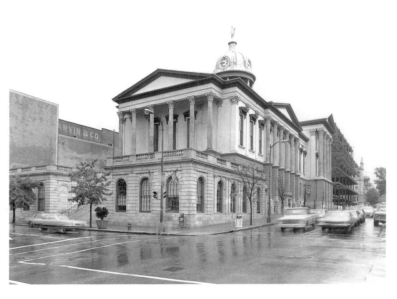

Plate 183. Old Newberry County Court House, Newberry, South Carolina, 1849–53 with later additions. Architect Jacob Graves. Photograph by Stephen Shore.

Plate 184. Lancaster County Court House, Lancaster, Pennsylvania, 1852–55. Architect Samuel Sloan (attributed). Photograph by Lewis Kostiner.

cities as Boston and Philadelphia, against the Grecian austerities of the 1830s and '40s. The great size and the conspicuous, if moderate-sized, dome approached the large scale and the complexity of massing of contemporary state capitols almost to the extent of the court house in St. Louis.

Much more modest is L. A. Shumaker's Pittsylvania County Court House of the same year, 1853, in Chatham, Virginia;

but the four Doric columns of the portico are raised on high piers and a staircase rises at the center of the front. The plain and rather dissonant clock-tower appears to be later (*Plate 185*). However, the architecturally illiterate court house by Frederick B. Guenther, built over the following years 1853-56, for Roane County, Tennessee, with the Doric columns of its porticos stretched to three-story height, has an unusual vernacular sort of monumentality that is not

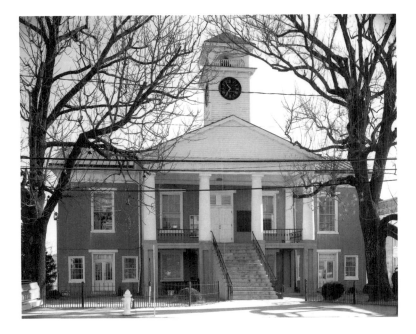

Plate 185. Pittsylvania County Court House, Chatham, Virginia, 1853. Architect L. A. Shumaker. Photograph by Stephen Shore.

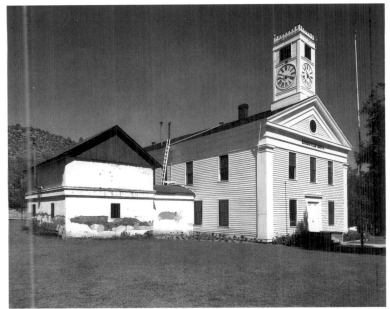

Plate 186. Mariposa County Court House, Mariposa, California, 1854 with later addition. Architect unknown. Photograph by Harold Allen.

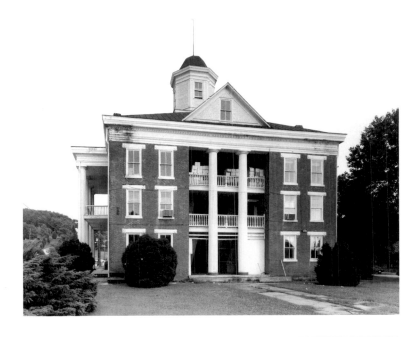

Plate 187. Old Roane County Court House, Kingston, Tennessee, 1853–56. Architect Frederick B. Guenther. Photograph by Tod Papageorge.

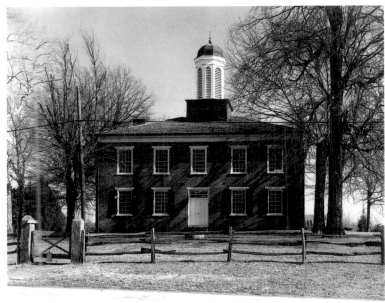

Plate 188. Tishomingo County Court House, now in Alcorn County, Rienzi, Mississippi, 1854. Architect unknown. Photograph by Geoff Winningham.

unworthy of its isolated setting (*Plate 187*). This cost only $9,400 despite its considerable size and brick construction.

Across the continent in California the Mariposa County Court House of 1854 in Mariposa, doubtless designed by the builders F. V. Fox and A. F. Shriver, is the oldest continuously used court house in the state (*Plate 186*). This is of wood, however, not stone or brick and, though much more

plausible in its Grecian vernacular detailing than Shumaker's, it could easily be a church somewhere in the Middle West or even in the Northwest, so national had the Greek become by the '50s.

A much simpler but more elegant example of the Grecian vernacular, in this case of brick, is the old Tishomingo County Court House now in Alcorn County, in Rienzi,

Mississippi, which is also dated 1854 (*Plate 188*). With its slim octagonal lantern flanked by carefully proportioned chimneys, this is a real urban ornament of the court square. Presumably it was also designed by the unrecorded builders, not by an architect. The cost is not known, but was doubtless, like Shumaker's, under $10,000.

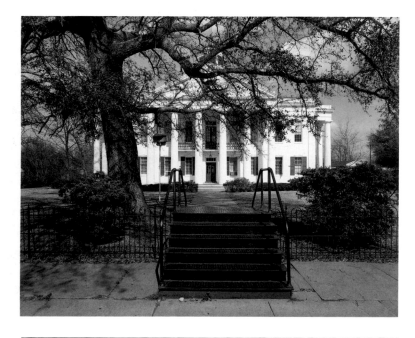

Plate 189. Hinds County Court House, Raymond, Mississippi, 1857–59. Builders George, William and Tom Weldon. Photograph by Jim Dow.

Grecian court houses now proliferated, many of them by such "local architects" as A. B. Hendren, who built that of Rowan County in Salisbury, North Carolina, in 1855, and also one for Guilford County. Others were by builders, such as the Stark County Court House in Toulon, Illinois, by Parker C. and Elias Spaulding of the same date, or those of Hinds County of 1857-59, by the Scotch-Irish immigrants George, William and Tom Weldon at Raymond, Mississippi, and for Warren County, in Vicksburg, Mississippi, 1858-61 (*Plates 13, 189, 12*). The last has an exceptionally broad and carefully detailed portico of six Ionic columns and a two-staged octagonal lantern with a cupola. Neither an architect nor a builder was the attorney, Henry C. Wellman, who received fifteen dollars for his plans for the court house of Ralls County in New London, Missouri, about the same time as the Warren County Court House in Vicksburg (*Plate 193*).

So the story runs on, as was indicated earlier, not only through the years that followed the Panic of 1857 but even the war years of the early 1860s. The late examples rarely

rival those of the '40s and early '50s. More and more the well-established "purity" of the Grecian was corrupted by novel detailing. To that it is hard to give any name other than "Early Victorian," even though the term is not very appropriate for what was developing in mid-century American court-house design, with little or no influence from Victorian England. Even when porticos still dominate the composition, as in the very large Northampton County Court House in Easton, Pennsylvania, of 1860-61, the richer and grander Corinthian order, usually at very large scale, takes the place of the earlier Doric and Ionic and often follows Roman rather than Grecian models (*Plate 192*). Lanterns generally became larger and more elaborate as, for example, that on the Boyle County Court House in Danville, Kentucky, which the architect James R. Carrigan rebuilt at a cost of $15,000

Plate 190. Lantern, Boyle County Court House, Kentucky. Photograph by Lewis Baltz.

Plate 191. *Boyle County Court House, Danville, Kentucky, 1862. Architect James R. Carrigan. Photograph by Lewis Baltz.*

Plate 192. *Northampton County Court House, Easton, Pennsylvania, 1860–61. Architect unknown. Photograph by Bob Thall.*

Plate 193. *Ralls County Court House, New London, Missouri, c.1857–59. Architect Attorney Henry C. Wellman. Photograph by Harold Allen.*

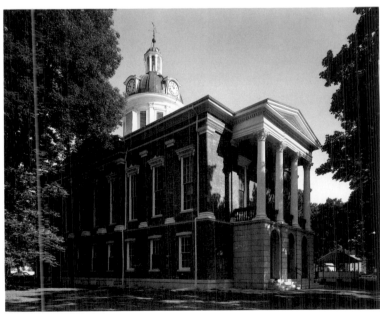

Plate 194. *Switzerland County Court House, Vevay, Indiana, 1862–64. Architect David Dubach. Photograph by Bob Thall.*

in 1861-62 after a fire in 1860, which overloads so heavily the portico below (*Plate 191*). This lantern offers a premonition of the towers that would, after the Civil War, become as standard a feature of court houses as columned porticos had been for more than a generation (*Plate 190*).

So also on the Switzerland County Court House at Vevay, Indiana, of 1862-64, and on the nearly identical one built for Jefferson County, the architect, David Dubach from Madison, Indiana, more than balanced the four-columned Corinthian porticos raised on high bases with a big circular lantern roofed by a dome which was broken in silhouette by four "dormers" housing clock faces (*Plate 194*).

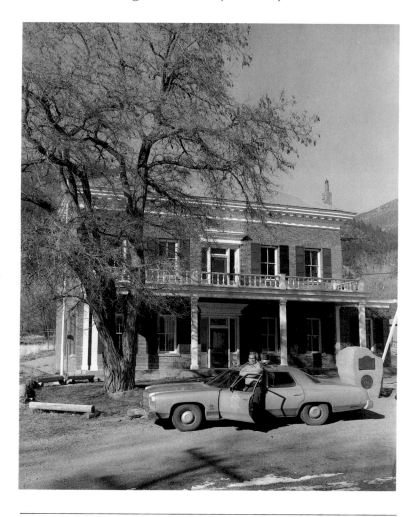

Plate 195. Old Douglas County Court House, Genoa, Nevada, 1863–65. Architect unknown. Photograph by Ellen Land-Weber.

If most court houses of the early to mid-'60s look forward toward the pompous sort of design which was particularly characteristic of the '70s but lasted until after 1890, a few in remote areas continued to be in the sort of Grecian vernacular that was almost domestic in character. A fine ex-

ample is the one at Genoa, Nevada, for Douglas County, completed in 1865 (*Plate 195*). With its generous piazza across the front, which was rebuilt in the restoration that began in 1971 by the architect Edward Parsons, this could well be the house of a prosperous farmer of the '30s or '40s erected anywhere westward from New York State across the Middle West and even in Oregon in the Northwest. Not surprisingly, this is the oldest court house in the state of Nevada and now the Museum of the Carson Valley Historical Society.

By the early '70s, before the financial crash of 1873 inhibited building to a degree the Civil War had not done ten years before, several new sorts of architectural design had come into favor. But the situation of court houses is rather special. The Grecian taste of the second quarter of the nineteenth century had found in the design of court houses what could be considered its most characteristic outlet. But there was no longer any one dominant mode even for court houses, and post-Grecian taste found expression in a great variety of Romantic modes, most of which impinged very little on court-house design.

According to the accepted scenario of American architectural history a Gothic Revival succeeded in the 1840s and '50s the Greek Revival of the preceding decades. As the paragraph above makes evident, the Grecian mode in court-house design came to no abrupt end. It is worth noting, however, that very, very few Gothic court houses were designed and erected in those years when at least one Gothic statehouse, James Dakin's at Baton Rouge, Louisiana, was going up. There is a court house, however, built in 1851 for the independent city of Fredericksburg, Virginia, which should be mentioned since it was the work of a leading Gothic church-architect, James Renwick, who also built Grace Church and St. Patrick's Cathedral in New York (*Plate 196*). Carroll Meeks's term "Picturesque Eclecticism" is most descriptive of what was actually being built in the mid-century decades. The Gothic was largely reserved for churches, and Episcopal ones at that, emulating those of the English Ecclesiologists. Other churches, if not in the '40s still Grecian like court houses, were in a vaguely medieval, round-arched mode. This can hardly be described as Romanesque and was usually called by contemporaries Norman or Lombard or even Tuscan. This mode was close to what in Germany is called the *Rundbogenstil* (round-arched style) and, indeed, in

Plate 196. Fredericksburg Court House, Virginia, independent city, 1851. Architect James Renwick. Photograph by Richard Pare.

Plate 197. Decatur County Court House, Greensburg, Indiana, 1854–60. Architect Edwin May. Photograph by Lewis Kostiner.

the '40s various central Europeans such as Leopold Eidlitz and Alexander Saeltzer in New York or Paul Schulze in New England had actually brought it with them to America.

In domestic architecture A. J. Downing and other authors of the increasingly popular House Pattern books offered various alternative sorts of design: "Tudor Parsonages," towered "Italian Villas," Swiss Chalets, and something vaguely called "Bracketed." These were to be chosen according to the landscape character of their rural settings and none was suitable, in the way the temples had been from the first, to the formal urban setting of a town square. For all their lack of a fixed vocabulary of forms and the syntax of proportion and detailing the Grecian offered, however, these modes were not without influence on court houses. The asymmetrically placed towers of both the churches and the Italian Villas provided an exciting substitute for the earlier lanterns and cupolas, features that at best had no very authentic ancient source except the Choragic Monument in Athens. The Italian Renaissance mode, when used for court houses, never reached the urbane elegance of Charles Barry's London Clubs as emulated in this country with some success by such a later immigrant from Britain as John Notman in Philadelphia or by Ammi Young for federal buildings. That mode, however, suggested the capping of windows with cornices and even pediments and the quoining of the corners of facades with rustication, motifs that were popular on court houses. Particularly the heavy crowning entablatures—above all those carried on modillions become real brackets quite as in the domestic Bracketed—reflected the bolder scale, wider membering, and greater plasticity that the taste of the time favored in the exploitation of all the new variants of the Picturesque.

The results were necessarily tentative, producing mostly near vernacular work that was set apart from contemporary domestic design not so much in quality as by their more nearly monumental scale. This is true at least for the '50s and even most of the '60s, before a grander mode appeared in the presidency of Grant, whose name is often applied to it. As is often the way with stylistic changes in architecture, the new sort of court-house design seems to have been introduced in a remarkably mature example. This was the work of an established architect, Edwin May of Indianapolis, a professional who was in part responsible for the later Indiana Capitol that replaced Town & Davis's Grecian

185

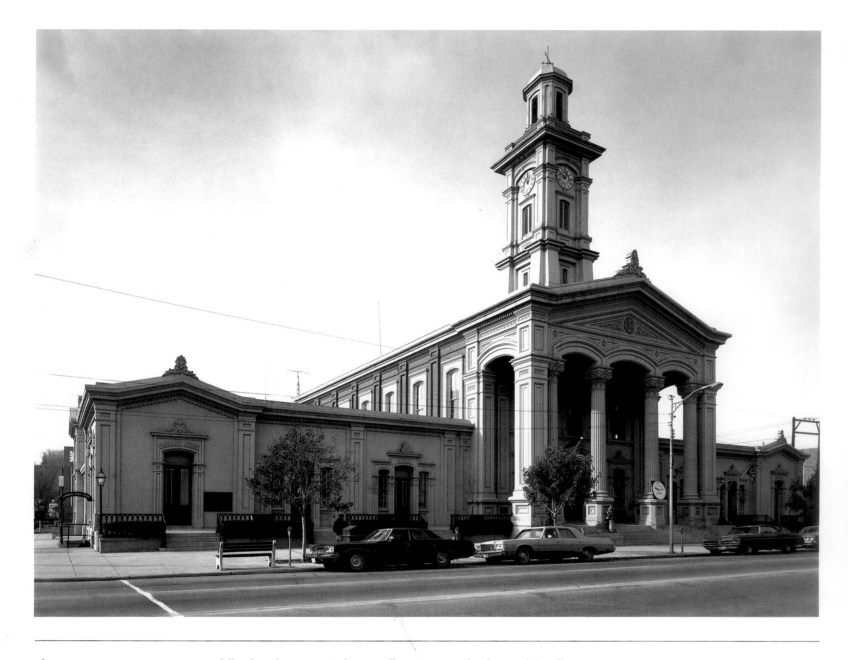

Plate 198. Ross County Court House, Chillicothe, Ohio, 1855. Architects Collins & Autenrieth. Photograph by Allen Hess.

temple, and also for six other Indiana court houses. For the Decatur County Court House at Greensburg, Indiana, built over the years 1854-60, he had some $30,000 to spend and made the most of it (*Plate 197*). The most prominent feature is the very tall clock-tower, rivaling in height Pollard's in Petersburg, Virginia, which is here set asymmetrically back from the right-hand corner of the facade. Built of brick, this has round-arched openings and a heavy triple cornice below the roof which is of concave curvature. Characteristically for the new mode, the entrance door has not only a very heavily decorated archivolt, as does the window above, but also flanking colonnettes in the jambs. High up, a covered belfry stage has simple round-arched tracery, the whole impression as a result being rather a church tower. It is

difficult to distinguish the original work of the 1850s on this court house from the effects of an 1890 remodeling; yet it seems probable that the main block is still basically original, except for the 1903 rock-faced stucco surface.

That main block, all the same, is different now. The present stucco surface of the walls, which imitates quarry-faced masonry, combined with the recurrent round-arched windows in several sizes, all here with heavy hoods, seems almost premonitory of the Richardsonian court houses of a generation later. But the organization of the masses, with a tall central section that projects and a low crenellated tower on the left to balance the taller clock-tower on the right, is not unlike a much expanded version of a contem-

porary towered Italian Villa or an Evangelical church in the "Lombard" mode. The design was probably devised by May's associate on the capitol, Adolf Scherrer, a Vienna-trained Swiss.

Quite different, but even more distinctly Germanic, is the Ross County Court House in Chillicothe, Ohio, built in 1855, the year after May's was begun, by Collins & Autenrieth of Philadelphia (*Plate 198*). Again, it is the work of well established professionals and the name of one of them suggests a Central European origin. Stilted segmental arches, though perhaps first used by C. R. Cockerell in England, were a frequent alternative to round arches in the German *Rundbogenstil*. The low-pitched gables, carefully avoiding the pedimental form, and the paneled pilasters are associated equally with such German contemporaries as Hübsch in Karlsruhe or Bürklein in Munich. Only the clock-tower retains some resemblance in its detailing to the lantern towers of the Greek Revival; but its asymmetrical location, like that of the tower at Greensburg, is as characteristic of the new tastes as the organization of the porticoed block—so totally un-Grecian—and its low side-wings below that end in echoes at the roof line of the main block. Such an example of German Picturesque Eclecticism is rivaled in mid-century in America only by the work in New York of Leopold Eidlitz, mostly now lost, or by Alexander Saeltzer's Astor Library of 1849 there on Lafayette Street which now houses the Public Theater.

The St. Joseph County Court House in South Bend, Indiana, built at a cost of over $30,000 and completed in 1855, is the work of a well established big-city architect, J. M. Van Osdel of Chicago, responsible for many buildings there before and after the fire of 1871 (*Plate 56*). This South Bend court house is a more transitional work dominated still by a temple portico, though with very uncanonical capitols derived from Minard Lafever's. The reflections of the new taste are otherwise: heavy entablatures on plain scrolled members above the segmental topped windows and the bold membering of the lantern with its clock. The work of Van Osdel represents the degeneration of the Grecian rather than any such positive exploration of the new eclecticism of May and Scherrer or Collins & Autenrieth.

Far to the west, the Colusa County Court House in Colusa, California, completed by the "architect" Vincent Brown of

Marysville in 1861 for some $21,000, though a good deal smaller, is quite similar (*Plate 63*). This is true especially of the capitals of the paired columns, two stories tall, that support the pedimented porch on the front. Mentioned here, out of sequence, this is a good example of the simplification and reduction of established court-house types, as the Far West picked up belatedly the successive modes initiated in the East and the Middle West.

Plate 199. Windsor County Court House, Woodstock, Vermont, 1855. Architect Thomas W. Silloway. Photograph by Richard Pare.

Quite different is the court house of Windsor County, at Woodstock, Vermont, built by Thomas W. Silloway for $14,000 in 1855 (*Plate 199*). Silloway was both an architect and a Unitarian minister who would be assigned two years later, the difficult job of remodeling and practically rebuilding Ammi Young's Grecian capitol of the state at Montpelier after a fire. The heavy cornices he would use over the windows there had already appeared on this court house of brick with white-painted trim. He also introduced in the upper story round-arched windows in pairs and these followed the new taste in their rather heavy but still flat hoods, as do the chains of big bold quoins that run up the corners. He retained, however, the unbroken block-shape of earlier court houses though he topped his block with a relatively plain, even if vigorously projecting, cornice on brackets. All the same, shallow vertical strips articulate the front even though they are no longer detailed as Classical pilasters.

Plate 200. Plymouth County Court House, Plymouth, Massachusetts, 1820 with later alterations and additions. Architect-builder John Bates. Photograph by Nicholas Nixon.

Like the Montpelier Capitol, the Plymouth County Court House in Plymouth, Massachusetts, last in descent from the surviving Colonial court house of 1749, is a remodeling (*Plate 200*). The 1820 court house by the builder John Bates was drastically remodeled in 1857 by Bates, now become an "architect," at an expenditure of $24,000, twice what the earlier building had cost. One may hazard the guess that the central portion of the present facade and even perhaps the pilasters on it date from 1820, though the balustrades above, which flank the non-pedimental gable with its statue of Justice in a central niche, are probably of the later period. The end bays without pilasters would also be of 1857, as

their characteristically round-hooded windows—these last repeated in two of the bays of the central portion—make evident. The lantern with its bell-shaped cupola is less definitely in the new taste, but probably does not go back to 1820.

A rear wing was added at Plymouth in 1881 and a second addition was made in 1962. The county buildings, the jail at the rear, and the Registry of Deeds across the street, all survive. The square in front seems to have preceded the building of the court house as the Bartlett-Russell house on the corner, now a bank, is a Bulfinch-like brick block of the first

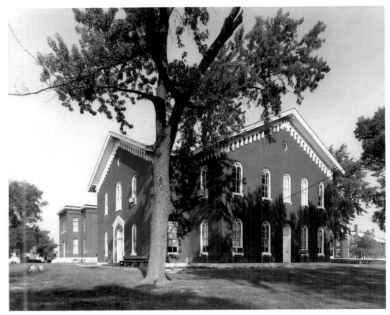

Plate 201. *Rear elevation, Caswell County Court House, Yanceyville, North Carolina, 1858–61. Architect John William Cosby. Photograph by William Clift.*

Plate 202. *Macon County Court House, Macon, Missouri, c.1864–66. Architect-builder Levi Aldrich. Photograph by Tod Papageorge.*

decade of the nineteenth century. The main streeet at the bottom of the square is appropriately called Court Street.

Despite the crash of 1857 and the cutback of the war, court-house construction continued in the late '50s and early '60s, as has already been noted, and now the South, which earlier did not take to the new mid-century modes as whole-heartedly as the Middle West or even the East, responded more creatively to the new taste. The Caswell County Court House at Yanceyville, North Carolina, built by John William Cosby in 1858-61, though small, is a striking example, al-most rivaling in novelty those by May, or by Collins & Autenrieth, and surpassing in bold assurance those of Sillo-way and Bates (*Plate 201*). Height is emphasized not only by the dimensions of the top story but by the heavy vertical strips that trisect the facade. These project between tall and narrow round-arched windows. These openings are defined by sunken edge-members rising through the first story and are elaborated with simple tracery inside their arched tops. All this is not unlike the treatment of "Lombard" church facades of these decades. The cornice above, however, mounting in a broad curve over the central portion, is a much magnified example of the domestic "Bracketed." Below the brackets, the line of the cornice is further emphasized by a bold three-dimensional member that crowns all three sec-tions of the facade between the pilaster strips. The compo-sition as a whole illustrates a Picturesque Eclectic vernacular mode even though it was designed by an architect, not by a

builder, and it is not unworthy of comparison with some of the finest court houses of the previous decades designed in the more monumental sort of Grecian vernacular.

Just at the end of the Civil War—completion date 1866—the architect-builder Levi Aldrich provided for some twenty-five or thirty thousand a similarly monumental-vernacular court house for Macon County in Macon, Missouri (*Plate 202*). The material is again exposed brick, and the plan a very blunt Greek cross. The same elements are used as at Yancey-ville, but with a lighter hand: traceried round-arched win-dows, here without hoods, and a bold cornice following the pitch of the roofs. This is phrased by paired brackets at the peak and on the ends of each gable. It is also vigorously underlined by a sort of machicolation. A broader arch capped by a small machicolated gable frames the entrance.

As often in this period, round-arched secular architecture of the sort often miscalled "Italianate" today is distinctly churchlike in flavor and that suggests one of the inter-mediary American sources for the mode. Small-town builders such as Cosby and Aldrich knew nothing directly of the *Rundbogenstil* of Central Europe or so one would suppose. Yet they could have heard of it from the German immigrants who settled in and after the mid-century in the Middle West and in Texas. Certainly the foreign professionals who had immigrated in the '40s to the cities of the Northeast were working consciously in the Central European mode during

189

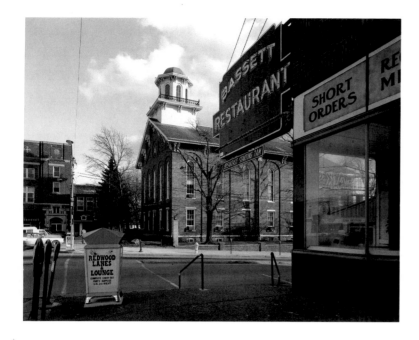

Plate 203. Steuben County Court House, Angola, Indiana, 1867–68. Architect Freborn Patterson. Photograph by Bob Thall.

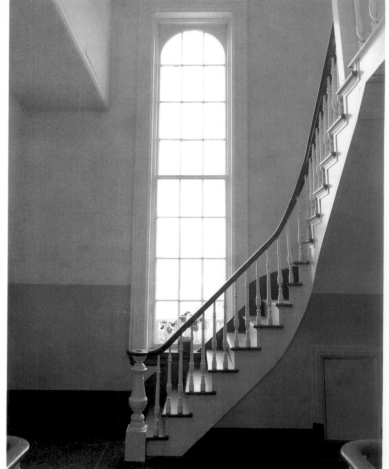

Plate 204. Steuben County Court House, Indiana. Photograph by Lewis Kostiner.

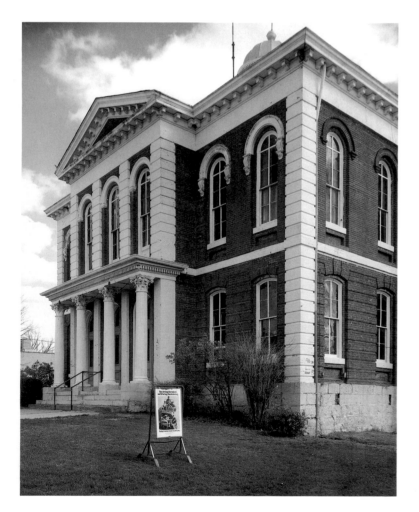

Plate 205. Warren County Court House, Warrenton, Missouri, c.1869–71. Architect Thomas W. Brady. Photograph by William Clift.

Plate 206. Pressed-metal ceiling, Warren County Court House, Missouri. Photograph by William Clift.

the 1850s and '60s both for their churches and for secular buildings of various sorts.

For the court house of Steuben County in Angola, Indiana, the architect Freborn Patterson at a cost of over $26,000 provided in 1867-68 a brick court house not unlike Aldrich's, though less interesting (*Plate 203*). The windows, arched in the upper story, are set in tall sunken panels, but the most conspicuous feature is the raking cornice carried far forward of the wall plane by recurrent pairs of brackets. There need be no hesitation in calling this court house "Bracketed," but it is hardly, even at third or fourth hand, to be considered Italianate, nor should it be called "Early Victorian" since it would be hard to find anything in Victorian England that approaches it.

There is no evidence that the Philadelphia architect Samuel Sloan had European connections, yet his Pennsylvania court houses of the '60s were in the round-arched mode. The Northumberland County Court House of 1865-66 at Sunbury, Pennsylvania, is attributed to him and he is recorded as architect of the Lycoming County Court House, also in Pennsylvania but now demolished (*Plate 207*). At Sunbury the asymmetrically placed tower is reversed. The cost of the Sunbury building was $95,000. The marked asymmetry of the composition of these court houses by or after Sloan was still relatively novel at this early post-Civil War date.

Sloan, already credited with one exceptionally large and monumental post-Grecian court house at Lancaster, Pennsylvania, as well as those for Lycoming and Northumberland counties, offered more of a suggestion of his mature personal style in the Clinton County Court House at Lock Haven, Pennsylvania, which was contracted for at $93,000 in 1867 but eventually cost over $100,000 when completed two years later (*Plate 208*). The tall arched windows here, with traceried tops but no hoods, are familiar enough by this date. Yet the pilasters on the front seem rather *retardataire*, as if Sloan still found it hard to shake off the inhibitions of his Classical training. There is nothing inhibited, however, about his unmatched towers, even to the almost Gothic outline of their tops. But neither is there any of May's assurance of a decade earlier. It was a period when ignorance, a prerogative of the architect-builders remote from the big cities, was more valuable than the sort of preparation professional architects inherited from their youth. The most sophisticated architects with European training, such as R. M. Hunt and H. H. Richardson, were not yet building court houses, though the latter soon tried his hand at it with real distinction. Still later he would provide what became the favorite model for a decade and more of court-house building across the nation.

Round-arched windows in the upper story, segment-topped ones below, all hooded, together with a profusion of brackets

Plate 207. Northumberland County Court House, Sunbury, Pennsylvania, 1865–66 with additions. Architect Samuel Sloan (attributed). Photograph by Richard Pare.

Plate 208. Clinton County Court House, Lock Haven, Pennsylvania, 1867–69. Architect Samuel Sloan. Photograph by Richard Pare.

Plate 209. *Delaware County Court House, Delaware, Ohio, 1868–70. Architect R. N. Jones. Photograph by Richard Pare.*

under the boldly projecting cornice of the nearly flat roof, give character to the court house that an architect who was very likely local, R. N. Jones, built for $80,000 in 1868-70 for Delaware County, in Delaware, Ohio (*Plate 209*). The site is an open square surrounded mostly by rather small houses, not by mansions or commercial establishments. The court house, even more than the church, is typically the sole monumental structure in innumerable small towns such as this.

With its conventional cornice, central pediment, and one-story Corinthian porch, the court house, costing half as much as Jones's, at Warrenton in Warren County, Missouri, is rather conservative (*Plate 205*). But it is most carefully proportioned. Moreover, the corner chains of rustication and the windows, all arched and hooded, reflect the new taste with a dignity that recalls Bates's remodeling of the one at Plymouth, Massachusetts, in 1857. That the architect, Thomas W. Brady, came from the nearest metropolis, St. Louis, may be relevant. He completed the one at Warrenton as late as 1871, by which date Richardson's Hampden County Court House in Springfield, Massachusetts, had been commissioned though not begun (*Plate 248*).

By the late '60s an imported mode other than the Gothic, that reflecting more or less crudely Napoleon III's Paris, was well established in the United States. But the Second Empire

Parisian had little more appeal to those who commissioned court houses than the Victorian Gothic. The only exception was John McArthur, Jr. & Thomas U. Walter, Associates' vast structure in the center of Philadelphia; but that is so conspicuously Philadelphia's city hall it is not generally realized it is also a court house (*Plate 211*). Begun in 1871 and completed ten years later, it follows the New Louvre more closely in its mansarded corner pavilions than Bryant & Gilman in 1861 when they first emulated that Parisian model in their Boston City Hall and rivaled in elaboration the contemporary federal buildings of Alfred B. Mullett.

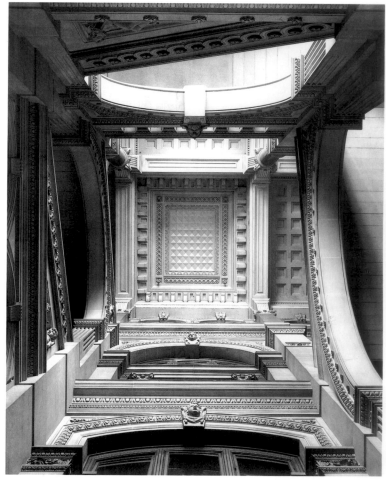

Plate 210. *Stairwell, Philadelphia City Hall, Pennsylvania. Photograph by William Clift.*

The Second Empire mode, at least in easily recognizable guise, had little more success with state legislators than with county authorities, although in the late '60s in Albany, Gilman as consultant modified in that direction Fuller & Laver's designs for the New York State Capitol. Even in Albany, the local architect John Cornelius did not follow this imported mode. Outside the big cities it seemed much

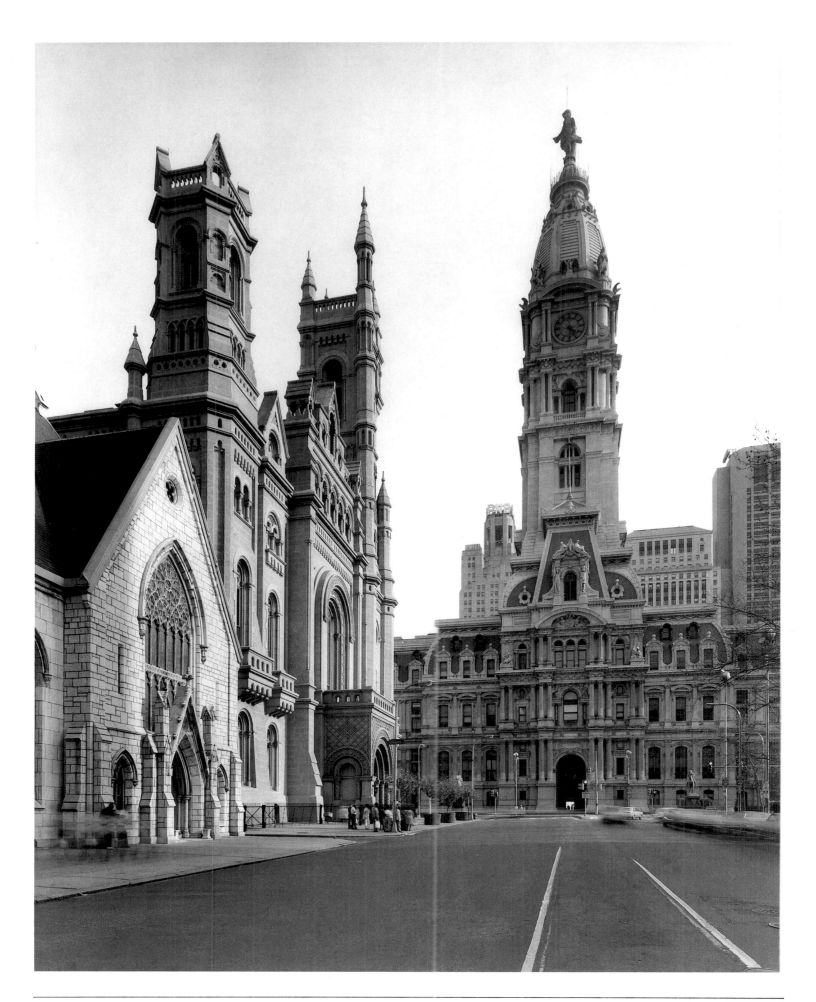

Plate 211. Philadelphia City Hall serving county functions, Philadelphia, Pennsylvania, 1871–81 (sculptural work completed c.1901). Architects John McArthur, Jr. & Thomas U. Walter, Associates. Photograph by Richard Pare.

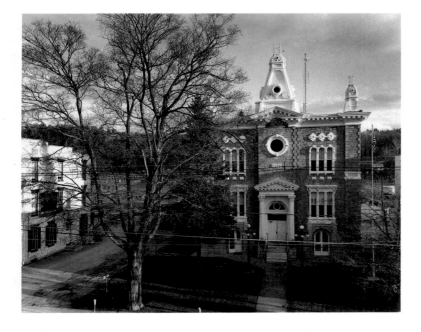

Plate 212. Schoharie County Court House, Schoharie, New York, 1870. Architect John Cornelius. Photograph by Patrick Linehan.

too metropolitan in its pretension. Cornelius's small court house of 1870, at Schoharie on the Erie Canal for Schoharie County, is pretentious enough; but only the high, almost pointed, mansard above the pediment on the front offers a sort of parody in minuscule scale of the current works of such Boston, Philadelphia and Washington architects as Gilman, McArthur and Mullett (*Plate 212*). The arched windows, though tripled here, link it rather with the court houses of the late '50s and early '60s. This structure has a certain technical interest as an early example of fireproof construction, the need for which would soon be called to national attention by the great fires of the early '70s in Chicago and Boston.

Another New York State court house, that which A. J. Lathrop built for Herkimer County at Herkimer at a cost of some $46,000, is somewhat larger but less pretentious in design; perhaps the repercussions of the crash of 1873, while this was in construction in 1872-74, dictated a more economical finish. Only sunken panels decorate the walls and there are keystones rather than heavy hoods atop the narrow frames of the arched windows (*Plate 15*).

Though completed for around $10,000 just before the crash in 1872, the Clay County Court House at Celina, Tennessee, for which D. L. Cookeville was both architect and contractor, is even simpler. The linteled windows still seem to

belong to the Grecian vernacular, but the doorways are arched and there is a big, rather churchlike, traceried window on the front and small brackets in pairs to support the quite uncanonical cornice. The whole has a sort of vernacular elegance unexpected in a remote part of Tennessee.

Five years later, when building activity was reviving nationally, Pickens County in Alabama completed, in 1877, a court house at Carrollton for some $12,000 (*Plate 64*). This is considerably larger and, with its arched and hooded windows—as usual segmental below and round-arched above—and the flat eaves of its low-pitched roof supported on paired brackets, somewhat more elaborate. The material is brick with the one-story porch, the corner quoins and the window detail painted stone-color—indeed, the quoins are actually of stone.

Also of 1877 is a tiny wooden court house in the Rocky Mountains that cost only between four and five thousand dollars. This was designed and built at Lake City, Colorado, for Hinsdale County by Jonathan Ogden (*Plate 214*). It is one of the most minimal of court houses, yet it carries paired brackets below the raking cornice and there is delicate rectilinear detailing at the carefully centered entrance door and around the five windows of the front above. Not least effective here is the design and the placing of the date-tablet.

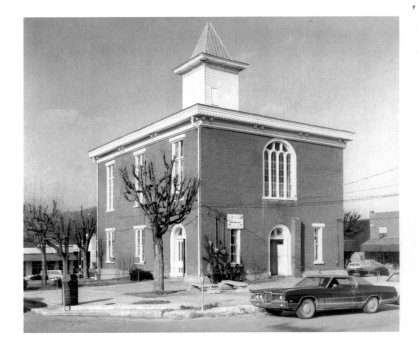

Plate 213. Clay County Court House, Celina, Tennessee, 1872. Architect D. L. Cookeville. Photograph by Jim Dow.

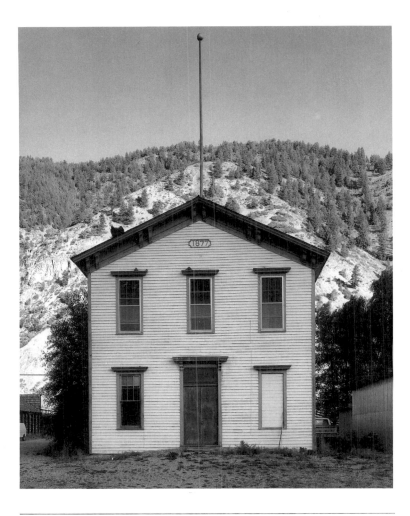

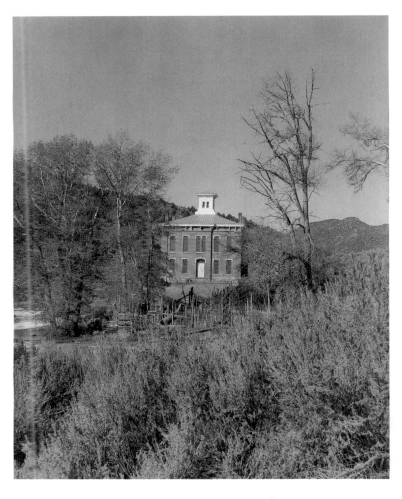

Plate 214. Hinsdale County Court House, Lake City, Colorado, 1877. Builder Jonathan Ogden. Photograph by William Clift.

Plate 215. Old Nye County Court House, Belmont, Nevada, 1874–76. Architect unknown. Photograph by Ellen Land-Weber.

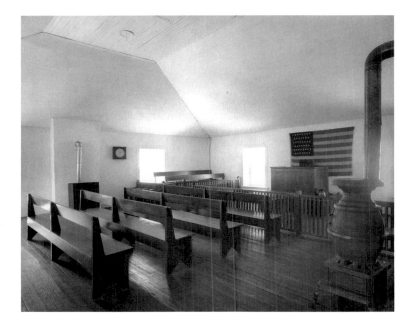

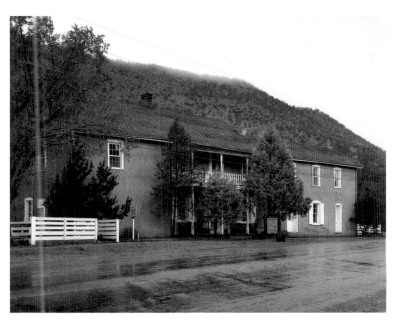

Plate 216. Old Lincoln County Court House, Lincoln, New Mexico, built as store, 1874. Architect-owner L. G. Murphy. Photograph by William Clift.

Plate 217. Old Lincoln County Court House, New Mexico. Photograph by William Clift.

In the Nevada "ghost town" of Belmont the Nye County Court House of 1874-76, in what was then a prosperous mining area, cost some six or seven times as much as that at Lake City (*Plate 215*). Built of brick, the segmental-headed windows—for none are round-arched—and the bracketed cornice were typical still for the country at large as this remote example from the Far West illustrates.

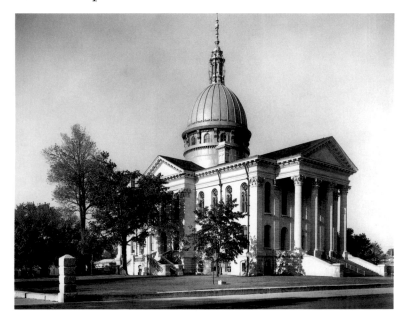

Plate 218. Macoupin County Court House, Carlinville, Illinois, 1867–70. Architect Elijah E. Myers. Photograph by William Clift.

Elijah E. Myers was responsible for several state capitols, beginning with that in Lansing, Michigan, and culminating in the one at Austin, Texas. He was also one of the most prolific designers of court houses. Myers was the architect for the Grant County Court House in Marion, Indiana, in 1880, the Seneca County Court House in Tiffin, Ohio, in 1884-85, and for Knox County in Galesburg, Illinois, in 1885-87. He also built the earlier court house for Macoupin County, Carlinville, Illinois, in 1867-70, where graft rather than post-war inflation explains the extraordinary increase in cost from the budgeted $50,000 to nearly $1.5 million, which was not paid off until 1910 (*Plate 218*).

Myers's design at Carlinville was conservative, still rather academically Classical with its Corinthian portico on the front, pilastered projections at the center of the sides, and central dome. It is, in fact, almost a small statehouse. Only the arched windows, segmental-headed below and round above with tracery, reflect the new tastes of the post-Grecian decades.

Another architect with a long continuing court house practice in Illinois, Indiana and Michigan, Myers's home territory, was Gourdon P. Randall of Chicago. He built the almost equally grand Morgan County Court House at Jacksonville, Illinois, in 1868-69, for no more than $204,000 (*Plate 219*). Much less conservative than Myers, Randall outdid Sloan's earlier unmatched towers with those on this big masonry block. These vary considerably in breadth and in height but they are all topped by tall mansards. Nothing else is even remotely French. The round-arched openings are consistently provided with plain flat hoods and, in the ground story, with simple keystones as well. The result owes its monumental presence, however, to the profuse use of rusticated masonry and to the bold arch-topped dormers that break out of the mansards of the two front towers above their bracketed cornices.

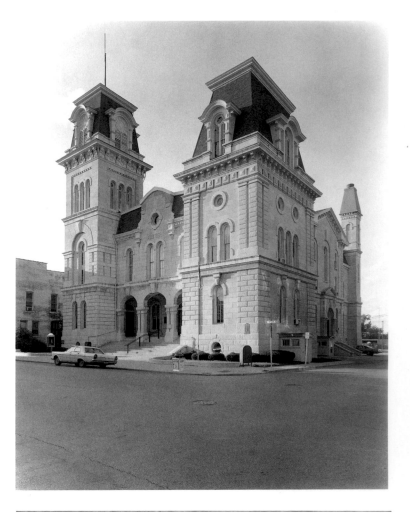

Plate 219. Morgan County Court House, Jacksonville, Illinois, 1868–69. Architect Gourdon P. Randall. Photograph by Lewis Kostiner.

The lavishness of the Age of General Grant is better illustrated in many Middle Western court houses and in their

sequels in Texas than in such Eastern public buildings by Mullett and his associates as were soon rising in Washington, New York and other big cities. Those owe something, however remotely, to Napoleon III's Paris, the great days of which were coming to an end at this time with the Franco-Prussian War of 1870.

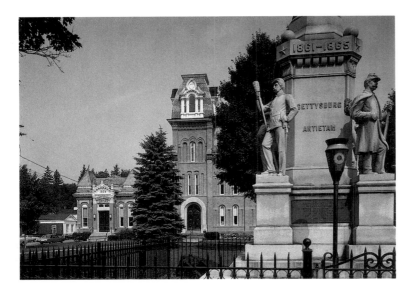

Plate 220. Delaware County Court House, Delhi, New York, 1869. Architect I. G. Perry. Photograph by Patrick Linehan.

I. G. Perry was an architect much employed by the State of New York. It was he who later brought the capitol at Albany to completion after Richardson and Eidlitz were dismissed in the early '80s. His Delaware County Court House in Delhi, New York, of 1869, has a prominent site in the court-house square (Plate 220). Like Randall's, it has mansarded corner towers that do not match and the mansards are very tall and convex in outline. The wall treatment includes sunken panels between the rather small and unhooded arched windows. An exceptional eclectic touch reflecting a favorite High Victorian Gothic motif is the use of pointed extradoses in the arches of the upper story of the taller left-hand tower.

Farther west, Joseph Ireland, a Cleveland architect, in the same year, 1869, the year after a fire destroyed the earlier court house and the business buildings around the public square, erected the Geauga County Court House in Chardon, Ohio (Plate 221). The detailing is familiar by this date, but the tower, with the heavy louvered and hooded lantern that tops it over a bracketed cornice which repeats that of the main block below, is still at the center of the front. The same

is true of another Ohio court house which followed in 1870-71, that for Logan County at Bellefontaine (Plate 224). Alexander Koehler, with over $100,000 to spend in these boom years, provided an equally conservative design but used fine ashlar masonry throughout and a mansard over the main block as well as the one on the tower. That last is decorated with polychrome slating. Both the polychrome of the roof and the extreme verticalism of the crown of the tower faintly suggest again the contemporary High Victorian Gothic. However, thanks to the almost academic regularity of the hooded windows, as usual round-arched above and segmental below, this actually comes closer to the public buildings in the big American cities that had so often emulated, ever since the completion of Bryant & Gilman's Boston City Hall in the opening years of the '60s, the Paris of the Second Empire. But this French note, even as faint as it is here, is rare on court houses.

Even more Academic in design is the Berkshire County Court House in Pittsfield, Massachusetts (Plate 223). The Boston architect Louis Weisbein eschewed most of the characteristic features of the Middle Western court houses of the period, providing no tower at all and detailing the grouped windows of the main story with subentablatures, molded archivolts and keystones. Only the haunched segmental windows below and the paired modillion brackets in the frieze of the main Corinthian pilaster-order above suggest the actual date of 1871; otherwise it might have been thought to be fifteen years later.

Particularly notable here is the absence of French mansards. These are a conspicuous feature, however, of the Chase County Court House of 1871-73 at Cottonwood Falls, Kansas (Plate 222). How much Weisbein had to spend in Pittsfield is not currently known, but John G. Haskell, the architect here, had some $42,000. Haskell, who practiced in Lawrence and Topeka, had designed the Kansas state capitol at Topeka in the late '60s. His Chase County Court House is much less Academic than the Kansas state capitol, though it is symmetrical in design and low pediments group the narrow arched windows in pairs.

Indiana court houses are especially striking in this period for their size and elaboration. The finest that survives is the one for Bartholomew County in Columbus, a small city known internationally for its twentieth-century building by

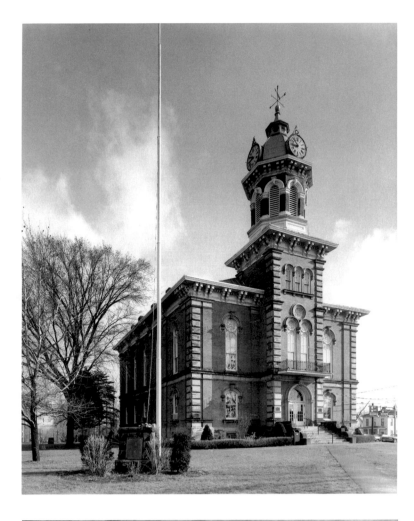

Plate 221. *Geauga County Court House, Chardon, Ohio, 1869. Architect Joseph Ireland. Photograph by Richard Pare.*

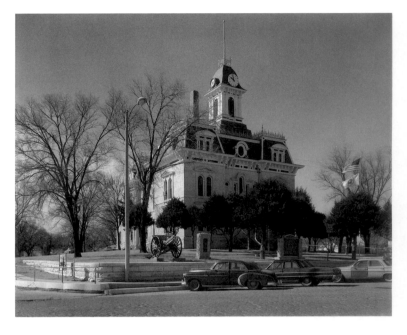

Plate 222. *Chase County Court House, Cottonwood Falls, Kansas, 1871–73. Architect John G. Haskell. Photograph by William Clift.*

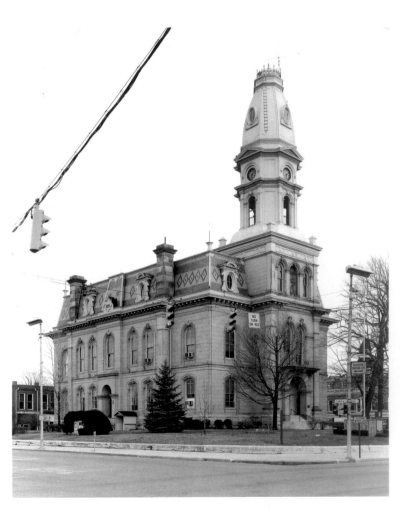

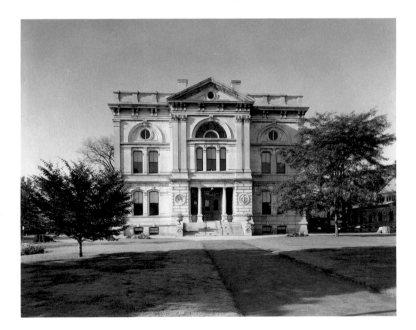

Plate 223. *Berkshire County Court House, Pittsfield, Massachusetts, 1871. Architect Louis Weisbein. Photograph by Nicholas Nixon.*

Plate 224. *Logan County Court House, Bellefontaine, Ohio, 1870–71. Architect Alexander Koehler. Photograph by Richard Pare.*

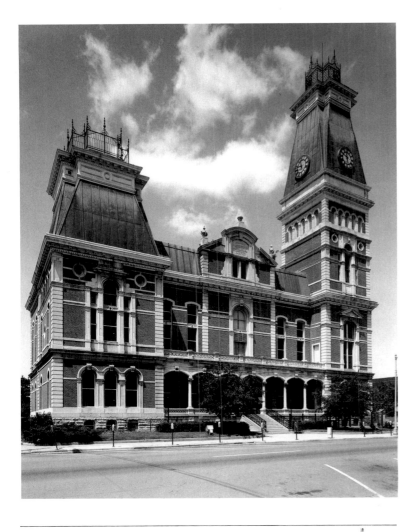

Plate 225. *Bartholomew County Court House, Columbus, Indiana, 1871–74. Architect Isaac Hodgson. Photograph by Bob Thall.*

Eliel and Eero Saarinen, Kevin Roche and others (*Plate 225*). The architect at Columbus was Isaac Hodgson of Indianapolis, who also built court houses for Morgan, Jennings and Henry counties. With over $200,000 to spend, Hodgson did not spare the stone trim on his brick walls, and balanced the very tall clock-tower on the northeast corner, capped by an exceptionally steep mansard, with square mansarded pavilions on the other corners. The trim is very diverse in character, from plain chains of rustication on all the corners to very complex window frames linking the two upper stories. Exceptional features for a court house are the segmental-arched loggia across the east front and the round-arched gallery below the mansard of the northeast tower. There are no brackets in the entablatures and only a few of the arched windows are heavily hooded. As much in spite of, as because of, Hodgson's idiosyncrasies, this is an outstanding example of a General Grant court house, rivaled only by those, mostly of a decade later, in Texas.

Much closer to European models, but of an earlier period, is another Indiana Court House, that for Knox County in Vincennes (*Plate 80*). The Indianapolis architect Edwin May and his Vienna-trained associate Adolf Scherrer—who doubtless was the designer here—detailed the asymmetrically towered block as consistently as their earlier court house at Greensburg, Indiana, of twenty years before, in the central European round-arched mode, eschewing mansards and other French motifs in favor of what contemporaries still considered Lombard or Tuscan detailing. Begun about 1872, this was completed in 1876 and cost $276,000, a large sum justified by its execution in fine ashlar of the limestone readily available in much of Indiana.

The May-Scherrer team also built other Indiana court houses as has already been mentioned, notably those for Decatur and Hamilton counties. But it was another state-capitol architect, John C. Cochrane of Illinois, who built in 1878-79 the Lake County Court House at Crown Point, Indiana (*Plate 226*). This has a more Academic flavor thanks to the five-part composition, the pediments in the center and on the ends, and the evenly spaced modillions—hardly brackets here—in the entablature. The arched windows, moreover, are unhooded and grouped by threes in a sort of arcade on both stories.

Among the five other court houses designed by Cochrane in the Middle West, that of Marshall County in Marshalltown, Iowa, was built hardly a decade later—1884-86—yet, despite various solecisms such as the high pitch of the pediments, the design is here wholly Academic in aspiration (*Plate 230*). All the same, the banded rustication of the lower story and the size and prominence of the clock-tower recall the vigorous originality of Cochrane's work of the previous decade.

Other Middle Western architects in active court-house practice in the late '70s and after were T. J. Tolan (1831-1883) and his son, Brentwood. Their headquarters was in Fort Wayne, Indiana, but one of their earliest and finest works is the court house of Van Wert County, in Ohio at Van Wert, built for just over $100,000 in 1874-76 (*Plate 228*). Although very tall, the clock-tower is above the entrance in the center, not on a corner. Its extreme height is echoed by that of the corner pavilions so that their vertical proportions counterbalance the horizontality of the various mansards as seen from the front. The stone membering of the details of the

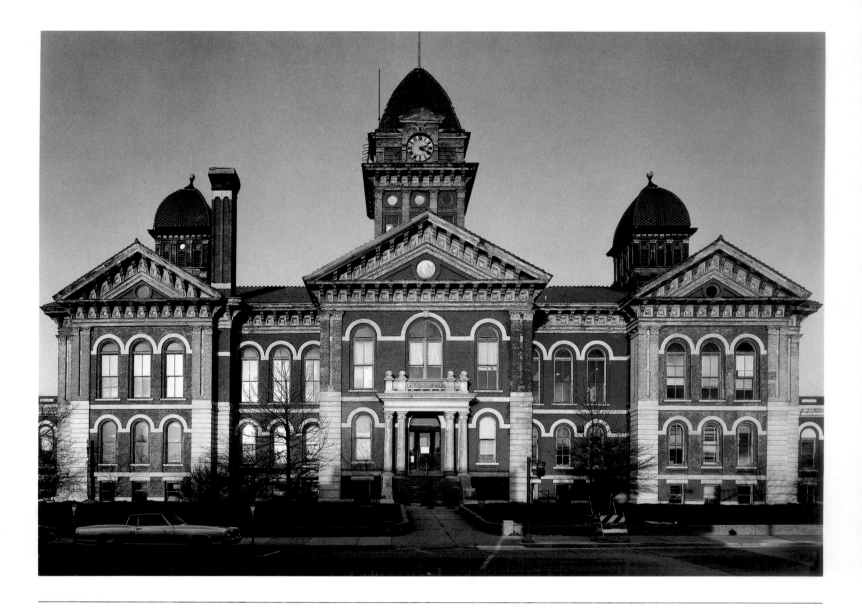

Plate 226. *Old Lake County Court House, Crown Point, Indiana, 1878–79. Architect John C. Cochrane. Photograph by Bob Thall.*

windows, almost obliterating the basic brickwork of the walls, is balanced by recurrent rustication on the corners of all the various articulated elements in the general massing. If there is some slight French feeling here, it is probably quite coincidental: what comes to mind is Louis XIII work of the early seventeenth century, not Napoleon III's New Louvre in Paris. Towered and mansarded, the Tolans' Davis County Court House at Bloomfield, Iowa, has much the same detailing as that at Van Wert, Ohio: rusticated quoins, heavily modillioned cornices, dormers breaking the mansarded roof and, crowning the tall clock-tower, a mansard so steep it resembles a Gothic spire topped here with a statue of Justice (*Plate 77*). Most effective here is the breaking forward of the front in three steps balancing at large scale the plastic elaboration of the pedimented groups of

windows in both stories. This Bloomfield court house was built in 1877-78. A year later is the court house the Tolans built for some $48,000 for Lagrange County at Lagrange, Indiana. This is simpler and brick-built, but the clock-tower is quite close to that of the earlier and larger one.

Still later, 1879-81, is the Tolans' court house for Parke County in Rockville, Indiana (*Plate 227*). Although it cost a great deal more, around $110,000, and is all of ashlar masonry, the detailing is much less plastic and the general effect rather chastened, even if hardly at all plausibly Academic. Though it cost almost twice as much, the Tolans' court house for Kosciusko County in Warsaw, Indiana, is not very different (*Plate 229*). The late date—it was completed in 1884 after the elder Tolan's death—is perhaps suggested

Plate 227. Parke County Court House, Rockville, Indiana, 1879–81. Architects Thomas J. Tolan & Son. Photograph by Bob Thall.

Plate 228. Van Wert County Court House, Van Wert, Ohio, 1874–76. Architects Thomas J. Tolan & Son. Photograph by Lewis Kostiner.

Plate 229. Kosciusko County Court House, Warsaw, Indiana, c.1881–84. Architects Thomas J. Tolan & Son. Photograph by Lewis Kostiner.

Plate 230. Marshall County Court House, Marshalltown, Iowa, 1884–86. Architect John C. Cochrane. Photograph by Bob Thall.

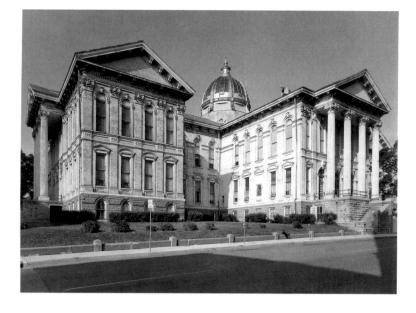

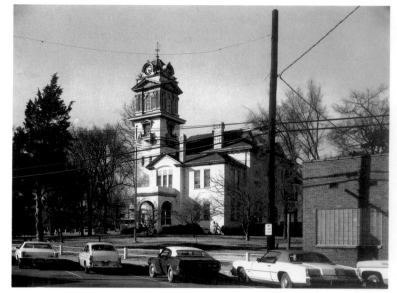

Plate 231. Buchanan County Court House, St. Joseph, Missouri, 1873. Architect P. F. Meagher. Photograph by Tod Papageorge.

Plate 232. Gwinnett County Court House, Lawrenceville, Georgia, 1872. Architect unknown. Photograph by Stephen Shore.

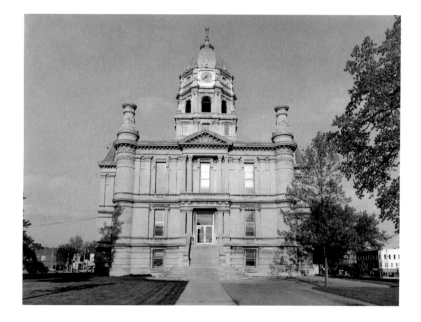

Plate 233. Side elevation, Whitley County Court House, Columbia City, Indiana, 1888–90. Architect Brentwood S. Tolan. Photograph by Lewis Kostiner.

Plate 234. Whitley County Court House, Indiana. Photograph by Lewis Kostiner.

by the still more chastened detail and the fact that the crowning feature is a dome rather than a tower. Even so, the mansards are more prominent here than those at Rockville.

Rather similar, though more plastically articulated, is another Indiana court house of these years—1881-85—built by the local architect Elias Max for Tippecanoe County in Lafayette (Plate 82). More original is one by the younger

Tolan, Brentwood S., built for Whitley County at Columbia City in 1888-90 for a little under $150,000 (Plate 233). The detail is rather flattened for the most part compared to that on court houses in Indiana of the previous fifteen or twenty years; but the cylindrical projections at the corners provide a unique plastic note that is still very much the taste of the '70s despite the rather delicate Renaissance detailing that is used in such profusion on the domed lantern.

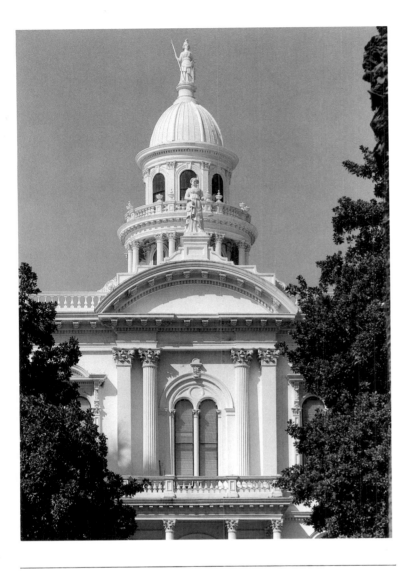

Plate 235. *Merced County Court House, Merced, California, 1874–75. Architect A. A. Bennett. Photograph by Pirkle Jones.*

The preceding account of several of the principal works of the prolific Tolans has carried the rather special and well-documented Indiana story down to 1890. But by the '70s the South was beginning to recover from the Civil War, and building activity was rapidly increasing in the Far West as well. The Gwinnett County Court House of 1872 in Lawrenceville, Georgia, is rather modest by contemporary Indiana standards at least in its detailing—indeed, it may well incorporate an earlier structure of 1849 (*Plate 232*). The round-arched porch and the triplet windows under a segmental bearing arch still suggest the '50s. But the tall clock-tower, for all the relative restraint of the detailing, clearly belongs by its height, and even more by its asymmetrical placing, to the '70s.

The court house of the next year, 1873-76, built by P. F. Meagher for Buchanan County at St. Joseph, Missouri—a

Middle Western rather than a Southern town—which cost only $180,000, is still more retardataire thanks to its giant Corinthian portico; but the window detailing throughout is more characteristic of the '70s, while the dome looks forward to the '80s (*Plate 231*). So does the one, here modeled on the new state capitol's dome in Sacramento, that crowns the Merced County Court House at Merced, California (*Plate 235*). This was erected from the design of A. A. Bennett for $56,000 in 1874-75. The prominence of the Classical orders, both the big columns underneath a segmental pediment on the central section of the front and those used in pairs for the colonnade around the drum of the dome, more than counterbalances the more typically 1870s treatment of the windows.

Despite the national depression, Virginia City, Nevada, was in the heyday of its silver boom in the mid-'70s (*Plate 236*). The authorities did not send east for Tolan or some other established court-house architect even though the sums they were ready to spend—contract of May, 1875, $68,489.50; cost by completion in February, 1877, $117,000—would certainly have justified the gesture. But the builder, Peter Burke, was able to provide Storey County with a rival to the Tolans' Middle Western court houses. It is not as large as many of those, but it is equally rich in its detailing. Although it has neither a clock-tower nor a mansard, the window enframements, with segmental pediments below and flattened ones above, are ornamented much in the mode of the furniture of the day that was called "New Grecian" and, indeed, such may have been Burke's inspiration, for one may presume he would hardly have known much about Parisian design even at third or fourth hand. It is more likely that the detailing of the trim throughout was developed at the foundry which cast the repeated elements. Perhaps these iron members were supplied locally, for Virginia City had an iron foundry, but they may equally well have been imported from San Francisco or even the East.

The South was more conservative. The Tate County Court House of 1875 at Senatobia, Mississippi, might well have been built twenty years earlier, when hooded, round-arched windows and semi-ecclesiastical towers first made their appearance on court houses (*Plate 85*). The designer in this case is unknown, doubtless a local builder. Where an architect was employed, as for the Cabarrus County Court House in Concord, North Carolina, the result is more impressive (*Plate 88*). Although both the round-arched and the hooded

203

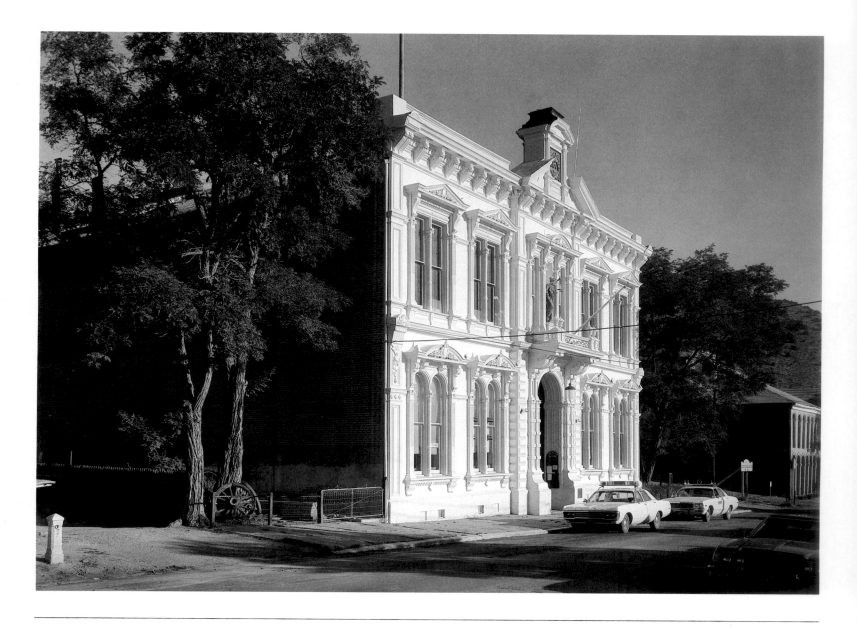

segmental windows are of a sort long familiar, the architect G. S. H. Appleget provided in 1875-76 an exceptionally elaborate mass-composition. There is a heavy porch below, with a pediment and tall lantern above, while dormered mansards crown the main block and a convex one rises over the lantern. This last provides a crowning accent that is almost like a pointed cupola, again reflecting faintly the High Victorian Gothic of the day.

More original is the smaller but presumably more expensive court house—it cost all of $100,000—for Montgomery County in Clarksville, Tennessee, of 1878 (*Plate 241*). Perhaps the architects, S. W. Bunting and C. G. Rosenplaenter, were aware of such lately published designs as had been entered in the competitions for the Providence, Rhode Island, City Hall, and the Union League Club in New York. The wall surfaces have become flat planes, the upper-story windows are grouped under broad arches with archivolts rather than hoods, and instead of mansarded towers, there are framed pyramidal tops to the central clock-tower and the corner bays.

In 1880, for Mono County at Bridgeport, California, the architect J. R. Roberts erected what is almost a copy in wood of Burke's cast-iron trimmed Virginia City court house of three or four years earlier, but with the addition of a man-sarded lantern above the pediment, here segmental, over the center of the front (*Plate 237*).

Plate 237. Mono County Court House, Bridgeport, California, 1880. Architect J. R. Roberts. Photograph by Pirkle Jones.

As one moves into the '80s, court-house design becomes generally more chastened, as was already true of that of Montgomery County in Tennessee. The court house for Hancock County, Georgia, that James Smith built in 1881-83 for only some $25,000 still has, however, a segmental-arched porch on the front, tall windows with hooded arches above, and mansards with convex-roofed central pavilions on the sides (*Plate 239*). The plain pediment and the relative simplicity of all the trim is, in this case, more likely to represent stylistic lag than an early reflection of the new and more archaeological Renaissance Revival, at this point barely initiated even in the metropolitan practice of McKim, Mead & White in the Northeast.

In Texas the story is rather different. Court-house architecture continued there to be bold and brash in the manner of the boom years of the late '60s and early '70s. A Dallas architect, William H. Wilson, who built the Red River County Court House in Clarksville for some $55,000, had the cour-

age to be quite original, using few familiar elements other than the convex mansard on the top of the clock-tower (*Plate 238*). Unique are the free-standing columns at all the corners of the T-squared mass with their diagonally set entablature blocks. But if these are exceptional in their large scale and their plastic emphasis, by contrast the limestone ashlar of the smooth wall-planes and the carefully ordered placing of the modest windows in three rows in the wings is equally unusual in this period without being at all premonitory of the '90s. The window tops are all segmental but even the entrance doorway, like the windows, is unframed. Especially elegant is the top story of the wings with three oculi in each below the entablature. That last is scaled up to the giant columns and to the total height of the block, yet is not inharmonious with the unframed openings.

Quite different and more typical of Texas in the '80s is the court house of Hill County at Hillsboro (*Plate 242*). One of nearly twenty by the architect W. C. Dodson, this has the

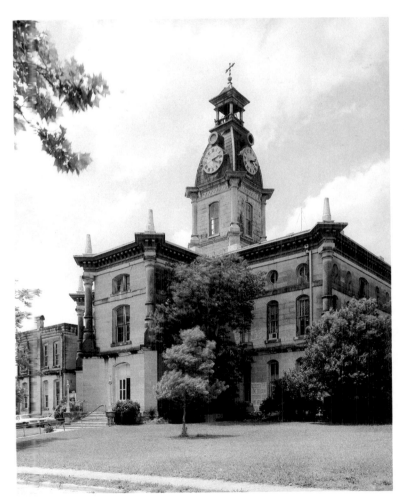

Plate 238. Red River County Court House, Clarksville, Texas, 1884–85. Architect William H. Wilson. Photograph by Geoff Winningham.

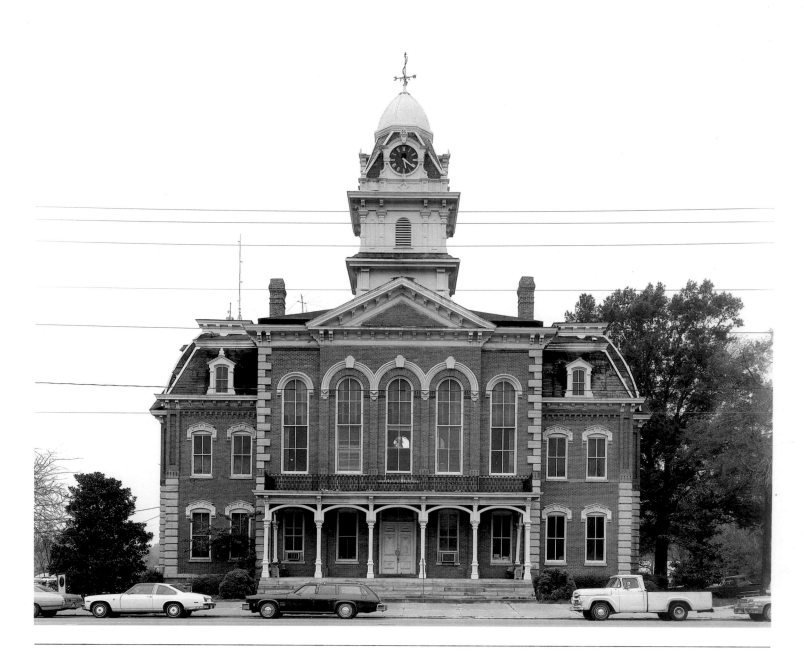

Plate 239. Hancock County Court House, Sparta, Georgia, 1881–83. Architects Parkins & Bruce. Photograph by Jim Dow.

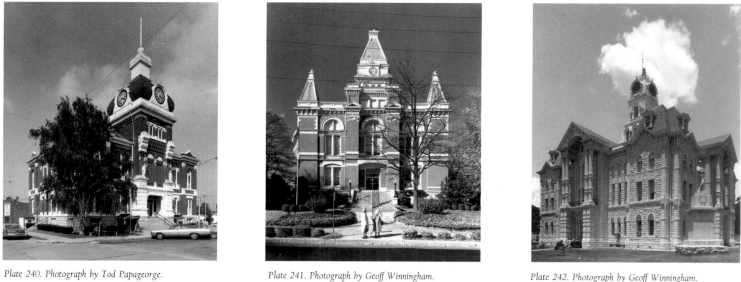

Plate 240. Photograph by Tod Papageorge.

Plate 241. Photograph by Geoff Winningham.

Plate 242. Photograph by Geoff Winningham.

Plate 240. Scott County Court House, Winchester, Illinois, 1885. Architects James Stewart & Co. Plate 241. Side elevation, Montgomery County Court House, Clarksville, Tennessee, 1878. Architects S. W. Bunting and C. G. Rosenplaenter. Plate 242. Hill County Court House, Hillsboro, Texas, c.1889–91. Architect W. C. Dodson.

crudity without the inventive elaboration of the best court houses elsewhere of the '70s. Dodson's use of rock-faced masonry even this late—the Hill County Court House was completed for $83,000 in 1891—reflects E. E. Myers's State Capitol at Austin, not the work of H. H. Richardson, which would be so influential nationally for a few years from this time on.

Another Dodson court house, designed by him in association with W. W. Dudley of Waco, is that of Parker County at Weatherford, Texas, which was built for some $55,000 in 1884-86 (Plate 92). The rusticated masonry of the walls here is less broken by the window trim, and the mansards—all convex in outline and also dormered over the corners—are more like the mansarded pavilions of Second Empire inspiration used on the public works of Gilman, Mullett and McArthur in Boston, Washington and Philadelphia in the previous decade.

On a court house of still later date, 1893-94, for Tarrant County in Fort Worth, the Kansas City architects Frederick Gunn and Louis Curtis retained rock-faced masonry but introduced two stories of coupled columns of Academic character as well as a main pediment and two subsidiary segmental pediments (Plate 247). The mode can already almost be called "Beaux-Arts"; certainly it is not even very laggard "General Grant."

Of a Texas brutality is the Scott County Court House of 1885 in Winchester, Illinois (Plate 240). The architects, James Stewart & Company, were from St. Louis and had $35,000 to spend. The extremely heavy membering is certainly not up-to-date for the mid-'80s, nor is it in any such worthy line of descent from the General Grant court houses, of which there were many in Texas. Original it is, but with none of the individual distinction of Texas's Red River County Court House of 1884-85.

Joseph Warren Yost of Columbus, Ohio, was an architect in active court-house practice in Ohio in the '80s. On his own or with his later partner, Frank L. Packard, he was responsible for some eight court houses in Ohio and Indiana. That for Belmont County at Saint Clairsville, Ohio, built by Yost for $150,000 in 1885-88, reflects its late date in the omission of the mansards and a general chastening of the detail (Plate 243). The result retains, however, a good deal of the monu-

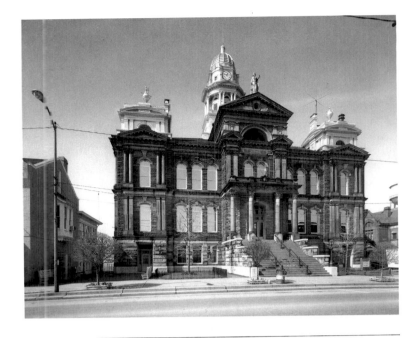

Plate 243. Belmont County Court House, Saint Clairsville, Ohio, 1885–88. Architect Joseph Warren Yost. Photograph by Jim Dow.

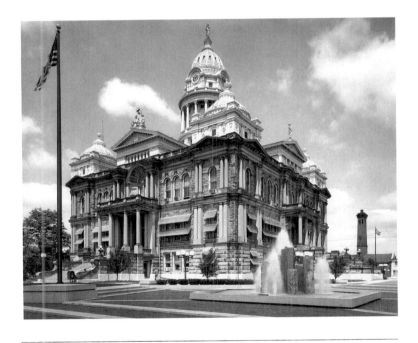

Plate 244. Miami County Court House, Troy, Ohio, 1885–88. Architect Joseph Warren Yost. Photograph by William Clift.

mental assurance of the '70s. Of the same years, 1885-88, but at a higher cost of $271,000, Yost built the Miami County Court House at Troy, Ohio (Plate 244). The design is equally proto-Academic and the most prominent feature is a dome of almost state capitol pretension. But the older sort of brazen assurance, still evident at Saint Clairsville, had now departed for the most part from the work of architects practicing in Eastern, Southern and Middle Western cities.

Plate 245. Benton County Court House, Corvallis, Oregon, 1887–89. Architect
Delos P. Neer. Photograph by Ira Nowinski.

Plate 246. Madison County Court House, London, Ohio, 1890–92. Architect
George H. Maetzel. Photograph by Jim Dow.

In the far Northwest, however, an architect established in
Portland, Oregon, Delos P. Neer, built several court houses
that retain, for all their simplicity, something of the earlier
vitality. His Benton County Court House at Corvallis, Ore-
gon, of 1887-89, still has various versions of motifs that were
first introduced in the East thirty years before (*Plate 245*).
The result is so circumspect as to be very dull by contem-
porary Texas standards.

Even later, and of Texan grandeur, is another Ohio court
house that is still of the General Grant order. The one for
Madison County at London, which cost $209,445, was built
as late as 1890-92 by George H. Maetzel (1837-1891), who
designed three other Ohio court houses (*Plate 246*). The rock-
faced masonry recalls Texas court houses in general and the
rings around the columns on the front are very like those on
Dodson's precisely contemporary Hill County Court House.
The whole mass, boldly broken both in plan and in ele-
vation, is covered with convex mansards while the straight-
sided mansards of the corner pavilions are almost swallowed
up by dormers as on the New Louvre in Paris.

Court houses in the wooden vernacular of rural American
building have rarely survived from the second half of the
nineteenth century. A charming example by an architect
named McGlynn is that for Wakulla County, at Crawford-
ville, Florida, of 1893 (*Plate 72*). Happily, this was moved
to its present site in 1949-50 when a new court house was
built on the old site. The elegant disposition of the many
narrow windows beneath the cross gabled roof—a feature
seen on only one earlier court house—is exceptional, for the
structure is domestic in scale yet, at the same time, public in
its dimensions.

By 1893, when the Wakulla County Court House was built,
two quite different sorts of design introduced by Eastern
architects in the '70s had superseded the General Grant
mode which dominated court house design in that decade.

Among the county court houses most familiar to students of
American architecture—to whom most of those considered
so far are still largely unknown—are the two by H. H. Rich-
ardson, one dating from the early '70s, the other from the
mid-'80s. The first had no influence on other court houses;
the second had a very considerable nationwide progeny in
the '90s. The young Richardson, Louisiana-born, had gone to

Plate 247. Tarrant County Court House, Fort Worth, Texas, 1893–95. Architects Frederick Gunn & Louis Curtis. Photograph by Frank Gohlke.

Plate 248. Hampden County Court House, Springfield, Massachusetts, 1872–74 with later alterations and additions. Architect Henry Hobson Richardson. Photograph by Nicholas Nixon.

the Ecole des Beaux-Arts in Paris after graduating from Harvard, and spent the war years of the early '60s there. But he also made visits to England, and it is his borrowing from the architects of the High Victorian Gothic, particularly William Burges and E. W. Godwin, that is prominent on his early Hampden County Court House of 1872-73 in Springfield, Massachusetts (*Plate 248*). Already "Richardsonian"— as his work and that of his many followers is called—in the use of round arches and rock-faced granite, this is by no means typical of his mature architecture and there is little resemblance to his winning design of these years for Trinity Church in Boston, which first made his national reputation.

The builders for the Hampden County Court House, which cost over $300,000, were Norcross Brothers, a Worcester firm Richardson continued to employ throughout his career. Old photographs indicate what the court house was like originally, when it had a high hip roof and tall stone dormers. Drastic changes were made in 1906 when the court house was remodeled by Richardson's successors, Shepley, Rutan & Coolidge. The most obvious change was the removal of the high roof and the dormers; but more unfortunate for Richardson's proportion was the splitting of the upper story, since that led to the substitution of two equal rows of windows for the original tall lights with high-set transoms.

Less serious, since not visible from the front, is the further extension of the court house to the east in 1910, still using rock-faced walling of granite from nearby Monson.

If the Hampden County Court House belongs, broadly speaking, to the High Victorian Gothic like its English sources, there are a few other court houses of around 1880, some few years before the influence of Richardson's mature style became widespread, that may be loosely grouped with it. If the general avoidance of Gothic in the pre-Civil War decades did not continue into the '70s, still court-house architects showed no such command of the High Victorian Gothic as W. A. Potter did in the Federal buildings he was responsible for during his brief tenure as Supervising Architect of the Treasury in succession to Mullett in the mid-'70s.

Although it is generally supposed that building activity revived by 1878 after the crash of 1873, there was little new court-house building before 1880. In that year Archimedes Russell erected the Otsego County Court House at Cooperstown, New York, which has two notable Gothic features. The big traceried window set in the stone-banded brick wall of the gable front was probably borrowed, not from contemporary English or American churches, but from Ware & Van Brunt's Memorial Hall, lately completed as Harvard College's Civil War Memorial in Cambridge, Massachusetts (*Plate 249*). The pair of low towers to the left may reflect

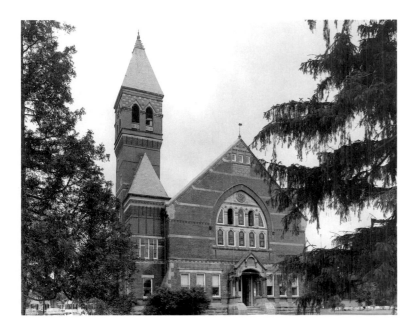

Plate 249. *Otsego County Court House, Cooperstown, New York, 1880. Architect Archimedes Russell. Photograph by Patrick Linehan.*

Ware & Van Brunt also. But the very tall tower between them, with its corbeled belfry stage and pyramidal roof, is rather original and easily rivals in interest the more conventional lantern-towers of the previous post-Civil War years.

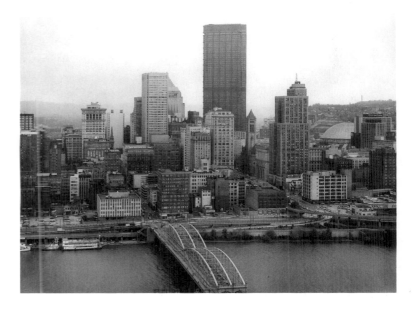

Plate 250. *Allegheny County Court House, Pittsburgh, Pennsylvania, 1884–88. Architect Henry Hobson Richardson. Photograph by William Clift.*

Towards the end of his life Richardson said that he would like to be remembered for two major works, the Marshall Field Wholesale Store in Chicago, begun in 1885, and the Allegheny County Court House in Pittsburgh, Pennsylvania, commissioned the previous year (*Plate 251*). Both were completed only after his death in 1886, the store in 1887 and the court house in 1888. Although never as famous as his Trinity Church in Boston of ten years earlier, this Pittsburgh court house was, to contemporaries, far more than the Field store, Richardson's climactic work. The rock-faced walls, more boldly structural in expression than even the work of the Texans; the ranges of round-arched windows, mostly flanked by colonnettes with carved capitals; the dormers breaking out of the square hip roofs of the corner pavilions, seemed to contemporaries an architectural language—they thought it was Romanesque—which could be used to express any type of structure, from houses and churches to libraries and office buildings. Particularly admired, and not unsuccessfully copied in Minneapolis, was the tower of the Allegheny Court House rising tall and slim above the pavilioned mass below (*Plate 252*). But the more remarkable arcaded interior court was a feature rarely if ever copied by the Richardsonians of the '90s (*Plate 253*). The verticalism of the tower and its

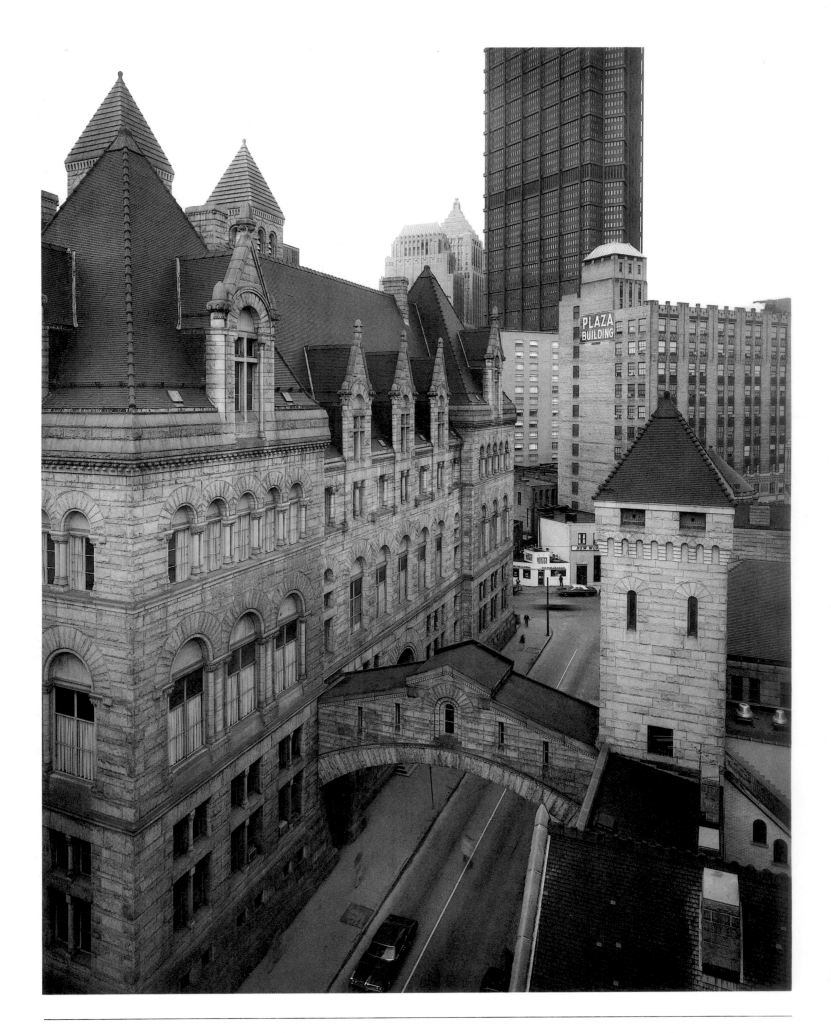

Plate 251. Allegheny County Court House, Pittsburgh, Pennsylvania, 1884–88. Architect Henry Hobson Richardson. Photograph by William Clift.

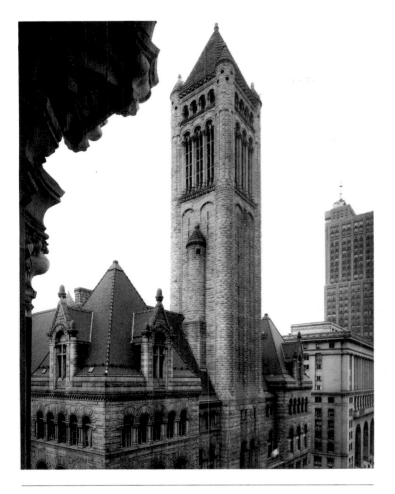

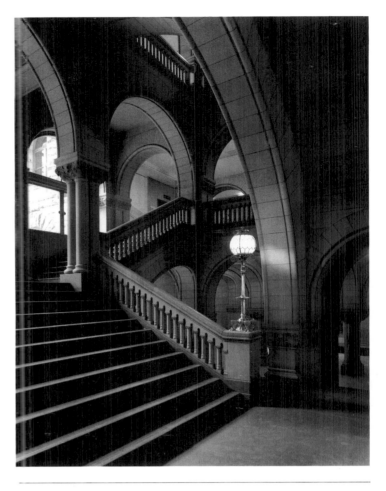

Plate 252. Allegheny County Court House, Pennsylvania. Photograph by William Clift.

Plate 253. Allegheny County Court House, Pennsylvania. Photograph by Bob Thall.

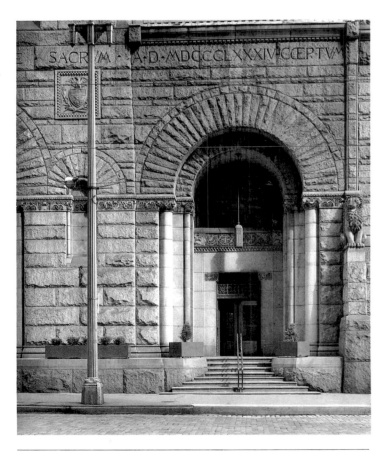

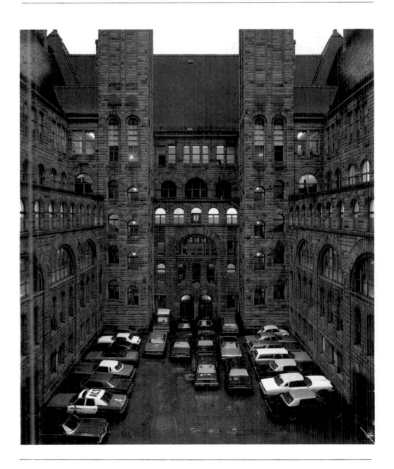

Plate 254. Allegheny County Court House, Pennsylvania. Photograph by William Clift.

Plate 255. Interior court, Allegheny County Court House, Pennsylvania. Photograph by Bob Thall.

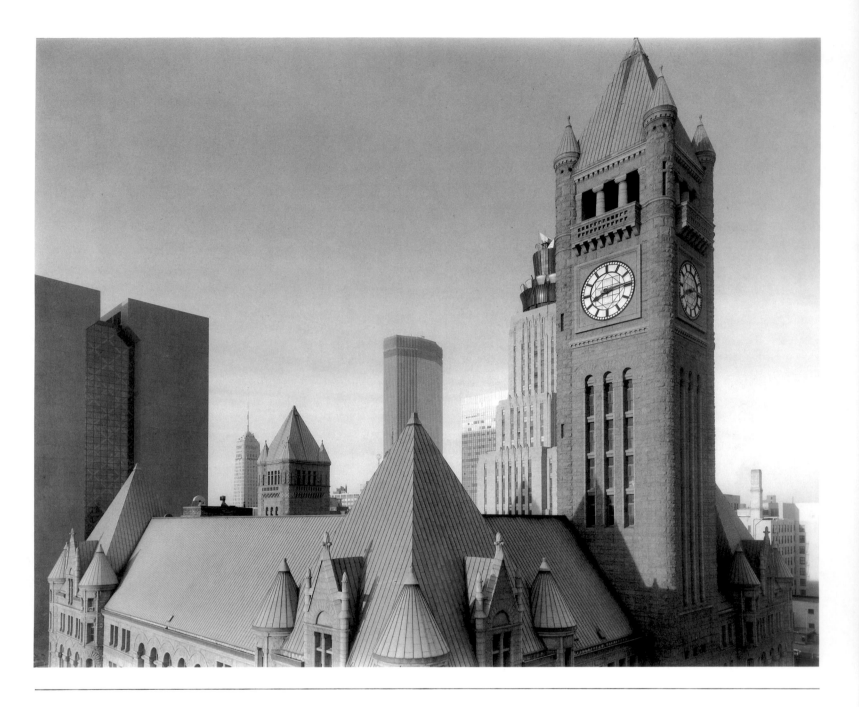

Plate 256. City-County Municipal Building, Hennepin County, Minneapolis, Minnesota, c.1887–1906. Architects Long & Kees. Photograph by Frank Gohlke.

plastic shaping by the tall tourelles on the corners—an upward elongation of Richardson's famous crossing tower on Trinity adapted from a Spanish Romanesque model—offered positive suggestions for the design of the new skyscrapers of the late '80s and '90s. For once, a county court house was a major event in the history of American architecture!

The first court house to show unmistakably the influence of Richardson's mature work of the early '80s is the Hampshire County Court House in Northampton, Massachusetts, begun like that in Pittsburgh, in 1884, and completed two years earlier (*Plate 262*). Both the Hampden County Court House

of the early '70s and the Allegheny County Court House of the mid-'80s are monochromatic. More characteristic of Richardson's middle years was the combination of rock-faced walling of granite—preferably the very pale pink granite from Medford, Massachusetts, which he had first used on Trinity Church in Boston—with profuse trim of the Longmeadow brownstone which he had employed on his earliest work, the Unity Church in Springfield of 1866-69.

Henry F. Kilburn, the New York architect who built the Northampton court house, not only combined rock-faced granite walling and brownstone trim throughout, but used

them boldly to band the arches of his porch, and supported those arches on polished granite columns, a motif more characteristic of the High Victorian Gothic than of Richardson's work of this late date.

Kilburn designed his court house too early to be influenced by the Allegheny County Court House. Not so Long & Kees in Minneapolis. They began the City-County Municipal Building, a vast structure to house both the city administration and the Hennepin county courts there, in 1889 after winning the competition for it two years before, just as the Pittsburgh court house was reaching completion. They followed closely Richardson's model, especially as regards the quadrangular court and the tall tower, which rivals in elegance of silhouette its prototype in Pittsburgh (*Plate 256*). The material here is pinkish-red Ortonville granite laid as random-coursed ashlar. The building, on which the cornerstone date is 1891, was many years in construction, having been completed only in 1906 at a cost of over $3 million, probably the most expensive in the nation up to its time.

The grandest Richardsonian court house in Texas came relatively early, that for Dallas County in Dallas (*Plate 129*). This was built in 1890-91 for $350,000 by the Little Rock firm of Orlopp & Kusener, who were also responsible for the Pulaski County Court House in Little Rock. The Dallas court house is overshadowed today by a skyscraper block, completed in 1965 to house county offices, which was erected at right angles to it on another side of the court square by a local professional group, the Associated Architects and Engineers. The old court house holds its own, for it has a massiveness worthy of Richardson himself and a very discreet and literate use of the familiar arched detail in rock-faced stone. The many round towers vary the silhouette without detracting from the symmetrical organization of the facades. Its only rival nationally is the City-County Municipal Building in Minneapolis, by Long & Kees, of which the cornerstone was laid in 1891, the year the Dallas court house was completed, although it was designed well before that. In the Middle West, however, the Richardsonian was never as popular as in Texas.

H. C. Koch, a prominent architect of Milwaukee, was the designer of eight court houses in Wisconsin, Iowa and Kansas. That for Marshall County at Marysville, Kansas, of 1891 is less canonically Richardsonian (*Plate 265*). The composi-

tion follows a formula that had often been used until designers, from the mid-century on, began to favor asymmetry. But the tower here, though in the center of the front, is handled with considerable sophistication. Although the columns of the porch below the tower are absurdly massive, the polished granite cylinders of their shafts offer a note of real luxury in contrast to the brick walls and simple stone trim. The irregularly octagonal tower leads up to a high pointed roof, broken by Richardsonian dormers, past ranges of stone-mullioned and transomed lights in the shank. By contrast the gables at the corners are rather petty and break the grand sweep of the main hip-roof as it rises around and behind the tower.

Koch's court house is original in a quite positive way. The court houses of the Cleveland architect T. Dudley Allen, seven of them in Ohio, Nebraska, Minnesota and Iowa, are more typically Richardsonian, but in a crass and vulgar version very remote from Richardson's own work of a decade earlier. The Hardin County Court House in Eldora, Iowa, built by Allen in 1891-92, shows none of the monochromatic restraint of Richardson's Allegheny County Court House (*Plate 257*). Reversing the usual dark-against-light formula, the walling here is red brick and the profuse rusticated trim of light-colored stone, with pattern in the two colors only in the diaper on the side gable. Although the facade below that gable is symmetrical, the elements of the massing are put together in a rather slapdash way with corner turrets that do not match and a clock-tower which is barely Richardsonian at all dominating the whole in the manner of the post-Civil War years. The cost was over $50,000.

The most prolific builder of Richardsonian court houses in those years was the San Antonio architect J. Riely Gordon, who had come from New York to practice in Texas. Together with D. E. Laub, Gordon completed in 1892 the Victoria County Court House in Victoria, Texas, for over $67,000 (*Plate 260*). Characteristically Richardsonian, this is of rock-faced masonry throughout with arched openings of varying proportions and even a diapered band below the eaves of the main block. Moreover, the mass builds up impressively from low quadrantal porches on the corners to tall gables paired on two of the facades and a clock-tower behind that dominates the whole. The profusion of features produces a rather restless effect and some of the detailing, notably the ridiculous little corner turrets, is quite out of scale with the broad

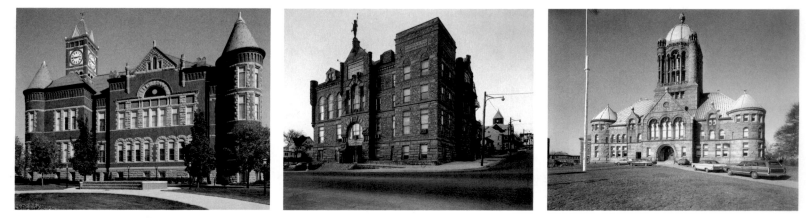

Plate 257. Photograph by Bob Thall.　　Plate 258. Photograph by Bob Thall.　　Plate 259. Photograph by Nicholas Nixon.

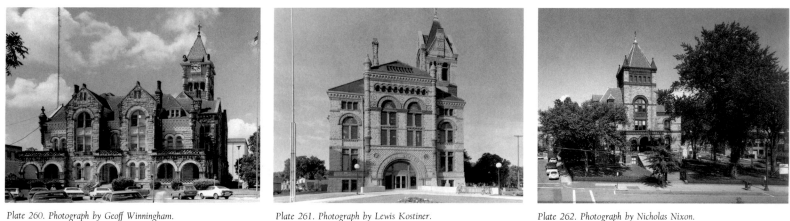

Plate 260. Photograph by Geoff Winningham.　　Plate 261. Photograph by Lewis Kostiner.　　Plate 262. Photograph by Nicholas Nixon.

Plate 257. Hardin County Court House, Eldora, Iowa, 1891–92. Architect T. Dudley Allen. Plate 258. Wapello County Court House, Ottumwa, Iowa, 1892–93. Architects Foster & Liebbe. Plate 259. Bristol County Court House, Taunton, Massachusetts, 1892–95. Architect Frank Irving Cooper. Plate 260. Victoria County Court House, Victoria, Texas, c.1891–92. Architects J. Riely Gordon & D. E. Laub. Plate 261. Winona County Court House, Winona, Minnesota, 1889. Architects C. G. Maybury & Son. Plate 262. Hampshire County Court House, Northampton, Massachusetts, 1884–86. Architect Henry F. Kilburn.

low arches of the corner porches and the main entrance in the center. Nevertheless, the Texan early achieved a competence at Richardsonian design not inferior to that of many of the Northeastern and Middle Western architects who knew Richardson's own work at first hand far better than he.

Rather similar, but somewhat less skillful in the handling of the recurrent arches in the rock-faced masonry, is the La Porte County Court House at La Porte, Indiana, of 1892-94 (*Plate 263*). The architect was Brentwood S. Tolan, who has been mentioned earlier as working with his father Thomas J. Tolan on many court houses in the Middle West beginning in the 1870s. Though Tolan had some $30,000 more to spend than Butz & Kaufman and twice as much as Gordon in Victoria, Texas, the result here represents no careful emulation of the original Allegheny County Court House by Richardson himself, nor does it have the variety of massing

and the boldness of detailing of the Texan court houses of the day by Gordon and others.

Foster & Liebbe of Des Moines built in the early '90s five court houses in Iowa, for Wapello, Page, Washington, Iowa and Lucas counties. That of 1892-93 for Wapello County at Ottumwa, Iowa, which cost just under $100,000, is exceptionally simple, with the emphasis on asymmetrical massing around an exceptionally broad square corner tower and a minimum of the usual Richardsonian arches (*Plate 258*). The ashlar masonry is of particularly high quality and the simplicity of the fenestration makes up to some extent for its rather uncoordinated spacing.

Not surprisingly the Bristol County Court House in Taunton, Massachusetts, built at a cost of $300,000 in 1892-95, successfully rivals the Texan and Middle Western versions of the

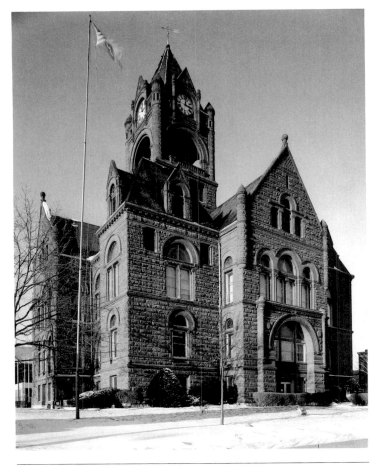

Plate 263. La Porte County Court House, La Porte, Indiana, 1892–94. Architect Brentwood S. Tolan. Photograph by Bob Thall.

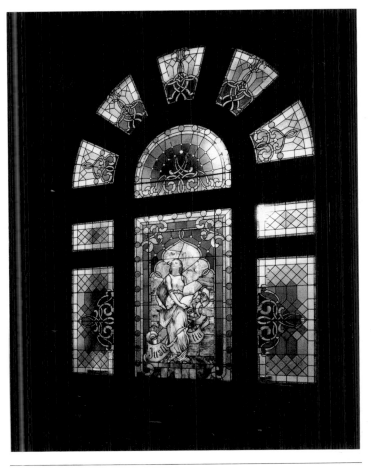

Plate 264. Stained-glass window, courtroom, La Porte County Court House, Indiana. Photograph by Bob Thall.

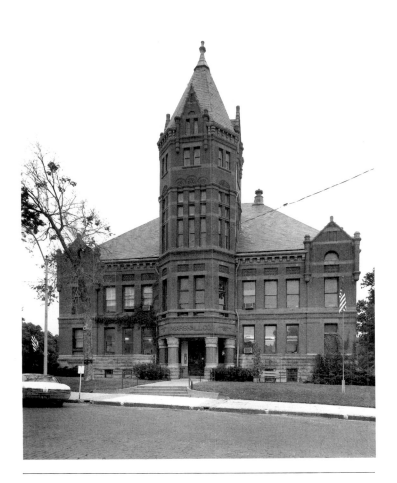

Plate 265. Marshall County Court House, Marysville, Kansas, 1891. Architect Henry C. Koch. Photograph by Tod Papageorge.

Plate 266. Marshall County Court House, Kansas. Photograph by Tod Papageorge.

Richardsonian court houses of the 1890s (*Plate 259*). The architect, Frank Irving Cooper, reflected here the rising current of post-Richardsonian Academic design in his near approach to symmetry on the front. The identical flanking towers at either end of the big facade counteract the irregularity of the fenestration between these massive terminal units and the broad central gable. This rises over grouped second-story windows above a characteristically broad and low entrance arch. The gable in turn leads up to a very large, centrally placed lantern. The dome on top of the lantern with its corner domelets is rather similar to the features that crown state capitols of the period, but it is not modeled like the more Classical ones on Walter's dome on the National Capitol in Washington.

The Chicago architect Henry Elliott was another prolific Middle Western court-house builder in these years of the early '90s with five to his credit in Illinois. Elliott's Jersey County Court House at Jerseyville, Illinois, of 1893-94, built for $40,000, likewise reflects the return to order and symmetry that had already been evident a decade earlier in Richardson's own Allegheny County Court House (*Plate 271*). Particularly un-Richardsonian here, yet hardly Academic, is the clock-tower which recalls a little R. M. Upjohn's Gothic dome on the Connecticut State Capitol of the 1870s.

A similar work in the diluted Richardsonian vein of these years is the McPherson County Court House at McPherson, Kansas (*Plate 267*). This was built, also in 1893-94, by the Topeka architect John G. Haskell, who was still working in Topeka on the state capitol, and an associate, J. F. Stanton, at a cost of some $40,000. Haskell had hitherto been more at home with Classical design as is evident from his original east wing of the state capitol.

Grander in scale and with a more skillful handling of conventional Richardsonian detail is the towered court house of Wood County at Bowling Green, Ohio, built along with other Ohio court houses by Joseph W. Yost and Frank L. Packard for $200,000 in 1893-96 (*Plate 268*). Though slightly churchlike, the great arch under the gable at the left end is an expressive and rather original Richardsonian feature. Plastically effective, moreover, is the way the tall clock-tower rises above the low, segmental-arched entrance porch between and to the rear of two turrets. Though Richardson had been dead for ten years when this was completed, it is

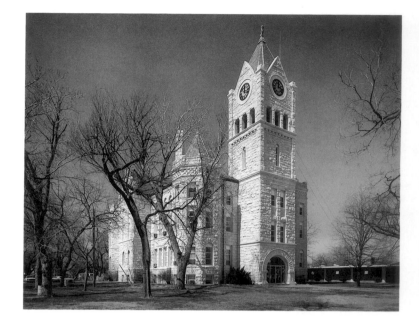

Plate 267. *McPherson County Court House, McPherson, Kansas, 1893–94. Architects John G. Haskell & J. F. Stanton. Photograph by William Clift.*

evident that it was not only in the commercial architecture of Chicago that a healthy line of descent from Richardson still continued even after the World's Fair of 1893.

All but totally undiluted in its Richardsonian style is the Blackford County Court House at Hartford City, Indiana (*Plate 269*). This was built for $130,000 by the firm of La-Belle & French from Marion, Indiana. The general *parti* is that of Richardson's Albany City Hall of 1881, but the turret-like bays on the side and the detailing of the tall corner tower rather follow his later Allegheny County Court House. Only the giant arch which rises over the inset section at the front entrance is at all exceptional here, but that is a happy addition to the existing repertory of popular Richardsonian features. The French firm from Marion built other Indiana court houses for White County, Monticello County and Trumbull County which are not unworthy successors of the Middle Western court houses the Tolans erected in the '70s.

Among the designs for Texas court houses by J. Riely Gordon, the one completed in 1892 at Victoria has been described. Three years later he erected that for Hopkins County at Sulphur Springs for some $10,000 less than the earlier one (*Plate 90*). But taste was changing and the simpler quadrangular massing leading up to a centrally placed tower reflects faintly, at least, the influence of the new and rising sort of Academic design first conspicuously illustrated in the tem-

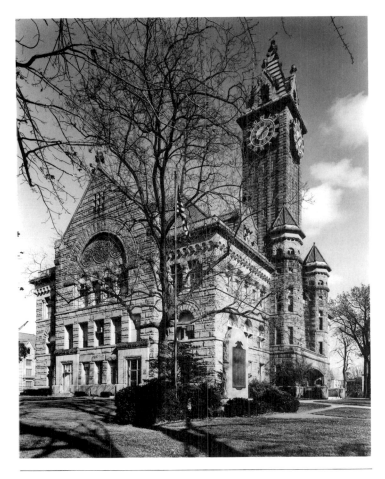

Plate 268. Wood County Court House, Bowling Green, Ohio, 1893–96. Architects Joseph W. Yost & Frank L. Packard. Photograph by Bob Thall.

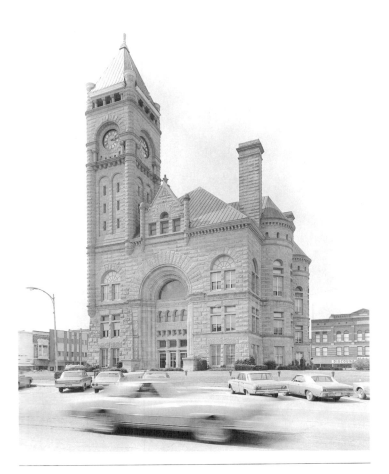

Plate 269. Blackford County Court House, Hartford City, Indiana, 1893–94. Architects Arthur LaBelle & Burt L. French. Photograph by Lewis Kostiner.

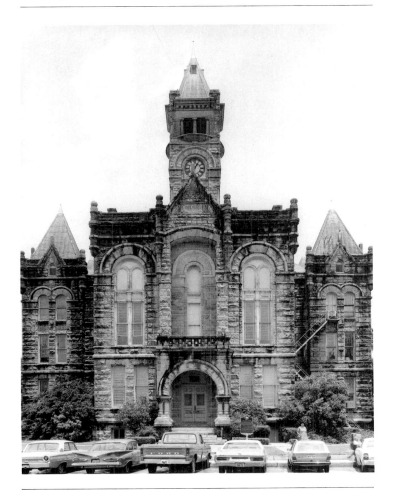

Plate 270. Lavaca County Court House, Hallettsville, Texas, 1897–99. Architect Eugene T. Heiner. Photograph by Geoff Winningham.

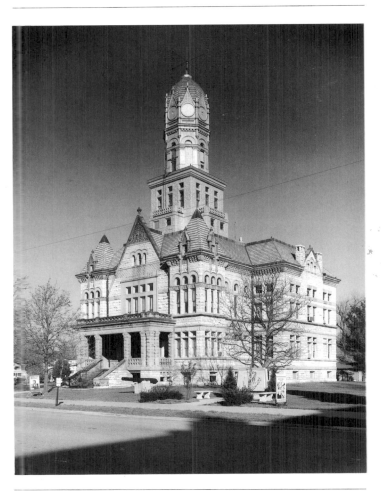

Plate 271. Jersey County Court House, Jerseyville, Illinois, 1893–94. Architect Henry Elliott. Photograph by William Clift.

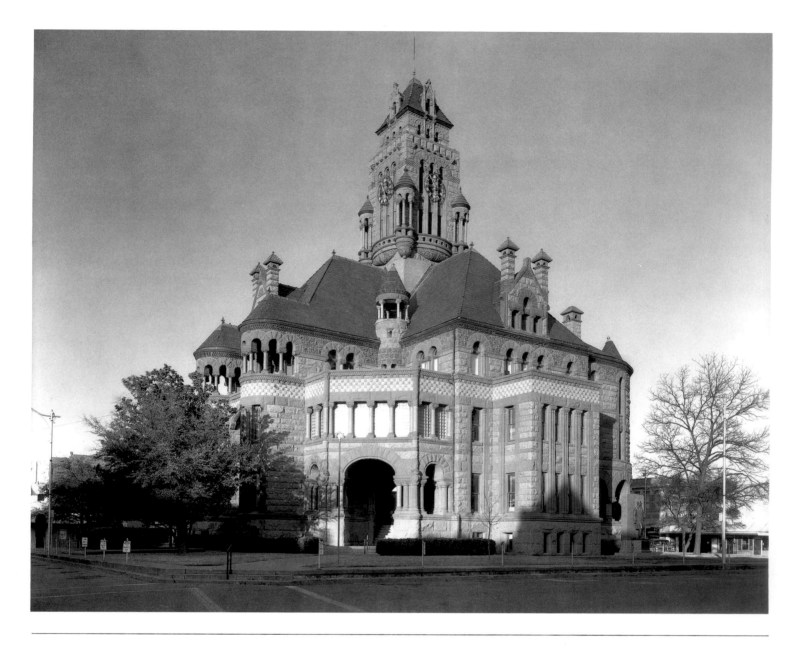

Plate 272. Ellis County Court House, Waxahachie, Texas, 1894–97. Architect James Riely Gordon. Photograph by Jim Dow.

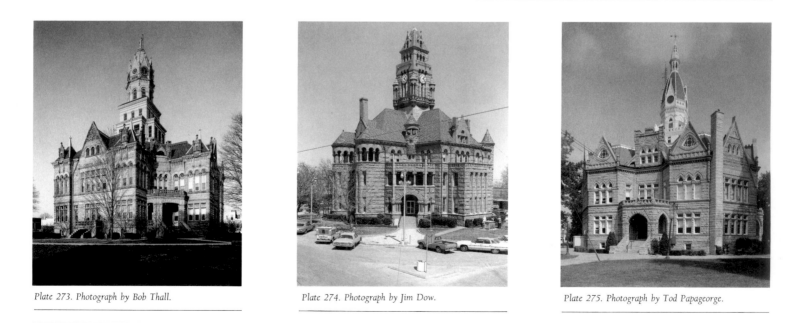

Plate 273. Photograph by Bob Thall. *Plate 274. Photograph by Jim Dow.* *Plate 275. Photograph by Tod Papageorge.*

Plate 273. Edgar County Court House, Paris, Illinois, 1891. Architect Henry Elliott. Plate 274. Wise County Court House, Decatur, Texas, c.1895–97. Architect James Riely Gordon. Plate 275. Pike County Court House, Pittsfield, Illinois, 1894–95. Architect Henry Elliott.

porary facades along the lagoon at the Chicago Fair of 1893. However, the characteristic Richardsonian bichromy of light rock-faced walling and darker trim was maintained and, indeed, developed decoratively in the checkerboard design running across, below the eaves. Very characteristic of Gordon, who rarely varied the plans of his court houses, are the arched quadrantal entrance porches flanking the front wings, while the plastic organization of the open belfry in the central lantern is in a sturdy vein not unworthy of Richardson's own work and certainly highly original.

Henry Elliott reflected new ideas less successfully than Gordon in his Pike County Court House in Pittsfield, Illinois, built in 1894-95 (Plate 275). Rather, this court house, for all the symmetry of its complex massing, still recalls the '70s in its use at this late date of pointed arches and a pointed dome atop the central tower that echoes again Richard M. Upjohn's Gothic one on the Connecticut state capitol.

W. C. Dodson continued to be an even more prolific builder of Texas court houses than his former pupil J. Riely Gordon, but he never mastered to the same degree the Richardsonian. Of the eighteen Texas court houses for which he was responsible, one of the largest, costing between $100,000 and $150,000, is that of Denton County at Denton, which was built as late as 1895-97 (Plate 120). The ungainly organization of the mass, with inset porches at the front corners, pedimented porticos on axes above all the facades and a tremendous domed lantern, rivals in its size and elaboration those on the Texas court houses of the previous decades. It shows little or no comprehension, however, of either the Richardsonian or the rising Academic reaction as propagated nationally by the Chicago World's Fair two years before it was begun.

Gordon's contemporary court house of comparable cost for Ellis County at Waxahachie, Texas, of 1894-97 is by contrast one of the most interesting and literate of all the Richardsonian court houses (Plate 272). The familiar elements—rock-faced granite walling, varied with somewhat darker trim, checkerboard patterns and, of course, innumerable round arches of various shapes and sizes contrasting with linteled galleries—are put together skillfully to form a complex mass composition, at once unified as a whole and varied in the combination peculiar to Gordon of rounded and rectangular plan elements. On top, the lantern over the crossing uses the

Richardsonian detail profusely yet is quite independent of Richardson's own more smoothly tapered towers. Gordon's Wise County Court House at Decatur, Texas, completed in the same year, 1897, and for about the same cost is almost identical (Plate 274).

More original is the modest court house for Johnson County in Warrensburg, Missouri, built by George E. McDonald in 1896-97 for about a third the cost of Gordon's in Texas (Plate 278). The Richardsonian influence here is restricted to the rock-faced masonry and a few arches, but the symmetry of the composition, broken only in some of the subordinate window spacing, is almost academic though quite without Italian Renaissance detailing. On the contrary, the stepped gable in the center of the side elevation and the S-curved roofs of the corner towers suggest the Renaissance of northern Europe. If these features are original and not later additions, McDonald's choice of eclectic stylistic sources was exceptionally wide.

The Indiana court house of Jasper County at Rensselaer of 1896-98 is not dissimilar in spirit, and is even more symmetrically ordered (Plate 281). But the detailing of the front dormers, at the portal and on the tower, is Late Gothic, while nothing is specifically Richardsonian except the rock-faced masonry, here monochromatic, and perhaps the transomed windows. The architects were Alfred Grindle and Charles R. Weatherhogg from Fort Wayne, not exactly metropolitan architects, yet clearly more professionally trained than any of those practicing in Texas except Gordon. The orderliness of their facades is up-to-date for the late '90s, but there is no reflection of the new Renaissance mode in the detailing.

The elderly Texas architect W. C. Dodson, practicing now as Dodson & Dudley in Waco, could only echo rather clumsily Gordon's Richardsonian court houses in Texas when he built that for Coryell County at Gatesville (Plate 279). Though he had only some $70,000 to spend, he included a quite un-Richardsonian porch with four Corinthian columns and a pediment, still much in the spirit of the very belated Grecian court houses of the '60s and '70s. The dates of this are 1897-98.

A similar but less interesting court house of the same years, 1897-98, is that for Starke County at Knox, Indiana (Plate 1).

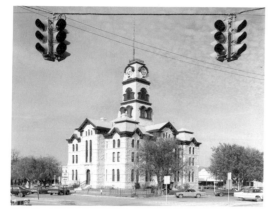

Plate 276. Photograph by Jim Dow.

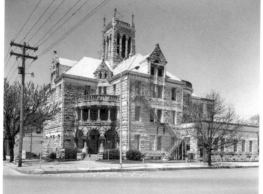

Plate 277. Photograph by Jim Dow.

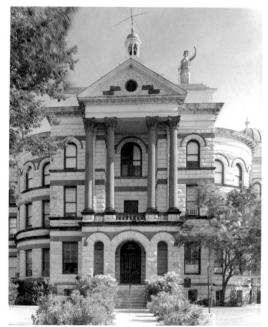

Plate 278. Photograph by William Clift.

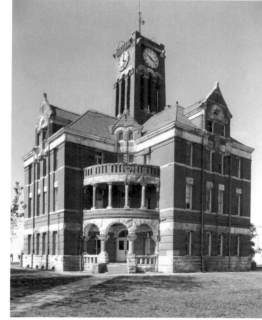

Plate 279. Photograph by Geoff Winningham.

Plate 280. Photograph by Jim Dow.

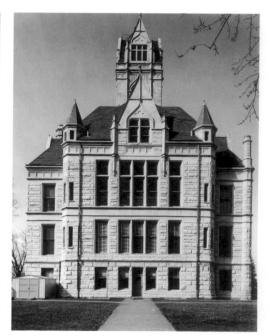

Plate 281. Photograph by Bob Thall.

Plate 276. Hood County Court House, Granbury, Texas, c.1889–91. Architect W. C. Dodson. Plate 277. Comal County Court House, New Braunfels, Texas, 1898 with later alteration and addition. Architect James Riely Gordon. Plate 278. Side elevation, Johnson County Court House, Warrensburg, Missouri, 1896–97. Architect George M. Anderson. Plate 279. Coryell County Court House, Gatesville, Texas, 1897–98. Architect W. C. Dodson. Plate 280. Lee County Court House, Giddings, Texas, 1898–99. Architect James Riely Gordon. Plate 281. Side elevation, Jasper County Court House, Rensselaer, Indiana, 1896–98. Architects Alfred Grindle and Charles R. Weatherhogg.

The architects of this, Wing & Mahurin, a Fort Wayne firm, combine Late Gothic detailing here with Richardsonian rock-faced masonry, as they did on their Hancock County Court House. That was completed in the same year, 1898, but must surely have been begun a year or two earlier.

Although Gordon's personal kind of Texas Richardsonian did not develop much, he still maintained his standards in the court house he built—at the bargain price for the period of around $37,000—for Comal County at New Braunfels in 1898 (Plate 277). The plan is the same he had been using for some time, but the detailing is less elaborate and

the rock-faced masonry monochromatic. He seems to have saved money here particularly on the extremely modest square lantern. His Lee County Court House at Giddings, Texas, 1898-99, was also built at a bargain price: $35,493 (Plate 280). The plan and design is the same he had been using for some years, though the walling is of brick rather than rock-faced stone.

Just as the new century began, 1900-01, Samuel Hannaford of Cincinnati built for some $150,000 the Greene County Court House at Xenia, Ohio, with rock-faced walling and many arched windows (Plate 282). This example of the ulti-

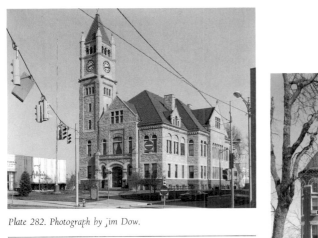

Plate 282. Photograph by Jim Dow.

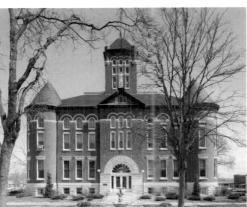

Plate 283. Photograph by William Clift.

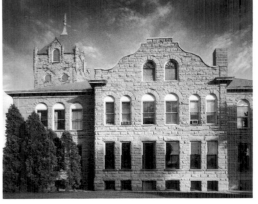

Plate 284. Photograph by William Clift.

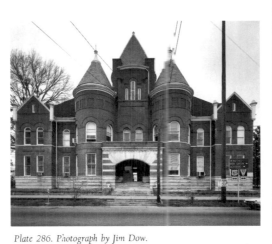

Plate 286. Photograph by Jim Dow.

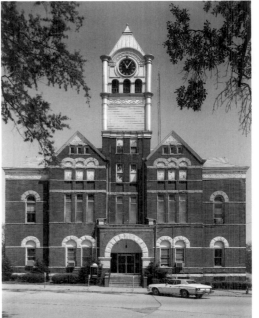

Plate 287. Photograph by Jim Dow.

Plate 285. Photograph by Jim Dow.

Plate 282. *Greene County Court House, Xenia, Ohio, 1900–01. Architect Samuel Hannaford.* Plate 283. *Anderson County Court House, Garnett, Kansas, 1901–02. Architect George P. Washburn.* Plate 284. *Huerfano County Court House, Walsenburg, Colorado, 1904. Architect C. A. Henderson.* Plate 285. *Bradford County Court House, Starke, Florida, 1902. Architect unknown.* Plate 286. *Jefferson County Court House, Fayette, Mississippi, 1902. Builders Andrew J. Bryan & Co.* Plate 287. *Henry County Court House, McDonough, Georgia, 1897. Architects Golucke & Stewart.*

mate degradation of the Richardsonian court house is quite unrelated to the inspiration Sullivan and Wright had been finding in Richardson's work since the '80s. Hannaford still used, for example, on this court house a prominent tower above one corner. Such a dominating asymmetrical feature goes back to mid-century, but it is one those inspired by Richardson often maintained as he had done on his Albany City Hall of 1881. But more characteristic of the latest and most dilute Richardsonian is the symmetry of the court house the Kansas state architect George P. Washburn built, among other Kansas court houses, for Anderson County at Garnett (*Plate 283*). The round-corner towers and the broad

low entrance arches are obviously Richardsonian and the pediment, even though that seems of a rather different inspiration, had already been used by Richardson himself on Sever Hall at Harvard in the late '70s.

Considerably more interesting and even up-to-date is the Jefferson County Court House at Fayette, Mississippi (*Plate 286*). This cost only $23,000; the fact that the builders —who presumably also provided the design—Andrew J. Bryan & Co., went broke may well explain a certain penury in the detailing. But the broad segmental arch at the entrance is a rather original variant of the more usual Richardsonian

Plate 288. *Cumberland County Court House, Crossville, Tennessee, 1905. Architect unknown. Photograph by Tod Papageorge.*

entrance; and the composition builds up most effectively from the flanking gables to the two round turrets and the central lantern. Except for the entrance arch, this is carried out entirely in brick like Richardson's Sever Hall or his late New London Railroad Station in Connecticut. The Jefferson County Court House was built in 1902 as was the cheaper —$12,500—and considerably less original one for Bradford County, in Starke, Florida (*Plate 285*).

In general, however, the Richardsonian influence in the early years of this century became feebler and feebler, particularly in more remote areas. The Huerfano County Court House in the Far West in Walsenburg, Colorado, shows little more of the Richardsonian vocabulary than the rock-faced walls and a few plain round arches (*Plate 284*). This was built in 1904 for only $35,000 by C. A. Henderson of Pueblo. The very modest court house erected in 1905 for Cumberland County at Crossville, Tennessee, for $23,000, is much simpler

but more original in design (*Plate 288*). The big ground-story arches at the entrance are paired, the windows above paired and linteled, and the masonry smooth. Considering the prominence of the stepped gable, perhaps this should not be considered Richardsonian at all. As with the very belated Grecian court houses of the 1870s, the current of Richardsonian design which swept the country—and not least court-house architecture—in the '90s had finally receded.

In a very broad sense the Richardsonian, especially as used for court houses, can be considered a terminal phase of Romantic Eclecticism, which had already begun in the 1850s to drastically modify court-house design as in the last years of the Greek Revival. This Richardsonian mode was at last coming to an end. In the later decades of the nineteenth century there was a similar reaction, but in the opposite direction. Starting as early as the late 1870s, there was what can be described as a "return to order," not least evident in much of Richardson's most mature work—from Sever Hall at Harvard in the late '70s to the Marshall Field Wholesale Store in Chicago at the end of his life. That this was significant as regards his Allegheny County Court House in Pittsburgh has already been noted, particularly the symmetry of its design. Moreover, his avoidance of the picturesque there—on the court house, if not the jail—was often emulated by his many imitators in their own court houses.

George B. Post introduced Italian Renaissance arcading, at first not too dissimilar to the Richardsonian sort, in the mid-'70s as well as the High Renaissance dome; the one at the Long Island Historical Society's building in Brooklyn and the other, also in Brooklyn, over the Williamsburgh Savings Bank. In the '80s the New York firm of McKim, Mead & White, two of them former assistants of Richardson, promoted a more archaeological Renaissance Revival, soon paralleled by a Colonial or Georgian Revival. Binding together these late revivals was the Academic doctrine of the French Ecole des Beaux-Arts, where Hunt, Richardson and McKim were followed by an increasing number of American students of the next generation. To subsume these linked disciplines under a single stylistic label has always been difficult, even though the men who first accepted them had no qualms about mixing the stylistic genres and usually considered the whole amalgam a return to the supposedly "Classical" architecture of the first half of the nineteenth century, if not that of the late eighteenth century.

The return to order—to use a phrase broad enough to include the early skyscrapers of Sullivan and even the first houses of Wright, the major American works of the years around 1900—never gave to court-house design in the '90s and the early years of the new century the readily recognizable sort of monumental character that American architects from the Grecian of the '30s and '40s to the Richardsonian, even down into this period, so often achieved.

Plate 289. Brooks County Court House, Quitman, Georgia, 1859 with later additions. Architect John Wind. Photograph by Jim Dow.

The earliest example, specifically, of the new sort of Italian Renaissance influence on American architecture found at a court house is in the one for Brooks County at Quitman, Georgia; this was remodeled in 1882, the date inscribed on the facade (*Plate 289*). This court house had first been built in 1859 by John Wind for some $15,000. On the 1882 remodeling another firm of architects, Bruce & Morgan, spent almost $13,000, so that the exterior today is largely their work. The pilasters at the corners of the main rectangular block are doubtless of 1859, but the original entablature of that period was evidently flattened in the remodeling and an attic story added above it. Other than the somewhat ambiguous window treatment, very likely inherited in the main stories, the one unmistakable Renaissance note is the delicate garland—so reduced in scale by contrasts to that of the pair of broad, low arches below—in the frieze. The frieze is continued across the front projection, doubtless entirely a new addition. For 1882, the year the first Italian Renaissance work of McKim, Mead & White, the Villard Houses in

New York, was commissioned, this facade is an extraordinary creation. The pair of arches at the base are still Richardsonian in their proportions, even though Academic in the detailing of the broad archivolts; but the paired windows above, with the small panes typical of contemporary Queen Anne domestic architecture, are crowned by bold yet delicately detailed pediments carried on Renaissance scrolled members that are very remote from the ungainly brackets of the mid-century. The scrolled modillions of the cornice above the garlanded frieze are similar, while the lunette in the pediment, with its smoothly rusticated voussoirs scaled to the flat quoins on the corners, is almost Colonial Revival in character.

Plate 290. Tuscarawas County Court House, New Philadelphia, Ohio, 1882–85. Architect Thomas Boyd. Photograph by William Clift.

Equally remarkable for the date, but entirely different, is the big court house begun by Thomas Boyd for Tuscarawas County at New Philadelphia, Ohio, also in 1882, which was completed in 1885 (*Plate 290*). Like the St. Louis City Court House of a generation earlier, this is designed more

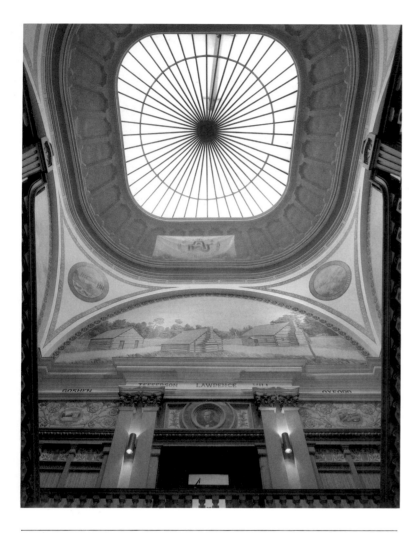

Plate 291. Tuscarawas County Court House, New Philadelphia, Ohio, 1882–85. Architect. Thomas Boyd. Photograph by William Clift.

Plate 292. Todd County Court House, Long Prairie, Minnesota, 1883 with later additions. Architects P. J. Pauley Jail Outfitters. Photograph by Lewis Kostiner.

like a state capitol than an ordinary county court house. With its pedimented Classical porticos on all four sides below an over-scaled dome, it seems a return to the Classical, if not the Greek, Revival of an earlier generation. The detailing is correctly Academic, with none of the solecisms of the mid-century; yet the dome—square in plan with rounded corners—is a modification of a standard feature owing nothing in this case to Walter's dome in Washington. Up to this period court houses rarely had interiors of much architectural interest; now in those that were of state-capitol size and pretention they were often introduced. Here at New Philadelphia the great square chamber below the dome, so like the rotundas in state capitols, is exceptional with its warped pendentives over lunettes filled with murals and the broad skylight above. (Plate 291).

In 1883, while the court house at New Philadelphia in Ohio was in construction, a court house for Todd County of transitional design rose in Long Prairie, Minnesota (Plate 292). The architects were the P. J. Pauly firm of jail outfitters, hardly the sort of practitioners one could have supposed likely to be well informed concerning projects then current in New York. Yet, for all the relative simplicity of the design of this, the symmetrical massing dominated by four pediments and the distinct modulation of the character of the groups of arched windows away from the Richardsonian and toward the Italian Renaissance is the more notable when one recalls that the Allegheny Court House was not yet begun and the Villard Houses in New York still in construction. Unfortunately, despite a fine raised site, the intrinsic quality of the work is not up to its historic importance when compared to the more conventional and vastly more expensive Ohio court house, which was still rising, or even to the one in Georgia as remodeled the year before.

Of a wholly different order is the Vanderburgh County Court House in Evansville, Indiana (Plate 293). Evansville has one of the very few High Victorian Gothic federal buildings which were designed by W. A. Potter in his brief tenure as Supervising Architect of the Treasury in the mid-'70s. Whether or not the authorities were out to rival that when they spent over $400,000 on this court house in the late '80s—it was not completed until 1891—they certainly obtained from the architect, Henry Wolters of Louisville, one of the most extravagant urban piles of the last decades of this century. "Return to Order" is hardly the phrase for a com-

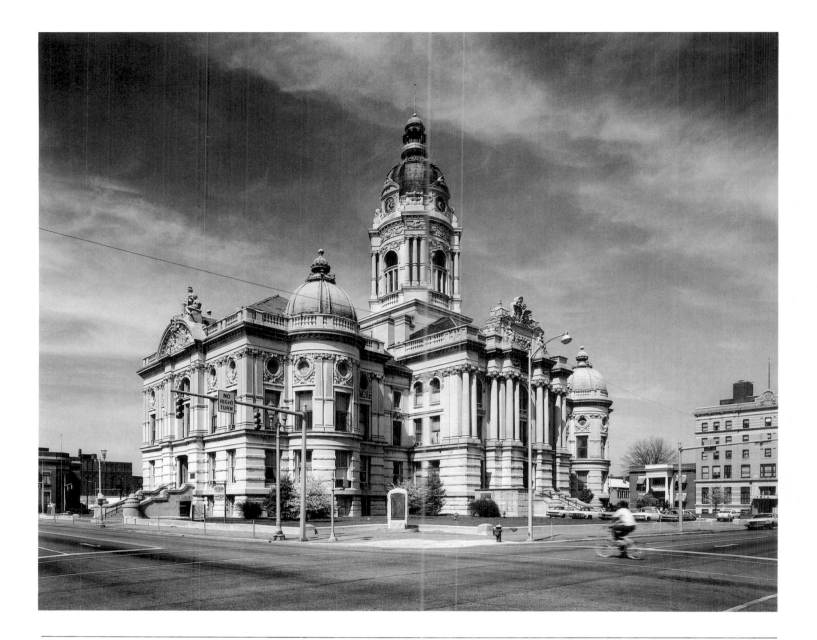

Plate 293. *Vanderburgh County Court House, Evansville, Indiana, c.1887–91. Architect Henry Wolters. Photograph by William Clift.*

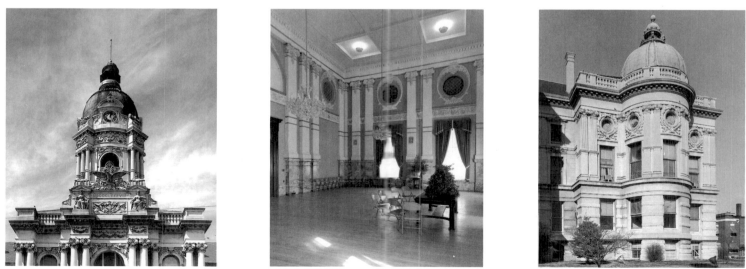

Plate 294. *Photograph by William Clift.*

Plate 295. *Photograph by Lewis Kostiner.*

Plate 296. *Photograph by Lewis Kostiner.*

Plates 294–296. *Details, Vanderburgh County Court House, Indiana.*

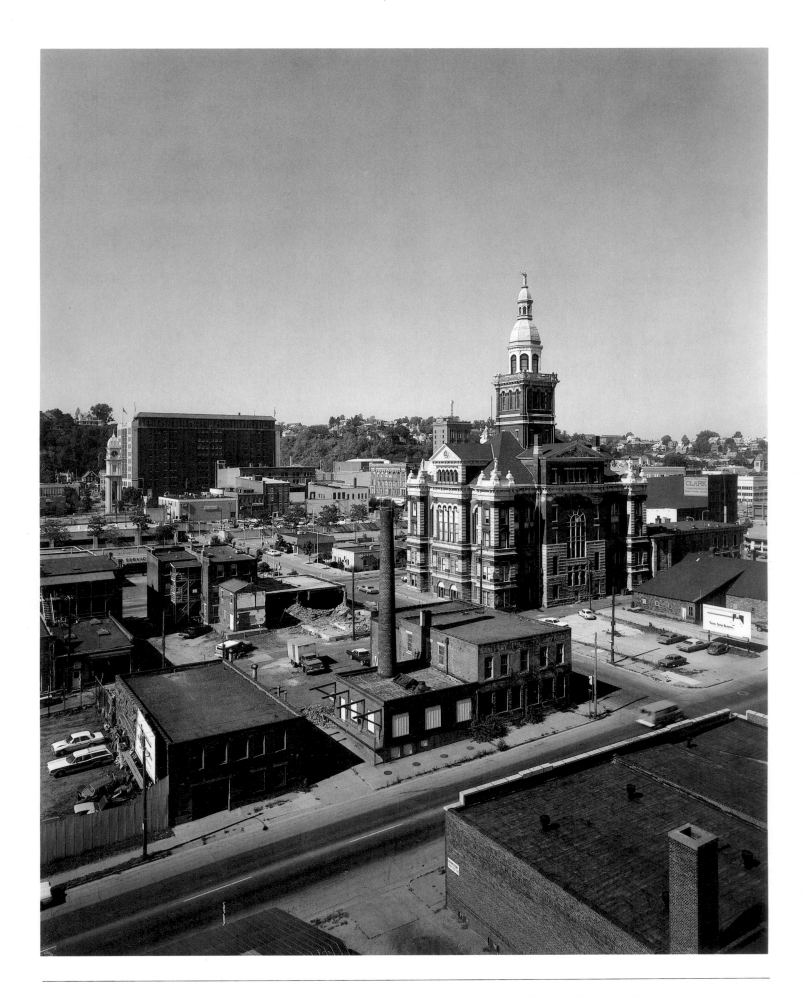

Plate 297. Dubuque County Court House, Dubuque, Iowa, c.1890–93. Architects Fridolin Heer & Son. Photograph by Bob Thall.

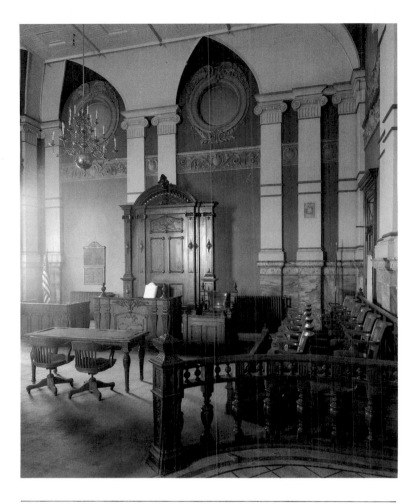

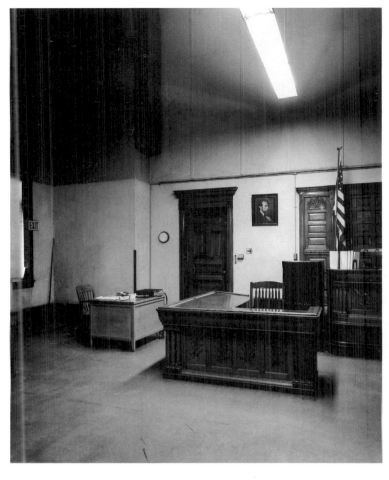

Plate 298. Vanderburgh County Court House, Evansville, Indiana, c.1887–91. Architect Henry Wolters. Photograph by William Clift.

Plate 299. Dubuque County Court House, Dubuque, Iowa, c.1890–93. Architects Fridolin Heer & Son. Photograph by Bob Thall.

plexity of massing that had rarely been equaled even in the post-Civil War decades and a profusion of prominent individual features, from rounded bays capped with domelets to porticos loaded with clusters of columns and a tall central lantern equally loaded with attached columns over the whole. This is neither Renaissance Revival nor Neo-Colonial; it is what Americans, justly or unjustly, think of as "Beaux-Arts," though it is unlikely that Wolters had studied in Paris. For this major work, however, he could well have employed one of the young men who were then returning from the Paris Ecole. Although such architects had been especially trained there to design public buildings, they could hardly hope as yet to obtain important commissions themselves from provincial county authorities.

When the Evansville court house was completed in 1891 the designing of the Classical facades of the Chicago World's Fair had not begun, though McKim, Mead & White in that year offered a very sophisticated version of eclectic Academic design in the winning competition project for the Rhode

Island State Capitol, which was begun only four years later. But what Wolters built in the early '90s was really unique, if premonitory of what was coming around 1900.

The Dubuque County Court House in another good-sized Middle Western city, Dubuque, Iowa, completed two years later than Wolters's in 1893, was neither as grand nor as expensive—under $180,000 (Plate 297). The local architects, the two Fridolin Heers, father and son, were of German origin, although that did not influence their design. The elements are all familiar and there is none of the new, almost Baroque, exuberance of that at Evansville in the mixture of faintly Richardsonian and loosely Classical features below a square lantern topped with a traditional, but hardly Neo-Colonial, cupola.

Unrelated to these grand, if provincial, urban structures is the modest court house dated 1891 for Rhea County in Dayton, Tennessee (Plate 300). Here, as at Dedham, Massachusetts, the primary interest is historical and not architec-

229

Plate 300. Rhea County Court House, Dayton, Tennessee, 1891. Architects W. Chamberlain & Co. Photograph by Geoff Winningham.

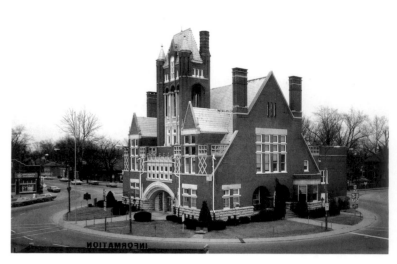

Plate 301. Nelson County Court House, Bardstown, Kentucky, 1891–92. Architects Maury & Dodd. Photograph by Lewis Baltz.

tural, for this was the scene of the so-called "Monkey Trial" at which, in 1925, Clarence Darrow for the defense was pitted against William Jennings Bryan as prosecutor. But, if the trial indicates in what a primitive region Rhea County lay, the court house, built in 1891 by W. Chamberlain & Co. from Knoxville, is the only one that at all reflects in these years of the early '90s Louis Sullivan's great contributions to skyscraper design in St. Louis, Chicago and Buffalo. The Dayton court house is no skyscraper, but in the organization of the facade the long-established formula of squarish block and corner tower is handled with exceptional elegance and restraint. The arches in the ground story and on the lantern are no longer Richardsonian, nor yet Renaissance, and only the small panes used in the windows suggest at all the Neo-Colonial.

Similarly original among court houses of the '90s is the one for Nelson County in Bardstown, Kentucky, of 1891-92 (*Plate 301*). With only $33,000, the architects, Maury & Dodd, produced a somewhat more elaborate design that includes

a vigorously Richardsonian segmental arch at the entrance and corner turrets on the tower above. But, for all of the French Early Renaissance flavor of the two dormers on the front, the large window areas are in the main non-stylistic. Certainly there is no echo yet of the Academic Classicism Burnham and his associates were introducing along the lagoon at the World's Fair at precisely this point, much less the new Italian Renaissance and Colonial Revival alternatives of the day which were already favored in the Northeastern cities.

In the Northwest, however, there is the big and expensive court house—it cost $273,000—for Spokane County in Spokane, Washington, of 1894-95, which reflects one of the metropolitan modes (*Plate 303*). Willis A. Ritchie obtained the commission in a competition with a design altogether exceptional for the profusion and the accurate execution of its Early French Renaissance detail. That mode had been introduced in the East for use on millionaires' mansions in the late '70s, but it was never much employed for public buildings, perhaps because it seemed to require a profusion of carved stone detail. The round corner towers seem little more than a variant of the Richardsonian ones of the day and the tall central tower is even more a descendant of Richardson's in Pittsburgh begun ten years before. In its picturesque massing, with emphasis on the tall tower at the center and on the lower towers on the corners of the two side blocks, the rather spectacular Spokane court house is linked to the still completely Richardsonian court houses of J. Riely Gordon in Texas of the mid- and late '90s.

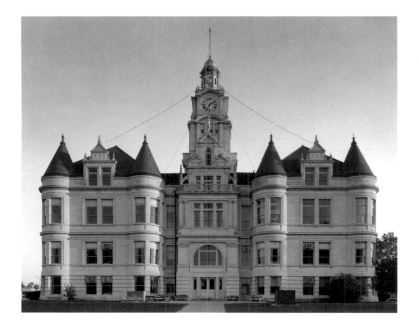

Plate 302. *Dallas County Court House, Adel, Iowa, 1902. Architects Proudfoot & Bird. Photograph by Bob Thall.*

Plate 303. *Spokane County Court House, Spokane, Washington, 1894–95. Architect Willis A. Ritchie. Photograph by Lewis Kostiner.*

Of the more archaeological Renaissance sources first drawn on in the East some fifteen years before, the Italian ones were generally more influential than the French, and Eastern architects were soon employing Italian Renaissance design for court houses.

In the post-Civil War decades Andrew Jackson Warner had dominated the architectural scene in Rochester, New York. By the early '90s his son, J. Foster Warner, had succeeded him and continued as the principal local designer into the 1920s. In 1905 he collaborated with McKim, Mead & White on the big house for George Eastman, the Kodak magnate. A decade earlier, his Monroe County Court House of 1894-96 illustrated how well he already understood that leading Eastern firm's sort of Renaissance Revival design (*Plate 304*). The great cornice, at once bold and chaste, recalls that on the Boston Public Library, just completed, and the proportions of the block are those of a Roman palazzo of the Renaissance, like their Villard Houses in New York, while the grouping of the arched openings, with the rhythm doubled in the top story, echoes theirs on the skyscrapers they began for the New York Life Insurance Company in 1888 at Omaha and at Kansas City in the Middle West.

The great feature of Warner's court house is the interior court with its Italian Renaissance arcading executed mostly in marble. The arcades are crowned by an attic filled with

Plate 304. *Monroe County Court House, Rochester, New York, 1894–96. Architect J. Foster Warner. Photograph by Patrick Linehan.*

Plate 305. Placer County Court House, Auburn, California, 1894–98. Architect John M. Curtis. Photograph by Pirkle Jones.

Plate 306. Kings County Court House, Hanford, California, 1896. Architect W. H. Willcox. Photograph by Pirkle Jones.

extremely elaborate—and less correctly Italian—plaster decoration. In the absence of court houses by the leading New York architects of the day, this can serve as their surrogate (*Plate 121*).

The Monroe County Court House in Rochester has no tower, nor even a lantern. The big court house for Placer County rising above Auburn, California, which was built for some $174,000 over the next four years—1894-98—by John M. Curtis, on the other hand, carries above a cruciform mass a colonnaded dome descending from Walter's on the national Capitol in Washington (*Plate 305*). Curtis had been the partner of Albert A. Bennett, who completed the California state capitol at Sacramento with its great dome, already based on Walter's, in 1874. Together and alone they both built various court houses and Glenn County had a dome, now demolished, just like the one at Auburn.

The materials used at Auburn, a light-brownish brick with the trim of terra-cotta, suggest the period of construction, for they reflect the general turn toward lighter tones in the '80s and '90s after the strong colors favored during the post-Civil War decades. The Monroe County Court House is also light-colored but all of ashlar masonry.

Another California court house, the one in Kings County at Hanford, which cost only a bit over $26,000—a seventh of that at Auburn—was designed in 1896 by W. H. Willcox (*Plate 306*). Willcox clearly had no idea of Colonial detail,

Eastern or Western, yet his remote model may, perhaps, have been eighteenth-century American rather than Italian Renaissance. Actually his detailing is, more likely, merely very laggard, as is often the case throughout the nineteenth century in California.

California had its own colonial past and there was less sentimental appeal in imitations of the Georgian sort of Colonial than there was in the East or the South. In the larger cities of the Middle West, moreover, a more Classical sort of Academic design, emulating the colonnaded facades of the Chicago Fair, was preferred both to the current Italian Renaissance and the Colonial Revival modes because of its monumentality and its assumed suitability for very big structures. When Brentwood S. Tolan, the son of Thomas J. Tolan, that leading Indiana court-house architect of the post-Civil War decades, designed the Allen County Court House in Fort Wayne, Indiana, in 1897, he drew little from his experience, first with his father and then on his own, with earlier Indiana court houses (*Plate 307*). One may well believe he drew more on the young draftsmen returning from Paris, who were readily finding employment with established firms in the big cities, and in those offices detailed the grandiose new projects in a near-Beaux-Arts manner. The crowning dome on this vast capitol-like structure at Fort Wayne does not follow the long popular Washington model. Rather, the four domelets at the corners in the clock stage seem to reflect already that of McKim, Mead & White's dome on the Rhode Island capitol, which was completed only in 1898,

232

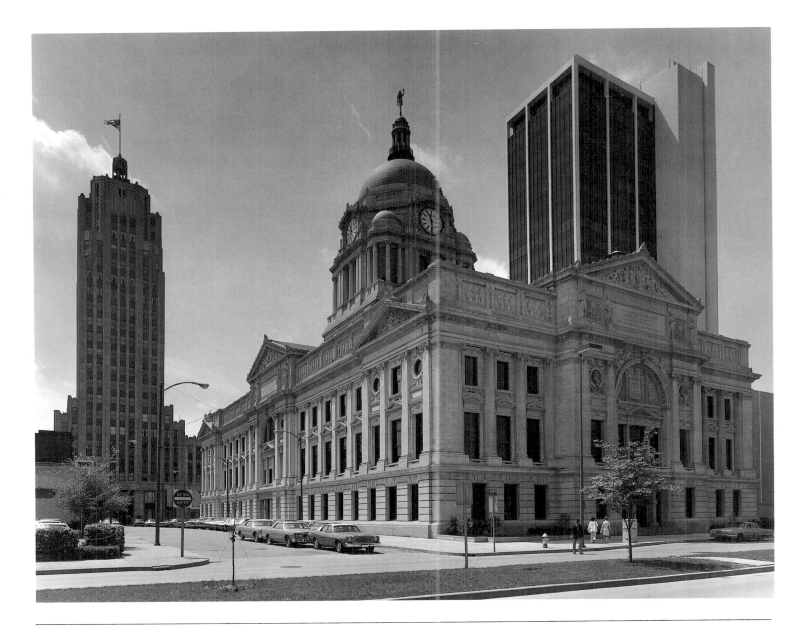

Plate 307. Allen County Court House, Fort Wayne, Indiana, 1897–1902. Architect Brentwood S. Tolan. Photograph by Lewis Kostiner.

Plate 308. Detail of polychrome tile on rotunda floor, Allen County Court House, Indiana. Photograph by Lewis Kostiner.

Plate 309. Detail of rotunda, Allen County Court House, Indiana. Photograph by Lewis Kostiner.

Plate 310. Photograph by Stephen Shore.

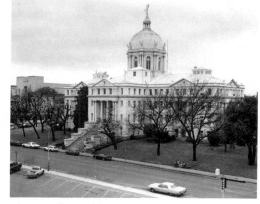

Plate 311. Photograph by Jim Dow.

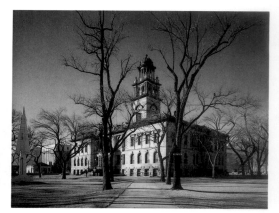

Plate 312. Photograph by William Clift.

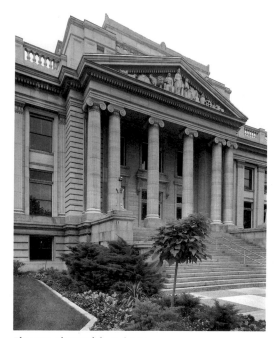

Plate 313. Photograph by Tod Papageorge.

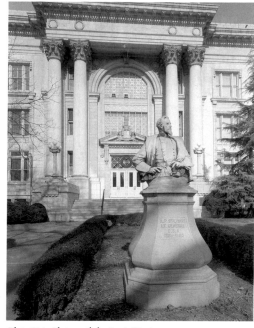

Plate 314. Photograph by Lewis Kostiner.

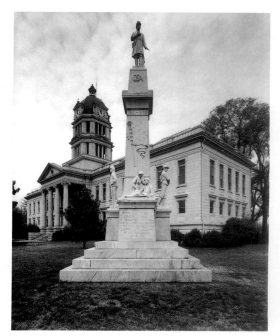

Plate 315. Photograph by Jim Dow.

Plate 310. *Decatur County Court House, Bainbridge, Georgia, 1902. Architect Alexander Blair. Plate 311. McLennan County Court House, Waco, Texas, 1900–02. Architect James Riely Gordon. Plate 312. El Paso County Court House, Colorado Springs, Colorado, 1903. Architect A. J. Smith. Plate 313. Utah County Court House, Provo, Utah, 1899. Architect Joseph Nelson. Plate 314. Hamilton County Court House, Chattanooga, Tennessee, 1913. Architect R. H. Hunt. Plate 315. Leflore County Court House, Greenwood, Mississippi, 1903–05 with later additions. Architect R. H. Hunt.*

though their project had been known since the beginning of the decade. Otherwise, this Fort Wayne court house is a heavy-handed descendant of the facades at the World's Fair of 1893 but massive and aggressive in an almost totalitarian way.

With the financial panic of 1893, building in general, and more particularly the erection of monumental court houses in the spirit of the White City in Chicago, dropped off to revive only toward 1900. But those depression years gave architects a chance to digest and mature the new Academic mode with the help of their increasingly well-trained assistants.

The Utah County Court House at Provo, Utah, was built in 1899, two years later than the one at Fort Wayne was begun (*Plate 313*). The architect, Joseph Nelson, handled his Classical elements with a finesse approaching that of McKim, Mead & White and produced one of the most correct of contemporary Academic structures. There is an almost eighteenth-century justness of scale in Nelson's detailing which is more European than Neo-Colonial.

Now J. Riely Gordon in Texas, still building competently designed Richardsonian court houses in the late '90s, turned to the new mode in the McLennan County Court House at Waco (*Plate 311*). Even more capitol-like than the Fort Wayne

court house, thanks to its more articulated cruciform massing, this lacks the rather international elegance of the one at Provo but avoids the ponderousness of the other, which it approaches in size, if not in scale. The Waco court house was built in 1900-02 at a cost of nearly $200,000.

More regional in character is a rather modest Southern court house of these years, that of Decatur County at Bainbridge, Georgia, erected in 1902 by Alexander Blair for $32,500 (*Plate 310*). In one major respect this is quite retardataire since the tall clock-tower rises at the corner of the quadrangular composition with a raised portico to the right and only a much lower balustrade-crowned tower to the left. But in other respects it is for the time, the opening of this century, quite up-to-date and in a Neo-Colonial rather than a Classical vein. Red brick walls with a profusion of white trim of a loosely Georgian order—in a sense both geographically and stylistically Georgian—had returned to favor as had already been true for a decade and more in domestic architecture.

Although better known for his Gothic Woolworth Building than for such major Academic work as the Minnesota Capitol and the New York Customhouse, Cass Gilbert was, after McKim, Mead & White, one of the leading practitioners nationally in the early twentieth century. Considering his predilection for murals and sculpture, it was fortunate that the Essex County authorities in New Jersey allowed him $41,000 for paintings and $56,000 for sculpture out of the nearly $2 million being spent on their court house at Newark in 1902-07 (*Plate 316*). In the rotunda the characteristic opulence of Cass Gilbert's architecture is generously served by E. H. Blashfield's painted pendentives under the central dome, while Gutzon Borglum's Lincoln of 1911 stands in front.

The Newark court house is no more typical than other earlier big-city examples of court-house design, even in the first decade of our century, beginning with the one of the mid-nineteenth century in St. Louis. But comparable aspirations led to the erection of increasingly large and monumental structures throughout the nation.

The El Paso County Court House in Colorado Springs rose in a resort largely settled by Easterners (*Plate 312*). Built by A. J. Smith in 1903, this is, after Warner's Rochester county

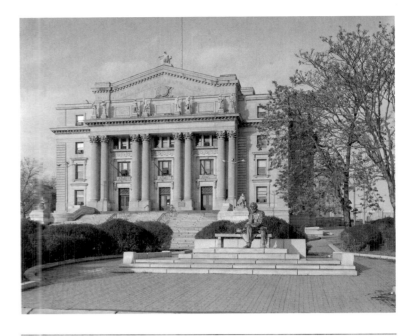

Plate 316. Essex County Court House, Newark, New Jersey, 1902–07. Architect Cass Gilbert. Photograph by Richard Pare.

court house of a decade earlier, the most competent of Neo-Renaissance court houses, both in the proportions of its major elements and the McKim, Mead & White-like assurance of the detailing.

Smith, indeed, was more accomplished at Academic design than Richard Howland Hunt, the son and successor of R. M. Hunt, the leading New York architect of the third quarter of the nineteenth century, in his Leflore County Court House in Greenwood, Mississippi, designed in 1903 and completed in 1905 (*Plate 314*). Such design was no longer the exclusive specialty of such metropolitan leaders as Gilbert, but something that could be effectively learned in American schools of architecture as well as in Paris, where more and more of the young were still going for postgraduate training. Hunt, like his father, had studied in Paris, but he and his brother Joseph—not involved at Greenwood—profited less than many others from their foreign training and their professional inheritance. Ten years later he worked not from New York but from an office in Chattanooga, Tennessee, when he built the Hamilton County Court House there (*Plate 315*). This Chattanooga court house is no more an example of correct Academic design than that for Leflore County.

The greatest court houses of Indiana are those of the post-Civil War years by the elder Tolan and his contemporaries. But the younger Tolan's gargantuan Fort Wayne court house

235

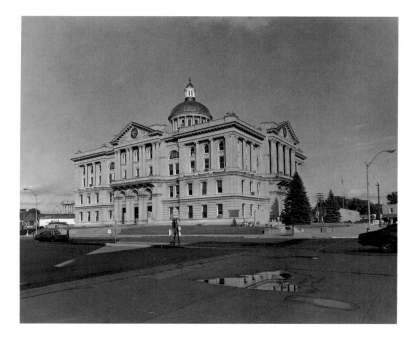

Plate 317. Huntington County Court House, Huntington, Indiana, 1904–06. Architect J. W. Gaddis. Photograph by Lewis Kostiner.

was easily rivaled within a year or two after its completion by the Huntington County Court House in Huntington of 1904-06 (*Plate 317*). Moreover, the architect J. W. Gaddis rivaled Warner's court at Rochester and Gilbert's rotunda at Newark in the colored marbles and the mosaic pavement of his round central interior space. Externally the square block, with pedimented porticos on each of the four sides, is in the main a conventional Academic exercise. The coupling of the columns, however, suggests emulation of late seventeenth-century French and English models in contrast to the more Louis XVI restraint of the general treatment. Thus the new mode was gradually becoming rather eclectic in its use of post-Renaissance sources, paralleling to some extent the more Neo-Georgian aspects of the Colonial Revival.

In the South, however, the red brick with light-colored stone trim of the Colonial was often favored. The Morgan County Court House at Madison, Georgia, of 1905-06, is a case in point, though its exceptional plan, with wings bent back from the central Corinthian portico and the whole borne down by a tremendous and quite un-Colonial square-domed lantern, set it apart as provincial (*Plate 319*).

Quite different is another stone-built court house of 1907-08, that for Esmeralda County at Goldfield, Nevada (*Plate 321*). Neither architect nor builder is known but someone, perhaps the local authorities, determined on a plain square block with machicolations above the corners and a very

small stepped gable, doubtless intending to suggest by its rugged simplicity a frontier fort.

Thus, at one end of the scale, county courts in the remote counties of the Far West could be housed still with the near-vernacular simplicity of the earlier decades of the previous century while, at the other, in the cities a national scale of grandeur and monumentality was increasingly approached. James Gamble Rogers, although best known for his Gothic work at Yale, ranked nationally with Cass Gilbert in these years. In 1909 Shelby County obtained from him a court house erected in Memphis, Tennessee, which was almost a copy of Mills's Treasury Building in Washington of the 1830s on which $1.5 million was spent (*Plate 323*). Even the Greek Revival could be revived, as had happened a decade before this with the extension of the court house in Worcester, Massachusetts (*Plate 50*).

Perhaps because Beaux-Arts training at the fountainhead in Paris or in the new American architectural schools rarely led to any serious command of the Colonial Revival or, at best, confused pre-Revolutionary work with that of the succeeding Federal period, the Neo-Colonial work was less competently handled when used for court houses than were other sorts of Academic design. The Neo-Colonial was, moreover, until the 1920s used chiefly, if not solely, in the South.

For the design of the Cumberland County Court House in the Northeast at Portland, Maine, however, which replaced one of 1816 built by Charles Bulfinch already demolished as early as 1858, the local architect George Burnham had the assistance of a leading Boston professional, Guy Lowell (*Plate 320*). With $1 million to spend, they made do with no humble brick structure in a Neo-Colonial vein. Rather, their stone-built facade was a reduced version of A. J. Gabriel's on the Place de la Concorde in Paris with all the moldings and the orders carried out with great precision. Such accurate copying is hardly Beaux-Arts in spirit, but this chaste French Louis XVI mode was actually more popular in America in the early decades of the century than the parallel Georgian of the American colonies. This example was on the Eastern seaboard, where there were the best historical reasons for returning to colonial sources.

A Far Western court house, that of Washoe County in Reno, Nevada, followed in 1911 (*Plate 322*). In that state court

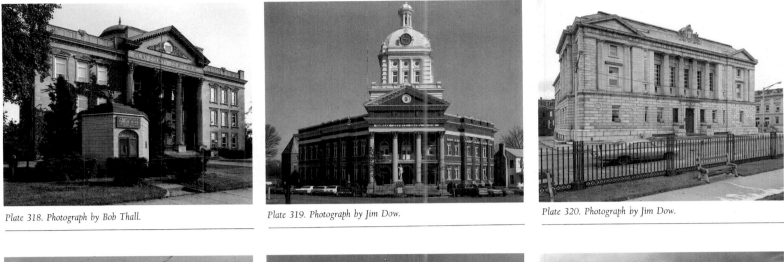

Plate 318. Photograph by Bob Thall.

Plate 319. Photograph by Jim Dow.

Plate 320. Photograph by Jim Dow.

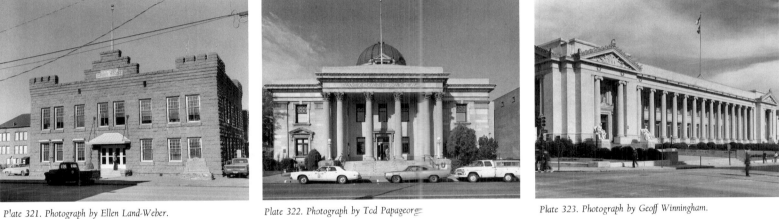

Plate 321. Photograph by Ellen Land-Weber.

Plate 322. Photograph by Ted Papageorge.

Plate 323. Photograph by Geoff Winningham.

Plate 318. Clay County Court House, Brazil, Indiana, 1912–14. Architect J. W. Gaddis. Plate 319. Morgan County Court House, Madison, Georgia, 1905–06. Architect J. W. Golucke. Plate 320. Cumberland County Court House, Portland, Maine, 1910. Architects George Burnham & Guy Lowell. Plate 321. Esmeralda County Court House, Goldfield, Nevada, 1907–08. Architect unknown. Plate 322. Washoe County Court House, Reno, Nevada, 1911. Architect Frederick J. DeLongchamps. Plate 323. Shelby County Court House, Memphis, Tennessee, 1909. Architect James Gamble Rogers.

houses could already be built without regard for cost, and at Reno the architect Frederick DeLongchamps had $250,000 to spend for the building, and a further $25,000 for furnishings, including—exceptional for a court house—murals painted by Robert Caples and Hans Mayer Kassel. The principal feature was the Academic portico at the center of the front with only a raking course above the cornice to reveal the plain hemispherical dome behind. Reno's court house was a good deal grander than the old State Capitol at Carson City.

Very similar to the Reno court house is an Indiana court house of this period, that of Hendricks County at Danville, completed in 1914 by Clarence Martindale for $225,000 (Plate 326). Here the principal feature is internal, not the less prominent central pedimented feature with two columns in antis. The rotunda here has a broad round stained-glass

ceiling, an elaborate element found in a number of Middle West court houses of these years. Even so, Indiana court houses were no longer what they used to be, fifty years before: monuments to Hoosier vigor with no regard for the negative restraints of Academic taste.

DeLongchamps followed his Reno court house with an exceptional structure completed in 1914 for Modoc County in Alturas, California (Plate 327). The plan is an irregular octagon and the portico across the full width of the broad front has eight Ionic columns of almost Grecian elegance. Above is a shallow Roman dome. The whole, surprisingly, cost less than $90,000—doubtless building costs were lower in California than in Nevada, or money flowed less freely.

Court houses were growing larger everywhere as county business increased. Though they were still designed pri-

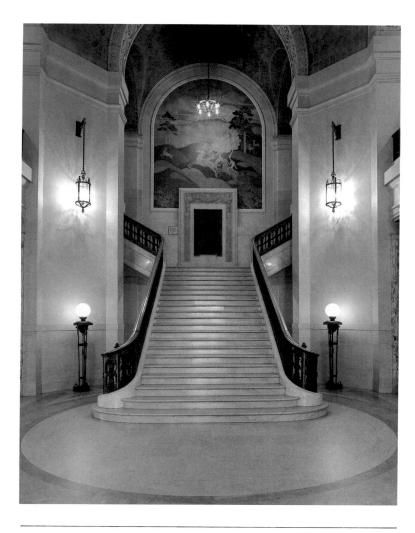

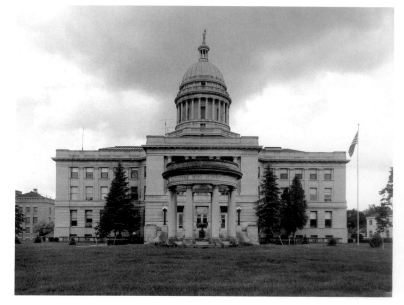

Plate 325. Cortland County Court House, Cortland, New York, 1922–24. Architect James Riely Gordon. Photograph by Patrick Linehan.

Plate 324. Stearns County Court House, St. Cloud, Minnesota, 1919–21. Architects Taltz, King & Day, Inc. Photograph by Lewis Kostiner.

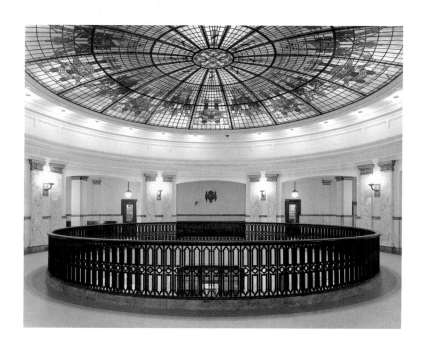

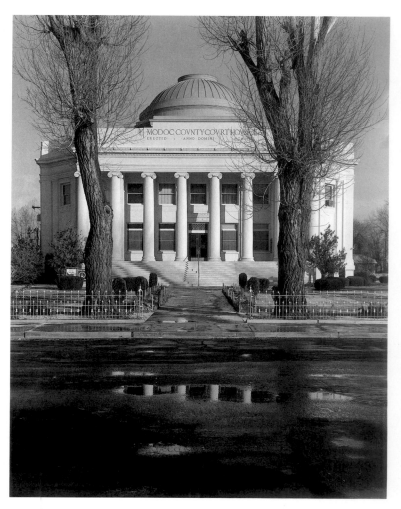

Plate 326. Hendricks County Court House, Danville, Indiana, c.1912–14. Architect Clarence Martindale. Photograph by Bob Thall.

Plate 327. Modoc County Court House, Alturas, California, 1914. Architect Frederick J. DeLongchamps. Photograph by Ellen Land-Weber.

Plate 328. Fulton County Court House, Atlanta, Georgia, 1914. Architects A. Ten Eyck Brown; Morgan & Dillon, Associated. Photograph by Stephen Shore.

marily as public monuments, not as office buildings, the emphasis was shifting. Always, court houses in cities had stood apart from those in more modest county seats. Now, in 1914, Ten Eyck Brown, in association with the firm of Morgan & Dillon, designed and built for Fulton County in Atlanta, Georgia, a nine-story office block (*Plate 328*). He retained, all the same, familiar Academic features, an inset portico of six Corinthian columns that runs through the third to the seventh stories and a pediment over the end.

The needs of a county office building were now beginning to distort the inherited monumental aspirations of county authorities. But the old ambitions did not die out in 1920 by any means. No less an architect than J. Riely Gordon was called north from Texas in 1922 to build an urban court house of the state-capitol type capped by a dome emulating the one in Washington. As with his court house at Waco, Texas twenty years earlier, there is no visible link with his series of Richardsonian court houses of the 1890s whatsoever, but he had never before had as much as $800,000 to spend.

Surprisingly the city, Cortland, New York, was not a large one, but it was the county seat of Cortland County (*Plate 325*).

The structure of Indiana limestone—so extensively used everywhere in these decades—replaced a modest brick one of about 1835. It reflected not only architectural ambition more than comparable to that of the Nevada county, which was beginning to serve a national clientele, but the practical need for increased office space, and did so perhaps as effectively as, and certainly more elegantly than, the tall Atlanta court house.

Stylistic lag, at least in relation to the accepted historical scenario of the period, had long been a characteristic of American court-house architecture. The situation had not changed around 1900. The Richardsonian, introduced for court-house design by Richardson himself at Pittsburgh in the mid-'80s, retained its popularity well into the new century. The "Academic Reaction," so to call it now, usually considered the successor to the Richardsonian, first affected court house design as early, even several years earlier than the Richardsonian. Well established as a preferred alternative to the Richardsonian in the '90s, it lasted for nearly half a century in that variety of related modes, from the Classical to the Neo-Colonial, which came to be considered "traditional." This lag is the most curious one, for it was in the years from 1890 to 1910 that a quite different sort of architecture developed in the Middle West and on the West Coast, the architecture of one or another of the so-called "Chicago Schools" and the Californians of the Bay Region and the south. Neither the urban architecture of Louis Sullivan and his Chicago contemporaries nor the suburban work of Frank Lloyd Wright, the Prairie School and the Californians in the years down to 1920 shows any visible influence in court-house design even locally, much less nationally. Not until 1918 was a Sullivanian court house commissioned—even in the Middle West, where Sullivan was still being employed to build small-town banks. This was the Woodbury County Court House at Sioux City, Iowa, of 1918 by William L. Steele, a former draftsman in Sullivan's office in association with Purcell & Elmslie of Minneapolis (*Plate 329*). Wright's only court-house commission came at the end of his life in the 1950s; the eventual completion of his Marin County Civic Center in California was actually posthumous (*Plate 151*).

The rejection of the new Middle Western sorts of architectural design of the 1890s for court houses was not purely a matter of taste, though that certainly played an important part.

County commissioners must generally have belonged to a quite different economic and social milieu than the urban magnates who commissioned the Middle Western skyscrapers and the private clients who employed Wright and others of his circle to build their suburban houses. But the buildings the Chicagoans were erecting, tall office blocks and wide-spreading dwellings, were hardly appropriate models for court houses. Those were only just beginning to grow into anything that was functionally comparable to skyscraper office buildings. The court houses had even less in common with the Prairie School houses. It was the essence of their social nature to provide focal monuments at the centers of towns and cities, not rambling edifices in the suburbs or in the country, as Wright's Marin County Court House would eventually be, more than a generation later.

Plate 329. Woodbury County Court House, Sioux City, Iowa, 1918. Architects William L. Steele; Purcell & Elmslie. Photograph by Bob Thall.

All the same, the Wright who built the Unity Temple in Oak Park, Illinois, in 1906 might have essayed a court house; indeed, its auditorium would not make a bad courtroom. But there was a problem of meaning. A Wright court house

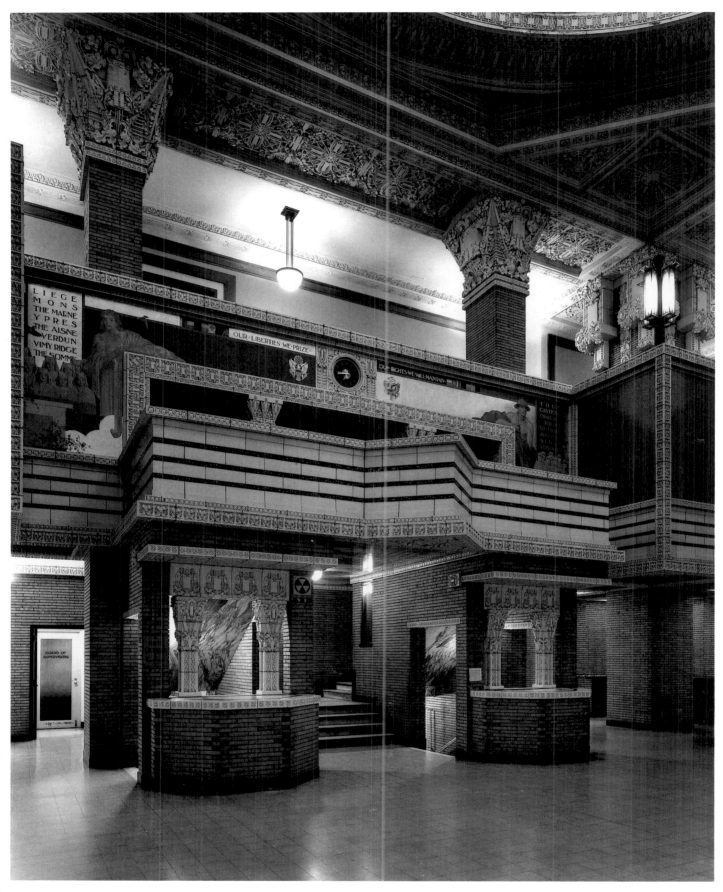

Plate 330. Lobby, Woodbury County Court House, Sioux City, Iowa, 1918. Architects William L. Steele; Purcell & Elmslie. Photograph by Bob Thall.

Plate 331. Lawrence County Court House, Bedford, Indiana, 1930. Architect Walter Scholar. Photograph by Bob Thall.

in the first quarter of this century would never have had the proper symbolic content any more than the Unity Temple seemed to contemporaries an intelligible example of church design.

There was a sort of cultural perversity or perhaps unwitting irony in the continued choice—first in the late '80s and '90s and then for several decades beyond 1920—of European models from the centuries between 1500 and 1800 for American court houses in the twentieth century; while that new sort of architecture—the architecture Wright would later christen "Usonian"—which the outside world admired as modern and peculiarly American was rejected. Less ambiguous in the presumptive motivation behind choice of style are the twentieth-century court houses that followed Neo-Classical modes. For their design a certain inherited continuity from—rather than a revival of—American public architecture of the second quarter of the nineteenth century might be claimed. The difficulty is that the larger domed and porticoed court houses usually aped state capitols, not their own ancestors of more modest size and pretention. The big domes in particular—still echoing most often that of the national Capitol in Washington as completed in the 1860s—provided a well-known symbol indeed, but a symbol of an inflated sort, doubtless quite appropriate to the legislative seats of the states and even that of the national Congress, not to lesser public bodies such as lower courts and county authorities.

Neo-Renaissance design used for court houses did not change much in the 1920s. Nevertheless, Walter Scholar's Lawrence County Court House of 1930 at Bedford, Indiana, where the limestone quarries used for so many court houses of the previous forty years were located, is of exceptional restraint and elegance (*Plate 331*). With its segmental-arched windows below and round-arched ones above, there is almost a reversion here to the Germanic round-arched style of the mid-century, but carried out with eclectic reference in the detailing both to *quattrocento* Italy and to France of the *dix-huitième*.

In contrast to court houses which had such international stylistic reminiscences were some examples in the Southwest and the Far West that sought rather to suggest a regional pedigree, Neo-Colonial in principle but reflecting the provincial late Baroque of Spanish Missions, not the English Georgian of the Atlantic states. The architect responsible for the most notable example, that of Santa Barbara County, at Santa Barbara, California, was William Mooser, whose father had built earlier court houses here and elsewhere in California (*Plate 332*). Erected in 1927-29 as part of an extensive scheme of urban renewal, all of similar design, this was a late specimen of the Mission mode that became so universally popular in southern California after the San Diego Exposition of 1915. The cost was $1.5 million.

Plate 332. Santa Barbara County Court House, Santa Barbara, California, 1927–29. Architects William Mooser Co. Photograph by Tod Papageorge.

Plate 333. Pima County Court House, Tucson, Arizona, 1928. Architect Roy Place. Photograph by William Clift.

Plate 334. Maricopa County Court House, Phoenix, Arizona, 1928. Architect Edward Neild. Photograph by Pirkle Jones.

Another such is the Pima County Court House in Tucson, Arizona, by Roy Place, a more monumental structure topped by a large dome surfaced with colored tiles laid in patterns (*Plate 333*). Here excavation had revealed a portion of the wall of the Spanish Presidio, thus lending historic aura to a design that was more influenced by its proximity to southern California than by real Spanish architecture, whether Old World Castilian or New World Mission.

In the Arizona capital, Phoenix, in the same year, 1928, Edward Neild was building a court house for Maricopa County (*Plate 334*). With $1.2 million to spend, he might well, even at this late date, have provided a structure of state-capitol order rivaling J. Riely Gordon's very late court house at Cortland, New York, completed five years before. But Academic Classicism was, at long last, losing its appeal at the same time that court houses in cities were becoming more and more public office buildings rather than public monuments. The change in scale and function encouraged modification of the still-dominant rule of "traditional" de-

sign and new models—provided by the latest New York skyscrapers rather than by the earlier and finer Chicago ones—now became popular.

With the new "skyscraper style" and now that city court houses such as Neild's might be some eight or nine stories tall—still a considerable height everywhere but in the largest metropolitan centers—architects gave up the Classical orders, substituting a more abstract treatment of wall surfaces marked by pseudo-structural modeling and culminating in shaped terminal features that usually included visible pitched roofs. None of this new stylistic amalgam goes back to Sullivan except for the change in scale and the verticalism which was still rather timidly and superficially expressed. Finally, though Neild largely eschewed it in Phoenix, there was the new ornament borrowed from the Paris Exposition of 1925 which has led to the current acceptance of the term "Art Deco" for the new American skyscraper mode of the late 1920s.

No skyscraper is the Criminal Court House of Orleans Parish in New Orleans built in 1929-31 by Diboll & Owen (*Plate 335*). The Depression of the early 1930s had not yet set in and the architects, with $1.7 million to spend, could provide a profusion of ornamentation. This was very provincial Art Deco as regards the end pavilions and more or less scraped Classical—but including here eight giant Corinthian columns fronting the central section. In contrast to the best buildings in this hybrid vein, those by the French-born Philadelphia architect Paul Cret—which influenced many former students of his, such as the Louisiana firm of Weiss, Dreyfous & Seiferth who built the State Capitol at

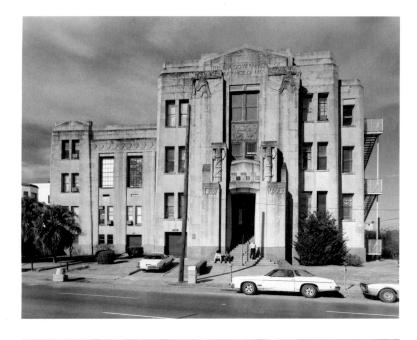

Baton Rouge for Huey Long—these public buildings had lost most of the positive qualities of the traditional architecture of the day without introducing any major innovations in design. At this point and in this state it is sobering to see fasces used as symbols of government on the exterior of a court house.

But straight Classical design was not yet quite passé in the United States. In the same years, 1929-31, the architect Albert Randolph Ross built the Milwaukee County Court House in Milwaukee, Wisconsin (*Plate 336*). He had over $7 million to spend and he used every penny of it. The result is the grandest American example of twentieth-century Classical design, yet one that might in Europe—in the 1930s if not today—be considered Stalinist.

The enormous rectangular block is so composed that its six or seven stories are disguised—as Academic tradition of a sort rarely respected in America was thought to demand—in a composition of three horizontal elements: a rusticated base incorporating two mezzanines above the ground-story arches; tall Corinthian colonnades on all four sides, framed by solid sections at the corners; and two plain, rusticated attic blocks on top. The scale is enormous, yet the architect achieved his super-monumental grandeur still in the old American traditions of the Federal style of the early republic and the Greek Revival style that followed.

For such smaller court houses as that of Washington County at Washington, Kansas, erected in 1932-33 by Overend & Boucher from Wichita, and that for Boulder County at Boulder, Colorado, by the local architect Glenn H. Huntington, completed in 1934, a sort of provincial Art Deco was now often used (*Plates 342, 339*). Sometimes, as in Boulder, where the material was a handsome local pink stone—it was carried out with real simplicity and massing that was not too obvious a parody of the latest urban skyscrapers.

In 1936, a mid-Depression year when local funds had largely dried up, federal money was beginning to flow through the Works Progress Administration into county court-house construction. The scraped Classical with Art Deco touches was almost the official W.P.A. style, and a good example of it is the Colfax County Building at Raton, New Mexico, built that year by Townes & Sunk and R. W. Vorhees (*Plate 337*). The combination of brick and stone is exceptional here, as is the extreme discretion of the ornament, nearer to that of the Prairie School than to what came from the Paris Exposition of ten years before.

Although building construction revived in the late '30s—with regard to county court houses, still in large part thanks to federal funds—the years of World War II and its aftermath in the '40s saw little building and no new stylistic innovations in court-house design. Up to this point the new

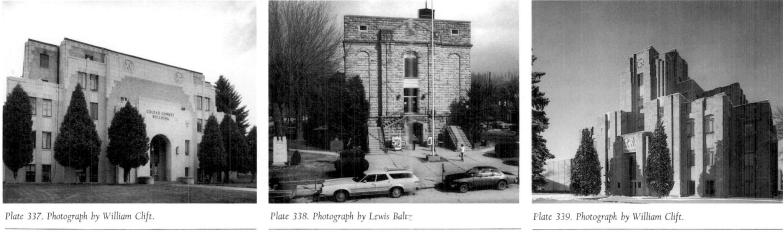

Plate 337. Photograph by William Clift. Plate 338. Photograph by Lewis Baltz Plate 339. Photograph by William Clift.

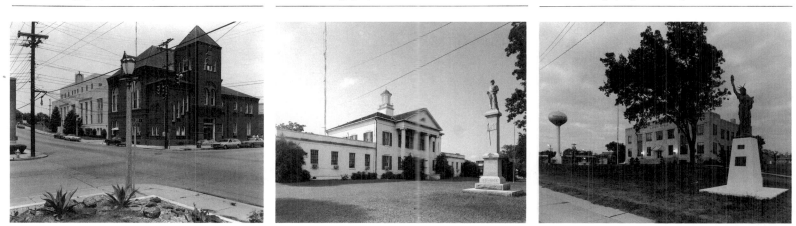

Plate 340. Photograph by Jim Dow. Plate 341. Photograph by Tod Papageorge. Plate 342. Photograph by Tod Papageorge.

Plate 337. *Colfax County Court House, Raton, New Mexico, 1936. Architects Towne & Sunk; R. W. Vorhees. Plate 338. Greenup County Court House, Greenup, Kentucky, c.1938. Architects:W.P.A. supervision. Plate 339. Boulder County Court House, Boulder, Colorado, 1934. Architect Glenn H. Huntington. Plate 340. Natchitoches Parish Court Houses, Natchitoches, Louisiana, 1889; 1939. Architects J. W. Smith; W.P.A. Plate 341. Madison Parish Court House, Tallulah, Louisiana, 1939. Architect J. W. Smith. Plate 342. Washington County Court House, Washington, Kansas, 1932–33 Architects Overend & Boucher.*

European modern architecture, more and more accepted both in the East and in southern California, had no more influence in this field than the architecture of the Chicago School had had earlier except for Steele's court house in Sioux City, Iowa, of 1918 (*Plate 329*).

A few court houses of the late '30s avoided the clichés of the period and retained an almost vernacular vigor despite W.P.A. sponsorship. Both the actual designer and the precise date of the Greenup County Court House at Greenup, Kentucky, are unclear (*Plate 333*). The result is in several respects very laggard—the rock-faced masonry, the sunken arched panels, and the external staircases—yet the proportions of the clock and the plastic variation of the wall surface have a truly architectonic character in contrast to the papery structures that are typical of what can loosely be called the W.P.A. period in the years before and following World War II. New evidence of a certain stasis in court-house design—

not an unfamiliar aspect in several earlier periods—is the retention, either out of historic piety or economy, of earlier court houses to which larger additions were now made in the W.P.A. mode, additions that overshadowed the original edifices. Characteristic is the Natchitoches Parish Court House at Natchitoches, Louisiana, as extended in 1939 with W.P.A. funds (*Plate 340*).

By contrast, historical piety could still take a different direction, particularly in the South. Here, in Louisiana, the Madison Parish Court House in Tallulah of the same year, 1939, is an exceptionally literate example of the Colonial Revival, or more precisely the Federal Revival, with a central block fronted by a pedimented Ionic portico and flanked—like a Virginia plantation house, not a Louisiana one—with one-story side wings (*Plate 341*). The architect was J. W. Smith, but the amount and source of the funds are not known.

245

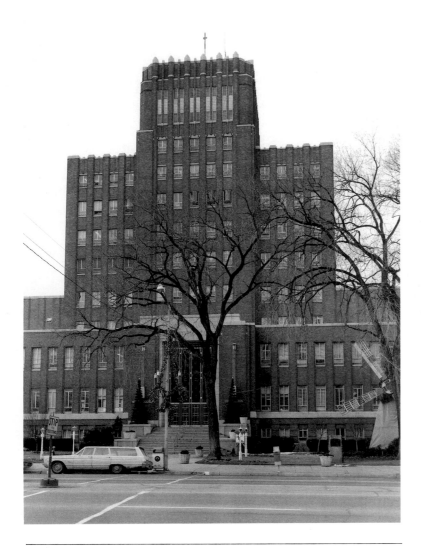

Plate 344. Chaffee County Court House, Salida, Colorado, completed 1932. Architect DeMordaut. Photograph by Lewis Kostiner.

Plate 343. Weber County Court House, Ogden, Utah, 1940. Architect Leslie S. Hodgson. Photograph by Ellen Land-Weber.

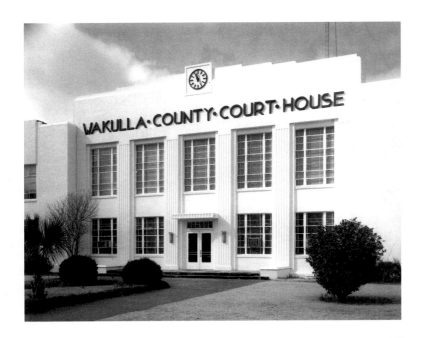

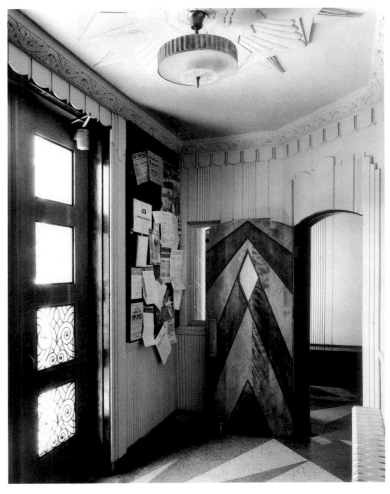

Plate 345. Wakulla County Court House, Crawfordville, Florida, 1948–49. Architect James A. Stripling. Photograph by Stephen Shore.

Plate 346. Lobby, Chaffee County Court House, Colorado. Photograph by Charles Traub.

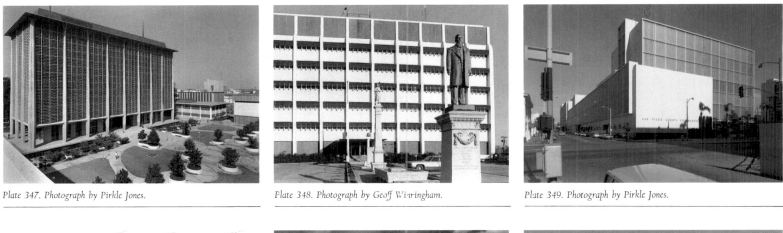

Plate 347. Photograph by Pirkle Jones.　　Plate 348. Photograph by Geoff Winringham.　　Plate 349. Photograph by Pirkle Jones.

Plate 350. Photograph by Lewis Kostiner.　　Plate 351. Photograph by Stephen Shore.　　Plate 352. Photograph by Bob Thall.

Plate 347. Fresno County Court House, Fresno, California, 1964–66. Architect Paul Harris. Plate 348. St. Mary Parish Court House, Franklin, Louisiana, 1950–51. Architects John W. Baker and Neild-Somdal Associates. Plate 349. San Diego County Court House, San Diego, California, 1958–61. Architects Hamill, Hope, Lykos & Wheeler, Associates. Plate 350. Butler County Court House, Morgantown, Kentucky, 1975. Associated Architects and Engineers Howard, Nielsen, Lyne, Thomas, Aldred, Henry & O'Brien, Inc. Plate 351. Houston County Court House, Dothan, Alabama, 1962. Architect Joseph L. Donofro. Plate 352. Stephenson County Court House, Freeport, Illinois, 1975. Architects Johnson, Kile, Seehausen & Associates, Inc.

The differences between court houses in such modest county seats as Tallulah and in towns that were now growing into cities were by this time considerable throughout the nation. The Weber County Court House in Ogden, Utah, built by Leslie S. Hodgson with W.P.A. funds in 1940, is a twelve-story office building (*Plate 343*). Its simplified and verticalized design is of the skyscraper mode but there is no profusion of Art Deco ornament here. This one lacks, moreover, as most court houses did henceforth, any recognizable external evidence whatsoever of its public function except insofar as it still dominates the local scene. How much was supplied by the W.P.A. for the Ogden court house is not recorded.

As has been noted, few court houses were built in the early and mid-'40s. That for Wakulla County at Crawfordville, Florida, of 1948-49 by James A. Stripling, with S. J. Curry & Co. as contractors, is a belated and heavy-handed example of the scraped Classical (*Plate 345*). It is almost totally devoid of decoration except for the fluted pilaster-strips that suggest the work of Paul Cret.

At the mid-century, precisely, a change becomes evident. With the economic recovery that followed the doldrums of the '40s, the new European architecture initiated a quarter-century before began to have its effect on court-house architecture as in other fields of American building. The exposed structure and the ribbon windows of the International Style seem first to have made their appearance on the St. Mary Parish Court House at Franklin, Louisiana, in 1950-51 (*Plate 348*). Here the architects, John W. Baker and Neild-Somdal Associates, revealed in the vertical membering the internal steel skeleton and made the most of the wide spans of the structure in the bay-width groups of identical windows in each of the five middle stories. This is varied only by story-high openings below at ground-floor level and again

in the top story below the flat roof. Ornament is entirely gone, as is axial symmetry. Yet the result is curiously anonymous, with no suggestion of the court house's public function.

Very similar in its anonymity is the four-story county office block incorporating the courts of Floyd County at New Albany, Indiana, built in 1960-61 by Ritz & Oakes (*Plate 148*). A curious link with the local Indiana past here is a borrowed symbol of nineteenth-century grandeur. This is the group of four Corinthian columns from the portico of the very belated Greek Revival court house that Stancliff & Vodges of Louisville, Kentucky, had built for Floyd County in 1865-67, now set up, all by themselves, before the new structure.

Contemporary with that Indiana court house is the one for Fresno County, California, completed by Paul Harris in 1966 (*Plate 347*). Harris had $8 million to spend, and the interest there is less in the court house block itself than in the grouping of structures housing various public functions in a formal garden setting.

Almost unbelievably, the present decade still saw Neo-Classical court houses erected. Such is the one for Butler County at Morgantown, Kentucky, dedicated in the fall of 1975 (*Plate 350*).

There could hardly be a sharper contrast than there is between the modest backwoods court house at Morgantown and the city-county buildings of Wayne County in Detroit, built twenty years earlier by Harley, Ellington, & Day, Inc. (*Plate 150*). Two tall slabs, one twenty stories, the other fourteen, house the county's needs as part of a new civic center. With $15 million to spend, the architects could rival the largest metropolitan structures of the day and were doubtless particularly inspired by the slab of the U.N. building in New York, the work of an international group of world-famous architects. Fine materials—all the solid portions are clad in white marble—bold planar combinations and strategically placed sculpture produce a modern example of monumentality in contrast to the increasingly utilitarian design of the earlier post-war years.

Beside the old Minneapolis Court House and City Hall of the end of the nineteenth century, the Richardsonian work of

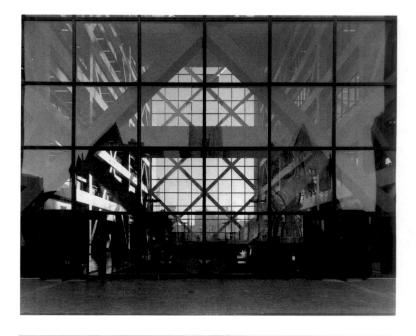

Plate 353. Hennepin County Government Center, Minneapolis, Minnesota, 1971–75. Architect John Carl Warnecke. Photograph by Frank Gohlke.

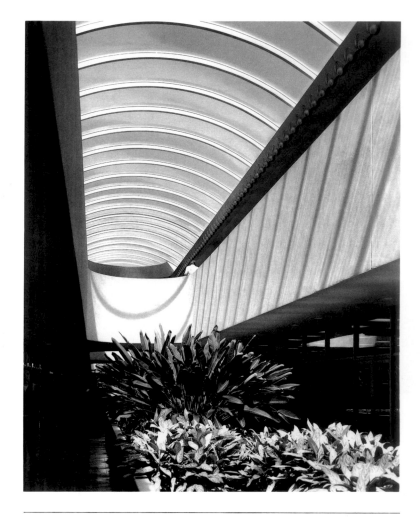

Plate 354. Marin County Civic Center, California. Photograph by Richard Pare.

248

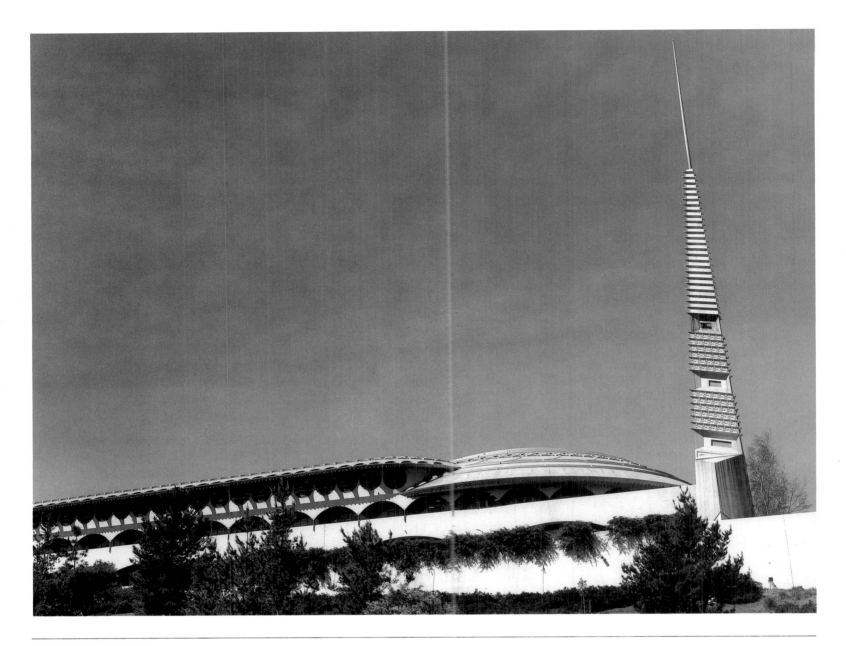

Plate 355. Marin County Civic Center, San Rafael, California, 1957–69. Architect Frank Lloyd Wright; completed by The Taliesin Associated Architects. Photograph by Richard Pare.

the local architects Long & Kees, John Carl Warnecke over the years 1971-75 built two linked blocks, one for the courts, the other for administrative services, that lack the impressive proportions and the fine materials of the Detroit slabs (*Plate 353*).

Even in good-sized cities, court-house blocks did not necessarily rise high now to rival commercial skyscrapers. In San Diego a group of four associated architects together with an engineer built at a cost of more than $11 million an extensive range of relatively low structures loosely linked together in the vocabulary of the International Style which had been naturalized by this time in the United States (*Plate 352*). The setting is less generous than at Fresno, but the massing is more varied and the scale less inhuman. This

is partly because the original building of 1958-61 was almost at once extended with a five-story annex in 1962-64.

The Marin County Civic Center at San Rafael, California, stands apart from the other post-war court houses—and, indeed, all twentieth-century court houses—in being the work of Frank Lloyd Wright (*Plate 355*). The project goes back to the early 1940s, but the complex was incomplete at the time of Wright's death in 1959 and was finished by his successors, the Taliesin Associated Architects, who completed the Hall of Justice wing in 1969. Unrelated to either earlier or contemporary court houses, this is a major late work of Wright which can be better appreciated when considered together with his other late masterworks than as part of the general court-house story. Nevertheless, its unique

Plate 356. Orange County Court House, Goshen, New York, 1970. Architect Paul Rudolph. Photograph by Patrick Linehan.

Plate 358. Grafton County Court House, Woodsville, New Hampshire, 1971. Architects Johnson, Hotvedt, DiNisco & Associates. Photograph by Douglas Baz.

Plate 357. Saratoga County Court House, Ballston Spa, New York, 1966–68. Architects Cadman & Dreste. Photograph by Patrick Linehan.

situation so very late in that story underlines the scarcity of contributions by the major American architects in each succeeding generation to the development of the county court house. Only Richardson was able to provide a model that the public early accepted as appropriate and that many architects nationally followed for decades. But there are no Wrightian court houses by his successors or by any other architects.

Somewhat comparable originality, however, marks the court house of Orange County at Goshen, New York, built by Paul Rudolph in 1970 (Plate 356). Among architects of his inter-

national standing, he alone was given this opportunity to show what could be done with the problem today. His solution remains wholly personal, however, and suggests no model from which others might develop a continuing vein of public-building design. Once again, as in the second quarter of the nineteenth century, it is evident that the modest needs of rural counties can be better served architecturally than can those of the bigger counties whose seats are in the large cities.

Still more modest and less boldly original is the slightly earlier brick court house of 1966-68 for Saratoga County, New York, at Ballston Spa, by Cadman & Dreste (Plate 357). With this anti-climactic, but not unworthy work the story comes to its current terminus. The story need not be summarized at this point. Its lessons are less those of the work done in the last quarter century than in the long years before. As a building type the earlier court houses present a rich sampling of vernacular design. They stand as symbols still valid today of the grass-roots vigor of older American architectural expression. This somehow died away in the twentieth century with the pursuit of stylistic correctness. It has not yet revived.

BIBLIOGRAPHY

SOURCES FOR

THE RECORD OF BUILDINGS AS EVIDENCE
PHYLLIS LAMBERT

I am most grateful to Herbert Mitchell, bibliographer of Avery Library, Columbia University, New York, for his invaluable help in identifying architectural publications in the United States, and to A. Hyatt Mayor and Weston Naef of The Metropolitan Museum of Art for their useful suggestions.

The statement by Charles Nègre is published in *Charles Nègre, 1820–1880*, by James Borcoman, Ottawa, 1976.

Sources not specified in the text are:

Artistic Houses, Being a Series of Interior Views of a Number of the Most Beautiful and Celebrated Homes in the United States, New York, 1883–84.

Destailleur, Hippolyte, *Catalogue de livres et estampes relatifs à l'histoire de la ville de Paris et de ses environs*, Paris, 1894. Auction catalogue.

———, *Catalogue de livres et estampes relatifs aux beaux-arts*, Paris, 1895. Auction catalogue.

Gillon, Edmund V., Jr., *Early Illustrations and Views of American Architecture*, New York, 1971.

Gower, H. D., L. S. Jast and W. W. Topley, *The Camera as Historian*, London, 1916; reprinted New York, 1973.

Hitchcock, Henry-Russell, *American Architectural Books*, 3rd edition, New York, 1976.

Léon, Paul, *La vie des monuments français*, Paris, 1951.

Mallet, Alain Monesson, *Description de l'univers, contenant les différents systèmes du monde et en particulier de la géographie ancienne et moderne, les plans et les profils des principales villes et des autres lieux plus considérables de la terre*, Paris, 1683.

Mayor, A. Hyatt, *People and Prints: A Social History of Printed Pictures*, New York, 1971.

Naef, Weston J., and James N. Wood, *Era of Exploration: The Rise of Landscape Photography in the American West, 1860–1885*, Boston, 1975.

Rudisill, Richard, *Mirror Image: The Influence of the Daguerreotype on American Society*, Albuquerque, N.M., 1971.

Sabin, Joseph, *Dictionary of Books Relating to America*, New York, 1867–68.

Sheldon, George William, ed., *Artistic Country-Seats: Types of Recent American Villa and Cottage Architecture*, New York, 1886.

Stone, Sir Benjamin, *Sir Benjamin Stone's Pictures: Records of National Life and History*, London, 1906.

Sutcliffe, Anthony, *The Autumn of Central Paris: The Defeat of Town Planning, 1850–1970*, Montreal, 1971.

SOURCES FOR

THE ORIGINS AND IMPACT OF THE COUNTY COURT SYSTEMS
PAUL C. REARDON

Adams, Henry, "The Anglo-Saxon Courts of Law," *Essays in Anglo-Saxon Law*, Boston, 1906.

Busch, Francis X., *Prisoners at the Bar*, Indianapolis, 1952.

Catton, Bruce, "The Dred Scott Case," *Quarrels That Have Shaped the Constitution*, New York, 1964.

Channing, Edward, *Town and County Government in the English Colonies of North America*, Baltimore, 1884.

Corwin, Edward S., "The Dred Scott Decision," *The Doctrine of Judicial Review: Its Legal and Historical Basis and Other Essays*, Princeton, N.J., 1914.

Hackwood, Frederick W., *The Story of the Shire*, London, n.d.

Hart, Albert Bushnell, *Practical Essays on American Government*, New York, 1894.

Hopkins, Vincent C., S.J., *Dred Scott's Case*, New York, 1967.

Kaplan, M. B., "The Trial of John T. Scopes," in Robert S. Brumbough, ed., *Six Trials*, New York, 1969.

Lancaster, Lane W., *Government in Rural America*, Princeton, N.J., 1957.

Levenson, Rosaline, *County Government in Connecticut—Its History and Demise*, Storrs, 1966.

Russell, Francis, *Tragedy in Dedham*, New York, 1962.

Sydnor, Charles S., *The Development of Southern Sectionalism, 1819–1848*, Chapel Hill, N.C., 1948.

Wager, Paul W., ed., *County Government Across the Nation*, Chapel Hill, N.C., 1950.

Waller, George, *Kidnap—The Story of the Lindbergh Case*, New York, 1961.

Webb, Sidney and Beatrice, *English Local Government from the Revolution to the Municipal Corporations Act: The Parish and the County*, London, 1906.

Wilson, Charles Morrow, *The Dred Scott Decision*, Philadelphia, 1973.

SOURCES FOR

NOTES ON THE ARCHITECTURE
HENRY-RUSSELL HITCHCOCK & WILLIAM SEALE

The Seagram Bicentennial Court House Project began in 1975 with an initial search of major libraries to determine the extent of source material available on county court houses. Other than scattered materials on individual buildings there are few researched surveys. One notable exception to this is Paul Goeldner's *Temples of Justice: Nineteenth Century County Courthouses in the Midwest and Texas*, an unpublished Ph.D. dissertation for Columbia University. Mr. Goeldner personally searched court-house records in twelve states and provided the most complete documented court-house survey available. This was the most important single source and a continuing point of reference.

The dearth of existing information necessitated contacting county officials directly. In order to gain basic visual and factual information about these buildings across the country, approximately five thousand letters and questionnaires were sent to the clerks and supervisors of all counties as well as state, county and local historical societies and bar associations. Among the data requested were the year, architect, contractor, extent of alterations, building site, and whatever visual evidence of the structure could be furnished. This provided a basis for deciding which court houses should be photographed and studied further.

The results of this mailing formed the core of the Seagram Court House Archive. It consists of news clippings, articles, pamphlets, county reports, court house feasibility studies, dedication brochures, postcards, snapshots and unpublished local histories and manuscripts. We are greatly indebted to the many county clerks, county commissioners, librarians, historians and local citizens who so enthusiastically assisted by delving into their county and historical records and who made an

important contribution to the success of the Project. A great deal of appreciation also goes to State Historic Preservation Offices for researching their state architectural surveys and files.

Additional material was obtained from architectural and historical books and articles in Avery Architectural Library, Columbia University, New York City, and the New York City Public Library. The archives of the National Register of Historic Places and of the Historic American Building Survey, both within the National Park Service, Department of the Interior in Washington, D.C., were invaluable.

Publications of noteworthy aid were American Institute of Architects Guides, state catalogues published by the Historic American Buildings Survey, and the state-by-state guides published by the W.P.A. (Works Progress Administration) in the 1930s. Several state chapters of the National Society of the Colonial Dames have published state surveys of county court houses, although they vary in detail.

Working with numerous source materials, there are often discrepancies as to architects, contractors, dates and cost of construction, among other facts. Ultimately, the best sources of information are the court house records themselves.

In addition to the above-mentioned sources, the following were also used:

GENERAL

A Courthouse Conservation Handbook. Washington, D.C.: Preservation Press of National Trust for Historic Preservation, 1976.
Goeldner, Paul Kenneth, Temples of Justice: Nineteenth Century County Courthouses in the Midwest and Texas, unpublished Ph.D. dissertation, Columbia University, New York, 1970. Includes Illinois, Indiana, Iowa, Kansas, Michigan, Minnesota, Missouri, Nebraska, Ohio, South Dakota, Texas and Wisconsin.
Greenburg, Ronald, chief ed., The National Register of Historic Places 1976. Washington, D.C.: National Park Service, 1976.

Historic American Buildings Survey Catalog. Washington, D.C.: National Park Service, 1941.
Seale, William, and Henry-Russell Hitchcock, Temples of Democracy: The State Capitols of the U.S.A., New York, 1976.
Short, C. W., and R. Stanley Brown, Public Buildings: A Survey of Architecture of Projects Constructed by Federal and Other Governmental Bodies, 1933–39. Washington, D.C.: U.S. Government Printing Office, 1939.

SPECIFIC

The American Courthouse. Auburn, Calif.: Lardner Lardner Architects & Associates, December 1975. Northern and central California historic court houses.
Campen, Richard N., Ohio—An Architectural Portrait, 1973.
Cole, Maurice, Michigan's Courthouses Old and New, 1974.
"Courthouse Series," Los Angeles Daily Journal, 1975–76. A series of articles on California county court houses.
Crane, Sophie and Paul, Tennessee Taproots, Old Hickory, Tenn., 1976.
Hardy, Janice, "Georgia County Courthouses," unpublished typescript, Georgia College, Milledgeville, 1977.
Harper, Herbert L., "The Antebellum Courthouses of Tennessee," Tennessee Historical Quarterly, Spring 1971, pp. 3–25.
Hermansen, David R., "County Courthouses in Indiana," unpublished typescript, Ball State University, Muncie, Ind., 1977.
——, Indiana County Courthouses of the Nineteenth Century, Muncie, Ind.,1968.
Radoff, Morris L., The County Courthouses and Records of Maryland. Part I: The Courthouses, Annapolis, Md., 1960.
Recchie, Nancy Ann, Ohio Courthouses—An Analysis of Representative Nineteenth Century Architectural Styles, unpublished master's thesis, University of Virginia, Charlottesville, 1976.
Robinson, Willard B., "Notes and Documents: The Public Square as a Determinant of Courthouse Form in Texas," Southwestern Historical Quarterly, January 1972, pp. 339–372.
—— and Todd Webb, Texas Public Buildings of the Nineteenth Century, Austin, Tex., 1974.
Welch, June Rayfield, and J. Larry Nance, The Texas Courthouse, Dallas, Tex., 1971.

INDEX

INDEX OF PHOTOGRAPHERS

*Plate 359. Cast-iron detail, Macoupin County Court House, Carlinville, Illinois, 1867–70.
Architect Elijah E. Myers, Photograph by William Clift.*